# Contents

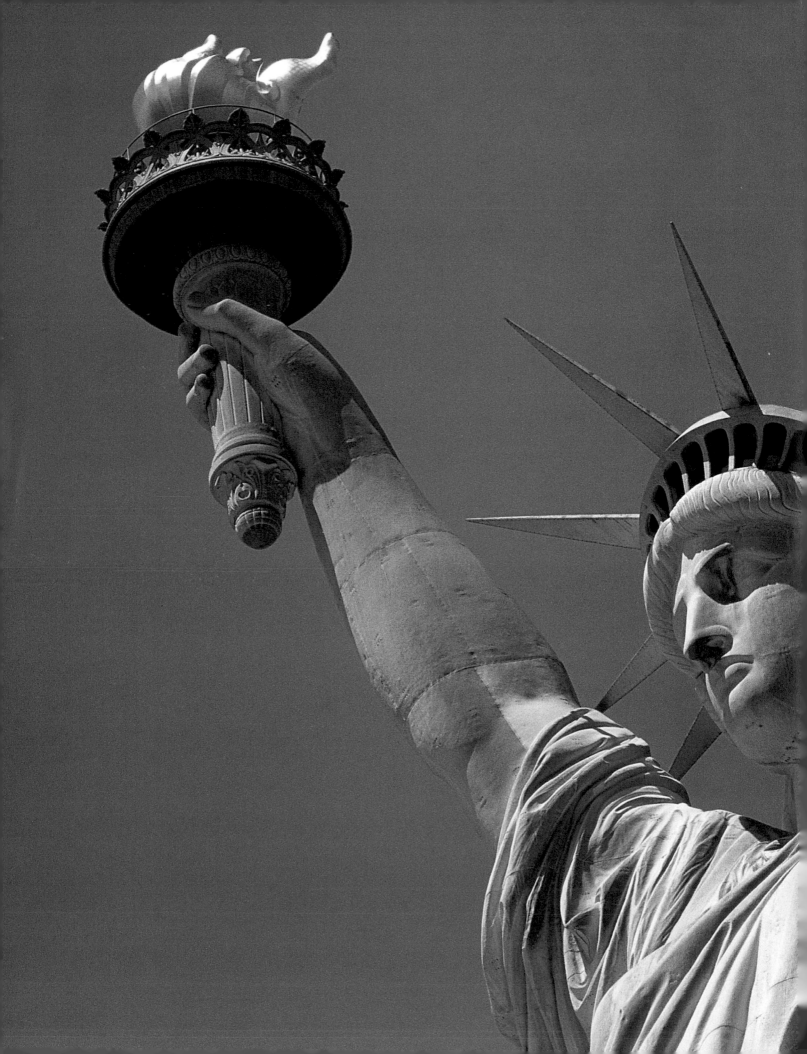

# Introduction

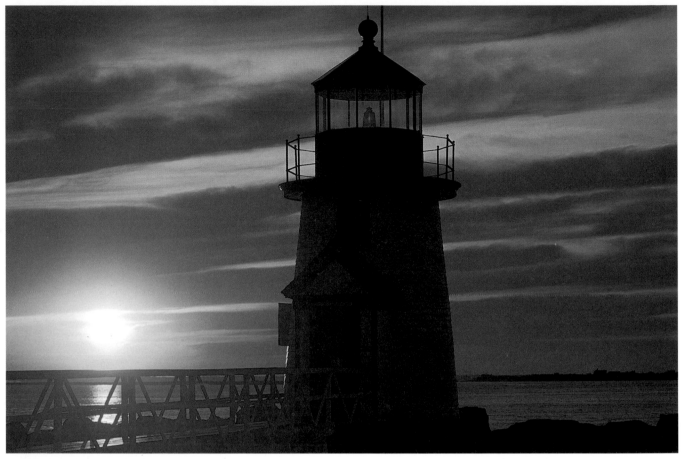

*Pervious pages:* **Statue of Liberty, Liberty Island, New York Harbor;** *Above:* **Brant Point Light, Nantucket, Massachusetts**

*"The considerations which enter into the choice of the position and character of the lights on a line of coast are either, on the one hand, so simple and self-evident as scarcely to admit of being stated in a general form, without becoming mere truisms; or are, on the other hand, so very numerous, and often so complicated, as scarcely to be susceptible of compression into any general laws."*
—ALAN STEVENSON

The presence or absence of light is an enduring theme in world history. Numerous spiritual traditions present the appearance of a founder or guru as the symbol of light. Christ told his disciples that "You are the Light of the World," while the Buddha urged his followers to "Be a lamp unto yourself." Historians long called the period between the fall of the Roman Empire and the rebirth of Classical civilization in Italy the "Dark Ages." During the Renaissance, artists strove to find new ways to present light and shadow, and the eighteenth-century Enlightenment sought to cast light wherever shadows existed. The Romantic artists felt that the use of light had gone overboard, and their work demonstrated the beauty of life at the edge point, where light and darkness come together. Is it any wonder, then, that lighthouses have become a vivid symbol of the human need to cast light out into the darkness?

Today lighthouses are in danger. The advent of radar and radio beacons has obviated the need for many of the beautiful towers that grace the coasts of most of the world's seafaring countries. Will they slowly fall into ruin, or will the better angels of our natures prevail, and steps be taken to preserve the wood, stone, concrete and fiberglass towers that have provided inspiration for so many people for such a long time?

Sailors have always had a special need for light; the hazards of navigation are formidable enough on a calm day, but compounded greatly at night and in severe

weather conditions and low visibility. So as sailing, exploration and trade began to increase in the world, so too did the need for navigational aids. The lighthouse provided early warning of submerged rocks, reefs and sandbars; sheer cliffs; rip tides; shallows in which ships could run aground; and other coastal hazards. They marked channels into safe harbor and served as daymarks and as landmarks by night, counteracting darkness, fog, haze, snowfall and squalls. In such conditions of low visibility, the beacon provided both a focal point and a potential source of rescue for mariners in distress, as lighthouse keepers came to play an increasingly active role in lifesaving endeavors.

## The Earliest Lighthouses

The first primitive lighting systems were probably bonfires lit on beaches. The drawback of this early system was that the local areas tended to run out of wood. "Wreckers" sometimes used fires to lure ships onto rocks to be pillaged. The builders of these early lights eventually realized that the Earth's surface is curved, and that a light must be placed on high to be seen far out at sea. Statistical evidence for this premise was not available until the nineteenth century, when the tables that we take for granted today came into existence. A light placed 10 feet above sea level can be seen for 8.06 miles; one placed at an elevation of 50 feet is visible for 12.55 miles; a light that stands at 100 feet can be seen for 15.91 miles; and a tower that has its focal plane at 200 feet is visible for 20.66 miles.

The first known major beacon building project began before 270 BC, when the Pharos lighthouse was lit at Alexandria, Egypt. Alexander the Great chose this ancient Middle Eastern crossroads for his eponymous city, and during the reigns of Ptolemy I and II, the Greek architect Sostratus of Gnidus built the Pharos on a 300-square-foot base in the city harbor. The famous Library of Alexandria was built at almost the same time. One of the seven wonders of the Ancient World, the Pharos figured in both art and literature.

This massive structure, estimated to have been some 400 feet high, emitted a light that could be seen as far as 33 miles out into the Mediterranean Sea. The acme of architectural achievement during the Hellenistic Era,

it remains vivid today in the minds of those who admire Classical culture. The Pharos was in use until AD 641, when Islamic warriors conquered Alexandria and the building was damaged in the siege.

The Arab geographer Edrisi visited the Pharos in the thirteenth century and commented:

*This lighthouse has not its equal in the world for excellence of construction and for strength, for not only is it constructed of a fine quality stone, called 'kedan,' but the various blocks are so strongly cemented together with melted lead, that the whole is imperishable....At a distance the light appeared so much like a star near the horizon that sailors were frequently deceived by it.*

Nothing, of course, is truly imperishable, and the great Pharos was finally felled by a series of earthquakes in the fourteenth century. Parts of the beacon are now being resurrected by a team of French archaeologists. Its famous name has been imparted to lights around the world: The French word for lighthouse is *"phare"* and the Spanish, *"faro."*

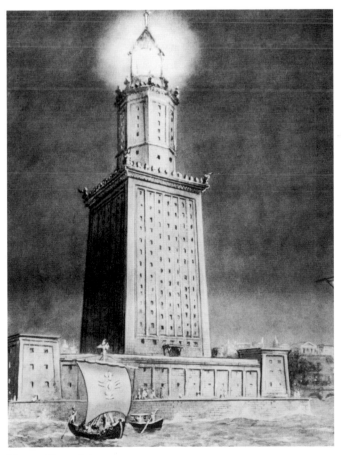

Pharos, Alexandria

The Mediterranean remained the center of lighthouse development for a long time. The Romans turned their hand to building lighthouses. From what we know of seacoast control during the Roman Empire, we gather that about thirty lights were established at key stations around the Mediterranean Sea and along the Atlantic coasts of France and Spain. During the reign of the Emperor Trajan, the Portus was built at the mouth of the Tiber River. One of the major engineering projects of the Imperial period, the Portus was celebrated on Roman coins bearing the image of the lighthouse. Modeled on the Pharos, the beacon was composed of three levels topped by a cylindrical apex housing the flame. Such structures as this helped to maintain the Roman concept of the Mediterranean as *Mare Nostrum* ("Our Sea").

Portus was especially important as the lighthouse illuminating the destination point for supplies of grain that were shipped from Alexandria for consumption by the people of Rome. Due to the prevailing northwesterly winds, it took the supply ships just more than a month to make their way from the Pharos of Alexandria to the light at Portus, but as little as two or three weeks to make the return trip, which was comparatively "downhill."

Other than the light at Portus, what we know about these Roman lighthouses is that they exemplified the architectural style known today as Romanesque. They were short, squat and had little window space, similar to the fortresses that were built inland throughout the Imperial period. But these lighthouses served a vital function, and many indeed were the sailors who must have been comforted by the presence of a bonfire or candles burning inside one of these crude structures. The desire for elegance in lighthouse architecture was a luxury that would have to wait.

The declining vitality of the Roman Empire after AD 300 was reflected in its architecture. Few new buildings were created, and those that existed were not repaired; thus the entire network of lighthouses and coastal connections that had made *Mare Nostrum* a reality began gradually to fade away. Not for more than 1,000 years would Europe truly recover from the fall of Rome, which is usually dated at AD 476.

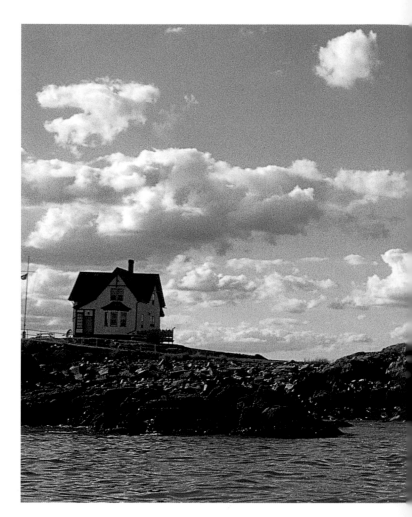

One bright spot emerged to challenge what historians refer to today as the Dark Ages. During the reign of Charlemagne, King of the Franks, the old Roman lighthouse at Boulogne on the French coast was restored and made to shine. This lighthouse, built by order of the emperor Caligula, was twelve stories high, each successive story smaller than its predecessor. This intricate architecture fell prey to intervening periods of darkness, warfare, invasion and famine. Known to the French as the *Tour d'Ordre* and to English sailors as the Old Man of Bullen, the tower finally collapsed into the sea in 1644.

Sailing techniques and the use of navigational aids also fell into a long malaise. Scholars today estimate that in 1300 it took just about as long for a Venetian or Genoan galley to cross the Mediterranean as it had for a Roman craft in AD 200—more than a millennium passing without discernible progress. Thus, while lighthouses may have been needed, none (or few) were built, and only negligible advances were made in the art of

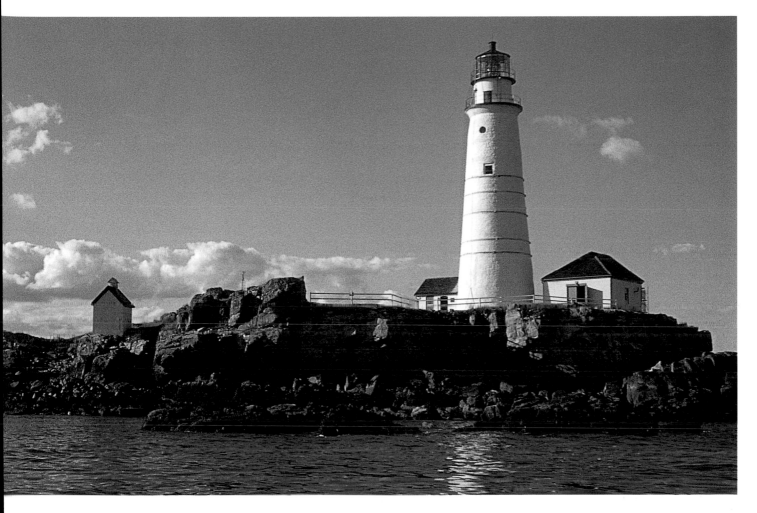

other navigational aids. Between 800 and 1100, the Norsemen (or Vikings) were the best sailors in the Western world, but to our knowledge they built no permanent coastal lights. Maritime improvements after 1300 were often due to adaptations from Arab vessels; the use of the lateen sail, for example, greatly enhanced the ability of ships to sail against the wind.

Undoubtedly, it was the ripple effect from the Mediterranean countries that made the difference in bringing lights and lighthouses closer to the world of Northern Europe, and, by extension, to North America. The advent of the High Middle Ages, and later the Age of Discovery, changed the scenario, especially for European sailors. Once again, Mediterranean sailors and architects led the way, but this time the knowledge and recognition of the need for lighthouses spread more quickly to Europe. Trade increased after 1300, and some of the new European nations began to bestir themselves and spread their canvas wings: Portugal was the first.

### The European Maritime Powers

Portuguese sailors had developed the caravel by around 1400 and soon reached the waters at the Southern tip of Africa en route to the "spices of the Indies" (the Spice Islands of Indonesia). At Sagres, on the southwestern corner of Europe, Prince Henry the Navigator (who himself never went to sea) established the first school for maritime navigation about 1420.

The coastal cities of Italy continued to lead the way within the bounds of the Mediterranean Sea. The first Italian light was probably at Meloria, built in 1157. Venice, Tino and the Straits of Messina all had lighthouses, as did the port of Genoa, where Antonio Colombo, uncle of the famous Christopher Columbus, was the tower's keeper in 1449. These lights, however, were symbols of an era of Mediterranean power that was destined to end, as the Atlantic states of Portugal, Spain, France and England each took up the gauntlet of lighthouse construction.

France gained ascendancy on the seas during the sixteenth century. While navigators like Jacques Cartier and Samuel de Champlain found their way to North America and explored the St. Lawrence Gulf and River, King Henry III commissioned Louis de Foix to build a light at Cordouan, where France's wine exports from Bordeaux reached the ocean. De Foix died shortly before the completion of his work, which was ongoing from 1584 until 1611. Built to function as a light, a chapel and a royal residence, the tower stood for many years as the apogée of lighthouse development. The first Fresnel lens, with a range of 21 nautical miles, was installed in the tower in 1823. Restored several times since, the light still guides ships entering the Gironde River.

The seventeenth century brought considerable acceleration in lighthouse development. Denmark established a national lighthouse service in 1650, as did Finland in 1696. England had its Trinity House, established in 1566, but the first light was not built until 1619, and Trinity House did not assume full control over the coast of England until the 1830s. The Crown granted licenses to private enterprises that took up the challenge of confronting maritime safety issues. The first great challenge the fledgling maritime nation faced was the monster reef off its southwestern shores.

The Pilgrim ship *Mayflower* sailed from Plymouth, England, on September 6, 1620. That same day, the ship's captain noted in his log the "wicked reef of twenty-three rust-red rocks lying nine and one half miles south of Rame Head on the Devon mainland…a great danger to all ships hereabouts, for they sit astride the entrance to this harbour and are exposed to the full force of the westerly winds and must always be dreaded by mariners. Leaving Plymouth, we managed to avoid this reef." Many ships were not so lucky.

The Eddystone rocks remained unconquered even as England grew in maritime size and strength during the seventeenth century. English sailors had found their way around Chesapeake Bay, the Strait of Magellan and many other shipping hazards before a solution was found to the problem that lay so close to home. As Plymouth grew in size and importance, it became more and more imperative to find an answer to the dreaded reef. As shipping between Britain and North America

increased, so too did the need for a remedy for the problem at Eddystone. French, Dutch and Swedish sailors were also threatened by the rocks.

Henry Winstanley was a member of the English generation that saw its nation rise to maritime greatness. Referring to the War of the Spanish Succession that ended in 1713, the naval historian Alfred Thayer Mahan remarked: "Before that war England was one of the seapowers; after it she was *the* seapower, without any second." While we cannot lay all of this at the feet of Henry Winstanley or the Eddystone Light, it's safe to say that the engineering feat that culminated in its construction was one of the great leaps forward in British maritime affairs.

For a time, English sailors laboriously rowed Winstanley and his small group of workers the 14 miles to the reef, where they put in 10 hours of work per day before they were returned to Plymouth. Given the hazards of small-craft navigation, Winstanley accomplished a major feat in keeping body and soul together while he erected the light that would become one of the world's most famous.

The rocks at Eddystone are almost fully submerged at high tide, making the work even more hazardous. During the first season, all that could be accomplished was the drilling of twelve holes, to allow for building the foundation. The second season yielded greater progress: The laborers built a base that was 14 feet in diameter, and the tower rose to 12 feet. During the third year the tower rose to 80 feet, and in the fourth and final year, it reached 120 feet. On November 14, 1698, Winstanley lit eleven candles at the top of the edifice, making lighthouse history.

The great engineer did not enjoy his success for long. He perished when his light was washed away by a tremendous storm that struck the coast of England in 1703, leaving the treacherous reef unmarked. A stark reminder of its danger came when the English ship *Winchelsea* was wrecked at Eddystone soon after she returned from a voyage to Virginia.

John Rudyerd built the second light at Eddystone. Made of wood, the tower was completed in 1709 and served faithfully until it burnt in 1755. John Smeaton designed and built the third tower, completed in 1759.

*Previous pages:* **Boston Harbor Light, Little Brewster Island, Massachusetts;** *Above:* **Seals Point Light, Cape St. Francis, South Africa**

After standing for 120 years, it was dismantled and brought ashore to Plymouth in 1882. The fourth and current tower was completed in the same year. For many years Eddystone Light was displayed on the British penny as a symbol of the nation's maritime sovereignty.

Well before this time, the Anglican bishop George Berkeley had made the statement: "Westward the course of empire takes its way." This would hold true for the building of lighthouses as well as the development of constitutional government and democracy in North America, which includes Canada, the United States and much of Old Mexico. Upon first glance at an atlas, one is struck by the importance of river systems and the network of the Great Lakes. The St. Lawrence and Mississippi Rivers present the easiest means of finding one's way into the continent, while the Columbia and Colorado lead the traveler to the Pacific Ocean. None of this was charted in 1500, and there were no lighthouses until at least 1700. But the potential was there for exploration, adventure, colonization and exploitation.

South America and the Caribbean, colonized by the Spanish and Portuguese, narrowly jumped the gun on their neighbors to the north. To the best of our knowledge, the first lighthouse built in the New World was the Morro Light of Havana, built around 1563 on the island of Cuba. The light was later incorporated into the Castle of the Three Kings of Morro, and UNESCO declared the area a World Heritage Site in 1982.

Completed in 1698, the same year as Eddystone Light, the Santo Antonio Lighthouse was the first to be built on the mainland of either North or South America. Commissioned by the Portuguese governor of Brazil, the stone lighthouse still guards the entrance to the harbor of Salvador City. The masonry tower is 59 feet high and its focal plane is at 72 feet above sea level.

## Lighthouses in the New World

France, Spain, Holland and England all built colonies in North America during the sixteenth and seventeenth centuries. Since all these colonies depended upon trade, the need for ports, harbors and lighthouses soon became apparent. The first certain example came on September 17, 1716, when the *Boston News Letter* reported:

Boston. *By virtue of an Act of assembly made in the First Year of His Majesty's [King George I] Reign, For Building and Maintaining a Light House upon the Great Brewster (called Beacon-Island) at the Entrance of the Harbour of Boston, in order to prevent the loss of the Lives and Estates of His Majesty's Subjects; The said*

*Light House has been built; and on Fryday last the four-teenth Currant the Light was kindled, which will be very useful for all Vessels going out and coming in to the Harbour of Boston.*

George Worthylake was the first caretaker of this, the first lighthouse built in North America. The light was a material representation of the fact that the new English colonies needed trade in order to thrive; the number of vessels entering Boston Harbor grew apace. It was no small feat to plan and build such a beacon: Our best estimates indicate that in 1716 there were only some seventy lighthouses in the world. That would soon change.

French colonists erected the second light on the mainland of North America. Located at the northern entrance to the harbor at Louisbourg on Cape Breton Island, the round, castlelike tower was 66 feet high and contained a circular stairway. Finished in 1733, the light had sixteen spermaceti whale-oil lamps. The

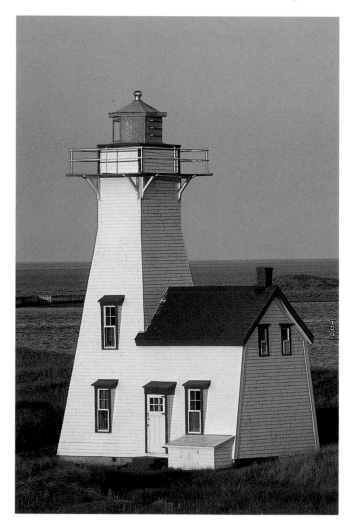

lighthouse burned down in 1736 and was replaced by the first concrete, fireproof building in North America. Ironically, the town, fortress and lighthouse were all captured by invading militiamen from Massachusetts in 1745; the only towns with lighthouses on the coast of North America were fighting each other! The lantern was shot away in the second siege of Louisbourg, accomplished by British forces in 1758. The tower slowly fell into ruin, and a visitor later wrote:

*While on its high and rugged steep*
*That o'erhangs the howling deep*
*The sailor's beacon claims devotion —*
*And looks like baron's donjon keep.*

As the British went on to conquer Nova Scotia and Eastern Canada, they built the first British-Canadian lights at places like Sambro, just outside of Halifax. British maritime supremacy in the New World seemed assured in the wake of the wars that brought French Canada under her sway, but later developments would change this. Meanwhile, the Dutch in New York's Hudson Valley and the Swedes of the Delaware Valley did not attempt to build any lighthouses. The Spanish in Florida may have built one at St. Augustine during the sixteenth century, but no positive evidence exists.

English colonists led the way in lighthouse construction along the East Coast. Brant Point Light on Nantucket Island; Tybee Island Light at Savannah; Beavertail Light in Narragansett Bay; Connecticut's New London Light; Sandy Hook, New Jersey, Light; Cape Henlopen Light at the entrance to Delaware Bay; Charles Town (later Charleston) Light; Plymouth Light; Portsmouth Light; and Cape Ann Light were all built prior to the American Revolution. The majority were built north of Delaware Bay, and this would remain the case until the 1820s.

After the American Revolution, individual states assumed responsibility for the lights in their areas. However, in August 1789, the seventh official act of the newly created Congress was to take responsibility for navigational aids throughout the new nation. President George Washington, once a surveyor, was involved in the process during the early years: He appointed lighthouse keepers and negotiated with contractors. Maine's Portland Head Light, and Old Cape

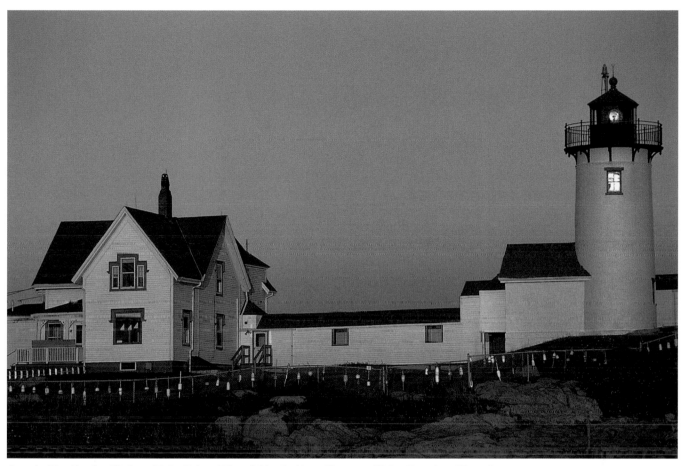

*Opposite:* **New London Harbour Light, Prince Edward Island;** *Above:* **Gloucester Light, Cape Ann, Massachusetts**

Henry Light, at the southern side of the mouth of Chesapeake Bay, were the first built under the auspices of the new U.S. government. Both still stand as vivid reminders of American initiative in maritime affairs.

Virtually no Americans had yet seen the Pacific Coast or the Great Northwest, but Russians were finding their way down from the Bering Strait and Alaska. About 1795 the Russians erected the first light on the West Coast, at Sitka, Alaska. Placed at the top of Baranoff Castle, it was reportedly 100 feet tall. Like the rest of Sitka, it was burned in an attack by the Tlingit in 1802, but was later rebuilt.

### Advances in Lighting Technology

How were these towers lighted over the centuries? The answer is multifold. During Roman times, many light towers had a bonfire either on top of the structure or underneath it, whence the light was reflected upward by convex mirrors. These techniques were perfected in the ancient world, but were gradually lost during the Dark and Middle Ages. The use of candles made for positive development during the Renaissance and the centuries that followed.

Eddystone Light and the lights in colonial North America were lit by candles and rated in terms of candlepower. No major developments occurred until the mid-eighteenth century, when the Frenchman Francois-Pierre Ami Argand designed a set of lamps and parabolic reflectors. He sought to overcome the fact that light naturally diffuses both horizontally and vertically, being emitted at 360 degrees from the center. The horizontal aspect—what sailors could see as they approached the light—was positive. But the loss of a large percentage—perhaps 50 percent—of the light to the vertical dimension diminished its effectiveness.

Argand improved upon the method used for 200 years. In his catoptric system, reflectors placed behind the illuminant spread the light and magnified its

strength. Invented around 1781, Argand's oil lamp with reflectors had a hollow, circular wick that allowed oxygen to pass evenly on both sides. This served to make the light brighter and smokeless.

England and France quickly adopted Argand's lamp system and their lighthouse administrations improved remarkably. It was not until 1812 that an unemployed Yankee ship captain named Winslow Lewis persuaded the U.S. government to use "his" lamp and lens system (undoubtedly copied from an example of the Argand system he had seen in Great Britain).

Lewis had installed his lamps in all of the American lighthouses by about 1816. His friendship with Stephen Pleasonton, director of U.S. lighthouses, allowed Lewis a virtual monopoly of lamps and lighting for the next forty years, thereby preventing the adoption of a revolutionary and far more efficient system.

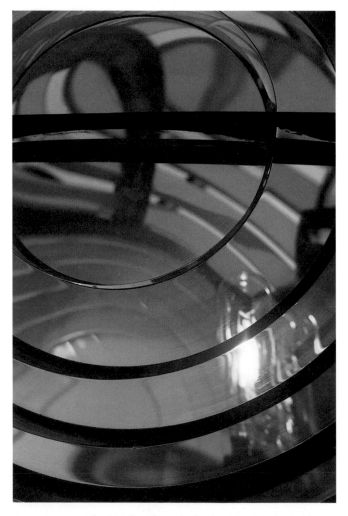

Lens, Anacapa Island Light, Channel Island National Park, California

Augustin Jean Fresnel was born in Brittany in 1788. After studying physics, he joined the French lighthouse establishment in 1813. Fresnel turned his attention to the vexing problem of the diffusion of light, and by 1822 he had mastered the problem for the time being. He created a series of lamps, since known as Fresnel lenses. Shaped like a glass beehive, the series of concentric circles of glass refract, or bend, the light so that it shines out horizontally rather than radially. His early efforts were not perfect; perhaps 10 percent of the light still diffused vertically. But that improvement was dramatic and gave rise to a tremendous increase in lighting and lighthouse efficiency.

Fresnel tested his device at the famous Cordouan lighthouse in 1823. He died in 1827, knowing that his instrument was successful, but unaware of how soon it would transform the international lighthouse system. In Scotland, the Stevenson family took up Fresnel's lenses and experimented with them, making them even more efficient, and during the 1840s and '50s, the British lighthouses were by far the best in the world.

The Fifth Auditor of the U.S. Treasury, Stephen Pleasonton, had responsibility for all the lights between 1820 and 1852. A career bureaucrat and a conscientious bookkeeper, Pleasonton preferred economy to ingenuity. Lacking nautical expertise, he entrusted the lighting to Lewis, whose insistence on using outdated Argand lamps instead of the new Fresnel lens held the nation back for nearly forty years.

Captain Matthew Calbraith Perry, who would "open" Japan to trade with the United States in 1853, brought the first pair of Fresnel lenses to the United States in 1840; they were placed at the twin towers at Navesink. Having demonstrated their great superiority, Fresnel lenses became standard, and when the Civil War began in 1861, nearly all American lighthouses had been fitted with them.

The question of how best to illuminate the lamps remained. During the colonial period, oil had been the method of choice. Spider lamps were designed around 1790; these were pans of oil in which four or more wicks could be placed. During the first half of the nineteenth century, Americans used whale oil, which was taken from the heads of sperm whales.

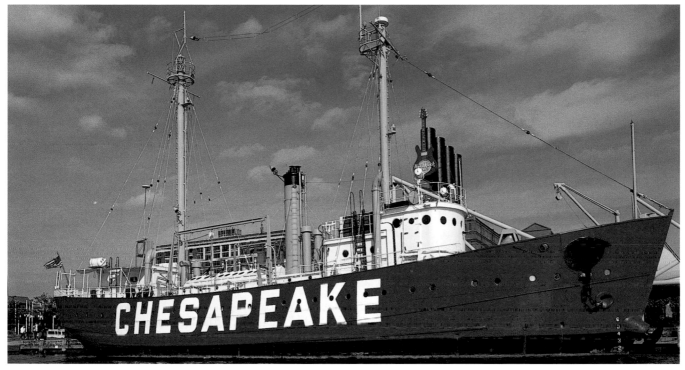

*Above:* **Chesapeake Lightship, Baltimore, Maryland;** *Overleaf:* **Lennard Island Lighthouse, Vancouver Island, British Columbia**

The price of sperm oil rose dramatically during the 1850s, and Americans began to experiment with colza (coleseed or rapeseed oil), the standard in France. Little rapeseed grew in the U.S., however, and the search led to the use of lard oil, and then kerosene, or mineral oil. By the turn of the twentieth century, most U.S. lighthouses used incandescent oil-vapor lamps. During the 1920s and '30s, the majority were converted to electricity.

Pleasonton's personal control of the lighthouse system was replaced by the Lighthouse Board, created in 1852, which was itself superseded by the Bureau of Lighthouses, established in 1910. In 1939 administration of the lights passed to the U.S. Coast Guard.

### The Golden Age of Lighthouse Construction

The most innovative and productive period for lighthouse construction in North America occurred between 1840 and 1900. Engineers faced the daunting task of finding ways to illuminate their hazardous coastlines. British Canada faced an even greater challenge on both east and west coasts due to the number of inlets, bays and zigzagging shorelines.

Henry Wadsworth Longfellow observed the importance of lighthouses. From his cottage on Nahant, north of Boston, he looked out at Minots Ledge Light, completed in 1853, and pondered:

*The rocky ledge runs far into the sea,*
*And on its outer point, some miles away,*
*The Lighthouse lifts its massive masonry, —*
*A pillar of fire by night, of cloud by day.*

Here Longfellow referred to the great accomplishment of American engineering that was to triumph over sand, shore, shoal, inlet, headland and rocky beach. Where, though, did the inspiration for that triumph come from?

The answer is Scotland. The craggy Scottish coast posed a formidable challenge to navigation. As industry and agriculture prospered during the nineteenth century, the need for improving safety along Scottish shores increased. Fortunately, one able family came to the rescue: the Stevensons. Robert Louis Stevenson, the author of *Treasure Island* and *The Master of Ballantrae*, came from a family steeped in civil engineering. His grandfather Robert Stevenson (1772–1850) became the engineer reporting to the Commissioners of the Northern (Scottish) Lighthouse Board in the 1790s. Here he undertook one of the most difficult engineering tasks ever attempted: the conquest of the reef known as Bell Rock.

The rock, or reef, stands north of the entrance to the Firth of Forth, just off the east coast of Scotland. Each high tide submerges the rock to a depth of 12 feet, and the location is at the mercy of the full blast of North Sea winds. Scottish captains reportedly skirted the rock by as much as 10 miles, but they were often driven upon it. During the storm of 1799, no fewer than seventy ships were wrecked on Bell Rock, which had earned its reputation in a medieval ballad: "And then they knew the perilous rock/And blest the Abbot of Aberbrothock."

Stevenson designed and directed the building of the Bell Rock Light between 1807 and 1811. Construction of the pillar-rock tower took enormous ingenuity. Stevenson designed a lantern for a temporary lightship whose light surrounded the mast, instead of using a number of small lanterns suspended from the yardarms. During the building of Bell Rock, he also designed the balance crane and the movable jib crane.

Alan Stevenson (1807–65) was Robert's oldest son. He planned to enter the Church, but was dissuaded, and in 1843 he succeeded his father as engineer to the Commissioners. During his career, Alan Stevenson designed ten lighthouses, the most famous of which is the great tower at Skerryvore.

Stevenson built Skerryvore Light on a rock 14 miles from the nearest land, the Isle of Tyree, off the west coast of Scotland. Constructed between 1838 and 1843, the end product, a 138-foot tower, housed a dioptric revolving lens, the first in the world.

David Stevenson (1815–86), the third son of Robert Stevenson, succeeded his brother as engineer to the Lighthouse Board. With his younger brother, Thomas (1818–87), he designed no fewer than thirty lighthouses. His work took him to Newfoundland, India, New Zealand and the Far East. Japan, forced to open itself to trade, discovered the need for lighthouses. Prior to 1850, virtually all of its island coastlines had been lit by bonfires. The Japanese government turned to Scotland and the Stevenson family, who built the first beacon for the Japanese Islands. Responding to the need for earthquake protection along the coast, David Stevenson devised the "aseismatic arrangements" that mitigated the effect of quakes on the optical apparatus

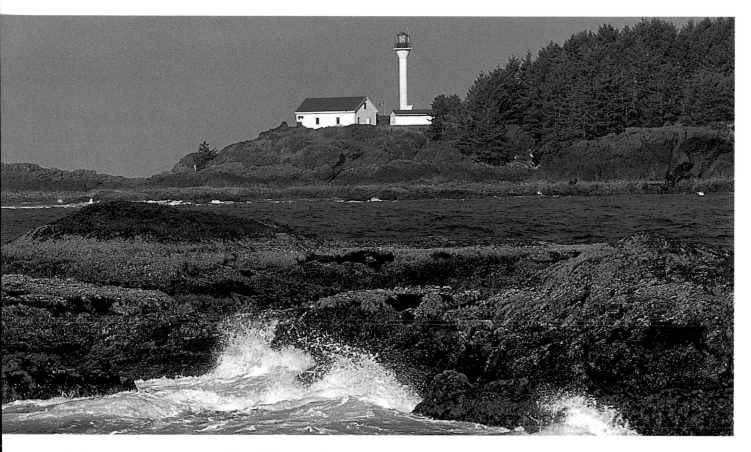

in the towers. Soon copied and then perfected, the Stevenson model became the Far Eastern standard. China would soon follow Japan's example. In 1870 Stevenson's report on the relative advantages of paraffin and coleseed (rapeseed) oil led to the selection of the latter, called colza, for use in Scottish lighthouses.

The renowned Robert Louis Stevenson (1850–94) was a son of Thomas Stevenson. Despite the infirm health that shortened his life to forty-four years, he completed his apprenticeship in the family discipline before taking up his literary career. Certainly, the world would have been the poorer without his delightful stories, novels and poems.

While England and Scotland had mastered the art of building lights in rocky locations, the United States would improve upon that art. Not even Scotland, with its famous Skerryvore Light, would pose greater challenges than those faced by the builders of St. George's and other American lights.

It is hard for us to appreciate what a "dark and dangerous" sea the Atlantic can be, especially because of the gap between the wind and weather systems of Europe and those of North America. Americans became aware of the Gulf Stream and its ameliorating effect upon our coastal weather during the 1770s, when Benjamin Franklin published a famous map of the stream. The fact that it brings warm air with it along the continental coast had much to do with patterns of settlement.

English, French, Dutch and Spanish navigators developed a pattern of sailing south-by-southwest from Europe to avoid the "windless" zone in the mid-Atlantic, where they risked being becalmed. Lighthouses were built to correspond with this pattern, as well as with local topography. Lights like those at Sandy Hook, New Jersey, and Cape Henlopen, Delaware, were essential for guiding in the sturdy vessels that had endured the long voyage from Europe.

### North American Maritime Expansion

Americans are a "westering" people, and that influence extended to maritime affairs during the nineteenth century. Even as Brigham Young led the Mormons west from Illinois to what is now Utah, others made their way across the Isthmus of Panama; still others

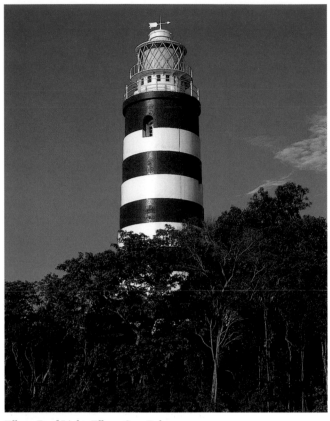

**Elbow Reef Light, Elbow Cay, Bahamas**

Often overlooked is the fact that Americans enjoyed a comparable experience. Their immense coastline had now been doubled by the addition of California and the Pacific Northwest, and Americans were to gain maritime advantages that would eventually surpass those of England herself. It might be said that if the nineteenth century was the "British century" by virtue of her fleet and trade, the twentieth century belonged to the United States.

Expansion was predicted by no less astute an observer than the Frenchman Alexis de Tocqueville. In his famous *Democracy in America*, de Tocqueville commented that "No other nation in the world possesses vaster, deeper, or more secure ports for commerce than the Americans….I think that nations, like men, in their youth almost always give indications of the main features of their destiny. Seeing how energetically the Anglo-Americans trade, their natural advantages, and their success, I cannot help believing that one day they will become the leading naval power on the globe. They are born to rule the seas, as the Romans were to conquer the world."

At the time of de Tocqueville's visit, the United States was still confined, as it were, to the East Coast, the Gulf Coast and the southern rim of the Great Lakes. Another leap of expansion followed ten years later, when the U.S. war with Mexico (1846–48) brought the Southwest and California into the American fold. Suddenly, full control of the great natural harbors at Puget Sound, San Francisco Bay and San Diego showed the need to illuminate coastal areas on both the Gulf of Mexico and the Pacific.

The heyday of American maritime expansion occurred in the two decades prior to the Civil War. Between 1843 and 1855, 2,656 merchant ships of all sizes were built in the United States, validating de Tocqueville's optimistic prediction. But lights were needed on all of the coasts — East, West, Gulf and Great Lakes — to continue the process.

British Canadians faced similar challenges. Thousands of immigrants made their way to Canada along the St. Lawrence River, which presented innumerable dangers to ships. Even if a ship were fortunate enough to reach Montreal, travelers still had to make their way out to the hazardous Great Lakes.

rounded Cape Horn and found their way to California. There they discovered an open but lightless coast. When gold was discovered in California in 1848, there was not a single lighthouse in the area that would become Baja, California, Oregon and Washington State, not to mention British Columbia.

What did exist was tremendous potential for maritime growth and development. The natural harbors within Puget Sound, the San Francisco Bay area and San Diego represented the opportunity for Americans to become a "two-ocean" people. Merchants could foresee the ability to trade with partners on the Pacific Rim to the same extent that they already traded with Europe.

Historians who account for Great Britain's growing power during the nineteenth century often focus on the English coastline itself. They point out that wherever one stands on English soil, the sea is never more than 70 miles away, using this fact to illustrate the point that necessity is the mother of invention. The English came to rule the seas well before the days of Queen Victoria because they were bred to it.

A new era in American lighthouse building began in response to this period of increased immigration and international maritime commerce. The 1850s saw the advent of new types of construction and a special confidence that wind- and wave-swept areas could be tamed through the building of lights. Of these, Minots Ledge stands out as one of the great achievements in American engineering prior to the Civil War.

Minots Ledge lies off Cohasset, just south of Boston, Massachusetts. The reef claimed the hulls of numerous ships and the lives of hundreds of sailors before the first light was erected in 1850. It stood for only one year before it was wrecked in a storm, causing some to declare that if God had meant to have a light there, He would have placed the beacon Himself. However, intrepid engineers set about the task of rebuilding the light. They finished their work in 1860, and the light remains today. Perhaps even more than Eddystone Light, Minots Ledge stands as a remarkable triumph of man over wind and water.

Longfellow's optimistic words were vindicated:

*A new Prometheus, chained upon the rock,*
*Still grasping in his hand the fire of Jove,*
*It does not hear the cry, nor heed the shock,*
*But hails the mariner with words of love.*
*"Sail on!" it says, "sail on, ye stately ships!*
*And with your floating bridge the ocean span;*
*Be mine to guard this light from all eclipse,*
*Be yours to bring man nearer unto man!*

Race Rock Reef stands a little more than half a mile southwest of Fishers Island, New York. Eight ships were lost there between 1829 and 1837 alone, and the growth of ferry boat travel between Long Island and the Connecticut shore increased the number of people exposed to the risk. As Americans turned to pleasure boating on Long Island Sound, the danger posed by Race Rock was a growing concern. Therefore, in 1871, the engineer Francis Hopkinson Smith and Captain Thomas Albertson Scott began laying the foundations for a light. It took seven long years to build the foundations; after that, the lighthouse itself took only nine months to complete. The erection of Race Rock Light gave a tremendous boost to the morale of American mariners in the area. Francis Hopkinson Smith went on to greater fame when he laid the foundations for the Statue of Liberty, a landmark that itself served as a lighthouse from 1886 until 1902.

Northern Florida may have seen one of the first lights in North America. It is suggested, though not proven, that the Spanish had a small light at St. Augustine. We do know for certain that when the United States acquired Florida in 1821, lights were built here and on several other sites. The Cape Florida Light was actually besieged by the Seminole in 1836, making it, along with Boston, Sandy Hook and Louisbourg Lights, one of the four that have seen armed combat. In 1861 nearly all the lighthouses on the Gulf and Southeast Coasts were seized by the Confederacy and put out of action for the duration of the Civil War.

The Gulf Coast remained unlit longer than the other coastal regions. Until the 1820s, such pirates as Jean Lafitte knew the Gulf better than did the U.S. Navy. The advent of the Civil War changed this, as admirals like David Farragut staged operations in the waters off Mobile Bay and New Orleans. As a result, the waters of the Gulf became better charted, more navigated and better lit over the next thirty years.

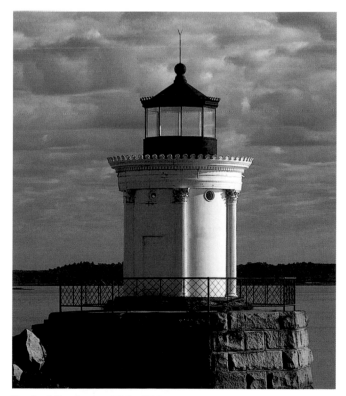

**Portland Breakwater Light, Maine**

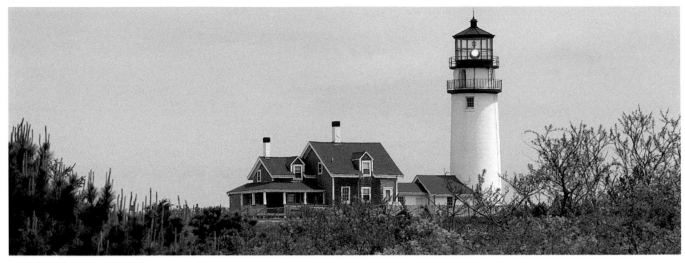

*Above:* Highland (Cape Cod) Light, Truro, Massachusetts; *Opposite:* Milwaukee Breakwater Light, Wisconsin

On the West Coast, mariners faced difficulties surpassing even those of the Atlantic. The most notorious "graveyard" was on the "bar" (sandbar) at Cape Disappointment, on the northern side of the mouth of the Columbia River, where Washington State and Oregon meet. The sandbar was created by the tremendous amount of silt deposited by the Columbia River on its journey to the Pacific Ocean. It was here that Meriwether Lewis and William Clark had completed their epic transcontinental journey of exploration in November 1805. By the best estimates available, we infer that more than 200 ships, large and small, came to grief at the treacherous mouth of the Columbia River. For a distance of at least 200 miles north and south of the river's mouth, dangers beset mariners in areas of the coastline that are known today for their natural beauty and splendid scenery. The federal government came forward again to assert control over the situation.

The Congressional act that established the Territory of Oregon in 1848 also provided for building lighthouses at Cape Disappointment and New Dungeness. Cape Disappointment received a first-order Fresnel lens. Even greater events began to unfold in 1852, when Congress authorized construction of sixteen lights on the West Coast: These were to be at Fort Point, Fort Bonita and Alcatraz Island in San Francisco Bay; Monterey; San Diego; Santa Barbara; the Farallon Islands off San Francisco; Humboldt Harbor; Crescent City; Smith Island; Cape Flattery (the northwest corner of the nation); Willapa Bay, Washington; and the mouth of the Umpqua River. Given the need for maritime safety, the work progressed rapidly, and all sixteen were completed by 1858.

These early West Coast lights did not appear very different from their counterparts on the East Coast. All of them were designed by the New England architect Ammi B. Young of the Treasury Department, who gave them the same Cape Cod dwelling-style design, with a tower rising through the center. The local Spanish Revival style would not emerge in lighthouse form until the end of the century.

More romantic in appearance were the Heceta Head Light in Florence, Oregon, and Cape Blanco Light in Port Orford, Oregon. Both were built in locations where navigational aids had long been needed; Spanish mariners had used the white cliffs at Cape Blanco as a landmark for centuries. But the greatest challenge that was met and overcome was that of building St. George's Light off the northwest coast of California.

Some sailors called it St. George Reef; others labeled it Dragon Rock. In either case, they referred to treacherous reefs that lay 14 miles off the coast. Many notorious sailing disasters occurred in the region; the most publicized was the loss of the sidewheeler USS *Brother Jonathan*, which came to grief there in July 1865 with the loss of 215 men. Ironically, "Brother Jonathan" was a term Victorian Britain used to describe her younger sibling, the United States.

But if St. George was to be the American equivalent of Eddystone Light, it took some time to put the pieces into place. The Lighthouse Board had the site surveyed in 1882, and between 1887 and 1892, the massive granite structure was raised at the enormous cost of $704,633 — the most expensive lighthouse built to that date in the United States.

On the Gulf of Mexico, the acquisition of Texas had brought a large new section of coastline to the United States. Much of it was not fit for navigation because of the strong tides and marshy lowlands that came right down to the shore. But some areas of Texas developed a thriving maritime commerce. One of them was Galveston, named for the Spanish governor of Louisiana during the American Revolution.

Bolivar Point Light was built on Bolivar Peninsula, just north of Galveston Island, in 1873. The sleek, brick-lined iron tower was a familiar sight to visitors to Galveston, which was known as the "Queen of the Gulf." September 8, 1900, brought an enormous hurricane that devastated the beautiful city and caused 6,000 deaths. But the 125 people who took refuge in Bolivar Point Light were safe, and the event was seen as a cause for rebuilding, rather than despair.

The navigational problems on the Great Lakes are often overlooked, yet these lakes constitute the largest body of fresh water on the planet: If they were emptied, it would take fifty years for the free-running Mississippi River to refill them to capacity. The Great Lakes could not be ignored by steamboat operators, coastal navigators and nautical engineers. Then the

lumber industry developed, fueled by German and Scandinavian immigrants, and the need for navigational aids on the Great Lakes increased.

Michigan today has more lighthouses (131) than any other American state. Both Lake Michigan and Lake Superior required numerous lights to guide vessels to shore. Tides and sudden windstorms added to the maritime dangers in the region. Lighthouse engineering flourished in the Lakes area, and some specific sites, like Split Rock and Round Island, required just as much work as the coastal locations. This is also true of Canada's Cove Island Light (1855–59), which is located in Georgian Bay, at the northern end of Lake Huron.

If the Great Lakes are often overlooked, one might claim that America's inland Eastern waterway is almost forgotten. The network of rivers, lakes and canals that connect New York City, Montreal and Buffalo were once known to most Americans. In fact, for generations the Hudson and St. Lawrence Rivers, Lake Champlain, the Mohawk River and the Erie Canal were vital points of entry and connection for immigrants and tradesmen.

Isle la Motte Light stands at the northern end of the island of the same name. Crown Point Light was completed in 1859, and Colchester Reef Light went into service in 1871. In 1952 the beacon was moved carefully, piece by piece, to the grounds of the Shelburne Museum, just south of Burlington, Vermont.

In 1846 Great Britain and the U.S. had agreed to draw the boundary between Canada and the United States at the 49th parallel of north latitude. This

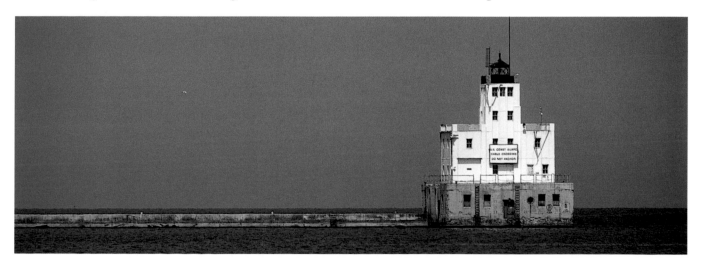

allowed both British and American ships to enter the Strait of Juan de Fuca and Puget Sound. The British-Canadian cities of Victoria and Vancouver grew up north of the boundary line, Seattle and Port Townsend on the American side.

Naturally, British ships tried to hug the northern side of the Strait of Juan de Fuca as they approached Victoria. Many of them ran aground, or were broken up at Race Rocks, just south of the city. This failure of maritime safety was an affront to British pride and technology. Granite blocks were cut in Scottish quarries and shipped all the way around Cape Horn to British Columbia, 16,000 miles away by sea. The work proceeded apace, and on Boxing Day (December 26) 1860, Race Rocks Light was lit. The magnificent tower remains today, one of the best examples of the famous Canadian "Imperial Lights."

Best known to mariners today is Estevan Point Light, on the west coast of Vancouver Island. Completed in 1909, the 98-foot tower has a rocketlike appearance, due to the use of reinforced concrete and a flying-buttress formation. From the time of its commissioning, Estevan Light has been a marking point for ships arriving from Hawaii and East Asia. It became known to virtually all Canadians in 1942, when the area was shelled by a Japanese submarine. This, the first foreign attack on Canadian soil since the War of 1812, was seen as the equivalent of the attack on the U.S. naval base at Pearl Harbor.

In Eastern Canada, the first important lighthouse built on the St. Lawrence River was Il Verte, completed in 1809. It was a milestone in making the great river safer for passenger ships and was used as a model for numerous other lights. It still stands today, the second-oldest operational lighthouse in Canada.

The Republic of Mexico entered the arena of lighthouse building at a rather late date. During the Spanish Colonial era, it appears that no significant lights were attempted, but after Mexico won its independence in 1819, things began to change. What consistently thwarted development was the lack of a cohesive equivalent to the North American Lighthouse Boards. Originally, Mexico was less committed to trade than its northern neighbors, and lighthouses were not a priority.

As the twentieth century dawned, Mexico found more of a need for navigational aids. Today there are a number of prominent lighthouses, some of them often visited by tourists. Most of the Mexican lights are called simply "El Faro." The light at Mazatlan stands on a hill called Cerro Creston, and *El Faro Mazatlan*, at 515

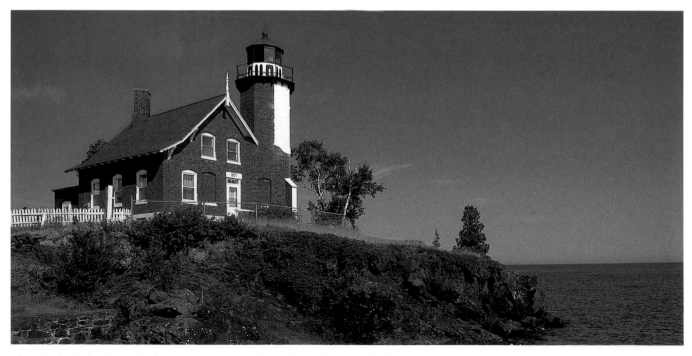

*Above:* Eagle Harbor Light, Michigan; *Opposite:* Point Pinos Light, Monterey, California

The United States flexed its muscles and acquired thousands of miles of new coastlines during the late nineteenth century. Alaska was purchased from Czarist Russia in 1867, and the Spanish-American War of 1898 brought Puerto Rico, Guam and the Philippines into American hands. An internal uprising, fostered by the interests of Sanford P. Dole and other powerful plantation owners, had made the Hawaiian Islands a U.S. territory five years earlier.

The first American lighthouse in Alaska was built on the site of the Russian beacon of a century before. Years went by before the Lighthouse Board took any action in Alaskan waters, but the Alaskan Gold Rush of 1897–98 brought hundreds of ships into those waters, many of which were lost in the tortuous channels of the long coast. Therefore, the Lighthouse Board appropriated $100,000, and between 1902 and 1905, a total of nine lights were built, seven of which illuminated the Inside Passage between Wrangell Strait and Skagway. Two of the most famous Alaskan lights are Scotch Cap, built in 1903, and Cape Sarichef, finished in 1904. Built on the "inside" and "outside" ends of the west coast of Unimak Island, they mark Unimak Pass, the primary passage through the Aleutian Islands into the Bering Sea. Cape Sarichef Light was the only manned lighthouse on the shores of that sea.

When the United States annexed Hawaii, the island archipelago had thirty-five lights of its own, eighteen operated by the government and the others run by private corporations. In 1909 an important light was built at Makapuu Point, on the southeastern end of Oahu Island, to provide a landfall for ships bound from the United States. Kilauea Point Light, at the northern end of Kauai Island, was built in 1913 as a marker for ships bound from China and Japan.

Puerto Rico had thirteen lights, all built by the Spanish after 1853, when the U.S. took possession at the turn of the century. One of the first built was on Mona Island, marking the Mona Passage between the Dominican Republic and Puerto Rico.

The progress of France, Britain and the United States was mirrored in other countries. Spain created its lighthouse service in 1846; Italy followed suit in 1860. Chile established its service in 1867; Brazil in

feet, is the second-highest lighthouse in the world. Another beacon crowns the Santiago Peninsula in the city of Manzanillo, and still another marks the area where Baja California drops off into the ocean.

### International Regulation and Standardization

The late nineteenth century was a period of standardization, especially in scientific and technical matters. Time zones were created in the 1890s, and scientific knowledge became wider in scope. Thus, lighthouse designs became more predictable after 1890, ending the era of marked individualism in tower construction. During this time, the nautical mile became an accepted unit of international measurement. Because the Earth's circumference varies between the equator and the poles, the length of a nautical mile has to vary as well. A nautical mile, which is meant to equal one minute of latitude, varies between 6,046 feet at the equator and 6,108 feet at either of the poles. Based upon latitude 48, the standard nautical mile is 6,076 feet (1,852 meters).

1876; and the recently formed Imperial Germany, in 1874. There was also a new trend toward cooperation in the construction of lighthouses: The best example occurred on the northwest coast of Africa in 1864.

Certain lighthouses stand out as "key sentinels" or "making lights," which delineate the beginning or end points of land. One of the most famous is Bishop Rock Light in the Isles of Scilly, off the southern coast of England. Bishop Rock is familiar to transatlantic passengers, who see it as the first sign of arrival in Europe. Late in 1907, the seven-masted schooner *Thomas W. Lawson*, carrying three times her own weight in cargo, came to grief on the rocks of Helewether Reef, just off Bishop Rock. So violent was the impact that all but three crew members perished at once.

Fastnet Light, located 4.5 miles off Cape Clear, the southwestern point of Ireland, is an important point of departure from European waters for vessels en route

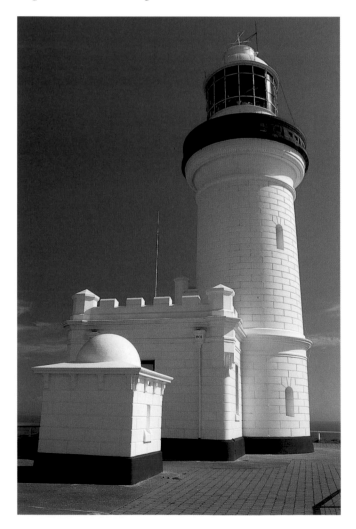

to North America. After leaving the waters of Fastnet, on a typical transatlantic course one sees no other light until Cape Race, Newfoundland.

Cape Spartel stands at the western entrance to the Strait of Gibraltar. Through an international convention, the Jabal Kebir Lighthouse was built on the Cape between 1864 and 1867, jointly owned by the United States, Austria, Belgium, Spain, France, Italy, the Netherlands and Sweden. This was an early example of the acknowledgment that "making lights" should be the common responsibility of all countries involved.

The heyday of American lighthouses probably came about 1910. In that year, the Lighthouse Board was replaced by the Bureau of Lighthouses, with one man, George Putnam, in charge of the whole affair. Putnam soon listed the status of the U.S. lighthouse system. In 1910 there were 11,713 navigational aids of all types. These included about 1,200 lighthouses and fifty-four lightships. Putnam remained at the helm for the next twenty-five years. During that time, the number of navigational aids of all kinds more than doubled, but the number of personnel operating them fell by 20 percent. This is attributable to the new technologies that were introduced, especially electrification.

In 1939 President Franklin D. Roosevelt decided to amalgamate the Lighthouse Service with the U.S. Coast Guard. He met determined resistance in the person of William McDemeritt, keeper of the Key West Light and commander of the Seventh Lighthouse District. When the president arrived in Key West to visit the lighthouse, McDemeritt confronted him and the two exchanged angry words. A famous photograph shows Roosevelt in his car with McDemeritt leaning over him. The anger was palpable, the moment decisive. Modern technology in the form of the New Deal would soon overpower the antiquated ways of the Lighthouse Service.

The twentieth century witnessed a gradual decline in lighthouse construction in the United States, Canada and Mexico. The appearance of radio towers and consoles has obviated the need for many lights, and narrow fiberglass beacons now stand on numerous remote islands and inlets. Although many towers remain, very few of these are manned.

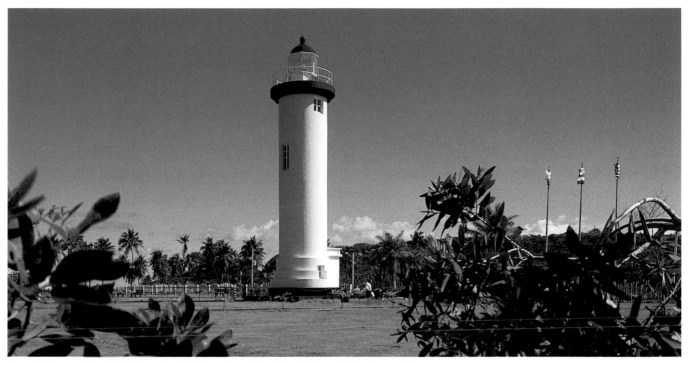

*Opposite:* **Byron Bay Light, New South Wales, Australia;** *Above:* **Rincon Light, Puerto Rico**

## Trouble Spots, "Graveyards" and Notorious Shipwrecks

Numerous trouble spots around the globe have been identified as particularly hazardous for ships and sailors. The waters south of Cape Horn, Chile, are known for their fierce winds, caused by the fact that there is no other land in that southerly latitude to obstruct the winds' power. Similarly, part of the coasts of Chile and Peru are known as the "Roaring Forties" (referring to their latitude), which have been the death of many sailors. But South America has no monopoly on this type of problem: It seems as though every area of the hemisphere has its own special clusters of navigational hazards, and many "graveyards" of the Atlantic, Pacific and Caribbean have been identified.

Canadians recognize at least two specific "graveyards" on their East Coast: the treacherous waters off Newfoundland, and Sable Island, 80 miles east of Nova Scotia. Since the days of John Cabot and the first transatlantic voyages, Cape Race, Newfoundland, has marked an important though extremely hazardous point of recognition for mariners from Europe. At least 100 ships of all sizes have been lost off Cape Race, some of them even after the first light was built there in 1856.

One of the worst disasters occurred in 1864, when the passenger liner *Anglo-Saxon* crashed on the cliffs just below the light: 290 people perished. But 130 others were rescued by the daring and fortitude of the lighthouse keepers, who risked their lives in the dark to save those who had found a ledge.

Consisting of a series of low-lying sand dunes surrounded by submerged sandbars, Sable Island lies directly in the path of merchant ships bound for Nova Scotia. Many wrecks took place on these lonely shores until a series of lights was built in the late nineteenth century. Today, the island is better known for its large number of wild horses. Where Canada and the United States meet, the tidal waves of the Bay of Fundy, between Nova Scotia and New Brunswick, are legendary for their height of up to 70 feet. The New Brunswick shore is better covered by lighthouses than the inland shore of Nova Scotia.

To the south, New England's shores have witnessed countless wrecks, many of which have occurred on the coast of Massachusetts. Reaching more than 70 miles into the turbulent waters of the Atlantic, Cape Cod presents a formidable obstacle for mariners. The combination of shifting sands and the tumultuous Atlantic

makes this a deadly area. Truro's Cape Cod, or Highland, Light is one of the many beacons erected to guide vessels around the peninsula. Standing more than 150 feet above sea level, the light—the oldest on the Cape—is visible up to 20 miles at sea.

Another hazard that sailors encountered in the waters off Massachusetts was the sudden and unexpected onset of dense layers of fog. The thick fogs that settle over the waters in this area make it virtually impossible to see potential hazards at sea. Boston's Minots Ledge Light was built to safeguard ships from the dangerous submerged reef under these conditions.

Another trouble spot lies in southeastern New England, where the waters of the Atlantic Ocean, Narragansett Bay and Long Island Sound meet. This confluence has created sailing and weather conditions that shift suddenly, throwing the unsuspecting sailor into confusion and danger. This area, too, has been called the "Graveyard of the Atlantic," as have the rocky waters between Point Judith Light, on the southern tip of Narragansett Bay, and Block Island North Light.

Located at the far eastern end of Long Island, the light at Montauk Point protects vessels from becoming stranded in the shallows created by the changing tides and warns of the dangerous shoals located just off the point. Farther inland, the Twin Towers of Navesink in Highland, New Jersey, were considered one of the most important guides on the Atlantic Coast. Built on a 200-foot cliff and equipped with the nation's most powerful lenses, the twin lights helped guide mariners through the narrow channel into New York Harbor.

The Delaware and Chesapeake Bays have a less fearsome reputation. These large bodies of water contain many inlets, islands and shoals, but they are well marked by dozens of lights, and the casualty rate for shipping has not been as severe. Just south of Chesapeake Bay, however, lies one of the most formidable dangers for mariners on the East Coast: the long line of barrier islands known as the Outer Banks, off the coast of North Carolina.

It was here that the first English settlement in North America was attempted, but the foundation of Roanoke was both ill designed and ill fated. Most people know that the colonists disappeared, but legends of the "Lost Colony" do not always mention that the rescue expedition was unable to fulfill its mission because of the dangerous storms that batter the area. Delightful to modern vacationers, except in the hurricane season, the Outer Banks remain perilous to navigators.

Just south of the Outer Banks, the northbound Gulf Stream comes closer inland than usual and collides with the cold waters of the southbound Labrador Current. These diametrically opposed systems create turbulent waters that culminate in the shallow Diamond Shoals, 15 miles off the Outer Banks. The "Graveyard of the Atlantic" off Cape Hatteras has witnessed thousands of shipwrecks, and several lights were built here to combat the navigational problems. Built on shifting sandy foundations, they were particularly prone to coastal erosion. Their weight and height only aggravated the difficulties of achieving stability. As mentioned later, the majestic Cape Hatteras Light was moved in 1999 when the threat of collapse became critical.

The Mid-South Atlantic coast between the Diamond Shoals and the Florida Keys would appear to offer calm sailing. Nothing could be further from the truth, and the lighthouses necessary for safety in that region had to be much taller than their counterparts to the north, because of the lack of highlands and bluffs.

The seemingly tranquil waters of the southern Atlantic can quickly become dangerous as darkness falls. Navigating the countless shoals and shallows is always difficult, and nearly impossible when a storm flares up. Countless lives have been lost in these deceptive waters. Careful mariners were, and are, able to negotiate the Gulf Coast, although the explorer Robert Cavelier de la Salle lost his way in 1682. Trinity Shoal, which lies halfway between the Mississippi River Delta and Galveston, extends some 23 miles out into the Gulf and presents a great hazard for shipping.

In the Gulf and along the southern Atlantic coast of the Southern states, perhaps the greatest danger to ships is from hurricanes. Memorable disasters occurred in 1846 at Key West, Florida's, Sand Key Light, and in Galveston, Texas (as described on page 23), in 1900. Tornadoes posed another threat, as seen in 1812 when a tornado ripped through North Carolina's Bald Head, on Cape Fear, and toppled its lighthouse. While the

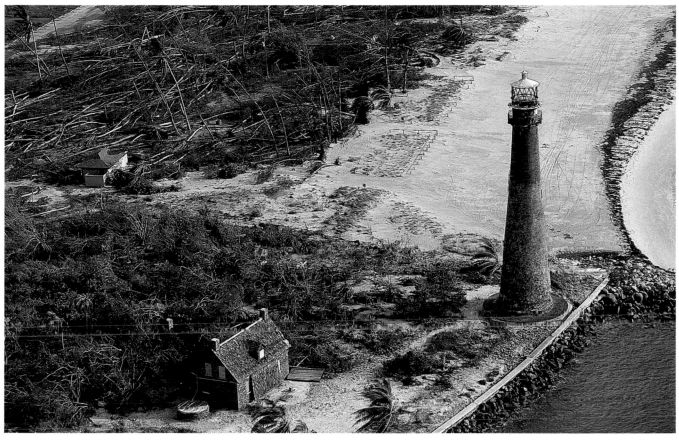

*Above:* Cape Florida Light after Hurricane Andrew, 1992

presence of a beacon can offer vessels at sea no protection from the elements in such severe weather, lighthouses in this region have compiled an impressive record of withstanding the onslaught of hurricane conditions and providing refuge. In 1992 the disastrous Hurricane Andrew wreaked devastation on parts of Florida, yet the Cape Florida Light remained standing.

Equally dangerous West Coast trouble spots for mariners include the waters that were long called the "Dragon Coast" by Spanish and, later, Mexican sailors. Southern California is known for surfing and beach parties rather than shipwrecks and disaster, but the story changes when we reach the Bay Area of central California. Sir Francis Drake was the first English mariner here, and he probably landed near what is now the site of Cape Reyes Lighthouse. This was one of the most expensive lights, due not only to the rocky cliffs and powerful surf, but to the fog that prevails here more than half the days of the year. Many Spanish ships, en route from the Philippines to Acapulco, came

to grief off the coast of northern California, but during modern times the creation of key lights like St. George's have prevented these disasters.

The Pacific Northwest and Canada's West Coast present special challenges. Some experts believe that the waters off the mouth of the Columbia River are among the most dangerous in the world because of the clash between the river and the ocean tides, which are unimpeded for thousands of miles up to that point. Even Lewis and Clark noted in 1805 that the waters in the area were "far from pacific." The rocky coastline is studded with submerged reefs, rocks and sandbars. The mouth and estuary of the Columbia River present a well-known and well-documented "graveyard"; more than 200 ships foundered there before Cape Disappointment Light began to function in 1857. Ironically, the supply bark *Oriole*, which was carrying materials for five new lighthouses, went aground on the infamous bar. The ship and its stores were lost, but the sailors were saved.

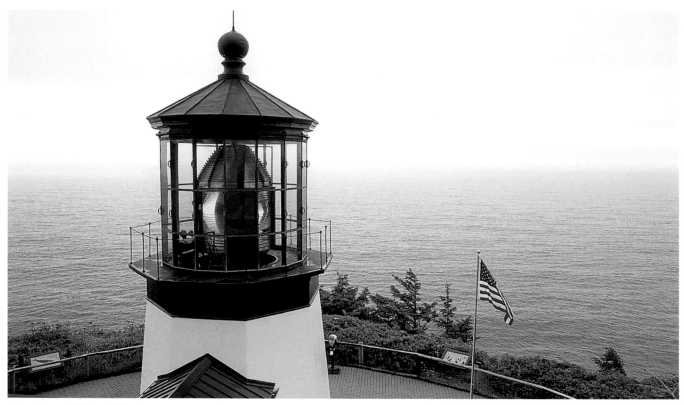

Cape Meares Light, California

Less well known are the dangerous waters just off Cape Flattery, which is the extreme northwest point of the Lower 48 states. Cape Flattery remains an isolated spot today; the Coast Guard sends personnel in by helicopter to check on the station, but no one lives there on a permanent basis. The importance of the site is doubled by the fact that many of the ships passing by are oil tankers bound for Seattle and Vancouver. If one should sink, it would cause an environmental disaster at least equal to that caused by the *Exxon Valdez*. Vancouver Island, 286 miles (460 km) long, has many inlets, rocks and reefs, which were first navigated by Captain James Cook in 1778 and became part of British Canada following the treaty of 1846.

The *Kuroshio*, or Japanese Current, compounds the dangers of this coastline. Even though it warms the waters off the coast, creating what some people call the "ectopia" of the coastline of Washington State and British Columbia, the Japanese Current sweeps ships along a rocky and often desolate area on the western side of Vancouver Island. The Canadian government in Ottawa recognized the need for navigational aids

here during the 1890s, when the railroad and lumber industries boomed, increasing oceangoing traffic.

The Trans-Canadian Railroad, completed in 1883, linked St. John's, Newfoundland, with Vancouver. Soon the West Coast began to flourish as first lumberjacks, and later gold seekers, made their way over the mountains. Even today, U.S. citizens have little appreciation for the vast extent and disparate nature of Canadian topography; the creation of the Canadian railroad system was far more difficult than that of the U.S. transcontinental line, completed in 1869.

Slowly, the hazards off the coast of British Columbia were tamed by greater understanding of the conditions and the addition of many aids to navigation. One of the first major projects was the construction of Carmanah Light on the north side of the Strait of Juan de Fuca. Working in cooperation with its American counterpart, Cape Flattery Light, Carmanah reduced the number of shipping fatalities in the Strait. This became even more important in the twentieth century, as the trade between Vancouver and the Orient began to boom, creating the phenomenon known as the

"Pacific Rim" trading partners. Other important lights were built at Lennard Island and Pachena Point.

Given the variety of trouble spots that exist on the Atlantic, Gulf and Pacific Coasts and the Great Lakes, one wonders how many ships have been wrecked. There is no doubt that the answer runs into many thousands. Some historians speculate that during the golden age of sail—approximately 1650 until 1850—one vessel per day was wrecked somewhere in the world. Lacking exact figures, we may look at some individual cases and examine the importance of these wrecks.

Treasure hunters abound today. Mel Fisher and his family searched for twenty years before they uncovered the wreck of the Spanish *Atocha* and its looted riches, now held and displayed by a private museum in Key West. The wreck of the *Whydah* (sunk in 1718) has recently been discovered off the eastern shore of Cape Cod. But relatively few people known about the great unsung American treasure hunter of an earlier day: Sir William Phips of Wiscasset, Maine.

Born in 1650, and having taken the sea as his trade, Phips learned of a Spanish treasure ship which had sunk off the coast of Hispaniola (now the Dominican Republic) in 1642. After seeking consent from the English king Charles II, Phips led two treasure-hunting expeditions to the area. On his second try, in January 1687, he found the wreck of the *Nuestra Señora de la Concepción*, one of the galleons of the Spanish treasure fleet of 1642. Phips brought to England gold and silver worth 210,000 pounds sterling and became the first colonial American to be knighted. It was more loot than Henry Morgan had gained in the famous sack of Panama in 1670, and Phips's haul would not be surpassed until the twentieth century.

One of the most famous shipwrecks occurred on the Great Lakes. On Sunday, November 9, 1975, the *Edmund Fitzgerald*, also known as the Queen of the Lakes, left Superior, Michigan, bound for Detroit. Built in 1958, the *Edmund Fitzgerald* was the largest iron-ore carrier ever built on the Great Lakes; she had compiled a noteworthy career to that date. During the night, winds up to 70 miles per hour struck the ship, and on the morning of November 10 she disappeared completely from the radar screen of a vessel in her wake.

The Canadian singer Gordon Lightfoot released "The Loss of the Edmund Fitzgerald," helping to make this one of the best-known wrecks in maritime history.

The loss of the *Edmund Fitzgerald* had been foreshadowed by that of the French vessel *Griffon*, the first European-style ship built on the lakes. The explorer La Salle launched her near Niagara Falls in 1679, and she survived her first voyage to present-day Detroit, but the *Griffon* never completed her return voyage.

Pirate stories abound on the East Coast, none more infamous than that of Blackbeard, whose real name was Captain Edward Teach. In 1717 he captured a French merchant ship and renamed her the *Queen Anne's Revenge*. After having blackmailed the people of Charles Town, South Carolina, into giving him supplies, Teach turned the vessel into Topsail (now Beaufort) Inlet, North Carolina. Both of his ships were lost on the sandbar, and the marooned Teach met his end on December 3, 1718, near the site of Ocracoke Island Light, built in 1803.

Pirates roved northern waters as well. Many English and French merchant captains went "a-pirate" during the early eighteenth century, and wrecks of their vessels lie at the bottom of the ocean. The recently discovered *Whydah*, built in 1716, was commanded by the pirate Samuel Bellamy. On April 26–27, 1717, Bellamy and his men ran aground off Wellfleet while on their way to Provincetown. At that time there were no lights in the area. Today, Nauset, Highland and other Cape Cod lights overlook the waters where diver and treasure hunter Barry Clifford found the wreck in 1998.

The many oil tankers now traveling the searoads constitute an environmental hazard of great proportions. This was seen on March 16, 1978, when the tanker *Amoco Cadiz* went aground on Men Goulven Rocks, as it entered the English Channel. Thousands of French soldiers were deployed to clean up the oil spill, which nevertheless took a severe toll on the marine and coastal ecosystems of Brittany.

By 1900 both the United States and Canada had created national boards that oversaw aids to navigation. Enormous problems of distance and weather had been overcome; indeed, the whole enterprise constituted one of the great achievements in world science and engineering. But what about the human element?

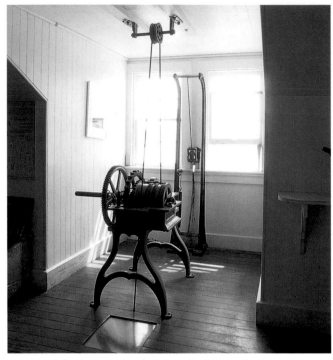

**Interior of Hooper Strait Light, St. Michaels, Maryland**

### The Lighthouse Keeper's Life

"Anything for a quiet life, as the man said when he took the situation at the lighthouse." This quotation from *The Pickwick Papers*, by Charles Dickens, exemplifies what many of us think about the life of the lighthouse keeper. In a world busy with phone, fax, e-mail and modem, not to mention television and video player, we yearn for what we no longer have: peace and quiet.

There is no way to measure the impact of all that "peace and quiet" on a human being, especially since there is only one official lighthouse keeper left in the U.S.: Scott at Boston Light. However, there were many tangible threats to the lighthouse keeper's well-being during the age of manned lighthouses, irrespective of the psychological pros and cons of extreme isolation.

Prior to the age of electricity, smoke, oils and chemicals permeated lighthouse buildings, and the keepers and their families were exposed to constant noxious, even toxic, fumes. These same substances led to a severe threat of fire, and many lighthouses burned to the ground, sometimes consuming their keepers in the flames. Every day, lenses and windows had to be cleaned to prevent oil, smoke and grime from building up and diminishing the effectiveness of the light beam.

Aside from the sheer drudgery of these onerous tasks, it entailed sustained exposure to harsh chemicals. Admired as heroes, little was known about the tedium and risks of these families' important work.

George Worthylake became America's first official keeper in 1716. The Province of Massachusetts Bay agreed to pay him 50 pounds sterling per year, which was supposed to be supplemental to the money he could earn as a harbor pilot and a tender of sheep on Little Brewster Island. But one misfortune followed another, and Mr. Worthylake soon petitioned Boston for a raise in salary. This was granted and the keeper rowed to Boston to collect the money. His small boat capsized within sight of Little Brewster Island on his return, and Worthylake and his family drowned. The incident was so distressing that the young Benjamin Franklin, still living in Boston, wrote a commemorative poem that has not survived. (Later, he assured readers that it had been less than memorable.)

Some keepers enjoyed better living quarters and easier access to the local town or port. Colonial keepers had to make the best of their situations. However, this changed with American independence—not necessarily for the better. George Washington established the Lighthouse Service as a government agency, and keepers were subjected to more guidelines than before. The worst period was the thirty years during which Stephen Pleasonton ran the Lighthouse Service. A conscientious bureaucrat, he skimped in every way he could and forced the keepers to make do. It's remarkable that anyone undertook such work under a blizzard of federal regulations and low budgets. Nor were such conditions confined to the United States.

Walter Erwin was the faithful and conscientious keeper of Point Atkinson Light, British Columbia, between 1880 and 1910. During that time he raised his family on the sum of $700 per year. The introduction of a foghorn in 1889 cut his pay in half, since he had to hire a young man at his own expense to keep the horn in operation. Erwin and his wife also experienced many health problems, largely work-related. Mrs. Erwin survived serious illness, but the couple continued to be plagued by one problem after another on their remote station. When Mr. Erwin finally stepped down

from his post in 1910, he found that a meager pension of $33 per month had been allocated to him.

However, better times were in store for the keepers. After 1852 their conditions improved, and the new Lighthouse Board created both uniformity and better pay within the service. Nevertheless, the occasional American lighthouse keeper "flipped his lid." Coast Guard workers today claim that New London, Connecticut, Ledge Light is haunted by the ghost of "Ernie," one of the early keepers. When Ernie's wife eloped with the captain of the Block Island Ferry, he threw himself from the top of the light. Allegedly, his ghost still plays tricks on members of the Coast Guard.

Cape Flattery Light, located on Tatoosh Island in Washington State, stands at the extreme northwest corner of the Lower 48 states. The isolation imposed by this site apparently drove one keeper to challenge an assistant to a duel in the 1860s. No one was harmed, because another assistant loaded both of the pistols with blanks, and the men were reconciled. But later, another keeper of the same light overcome by his iso-

lation attempted suicide by throwing himself from the cliffs. He survived the attempt, was rescued, recovered and eventually returned to his duties.

So much for Charles Dickens and the popular conception of blissful solitude.

Many heroes emerged within the lighthouse systems of the United States, Canada, Mexico and elsewhere in the world. In England, Grace Horsley Darling became a figure of national pride as a result of her courage. Born in 1815, Grace Darling was the daughter of William Darling, who, like his father before him, was the keeper of a lighthouse on Longstone, one of the Farne Islands. The seventh of nine children, Grace grew up in a typically isolated environment where duty was all. Her father frowned upon playing cards and other frivolous pastimes. On September 7, 1838, the steamboat *Forfarshire* was wrecked on the rocks near the lighthouse. Through her binoculars, Grace observed that a small group of survivors had found shelter on a rock. She and her father promptly rigged a cable to their rowboat and made their way out to the rock, well aware that they would need

*Above:* **The Lewis family inside Lime Rock Light, Newport, Rhode Island;** *Overleaf:* **Great Point Light, Nantucket Island, Massachusetts**

the assistance of at least some of the stranded passengers to make it back to the light. On their first try, the father and daughter brought off four men and a woman. They returned with the assistance of two survivors and rescued the four who remained.

To a nation steeped in maritime glory, and embarked upon the Victorian age, Grace Darling became the ultimate heroine. Both she and her father were awarded gold medals by the British Humane Society, and a trust was created to provide an income for the family. Grace received so many requests for locks of her hair that she was in danger of going bald! However, she made few trips off the islands, and remained a distant hero to the British people until she died of consumption in 1842.

The first female light keeper in North America was a Mrs. Thomas, who was tending the Gurnet Point Light at Plymouth, Massachusetts, when the state surrendered control of its lights to the federal government in 1790. But Idawalley Zoradia Lewis was the American counterpart to Grace Darling. She grew up at Lime Rock Light, near Newport, in Narragansett Bay, Rhode Island. "Ida" was hale and

hearty. She rowed her younger siblings to the mainland so they could attend school and helped her father tend the light. Lewis made a number of daring rescues in the 1860s and '70s. Her fame spread, and she was featured on the cover of *Harper's Weekly* in 1869, the same year that President Ulysses S. Grant came to visit her at Lime Rock. She received many marriage proposals by mail, but turned them all down and eventually married a local sailor. The union was not a happy one, and the couple soon separated. Although she remained officially married for the rest of her life, there was no doubt that her true union was with the lighthouse. It is not too much to say that Ida Lewis represented a new brand of heroine and heroism for Americans. To a nation influenced by the Victorian image of what a woman should be—delicate, refined and submissive—Ida Lewis was a bold example of the pioneer spirit.

Less well known than Ida Lewis, but equally brave and competent, was Abigail Burgess of Maine. "Abbie" grew up on Mattinicus Rock, some 34 acres of land 22 miles off the coast from Rockland. Her father, Sam

Burgess, was the keeper of its light. On January 19, 1856, while her father was ashore for supplies, a vicious nor'easter enveloped the island where Abigail, her invalid mother and her sisters remained:

> *Early in the day, as the tide rose, the sea made a complete breach over the rock, washing every moveable thing away, and of the old dwelling not one stone was left upon another....As the tide came the sea rose higher and higher, till the only endurable places were the light towers. If they stood, we were saved, otherwise our fate was only too certain. But for some reason, I know not why, I had no misgivings, and went on with my work as usual. For four weeks, owing to the rough weather, no landing could be effected on the rock. During this time we were without the assistance of any male member of my family. Though at times greatly exhausted with my labors, not once did the lights fail. I was able to perform all my accustomed duties as well as my father's.*

Marcus A. Hanna of Maine's Cape Elizabeth Light became one of the best-known lighthouse heroes of his day. On January 28, 1885, the schooner *Australia* crashed into the rocks just below the light.

Hanna made good time in reaching the ledge where the ship was wrecked, but only two of the crewmen had not been washed away. He made repeated, vigorous efforts to reach these two men, and was awarded a gold medal. Countless other examples of the legendary courage of lighthouse keepers around the world could be given.

## The Lure of the Lighthouse

Lighthouses remain an enduring symbol of human courage and fidelity. Although twentieth-century improvements in navigation technology have made many of the sturdy old towers obsolete, we see growing concern for their preservation as part of our national heritage. Emma Lazarus captured this spirit in her poem on the Statue of Liberty, which concludes: "I lift my lamp beside the golden door." From the Pharos to Eddystone, and from beach bonfires to lights kindled by mineral oil and electricity, the lighthouse has served as a sign of aspiration and assurance. It remains an object of beauty in a world that is all too often purely functional.

# Beach and Sandbar Towers

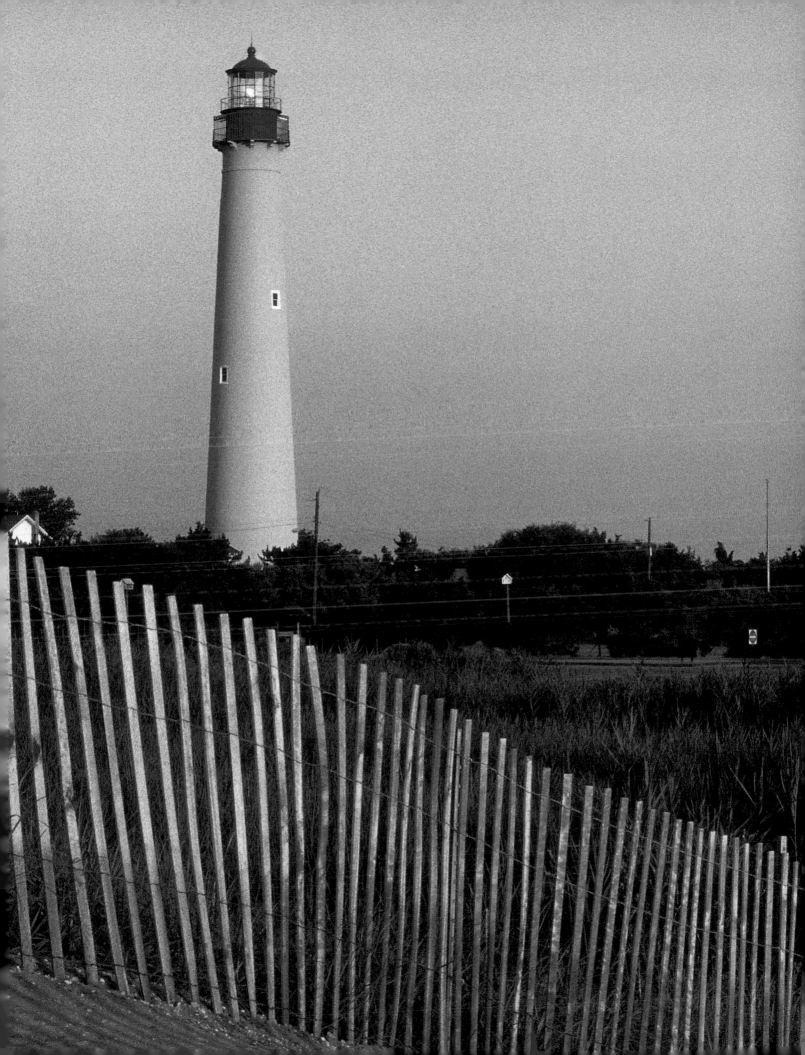

*"The most prominent points of a line of coast, or those first made on oversea voyages, should be first lighted; and the most powerful lights should be adapted to them, so that they may be discovered by the mariner as long as possible before his reaching land."*

— ALAN STEVENSON

The Scottish engineer Alan Stevenson emphasized the importance of "making lights" in his classic *Rudimentary Treatise on the History, Construction and Illumination of Lighthouses* (1850). He wrote with the confidence and authority of the leading engineer of his family, which had already designed two of the greatest lighthouses of the century: Bell Rock and Skerryvore. The Stevensons had also designed and shipped lighthouses to remote locations including Japan and India. The British Isles, however, have a greater need for reef, rock and cliff headland lights than for those designed for sandy foundations, and the family's expertise was greatest for the conditions they encountered at home.

American and Canadian engineers, who would soon be leading the way in lighthouse construction, had a wide variety of locations that required making lights, including challenging coastal sandbars and sandy lowlands like those of the Southeast region's coastline.

Today, we have a detailed understanding of the geological factors that enter into the evolution of sandbars and beaches. Sedimentary deposits brought by both oceans and rivers cause the gradual build-up of wide, shifting coastal zones. Wave erosion steadily removes and redistributes the sediment. In some areas, when erosion outweighs deposition, sandy coastlines recede over time, while in other areas the reverse is true.

Most of the East Coast has what is called a "trailing edge" coastline, which is geologically stable because it is not at or near the edge of a tectonic plate, and therefore not at risk of earthquake activity. These were the beaches and dunes that greeted some of the first Europeans who came to North America.

On the West Coast, seismic activity adds further instability to the shifting foundations of beach areas.

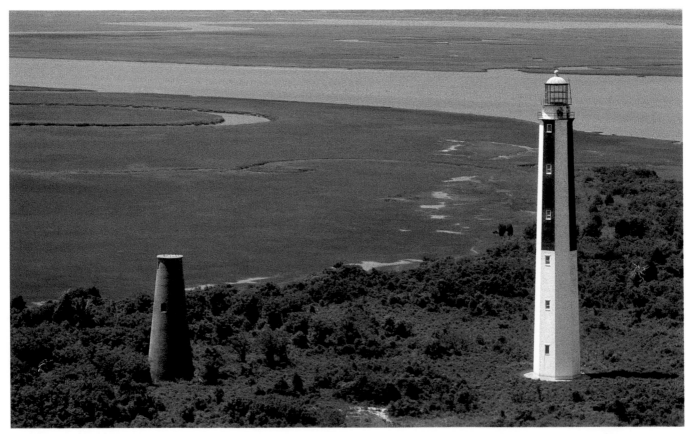

*Previous pages:* Cape May Light, New Jersey; *Above:* Old (left) and New (right) Cape Romain Lights, McClellanville, South Carolina

The engineers who built the early lighthouses did not have the advantage of knowledge of these geological features, with the consequent engineering implications, so their expertise was gained by trial and error.

A lighthouse built to guide mariners to shore from the open sea must be visible over the maximum achievable distance in order to be effective, as Alan Stevenson emphasized. This was especially crucial before the advent of other navigational aids like radar. The light source must be at a sufficient height to thwart the earth's curve for visibility at a distance. Therefore, lighthouses designed for visibility at maximum distance are placed on cliffs and headlands wherever possible, since the tower's base is already well above sea level. However, on low-lying shores lacking any cliffs or highlands, the lighthouse building itself must be tall (ideally, approximately 150 to 170 feet) in order for its light to be effective in darkness or poor visibility, or to be clearly visible from afar as a daymark.

As a result, the construction of making lights in low-lying sandbar locations poses the combined technical challenges of building tall—and therefore relatively heavy—structures on unstable foundations. They must be able to withstand exposure to the steady onslaught of the elements. In addition to height, the towers need minimal wind and wave resistance: Thus, they were usually built in cylindrical or conical forms.

The first areas of North America that were settled by European colonists included regions with long sandy coastlines. One thinks of the *Mayflower* anchored off today's Provincetown on Cape Cod, Massachusetts, where the Pilgrims signed the Mayflower Compact, and of Plymouth itself. Boston and nearby Newport, Rhode Island, as well as the sandy areas of New Jersey, follow a similar pattern of low-lying coastal shores and barrier islands with miles of beachfront. From the Pilgrim and Puritan settlements in New England and the Mid-Atlantic region to the Dutch and Swedish colonies in New York and Delaware, early mariners reached the New World on the Atlantic coastal plain. Spanish colonists came ashore as early as 1565 and founded St. Augustine in what is now Florida, where long stretches of beach and sandy soil also predominate.

Crude bonfires built along the shores probably served as the first coastal lights for these colonists. They seemed to suffice for the first eighty years, during which time the English population in North America grew to some 200,000 settlers. But as population and trade among these settlements increased, especially in the Northern colonies, the need for safe navigation grew apace. We can only guess as to how so many of the early passenger ships did manage to make it safely into port; the odds were usually against it.

Boston, Massachusetts, was the first North American town to make lighthouse construction a priority. Located on Little Brewster Island in the outer part of Boston Harbor, Boston Light was first lit in 1716, marking a milestone in maritime safety for the New World. Thirty years later, the beacon at Brant Point on Nantucket Island was put into service.

As technology improved and the population grew, many lighthouses were constructed along the shores of New Jersey and Delaware. Cape May Light, finished in 1859, at the northern entrance to Delaware Bay, is a good example of the slender, elegant towers built in the mid-nineteenth century in that region. Barnegat Light on New Jersey's Long Beach Island is a 172-foot tower that was completed in 1859 under the auspices of the Lighthouse Board.

The Mid-Atlantic and Southern shores developed less rapidly, and lighthouse construction did not occur on a similar scale until much later than in the Northeast. John Smith and the first English settlers in the Mid-Atlantic region reached the Chesapeake Bay area in 1607. "Heaven and earth never agreed better to frame a place for man's habitations," wrote Smith, the adventurer and pamphleteer of his generation. It was an agreeable location, and if there were considerable hazards for mariners to negotiate, there were also favorable harbor conditions: The current waters were so deep at Jamestown that ships could ride at anchor while tied by lines to trees. The bay consists of a series of drowned river valleys, and its tidal range varies from some 6 feet at the entrance to a level of change that is barely perceptible in the northern parts. Inside the mouth of the estuary, a series of islands, inlets, bays, coves and peninsulas demands careful navigation.

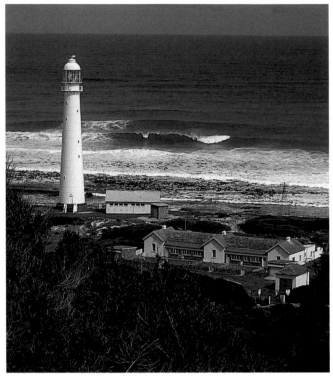

Kommetjie Light, Cape Town, South Africa

Those early colonists had to be excellent sailors, because the region did not receive its first light until 1792—Old Cape Henry Light, at the southern entrance to Chesapeake Bay. The original 90-foot tower at Cape Henry was completed in less than a year, using freshly quarried sandstone. Cracks began to appear by the 1870s, and a new cast-iron cylindrical tower was completed in 1881. The two towers stand today, vivid testimony to the engineering skill of two very different generations, almost ninety years apart.

With the development of screwpile technology in the late 1840s, several such lighthouses were constructed on Chesapeake Bay. The screwpile foundation, developed in England, consisted of up to eight long steel legs with large screws at either end. These legs were screwed deep into the ocean floor; then foundation-bearing rods were screwed into the top of the legs. This technology worked best when the legs could be drilled into solid rock or compacted sand. It was inadequate for shifting sand and unsuitable for cold climates, because the foundations proved vulnerable to floating ice. A more substantial foundation than the screwpile was achieved by adding large piles capable

of supporting layers of granite upon which foundations could be laid. This method proved suitable for construction on sandbars and low-lying islands.

Chesapeake Bay marks the dividing line between the Mid-Atlantic region, which required medium-to-short towers placed on headlands as well as some taller structures, and the Southern region, where very tall towers were and are required to cast a light far enough to be useful. Many of these elegant towers are especially attractive because of the distinctive patterns and colors painted to make them effective daymarks.

The Southeast has the highest percentage of sandbar and beach lights because it has few highlands, so American architects and engineers were challenged to refine ways of rooting and anchoring lighthouses in the sand. Cape Hatteras Light, located on the Outer Banks of the North Carolina seashore, is the classic example of a beacon designed for this type of location. The light guides sailors around the treacherous reefs of the Diamond Shoals; by day, its black-and-white spiral bands are visible for miles.

Coastal erosion has threatened Cape Hatteras Light from the beginning. The second time the light was built, in 1870, it was placed more than 200 feet from the water, but constant wave erosion eventually made dangerous encroachments. In the late summer of 1999, the Cape Hatteras Light was moved farther inland.

Florida has the longest coastlines of any American state except Alaska. When the United States added Florida to the Union in 1819, there may have been one light, at Spanish St. Augustine, but that was all. This peninsular state also lagged far behind its Northern counterparts in shipbuilding and trade; one study indicates that in 1800, St. Augustine was visited by only twenty oceangoing ships while Charleston, South Carolina, received more than 800. Although explored by Europeans as early as 1542, Florida received its lighthouse system much later than the rest of the East Coast. It was the U.S. Navy that recognized the importance of improving marine safety on this coastline in the early nineteenth century, and during the 1830s and '40s numerous lights sprang up on both the east and west coasts. St. Augustine Light was put into service in 1824 and Cape Florida Light followed in 1825.

The Space Race of the 1960s made Cape Canaveral a well-known name. More than a century before, a 65-foot brick tower had been completed on the cape, in 1848. However, like St. Augustine Light to the north, it was known for the weakness of its light. In fact, many ship captains who were grounded on the shoals while searching for the light complained that they would be better off if Cape Canaveral had no light at all. The beacon was replaced in 1868 by a 145-foot tower that still stands. This second light attracted much interest both abroad and at home.

A second burst of lighthouse construction occurred in Florida during the dozen years prior to the outbreak of the Civil War. Army Lieutenant George Gordon Meade (1815–72) supervised the building of several lights, the most advanced of which was the one at Carysfort Reef, Key Largo, built in 1848 on a screwpile foundation. Meade oversaw the construction of the 110-foot iron skeleton tower, which still remains today. Its smooth, slim bars and open interior allow wind and waves to pass through with a minimum of resistance, easily surpassing the stability of the solid cylindrical and conical steel or masonry towers in this respect. Meade also designed the Jupiter Inlet Light, completed in 1860, with the future Confederate general Robert E. Lee acting as surveyor.

The size and power of the Mississippi Delta provides different conditions in the Gulf of Mexico. No fewer than three lights were placed at different exits from the delta during the nineteenth century, but all of them lost their usefulness because of the accumulation of sediment. The Louisiana coast displays one of the highest annual rises of sea level: Grand Isle, Louisiana, shows a yearly increase of 3.7 inches; Galveston, Texas, comes close with a rise of 2.4 inches; and Port Isabel, Texas, shows an increase of 1.4 inches per year.

The Gulf Coast presents a surprising variety of shores. There are beaches, rocky areas, and many bays and inlets that once served as lairs for pirates like the infamous Jean Lafitte. There are relatively few towers in this region, and most of these were constructed after 1820. Almost all of the prebellum lighthouses were disabled by Confederate troops during the Civil War, after which it took years to "relight" the Gulf.

The U.S. Navy established one of the first lights on the Gulf of Mexico in 1824 at Pensacola, on Florida's Gulf coast. This lighthouse was needed to guide the ships that were commissioned to clear the region of pirates, and Pensacola, with its excellent natural harbor, was an obvious choice. The original 45-foot tower, built on a sandy spit outside the harbor entrance, was replaced by a 160-foot brick tower in 1858. This second tower has withstood many hurricanes and even a Union bombardment during the Civil War.

The Sand Island Light at Mobile, Alabama, a mighty 150-foot brick tower, was completed in 1859 by Thomas Leadbetter, an army officer and engineer in charge of all fortifications on the Gulf Coast. A mere two years later, to prevent its use by Union forces, Confederate general Leadbetter sent a raiding party to blow up the very light he had built. The second tower on this site was completed in 1872. During the 1906 hurricane, the

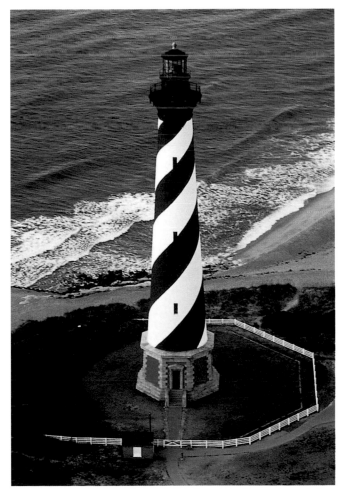

Cape Hatteras Light, North Carolina

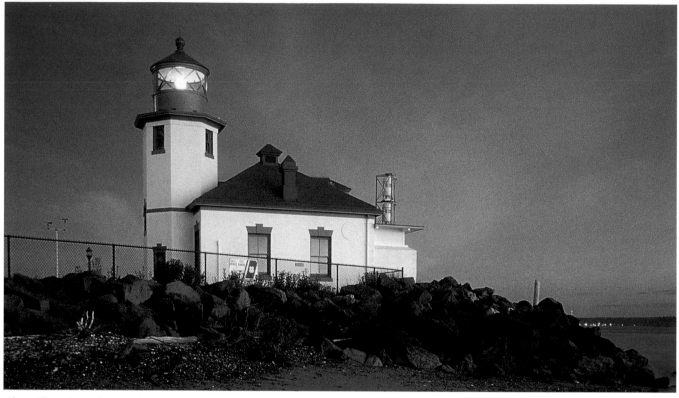

*Above:* **Alki Point Light, Seattle, Washington;** *Opposite:* **Assateague Island Light, Virginia**

light, its keeper, his wife and their house were swept out to sea. Still another tower was built to mark the hazardous island; this tower stands today.

Bolivar Point Light in Galveston, Texas, was first built in 1852, but, like the first beacon at Sand Island, it fell victim to Confederate troops during the Civil War. A second light was finished in 1872, and the 117-foot tower became a place of refuge for Galveston citizens during the terrible hurricane and flood of 1900. It remains a favorite Texas landmark today, as does Port Isabel Light, at the southeastern corner of the state.

Spanish sailors were the first Europeans to encounter the dangers of navigating the coast of California. However, Spanish settlement was confined largely to the Franciscan Missions, and there was no parallel to the commercial growth of the East Coast during the Spanish era. Lighthouse construction on the California shores began only after the Gold Rush of 1849 and the subsequent population boom. Farther north, Russian traders and missionaries visited the shores of present-day Alaska and British Columbia, but their sailors had to navigate without lighthouses.

The Pacific shoreline is a "leading edge" coast, located where the oceanic edge of one tectonic plate converges with the continental edge of another. Therefore, it is at a high risk for earthquake activity. Erosion prevails over deposition here, creating rugged, craggy cliffs that endure waves of tremendous strength. With these highlands along the Pacific shores, the tall cylinders of the low-lying East Coast regions are rarely necessary. Few West Coast lights of the United States or Canada exceed 50 feet in height.

The Great Lakes contain a larger percentage of beach lights than any area except the Southeast. The shores of these lakes have been worn down through millennia of coastal erosion, and the action of frost and ice during the severe winters. However, conditions are no match for the ocean coasts, where the mighty surfs and tidal waves engulf and shift beaches at a much more significant rate. The lighthouses of this region are featured in chapter 5.

In spite of the diversity of lighthouse shapes and sizes, the brightly painted, soaring cylinders of those designed for sandbar locations are, for most of us, the "classic" lighthouse, as seen on the following pages.

## Little Sable Point Light *Opposite*

*Mears, Michigan*

The tall conical light at Little Sable Point was constructed in 1874 to mark a sandy headland on this lightly populated stretch of the Lake Michigan coast. The 107-foot tower matched its counterpart 30 miles to the north, Big Sable Point Light. Although the tower at Big Sable Point has been modified over the years, Little Sable remains virtually unchanged. Its materials were transported to the site by water. Built of red brick, which was originally whitewashed, the tower retains its original third-order lens and the light is still in service. During the 1950s, the lighthouse was automated and the keeper's dwelling demolished. Its location made this beacon a reference point for ships bound for the growing port of Chicago. Other lighthouses on the shores of the Great Lakes are featured in chapter 5.

## Currituck Beach Light *Above*

*Corolla, North Carolina*

Along with its more famous neighbors, Cape Hatteras Light and the tower at Bodie Island, the Currituck Beach Light was erected by the Lighthouse Board to illuminate the long strip of hazardous coastline along the Outer Banks. The 158-foot-tall conical tower, a classic making light for a sandy location, was completed in 1875. The masonry was left unpainted to distinguish it in daylight from the brightly painted Cape Henry Light to the north and Bodie Island Light to the south. The site also includes a picturesque Queen Anne-style keeper's house and a simple building that is used as a workshop. Now automated, the first-order Fresnel lens flashes a light every 20 seconds that can be seen up to 19 miles out to sea. Today the beacon is maintained by the Outer Banks Conservationists.

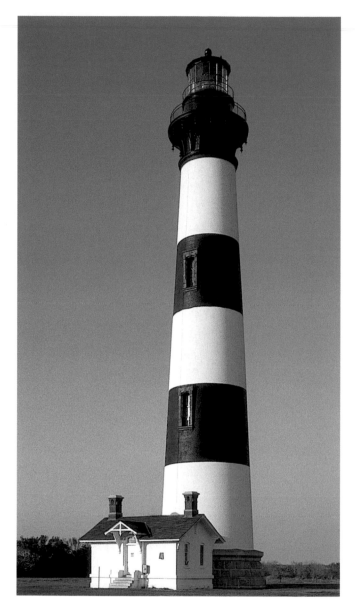

**Bodie Island Light** *Above*

*Bodie Island, North Carolina*

The distinctively painted lighthouse at Bodie Island is the third on this site. The first was built in 1848 by Francis Gibbons, who went on to design many West Coast lighthouses. The U.S. Treasury did not grant Gibbons a budget to use piles to secure the tower, and the shifting foundations caused it to lean precariously and, eventually, to topple over. Rebuilt in 1859, the second tower was blown up by Confederate troops during the Civil War. In 1872 the third beacon was erected on iron pilings in a granite foundation. Automated in 1931, the 163-foot tower is equipped with a first-order Fresnel lens that casts a light 18 miles out to sea.

**Bolivar Point Light** *Below*

*Galveston, Texas*

Discontinued in 1933, the lighthouse at Bolivar Point played an important part in the history of Galveston. Originally built in 1852, the beacon was torn down during the Civil War by Confederate troops, who reforged the cast iron for weapons. A second light was completed on the site in 1872. Standing 117 feet tall, the brick-lined conical, cast-iron structure was equipped with a second-order Fresnel lens. During the hurricane of September 8, 1900, the tower provided refuge for 125 of the town's residents who were able to climb to safety.

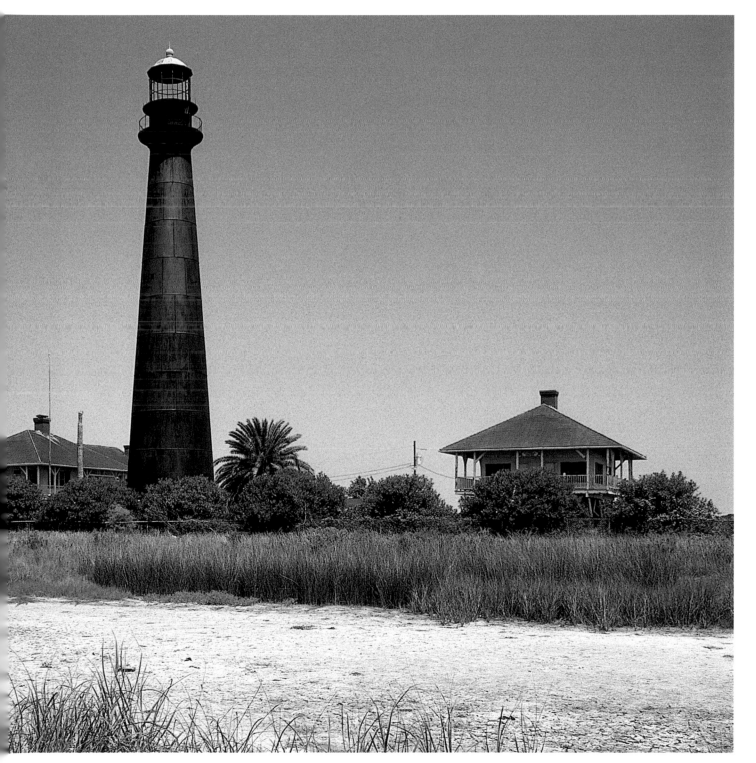

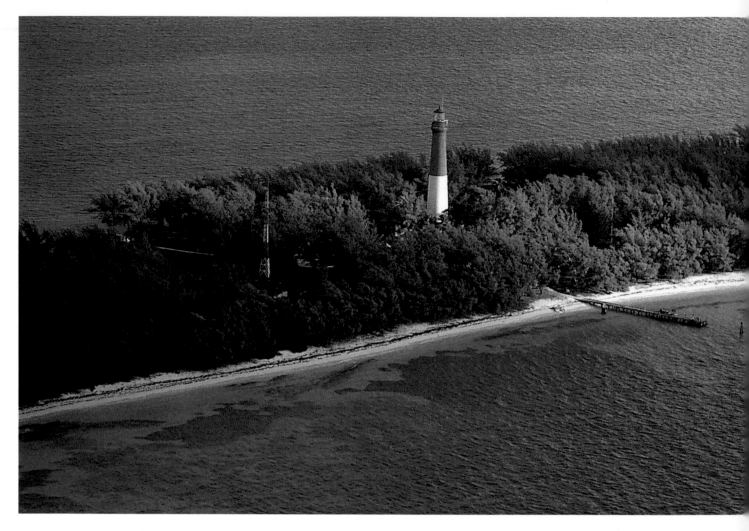

**Dry Tortugas Light** *Above*

*Loggerhead Key, Florida*

In 1836 the vessel *America* ran aground on the shoals surrounding Florida's Loggerhead Key. The wreck was attributed to the poor quality of the nearby Bush Key (now Garden Key) Light and the lack of a light on Loggerhead Key itself. Completed in 1858 at a cost of $35,000, the 157-foot tower, with its distinctive black and white painted markings, has withstood countless tropical storms and hurricanes to provide a strategic aid to safe navigation ever since. Now automated, its second-order Fresnel lens was replaced with a modern optic in 1986. The flashing white light can be seen at a distance of up to 25 miles at sea.

## Cape Henry Old and New Lights *Below*

*Virginia Beach, Virginia*

The decision to build a lighthouse to mark the entrance to Chesapeake Bay was made as early as 1774. Its construction, however, was interrupted by the outbreak of the Revolutionary War. In 1791 Secretary of the Treasury Alexander Hamilton appropriated $24,077 toward its completion and appointed John McComb contractor. Less than a year later, the 90-foot sandstone pyramidal tower (shown at right, below) was finished. Confederate forces successfully extinguished the light at the beginning of the Civil War, but Union forces restored it by 1862. During the 1870s, cracks began to compromise the structure, and plans were made to construct a new tower. The new building was placed on steadier foundations approximately 350 feet from the original light. Built of cast iron and painted in panels of black and white to make it an effective daymark, New Cape Henry stands 160 feet tall.

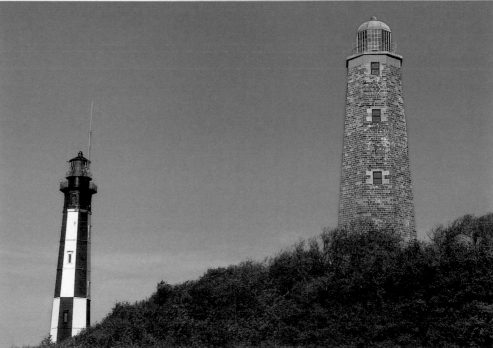

## Fire Island Light *Left*

*Fire Island, New York*

The first tower on this site, which is close to the busy port of New York City, was built in 1826. Only 74 feet tall, it was widely believed to provide inadequate warning of the dangerous shoals that lie along the ocean coast of Fire Island. When the freighter *Elizabeth* ran aground in 1850, losing most of her crew, Congress was prompted to organize the Lighthouse Board to monitor all lighthouses in the United States. Shortly after its creation, the Lighthouse Board authorized the construction of a new tower on this site. Standing 180 feet tall, the black-and-white striped beacon at Fire Island is equipped with a first-order Fresnel lens whose light is visible up to 25 miles out to sea. The flashing light earned the lighthouse the affectionate nickname "Winking Woman." Decommissioned in 1974, the tower has since been restored and relighted by a local preservation society.

## Isla Contoy Light *Opposite*

*Quintana Roo, Mexico*

A national wildlife park and bird sanctuary, Isla Contoy lies near the larger Isla Mujeres off the busy resort of Cancún, on the eastern coast of the Yucatán Peninsula. This island of sand dunes is fringed by treacherous coral reefs, and its location in the Caribbean Sea makes it vulnerable to hurricane-force storms each year. Cancún is Mexico's most popular tourist destination and a frequent stop for cruise ships.

## Mijas Costa Light *Page 52*

*Andalusia, Spain*

This handsome tower of local stone, attached to a tile-roofed keeper's dwelling, overlooks the coast near the entrance to the Mediterranean Sea, a route plied by ships since Phoenician times.

## Cousins Shore Light *Page 53*

*Prince Edward Island*

Originally part of the Cape Tryon Light, the beacon at Cousins Shore was moved to its current location during the 1950s. It is now used as a cottage.

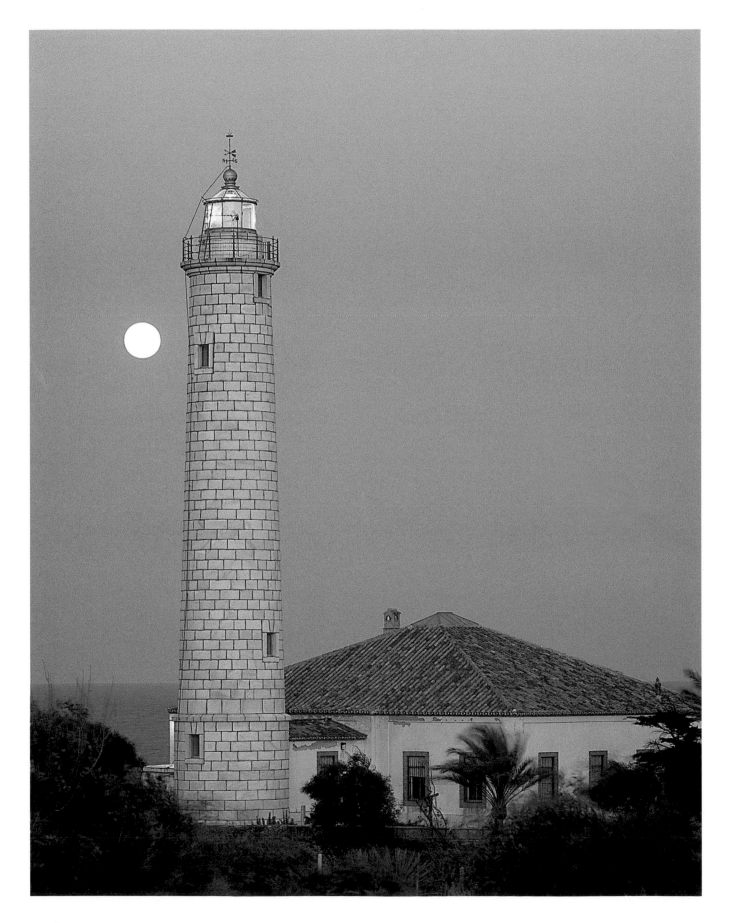

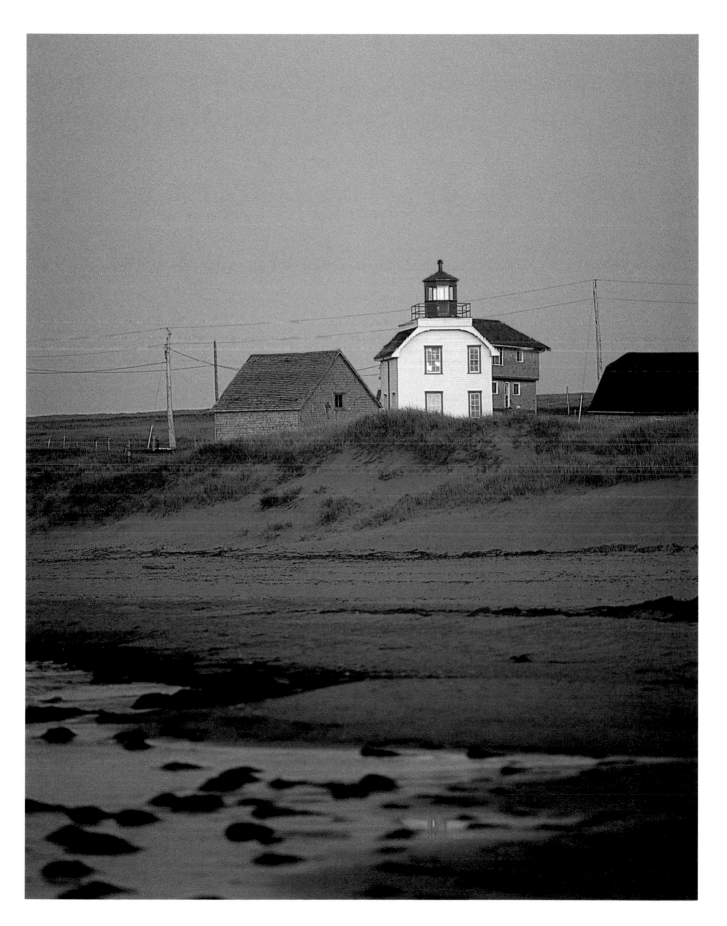

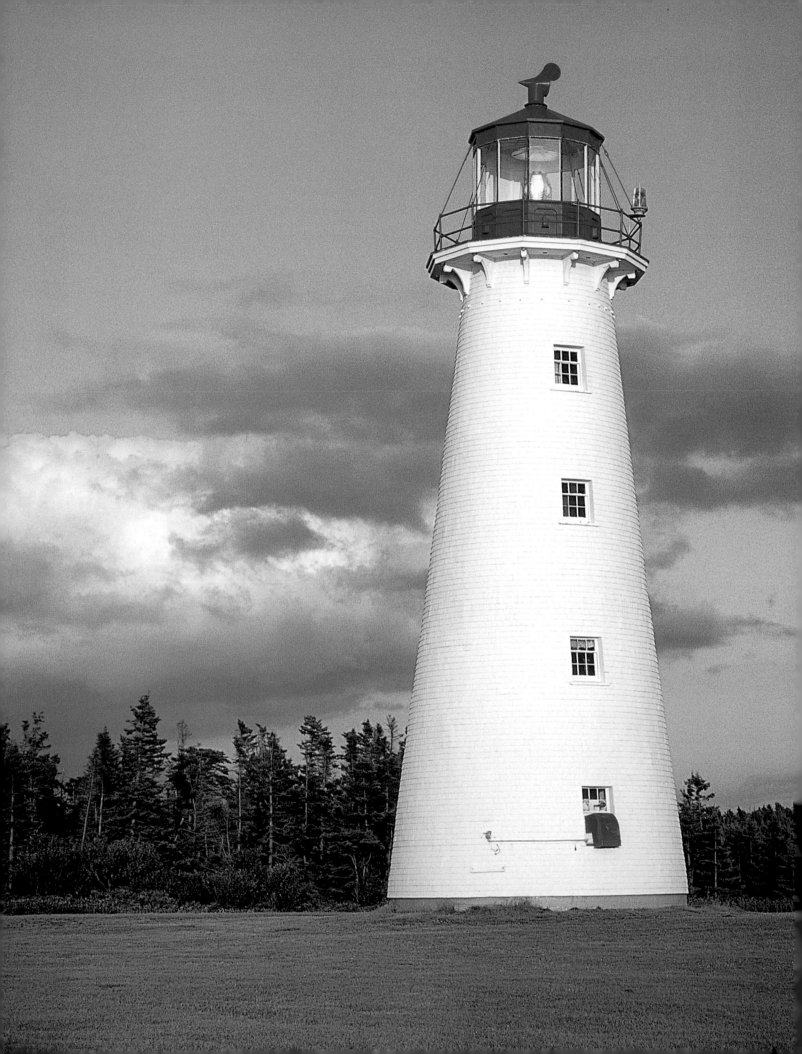

## Point Prim Light

*Prince Edward Island*

The lighthouse at Point Prim is located on the south shore of Prince Edward Island and marks the long peninsula that juts into the Northumberland Strait. Completed in 1846, the 60-foot tower's focal plane is 69 feet above sea level. The whitewashed conical tower — the oldest of this shape on the island — was designed by Sir Isaac Smith in 1845. Automated in 1969, the tower emits a flashing white light that can be seen up to 20 miles at sea.

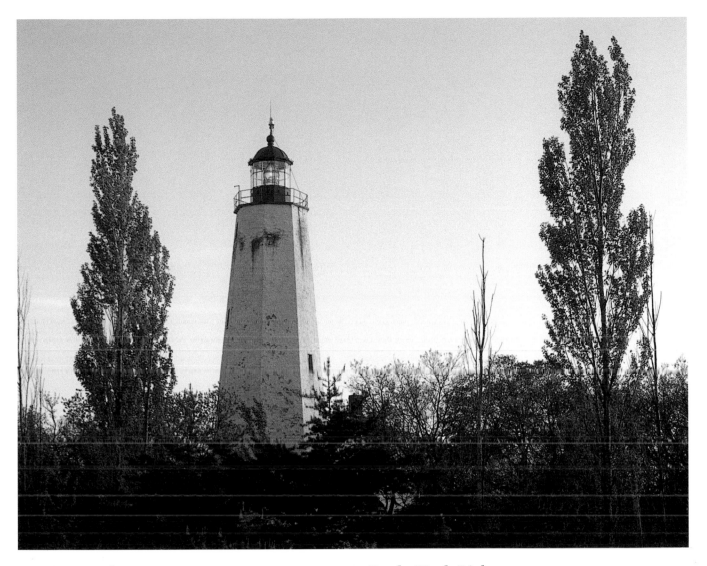

## Barnegat Light *Opposite*
*Barnegat, New Jersey*

Winslow Lewis built the first lighthouse on Long Beach Island, the low-lying barrier island off the coast of central New Jersey, in 1835. Almost twenty years later, lighthouse expert George Meade declared the tower structurally inadequate for this exposed site. His criticism fell on deaf ears though, and the light remained unaltered. Less than a year later, a storm destroyed Lewis's tower. The 172-foot beacon that stands on the site today was constructed in 1859 under the supervision of the Lighthouse Board at a cost of $45,000. The first-order Fresnel lens, visible up to 30 miles at sea, cost an additional $15,000. To avoid destruction by future storms, the tower has two concentric walls, the outer of which is 4 feet thick. Called "Old Barney," Barnegat Light was decommissioned in 1944.

## Sandy Hook Light *Above*
*Sandy Hook, New Jersey*

Sandy Hook Light has the honor of being the oldest continuously operating lighthouse in the United States. First lit on June 11, 1764, with a system of 48 wicks, the beacon was later equipped by its creator, Winslow Lewis, with an Argand lamp. In 1857 a third-order Fresnel lens was installed. Strategically located on a narrow point projecting 5 miles into New York's Lower Bay, the lighthouse was built to encourage trade via New York Harbor and was known originally as the New York lighthouse. After years of conflict between New York and New Jersey as to who should control the light, it was taken over in 1790 by the federal government. Today, Sandy Hook remains an important navigational aid and displays a fixed white light that can be seen 20 miles out to sea.

**Lynde Point Light** *Opposite*

*Old Saybrook, Connecticut*

When the first tower on this site at the western entrance to the Connecticut River was built in 1803, it was lit with whale-oil lamps. Because it was often obscured by low coastal fog and mist and was not tall enough to be visible at a distance, the original 35-foot-tall octagonal wooden tower was replaced in 1838 with a sturdy 65-foot pyramidal stone tower. Now automated, the fifth-order Fresnel lens displays a fixed white light that can be seen up to 14 miles at sea. A fog bell was added to the complex in 1854.

**West Point Light** *Above*

*Seattle, Washington*

Since it was put into operation in November 1881, the 23-foot square-shaped lighthouse at West Point has marked the promontory at the northern entrance to Seattle's Elliot Bay. Located at the foot of Magnolia Bluff in what is now Discovery Park, the beacon guides vessels through this heavily trafficked part of Puget Sound. The stucco-covered West Point Light is equipped with a complex fourth-order Fresnel lens that displays an alternating red and white light, which can be seen from more than 15 miles away.

## Nauset Beach Lighthouse
*Eastham, Massachusetts*

This site on the Atlantic Coast of Cape Cod was first lighted by three wooden towers known as the Three Sisters. Originally the north tower of the twin lights at nearby Chatham, the Bureau of Lighthouses had the Nauset Beach Light building moved from Chatham in 1923 to replace the remaining wooden tower at Nauset. Standing 48 feet tall, the conical cast-iron tower has its focal plane 114 feet above sea level. The light was relocated again in 1996, when coastal erosion threatened the site. Now automated, the red-and-white tower makes an effective daymark.

**Monomoy Island Light** *Below*

*Monomoy Island, Massachusetts*

Monomoy Point is located on the southern end of Monomoy Island, which is a long, narrow island south of the coast of Cape Cod at Chatham, projecting into Nantucket Sound. The first lighthouse on this exposed site was built in 1823. It was rebuilt in 1855 and again during the 1870s. No longer an active aid to navigation, the light at Monomoy Island is now part of the Monomoy National Wildlife Refuge, and is the property of the U.S. Fish and Wildlife Service.

**Old Field Point Light** *Opposite*

*Stony Brook, New York*

Deactivated in 1933, Old Field Point Light marked the entrance to the natural harbor of Port Jefferson on Long Island's north shore. Mainly frequented by pleasure boaters, this harbor is also used as a terminus for the passenger ferry to Bridgeport, Connecticut. This beacon is the second lighthouse on the site, one of many navigational aids on a stretch of coastline characterized by numerous inlets, bays, rocks and reefs. The first light, built in 1823, was replaced with the current tower, which is similar in design to several contemporaneous lights in the area, in 1868.

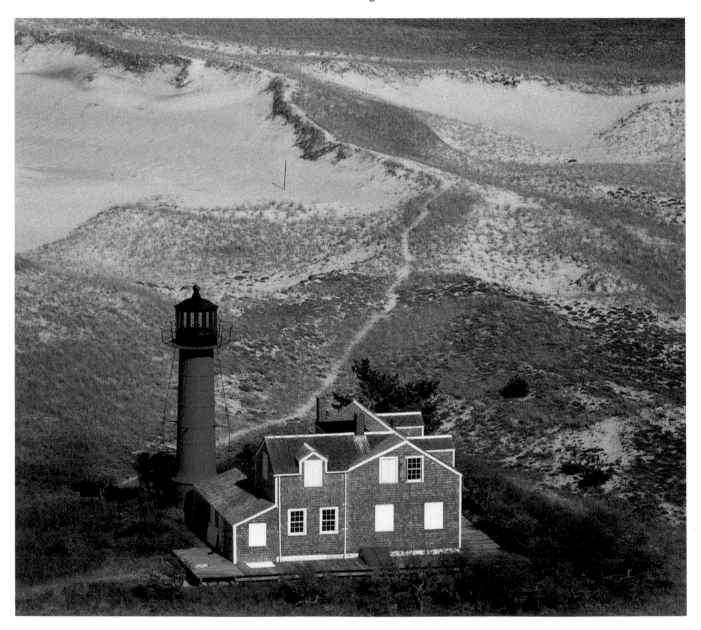

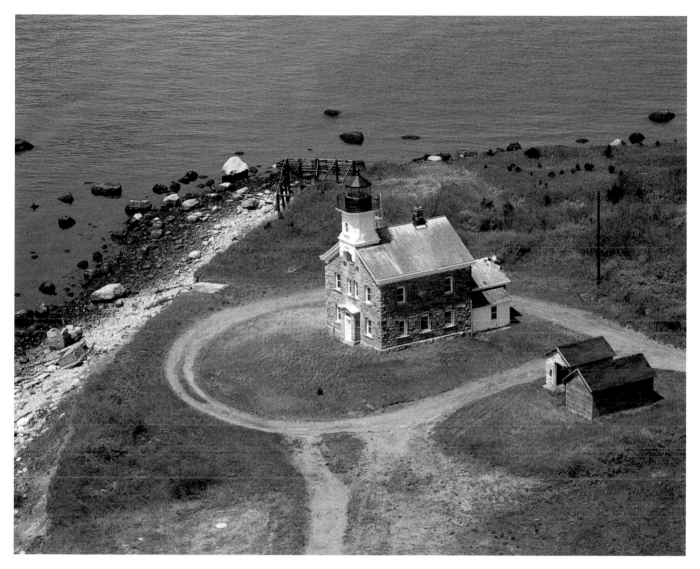

**West Point Light** *Page 64*

*Prince Edward Island*

The black-and-white striped, square pyramidal tower at West Point was the first light built on Prince Edward Island by the Department of the Marine. Completed in 1875, scenic West Point Light stands on the southwestern tip of the island and was manned until 1963 by just two successive keepers: William MacDonald guarded the light from 1875 to 1925, and Benny MacIsaac served from 1925 until 1963. Standing 58 feet tall, its focal plane is 67 feet above sea level, making it the tallest square-shaped lighthouse on Prince Edward Island. Its flashing white light is visible from up to 12 miles at sea. Originally red-and-white striped, the tower's colors were changed to black and white by the Canadian government in 1915.

**Great Point Light** *Page 65*

*Nantucket Island, Massachusetts*

Every 5 seconds the third-order Fresnel lens of the Great Point Light flashes alternate white and red lights that warn sailors away from the dangerous waters surrounding Nantucket Island. Located on the southern end of the island, the first tower was built on this site in 1785. After burning to the ground in 1816, it was rebuilt two years later as the existing 60-foot rubblestone beacon at a cost of $7,400. A third-order Fresnel lens was installed in the lighthouse in 1857. A storm destroyed the 1818 light in 1894, and in 1986 this white-painted landmark was reconstructed farther inland. The Great Point Light is now a part of the Coatue Wildlife Refuge.

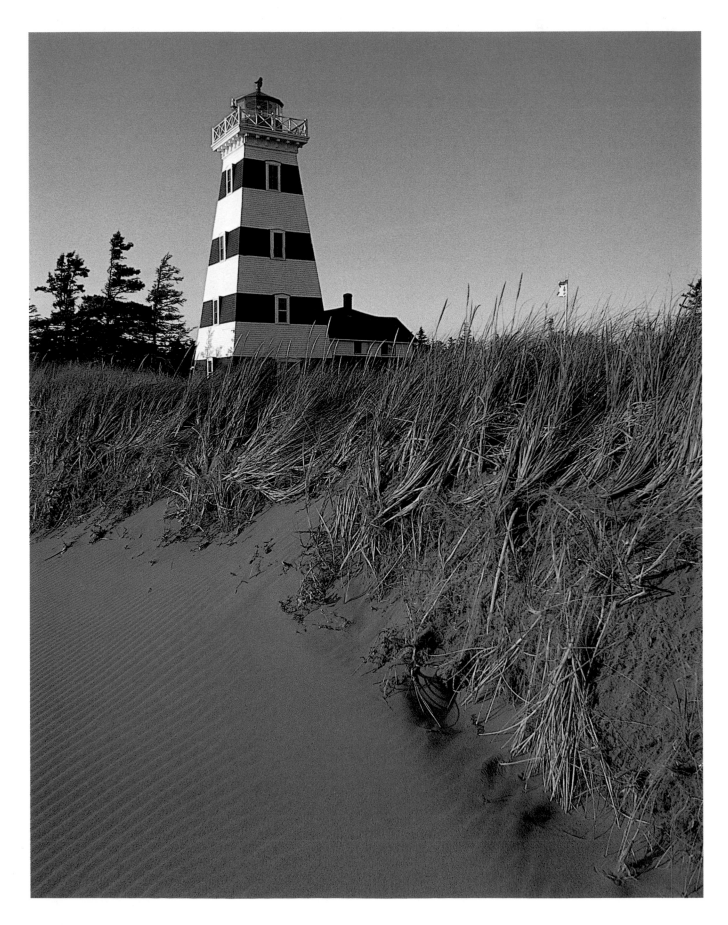

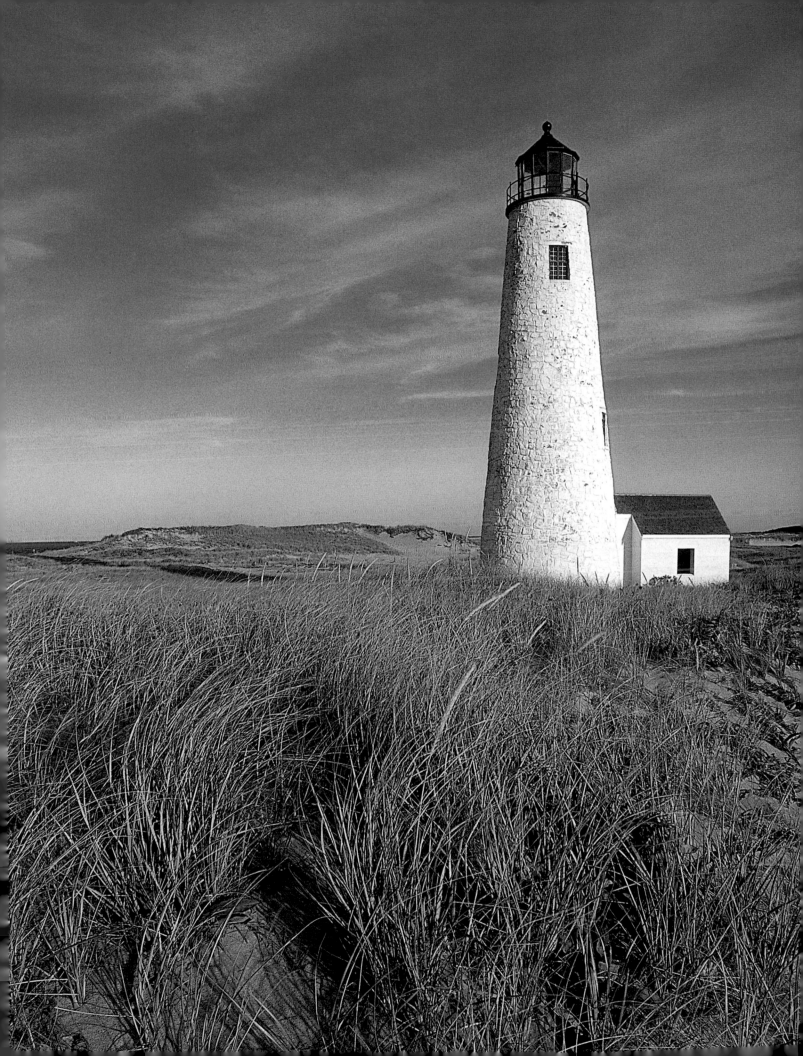

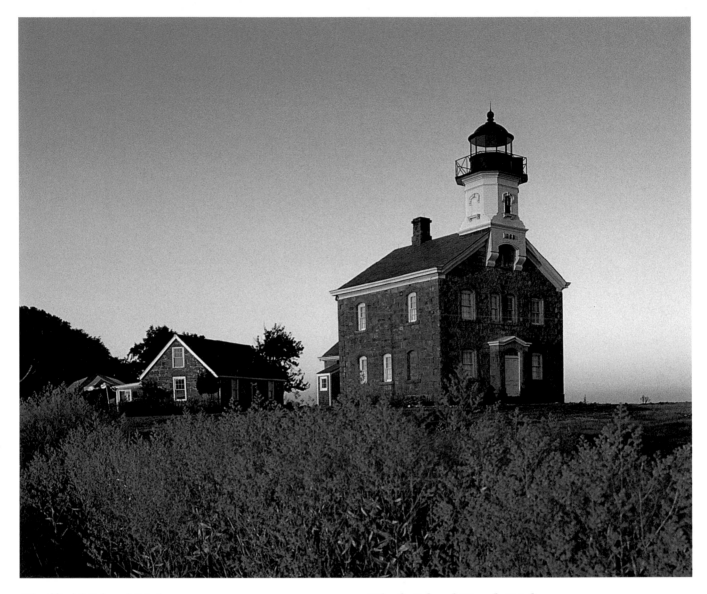

**Sheffield Island Light** *Above*

*Norwalk, Connecticut*

Restored and maintained since 1986 by the Norwalk Seaport Association, the Sheffield Island (once called Smith Island) Light is now part of a wildlife refuge. The two-story stone tower, one of a series built on the shores of Long Island Sound to a similar design, was built in 1868, the second lighthouse on the 53-acre site; the first was completed in 1826. After marking the entrance to the channel into the Norwalk River for almost two-thirds of a century, Sheffield Island Light was decommissioned in 1902, when the nearby Greens Ledge Light was constructed.

**Block Island North Light** *Opposite*

*Block Island, Rhode Island*

The 50-foot-tall Block Island North Light is the third lighthouse to mark Sandy Point, a dangerous sandbar that extends several miles north of the island. The first tower was built in 1829 and was 40 feet tall. In 1837 it was moved one-quarter of a mile inland. In 1857 a new tower was built on the site; it was replaced in 1867 with the existing building. The gray granite building is two stories high and served sailors approaching both Long Island Sound and Narragansett Bay. Automated in 1955, the light was decommissioned in 1973 and purchased by the U.S. Fish and Wildlife Service. In 1984 the town of New Shoreham bought the lighthouse and restored and relit the light with a federal grant five years later.

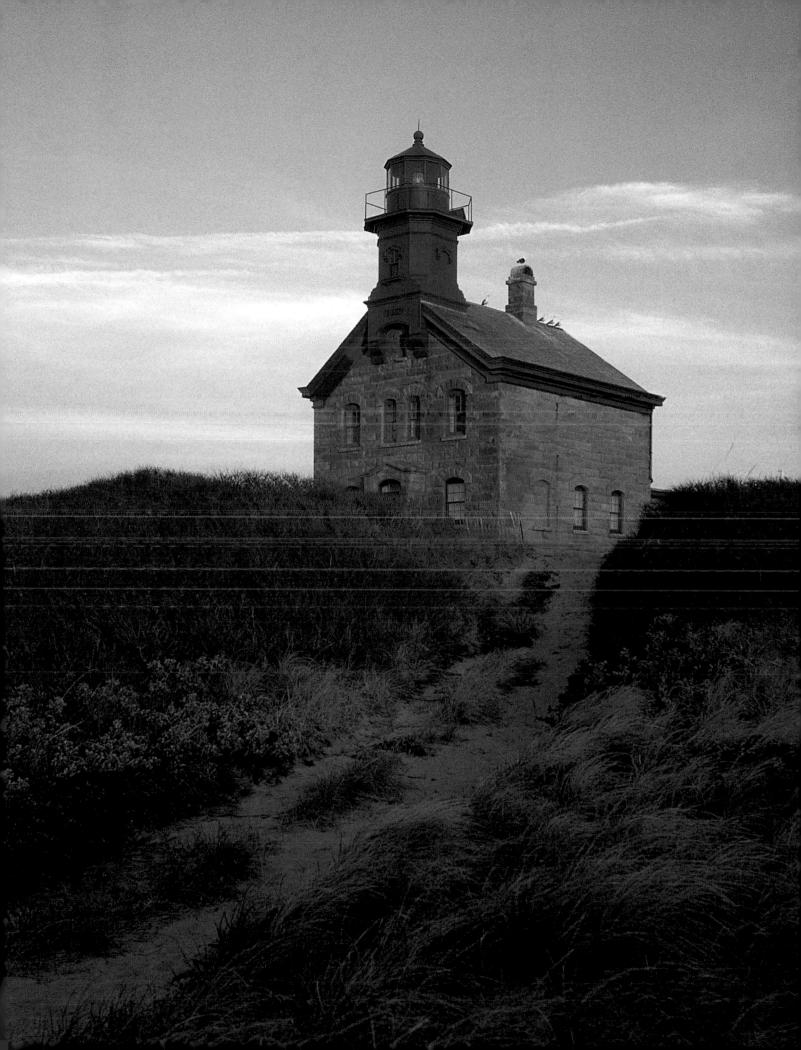

# Cliff Lights

*"The elevation of the lantern above the sea should not, if possible, for sea-lights, exceed 200 feet; and about 150 feet is sufficient, under almost any circumstances, to give the range which is required. Lights placed on high headlands are subject to be frequently wrapped in fog, and are often thereby rendered useless, at times when lights on a lower level might be perfectly efficient. But this rule must not, and indeed cannot, be strictly followed, especially on the British coast, where there are so many projecting cliffs, which, while they subject the lights placed on them to occasional obscuration by fog, would also entirely and permanently hide from view lights placed on the lower land adjoining them. In all such cases, all that can be done is carefully to weigh all the circumstances of the locality, and choose that site for the lighthouse which seems to afford the greatest balance of advantage to navigation."*

—ALAN STEVENSON

Cliffs and rocky coasts have long posed challenges to lighthouse builders and engineers, yet their prominence and height above sea level make some cliffs ideal locations for navigation lights. Many hazardous areas in Europe remained unlit for generations because engineers could not find a way to properly site and mount a lighthouse. On level or gently sloping headlands, access to cliff-edge lighthouse sites was simple. But on rocky, inaccessible cliffs with steep approaches from all angles, construction was necessarily problematic. With rare exceptions, these latter locations had to manage without lighthouses until the middle and second half of the nineteenth century, when technical advances in the design and materials used, including pulleys, screws and cables, allowed for easier hauling of masonry, wood and steel—and laborers—to the sites.

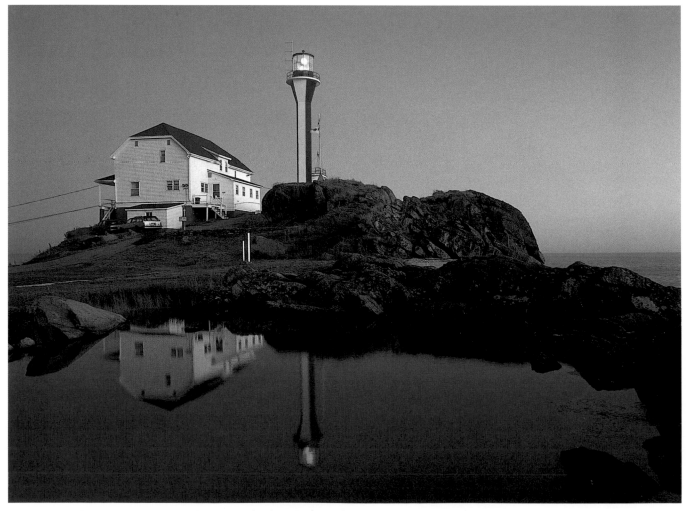

*Previous pages:* **Cape Disappointment Light, Fort Canby State Park, Washington;** *Above:* **Cape Forchu (Yarmouth) Light, Nova Scotia**

Roughly three-quarters of the world's continental and island margin areas are made up of rocky coastlines, often with concomitant strong tides, huge waves and high cliffs. In polar and subarctic regions, floating ice impedes waves and disperses some of their strength. Coral reefs have a similar effect. The characteristics of a coastline depend on a combination of the surf's strength and the type of rock involved, whether igneous, sedimentary, or metamorphic: Each type erodes in different patterns.

The West Coast of North America has high cliffs that are continuously eroded by the force of wave action traveling virtually unimpeded across the Pacific Ocean. Earthquake activity also destabilizes the coastline, where rock slides are common, especially along the mountainous coast of California. The shores of northern New England, where the Appalachian range approaches the ocean, are also characterized by rocky cliffs, notably in Maine. Newfoundland's coastline is similarly rugged.

The earliest cliff lighthouses on the continent were built on sites located on headlands and promontories with ready access for building. Several of these were constructed on the Maine coast. Portland Head Light, finished in 1791, is an 80-foot tower built on a 20-foot elevation, placing its light at 100 feet above sea level. It provides a welcome beacon for sailors entering Casco Bay. Pemaquid Point Light, built in 1827, warns sailors away from the dangerous rock formations of this site. Although it is only 38 feet tall, the light's focal plane is 80 feet above sea level, allowing for ample range.

The Twin Lights of Navesink, New Jersey, on the Atlantic Highlands, are another example of early cliff lights. Maritime traffic has entered New York Harbor for centuries, some vessels docking in Manhattan and others making their way up the Hudson River, as shown in Henry Hudson's log of exploration in 1609. U.S. lighthouse administrators recognized the need for a clear, strong signal in this region. Although New Jersey's Sandy Hook Light, finished in 1764, was already in place, its lantern was not sufficiently high above sea level to serve the purpose.

Two rubblestone towers were constructed on the Highlands at Navesink in 1828 to mark the western

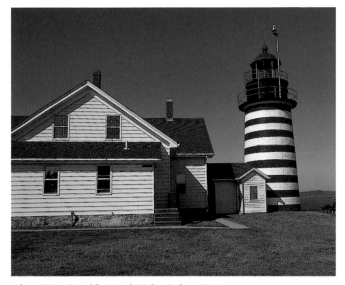

*Above:* **West Quoddy Head Light, Lubec, Maine**

entrance to New York Harbor. Despite their height—246 feet above sea level—ship captains complained that the lights were inadequate. It was not until 1840, when Commodore Matthew C. Perry brought the first two Fresnel lenses from France to Navesink, that a major improvement occurred. From then on, the entrance to New York Harbor became known as one of the best-lit in the world (later, the Statue of Liberty would serve for a time as another harbor light for Manhattan Island).

Alan Stevenson's 1850 treatise on lighthouse construction included the advice that: "Views of economy...should never be permitted to interfere with placing [a lighthouse] in the best possible position; and, when funds are deficient, it will generally be found that the wisest course is to delay the work until a sum shall have been obtained sufficient for the erection of the lighthouse on the best site." During the thirty years prior to 1850, considerations of economy had prevailed in the American lighthouse establishment, largely because of the influence of Stephen Pleasonton, the Fifth Auditor of the U.S. Treasury. Pleasonton had prevented the introduction of Fresnel lenses for as long as possible, always finding ways to skimp on building materials for new lighthouses. His decisions often resulted in false economies, as seen at the "Leaning Light" of Bodie Island (discussed in chapter 1). The funding situation changed, however, when the new Lighthouse Board was created in 1852.

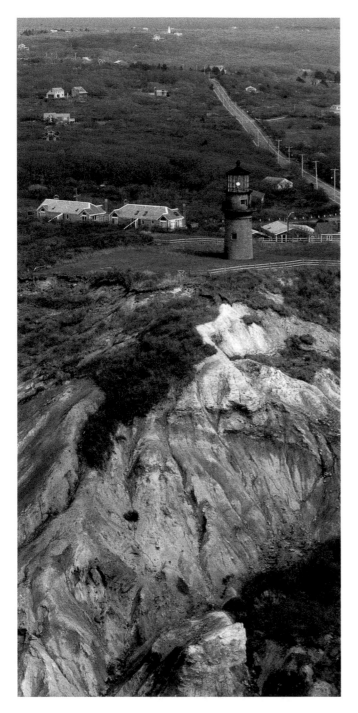

new and significantly different topography and geology. With the sole exception of the light in the old Russian fortress at Sitka, Alaska, the West Coast of the United States and Canada was as yet unlit: There were no existing navigational aids—and no major population centers—along this vast shoreline. The waters of the Pacific build tremendous strength in transit, and the surf slams into the coast with great force, carving high cliffs from mountainous and plateau areas from California up to British Columbia. What vacationers view as wonderful scenery was anything but for nineteenth-century mariners, and countless ships were lost along these shores. Navigational aids were imperative, and planners had to find suitable locations, disallowing sites that were undercut by wave action, or particularly subject to rock slides and erosion.

Two men played important roles in shaping the American lighthouse system on the West Coast. Ammi B. Young, an architect and engineer for the Lighthouse Board, designed compact lighthouse buildings that combined the keepers' quarters with the light itself, in the form of a Cape Cod-style dwelling with a short tower rising through the roof of the house. These structures were relatively simple, but there was often a problem in siting them and securing foundations adequate for stability and wind resistance.

Major Hartman Bache, who built the nation's first screwpile lighthouse in Delaware Bay in 1852, went west to pave the way for the new construction commissioned by the Lighthouse Board. A man of rare energy and foresight, he surveyed and sketched many areas where the first lights on the West Coast would be built, often at considerable elevations. Old Point Loma Light, built in San Diego in 1855, is only 40 feet tall, but it stands 460 feet above sea level. One of the region's first lights, Old Point Loma was deactivated in 1891 and replaced with an iron skeleton tower. Construction began in 1899 on the Point Sur Light, at Big Sur—a formidable challenge. By 1891 the builders had completed a 40-foot granite tower atop the cliffs with a focal plane 250 feet above sea level.

Point Reyes, 20 miles north of San Francisco, stands precariously on a 250-foot cliff and still displays its first-order Fresnel lens. The area is shrouded in fog for

Composed of nine unpaid but well-qualified members, the Lighthouse Board began by dividing the nation into twelve districts, the first of which started at the border between Maine and New Brunswick, Canada, and the last encompassing the entire West Coast, where new research and surveying were needed urgently.

The acquisition of the western coastal states of California, Oregon and Washington in the second half of the nineteenth century presented engineers with a

up to 110 days a year (a problem common to many cliff locations), and several keepers voiced their dissatisfaction with the site. "Solitude, where are your charms?…Better dwell in the midst of alarms than in this horrible place," wrote one of them in 1885.

Point Arena Light stands on a rugged cliff created by movement of the San Andreas Fault line. The first tower was built here in 1870, but the earthquake of 1906—which devastated San Francisco farther south—destroyed the station. A new 115-foot tower was finished the same year, this one buttressed against seismic activity by walls of reinforced concrete.

Point Cabrillo Light at Mendocino, California, was built in 1909. Only 47 feet high, it stands on a site 422 feet above sea level, making this the highest light in the United States. Both the light and its fog signal were vital for ships carrying lumber from Mendocino to San Francisco in the early part of the twentieth century.

As one travels north from Mendocino, the terrain becomes even more rugged. Trinidad Head Light occupies a jagged cliff face some 200 feet above the Pacific, and Battery Point (or Crescent City) Light, Oregon, illuminates some of the most beautiful scenery—and the most dangerous waters—along the West Coast. Cape Blanco Light is on the westernmost site in the Lower 48 states. Named by Spanish sailors

for its white cliffs, Cape Blanco received its light in 1870. The 59-foot conical tower has a focal plane 245 feet above sea level. Perhaps even more commanding is Heceta Head Light, in Florence, Oregon. It took two years and $180,000 to build the station, which houses a first-order Fresnel lens. Popular with photographers and tourists, Heceta Head is one of the most-admired scenes on the West Coast.

Tillamook, Oregon, is the site of a major achievement in American engineering. Tillamook Rock, rough and sheer, overlooks the most dangerous part of the Oregon coast. Here Pacific waters meet the powerful currents of the Columbia River estuary, creating a turbulent sea with record-breaking waves. It took weeks for surveyors to get a single man ashore to take measurements with a pocket tape measure. The builders then installed a derrick with a long boom, so that materials could be hoisted to the summit. Even so, it took from October 1879 until January 1881 to construct the tower, which is only 48 feet high. Every year it is assaulted by massive storms. In 1886 an official document reported that "the sea from the south-west broke over the rock, throwing large quantities of water above and on the building [a height of 150 feet]. The roofs on the south and west sides of the fog-signal room, and on the west side of the building, were crushed in."

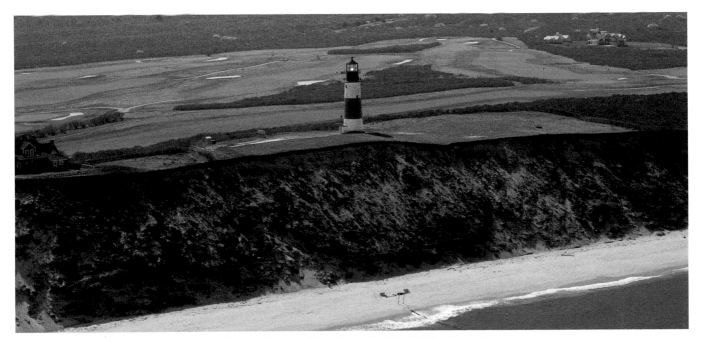

*Opposite:* **Gay Head Light, Martha's Vineyard, Massachusetts;** *Above:* **Nantucket Island Light, Massachusetts**

The mouth of the Columbia, the West's greatest river, is roughly four miles wide. Lewis and Clark arrived here in December 1805, but it was not until 1856 that Cape Disappointment received its lighthouse. The nearby North Head Lighthouse was completed in 1898, making this one of the best-lit estuaries in the world. Even so, the Cape Disappointment Coast Guard Station performs many life-saving missions each year, because sailors underestimate the power of this mighty confluence.

Countless vessels have foundered in the waters off the treacherous coast of the Pacific Northwest. The rugged terrain here made it almost impossible for nineteenth-century engineers to build lighthouses using existing methods, and lack of settlement made their construction less of a priority. Public outcry over the tragic wreck of the passenger steamer *Valencia* in 1906 was the catalyst needed for the U.S. and Canadian governments to begin work on beacons here.

Although there were some towers in British Columbia, including Vancouver's Cape Beale Light (1874) and Queen Charlotte's Egg Island Light (1874), large stretches of this irregular coastline were shrouded in darkness. Plans to build a light station on Vancouver Island's Pachena Point—the site of the fatal wreck of 1906—were quickly drawn up, and construction began within months. The combination of the treacherous cliff location and violent storms made construction a difficult—at times, an impossible—task. After more than a year of work, the nearly completed light was swept out to sea in one such storm. The construction team remained determined to emplace a light here.

Equipped with a first-order Fresnel lens, the lighthouse at Pachena Point went into service on May 21, 1908. Standing 188 feet above sea level, the tower emits a light that can be seen up to 35 miles at sea. The first keeper of the beacon at Pachena Point was John Richardson, who was joined by his sister and assistant, Gertrude. The remote location and isolation bred severe depression, and in the fall of that same year, Gertrude threw herself from the cliff to her death.

Although the volcano-born Hawaiian Islands were acquired by the United States in 1898, the Lighthouse Board did not assume responsibility for Hawaii's navigational aids until January 1, 1904. At this time,

Hawaii, which had nineteen primitive lighthouses, became a sub-district of the Twelfth Lighthouse District. Many of the existing towers were fitted with Fresnel lenses; others were rebuilt. More were constructed, including a number of notable cliff lights.

The isolated beacon at Kilauea Point was built on the island of Kauai in 1913 to service ships voyaging between the United States and the Orient. The 53-foot conical tower is located on a 180-foot-high promontory—the most northerly point of the principal islands. On the island of Oahu stands Makapu'u Point Light, built in 1909 to guide eastbound maritime traffic. Not only is the site 420 feet above sea level, but the 46-foot tower was equipped with a 12-foot-high Fresnel hyperradiant lens with an inside diameter of 8.5 feet, which is among the largest in use today. Automated in 1974, the light is visible for up to 28 miles at sea.

While large stretches of America's East Coast are low-lying, some crucial lights were built at well-known sites on cliffs and headlands. One example is Block Island Southeast Light, erected in 1875. Built in the Victorian Gothic style, Block Island Southeast was moved farther inland when the Mohegan Bluffs became eroded by the Atlantic. The lighthouse itself is only 67 feet high, but the cliffs give the first-order Fresnel lens an elevation of some 260 feet above sea level—the highest on the East Coast. Its location in Long Island Sound, at the entrance to busy Block Island Sound, makes it extremely important to mariners. During the notorious hurricane of 1938, the dedicated lighthouse keepers turned the lens by hand for several days to alert seamen to the dangers here. The Mohegan Bluffs continued to erode throughout the twentieth century, and in 1994 the lighthouse building was moved 200 feet west to its present location.

Newport, Rhode Island, remains one of America's prime attractions for yachtsmen and other pleasure boaters. Castle Hill Light marks the entrance to this busy harbor. Built into the side of the cliff on the southeastern entrance to the harbor, it has a long and interesting history. The prominent naturalist Alexander Agassiz (1835–1910) refused to allow a light station on his strategically located property. In response, steamboat captains painted the rugged cliffs white in order to

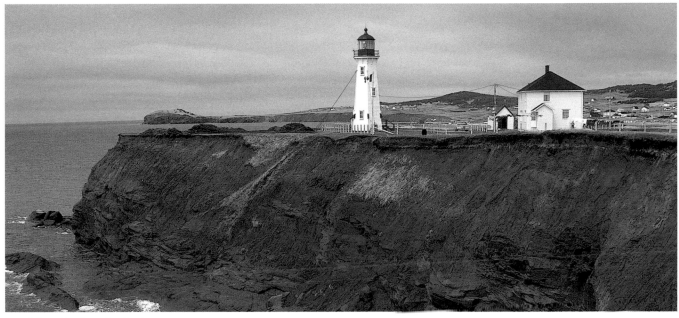

Magdalen Islands Light, Quebec

provide a point of reference visible by night. A light was finally built on this site in 1890. A working navigational aid today, its fifth-order Fresnel lens flashes a red light at 42 feet above sea level.

Maine's Bass Harbor Head Light, on the southwest side of Mount Desert Island, is justly considered one of the handsomest lighthouses in North America. The compact brick tower guards the entrance to Bass Harbor and is perched on a cliff that lifts the lantern's focal plane 56 feet above the water. Located near beautiful Acadia National Park, Bass Harbor Light is still equipped with its original fourth-order Fresnel lens.

Atlantic Canada displays a highly variable coast, ranging from the sands along the Bay of Fundy and Prince Edward Island to the glacier-molded rock of Cape Breton Island and Newfoundland. One of the most famous Canadian lighthouses is Peggy's Cove, located at the entrance to St. Margaret's Bay, just south of Halifax, Nova Scotia. While the cliff height here is not remarkable, immense Devonian granite ledges and boulders distinguish the site. Legacies of the last Ice Age, these formations are some 400 million years old. A massive monument to the generations who have made their living from the sea depicts thirty-two fishermen, their wives and children, a guardian angel and the legendary Peggy, for whom the village was named.

The changing coast of Atlantic Canada features sandy shores and rolling pastures alongside steep cliffs, as seen in the province of Prince Edward Island. Located on the northeastern tip of the island, the East Point Light was built in 1867 to overlook the dangerous confluence of the Gulf of St. Lawrence and the Northumberland Strait. The 65-foot wooden tower is perched on a steep cliff that places its focal point more than 100 feet above sea level. Three years after a British warship was wrecked in these treacherous waters in 1882, the octagonal light was moved farther west to provide greater visibility at sea. In 1908, threatened by severe erosion, the lighthouse was moved farther inland. A fog-alarm building was also added at this time. One of Prince Edward Island's last lights to be automated, the beacon at East Point continues to guide ships safely through these waters.

Lighthouses were constructed on steep cliffs and craggy outcroppings across the continent during the late nineteenth and early twentieth centuries, as trade and populations grew. Although these towers were often deceptively simple in design, the isolated and dangerous locations of many made it particularly hazardous to build them. Determined engineers and builders braved the elements to construct the beacons, many of which still signal mariners today.

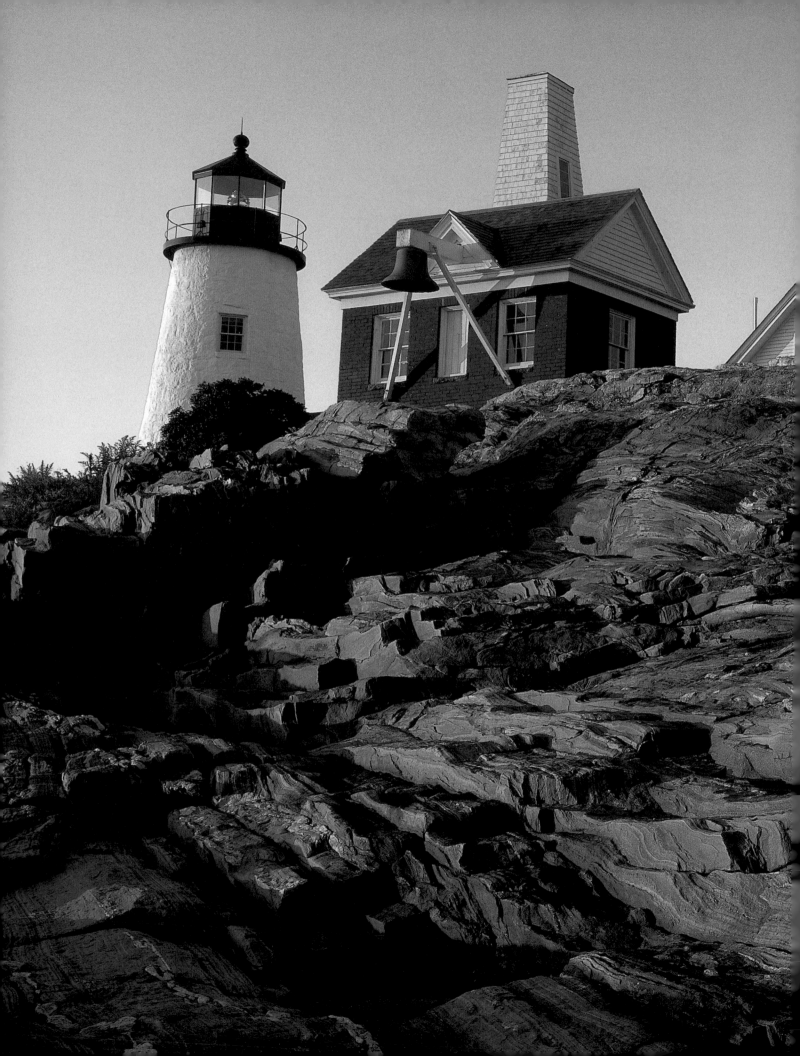

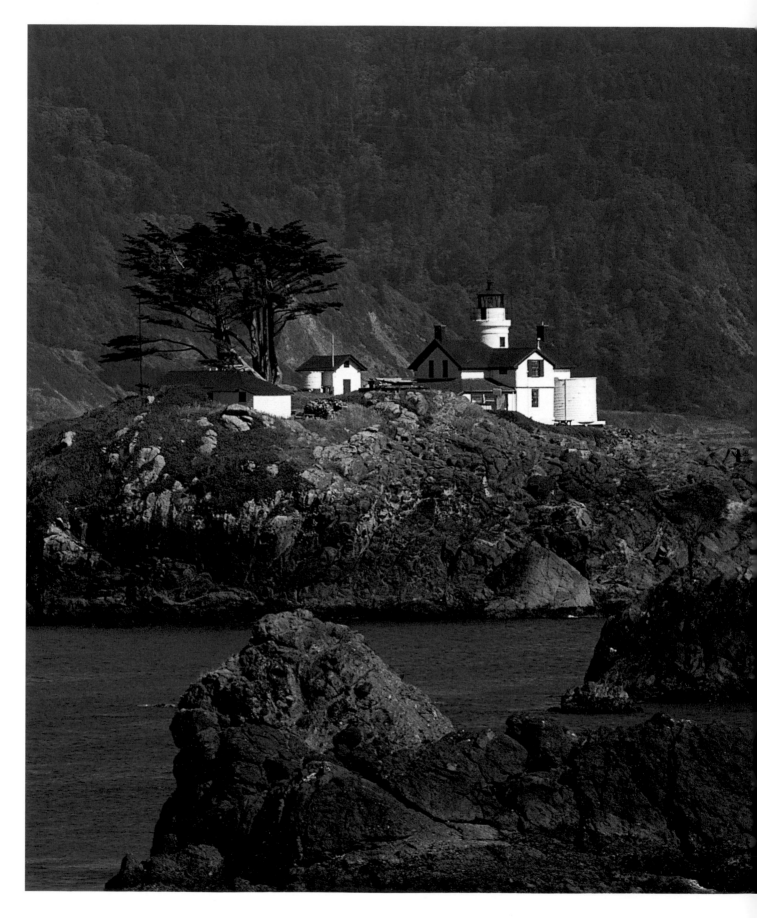

**Pemaquid Point Light** *Previous pages*

*Damariscotta, Maine*

Constructed in 1827 to mark the entrance to St. Johns Bay, Pemaquid Point Light is easily recognized by the unusual striated rock formations that surround it. Carved from glacial ice, the rock is a dangerous hazard to mariners. The first lighthouse on the site was built during John Quincy Adams's presidency at a cost of $4,000. Rebuilt in 1857, the tower was equipped with a fourth-order Fresnel lens. The 38-foot tower has its focal point 79 feet above sea level.

**Battery Point (Crescent City) Light** *Left*

*Crescent City, California*

Congress designated Crescent City as a lighthouse site in 1856 because it was one of the most important lumber centers on the West Coast. Outfitted with a fourth-order Fresnel lens, the simple Cape Cod-style dwelling guided ships safely through the treacherous waters that characterize this area. In fact, much of the redwood that passed through this harbor was used to build San Francisco. The light—isolated on its rocky site—was kept by Captain John Jeffrey and his family from 1875 until 1914. Automated in 1953, the tower was discontinued in 1965. Maintained by the Del Norte County Historical Society, the beacon was relit in 1982 as a private aid to navigation. Today the station houses the Battery Point Light Museum, which can be reached by visitors at low tide.

**Amphitrite Point Light** *Overleaf*

*Vancouver Island, British Columbia*

Located on the west-central shore of Vancouver Island, the light station at Amphitrite Point was established in 1915. The unusual tiered tower overlooks the entrance to Barkley Sound. Poised on a craggy outcropping 51 feet above sea level, the tower emits a light that can be seen 16 miles at sea.

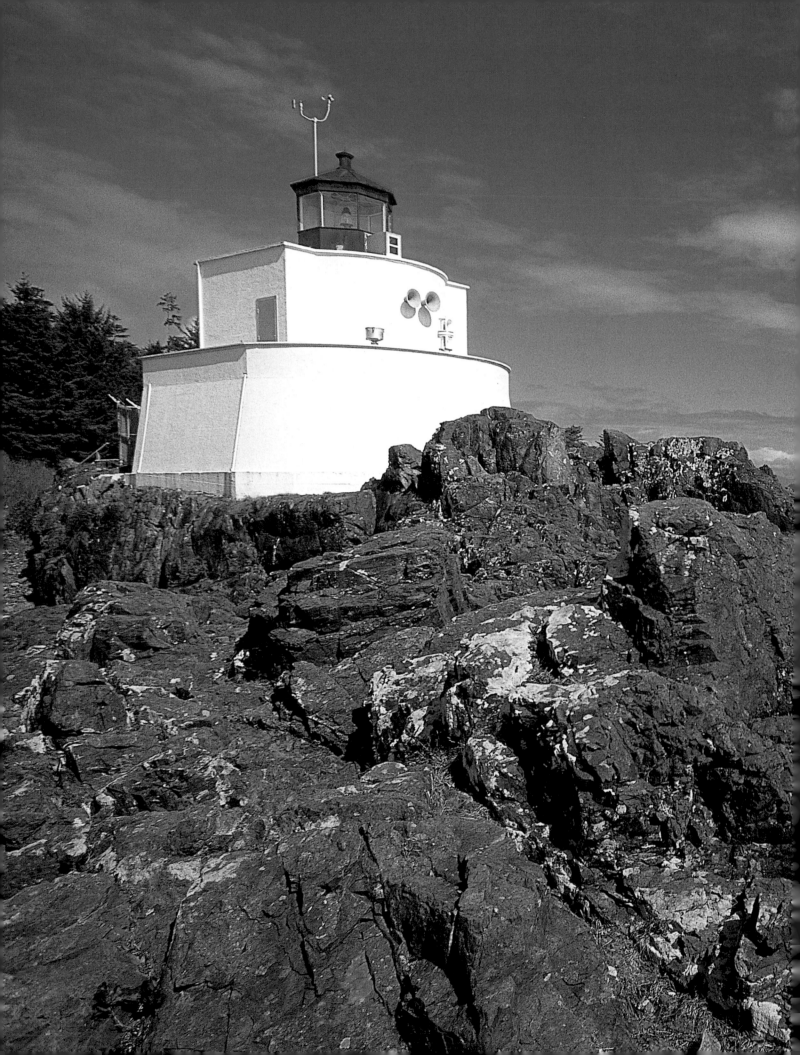

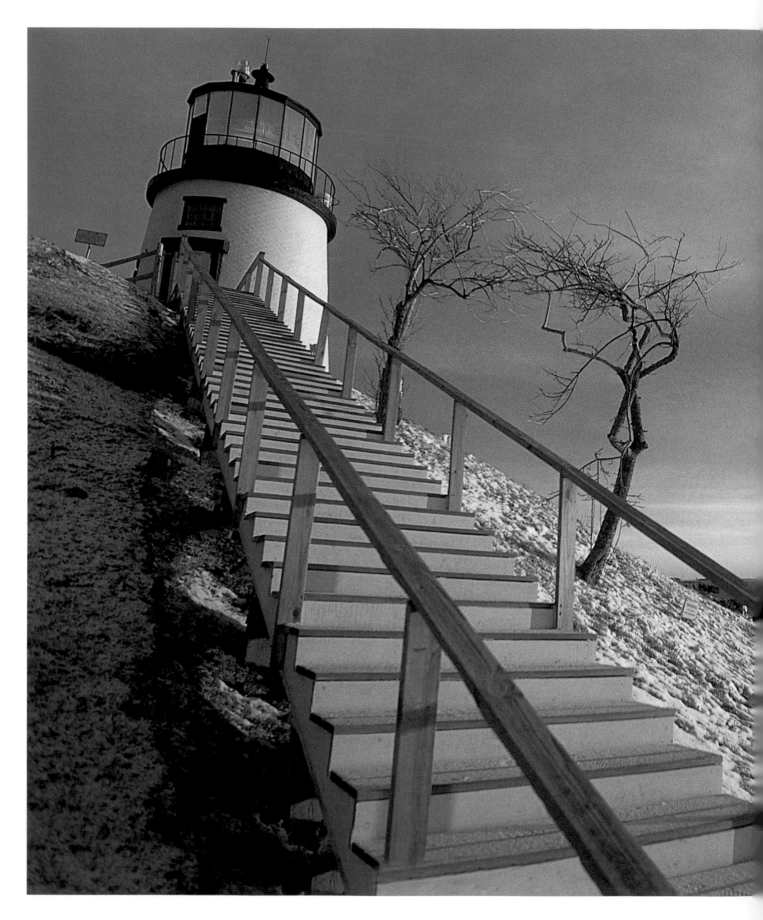

## Owls Head Light *Left*
*Rockland, Maine*

Perched on a steep cliff, 20-foot-tall Owls Head Light stands more than 100 feet above sea level. Built in 1826 to guide freighters carrying limestone into Rockland Harbor, the squat tower—which gained its name from the owl-like formation visible in the cliff face—remains largely unchanged. The cylindrical beacon is equipped with a fourth-order Fresnel lens that casts a fixed white light visible up to 16 miles at sea. During the 1930s, the keeper owned a dog named Spot which would bark and ring the fog bell by pulling on the rope when he heard a boat approaching.

## Beavertail Light *Page 84*
*Jamestown, Rhode Island*

The tower on Rhode Island's Conanicut Island is the third on this site. The first was built in 1749, but it was burned by the British during the Revolutionary War. The lighthouse was restored to service in 1790. The present tower dates from 1856. Originally equipped with a fourth-order Fresnel lens, the 52-foot square granite tower marks the entrance to Newport Harbor and Narragansett Bay. In 1991 Beavertail Light was outfitted with a modern optic that emits a flashing white light.

## Portland Head Light *Page 85*
*Portland, Maine*

On January 10, 1791, George Washington appointed Captain Joseph Greenleaf the first keeper of the Portland Head Lighthouse—Maine's first light and the first to be built under the auspices of the U.S. government. Construction on this historic tower had begun in 1787; in 1791 the light was equipped with a second-order bivalve lens and put into service. As technology advanced, the bivalve was replaced with a fourth-order Fresnel lens that was automated in 1989. Two years later, Portland Head received a with a modern revolving beacon that emits a flashing white light visible up to 25 miles at sea. Standing 80 feet tall, the graceful masonry lighthouse is 100 feet above the entrance to Casco Bay.

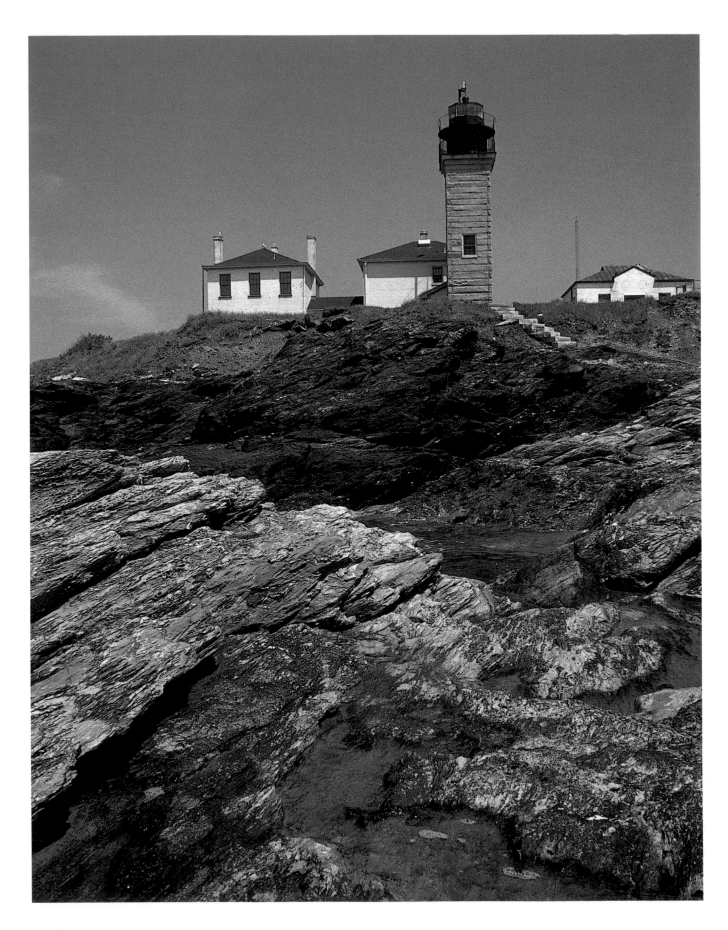

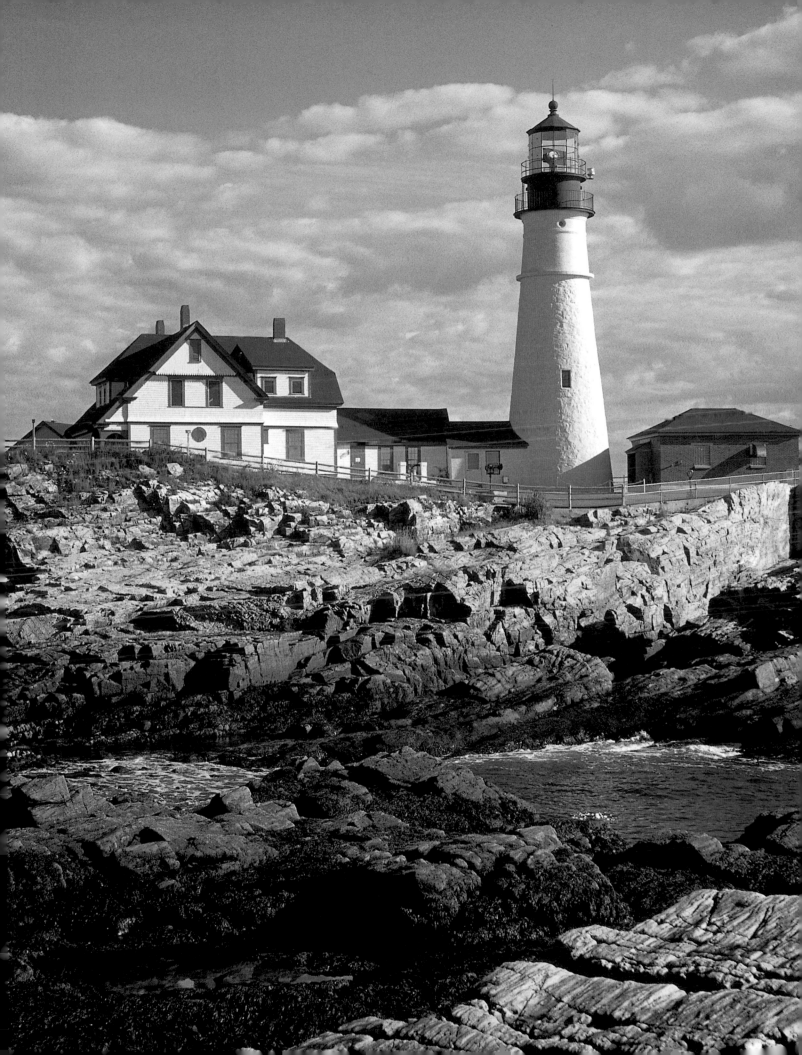

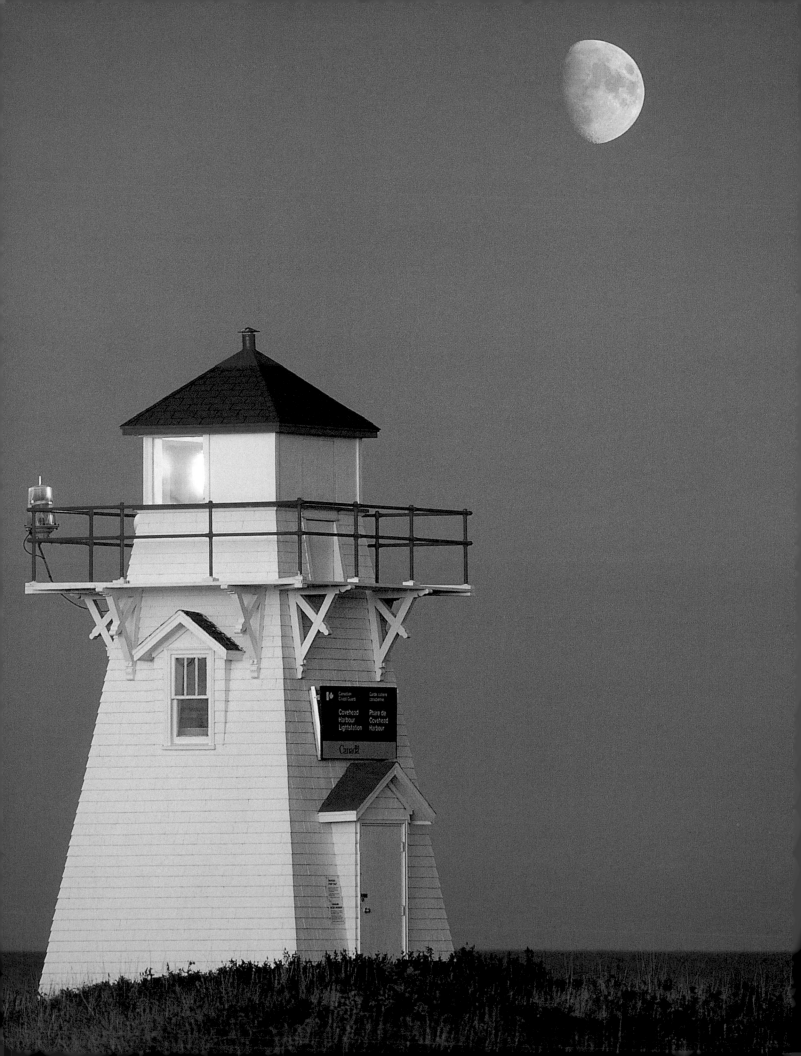

**Seacow Head Light** *Previous pages*

*Prince Edward Island*

Built in 1863, Seacow Head Light is located on the south shore of Prince Edward Island. The white octagonal tower is 61 feet tall, but its location places the focal plane 90 feet above sea level. Its flashing white light can be seen up to 12 miles at sea. Overlooking Northumberland Strait, the beacon at Seacow Head was eventually moved farther inland to protect it from erosion of the cliff face.

**Covehead Harbour Light** *Opposite*

*Cape Stanhope, Prince Edward Island*

The Covehead Harbour Light overlooks the beach at Cape Stanhope in Prince Edward Island National Park. The 27-foot wooden tower stands 34 feet above sea level and guides traffic on the Gulf of St. Lawrence. The red-and-white pepper-shaker-style lighthouse emits a flashing white signal that can be seen for up to 7 miles. The building also serves as a program center of the national park.

**Cape Byron Light** *Overleaf*

*Byron Bay, New South Wales, Australia*

Constructed of prefabricated concrete by Charles Harding, successor to James Barnet as the colonial architect of New South Wales, the lighthouse at Cape Byron was completed in 1901. The 59-foot tower is 387 feet above sea level and has the distinction of being Australia's most powerful lighthouse. Henry Lepaute, of the Parisian *Société des Establishment*, equipped the beacon with a first-order optical lens comprising some 760 pieces of prism glass. Visible up to 27 miles at sea, Australia's easternmost light emits a flashing white signal every 15 seconds.

**Ponta da Piedade Light** *Below*

*Lagos, Algarve, Portugal*

Located on the southern coast of Portugal, the town of Lagos overlooks the Gulf of Cádiz. The area is renowned for its picturesque beaches, many of which are surrounded by eroded cliffs. The Ponta da Piedade Light stands on the outermost point of the rugged Ponta da Piedade promontory.

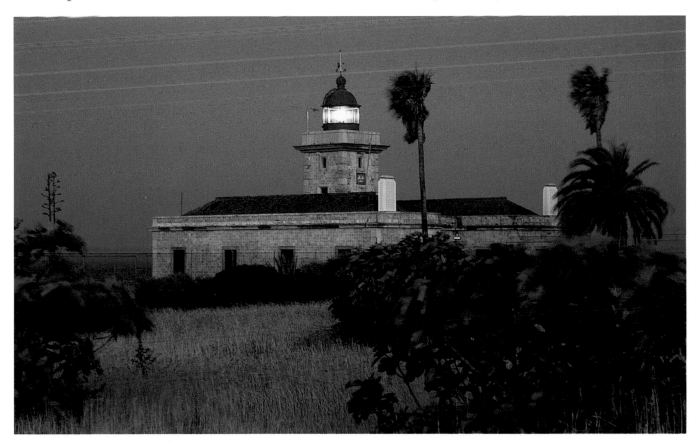

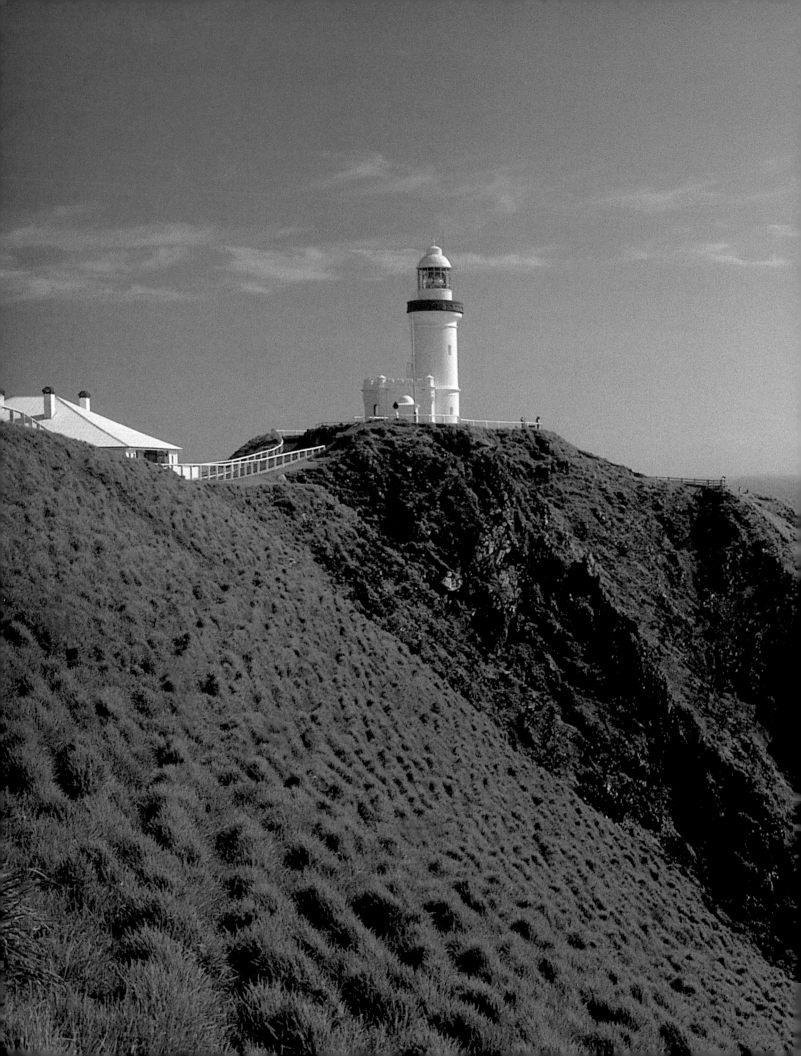

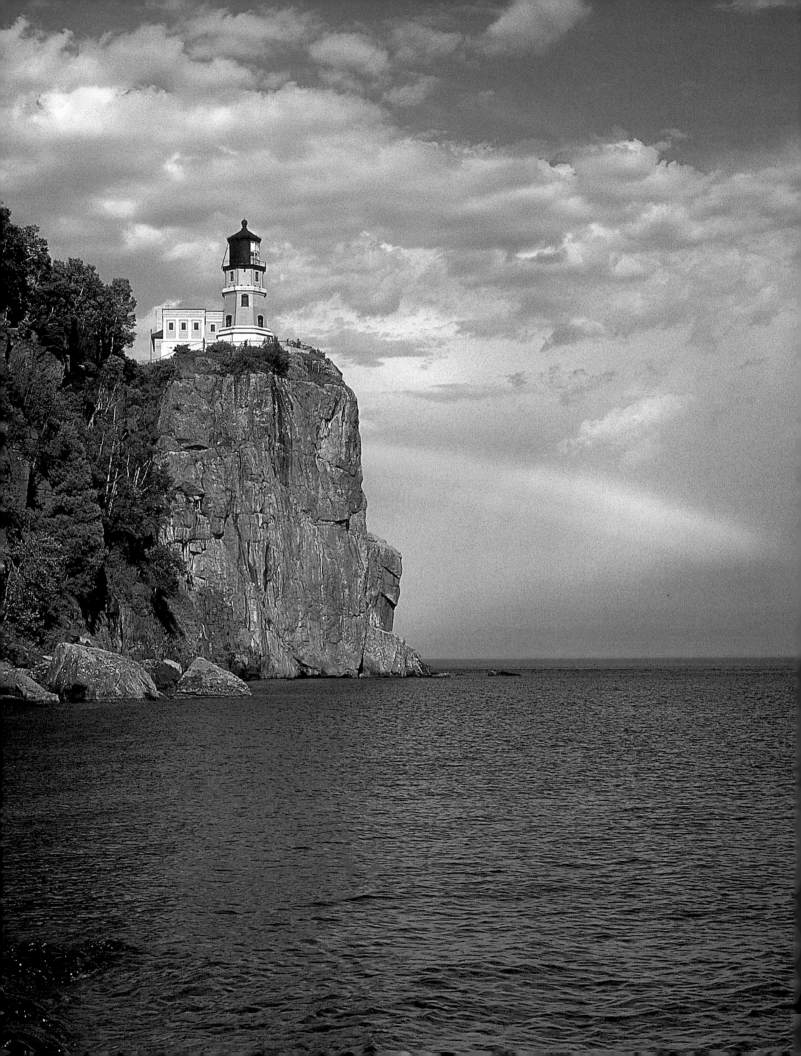

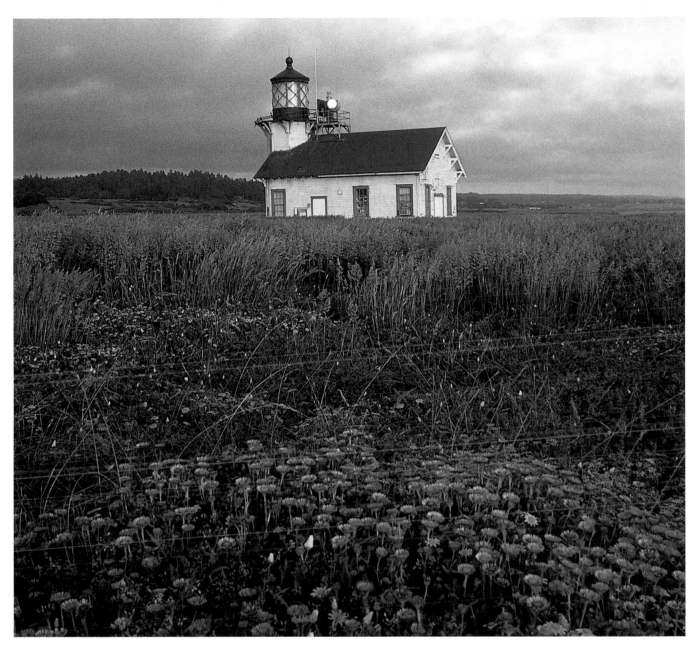

**Split Rock Light** *Opposite*

*Two Harbors, Minnesota*

This majestic light overlooks Lake Superior in Split Rock Lighthouse State Park. Materials for its construction had to be hoisted up the towering 120-foot cliffs. Completed in 1910, Split Rock Light is equipped with a third-order bivalve-type Fresnel lens that emits a fixed light visible up to 22 miles away. The lens comprises 252 different panels and weighs more than 4 tons. No longer an active aid to navigation, the light shines every year on November 10 to commemorate those who were lost in 1975 on the *Edmund Fitzgerald*.

**Point Cabrillo Light** *Above*

*Mendocino, California*

Point Cabrillo Light was built in 1909 to mark the entrance to California's Big River. Equipped with a third-order Fresnel lens, the 47-foot tower stands 422 feet above sea level, making it the highest lighthouse in the United States. Automated during the 1970s, the light was later replaced with an airport-style beacon, after which it slowly fell into disrepair. Developers had chosen the site for construction of fifty-five houses when the California Coast Conservancy rescued the light and restored it to its former beauty.

## Head Harbour (East Quoddy) Light *Below*
*Campobello Island, New Brunswick*

Easily identified by its huge red cross, what Americans refer to as East Quoddy Light and Canadians call Head Harbor Light stands on the northern end of rugged Campobello Island, which is perhaps better known as the location of the summer residence of Franklin Delano Roosevelt and his family. The light station was built on the rocky outcropping in 1829 and marks the international boundary between Canada and the United States. Now automated, the 45-foot octagonal tower emits a fixed red signal. The lighthouse is accessible only for two hours at low tide; visitors can easily become stranded at the light when high tide returns at the alarming rate of five feet per hour. Like many of Canada's lights, East Quoddy is marked with a red cross.

## Cape Neddick Light *Opposite*
*York, Maine*

Rutherford B. Hayes signed the order establishing the Cape Neddick Light in 1879. The 40-foot-tall cast-iron tower is on a rocky island affectionately referred to by locals as "the Nubble." Standing 88 feet above sea level, the tower is connected to the keeper's dwelling by a covered walkway. The picturesque cottage was designed in the Victorian style and built in the shape of a cross. Local pilots overflying the site check their directions on the north-south axis of the house. On January 12, 1923, the *Robert W.* was wrecked on the dangerous submerged rocks here. Keeper Fairfield Moore sprang into action and rescued Captain Mitchell and his son Stanley. Automated in 1987, the beacon emits a flashing red light.

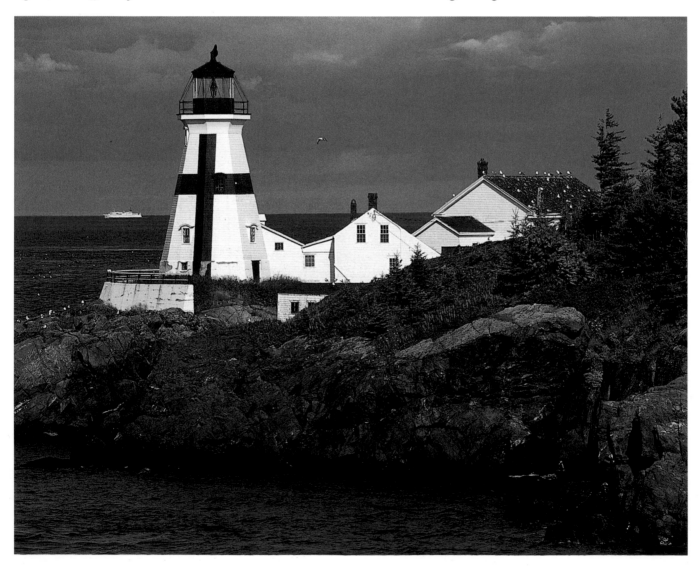

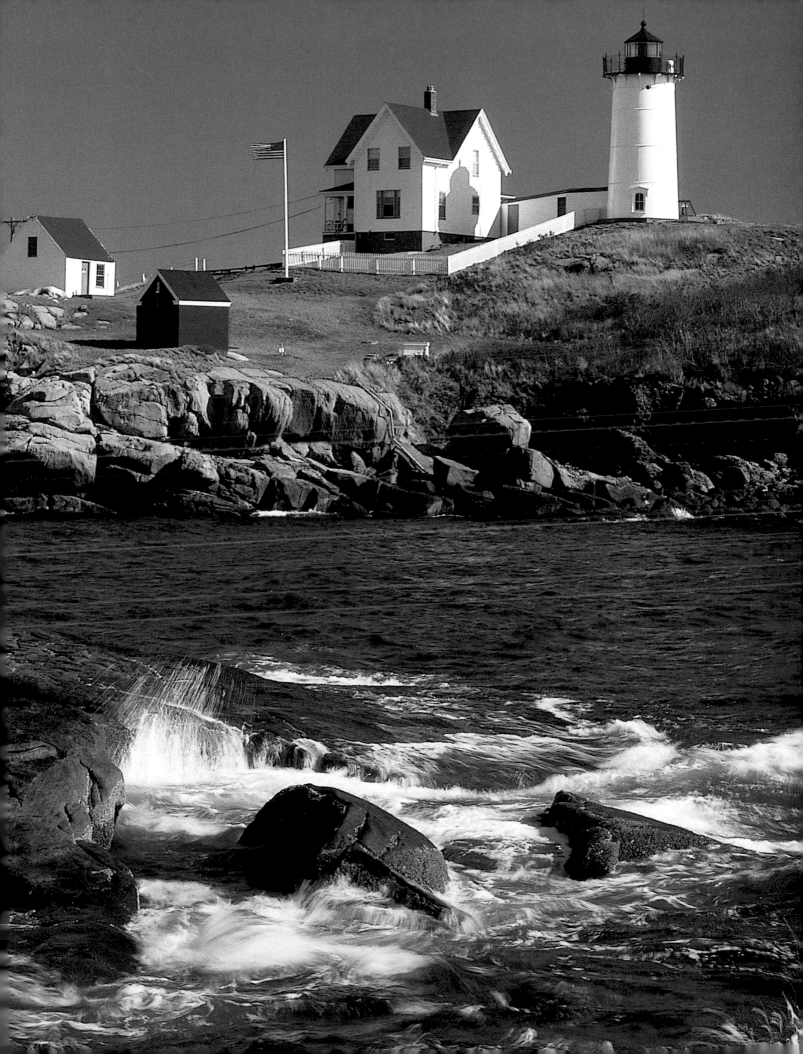

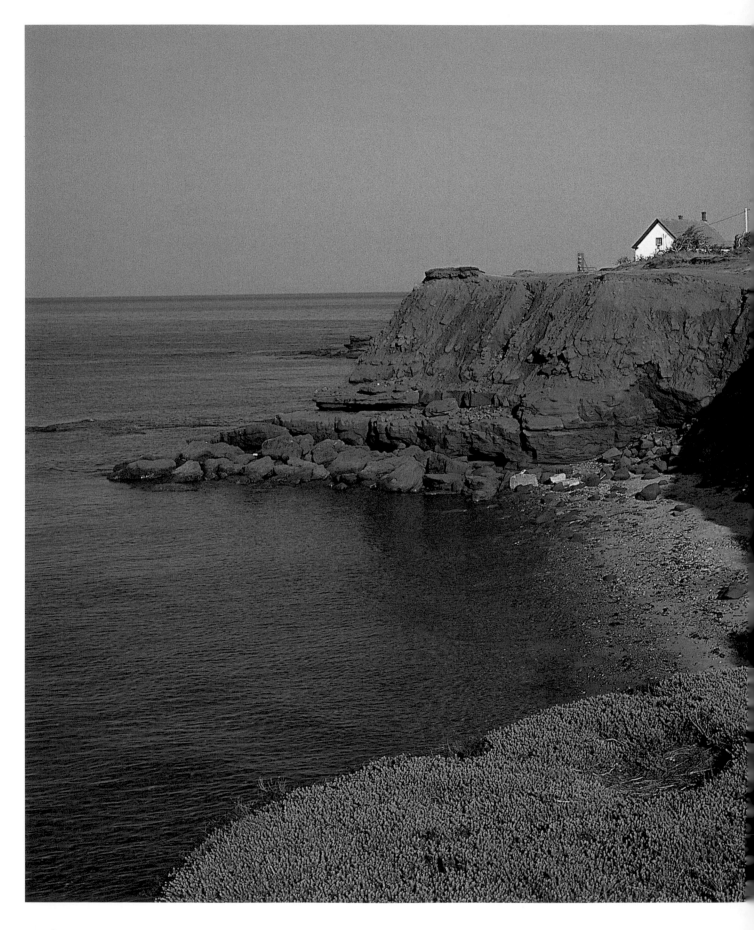

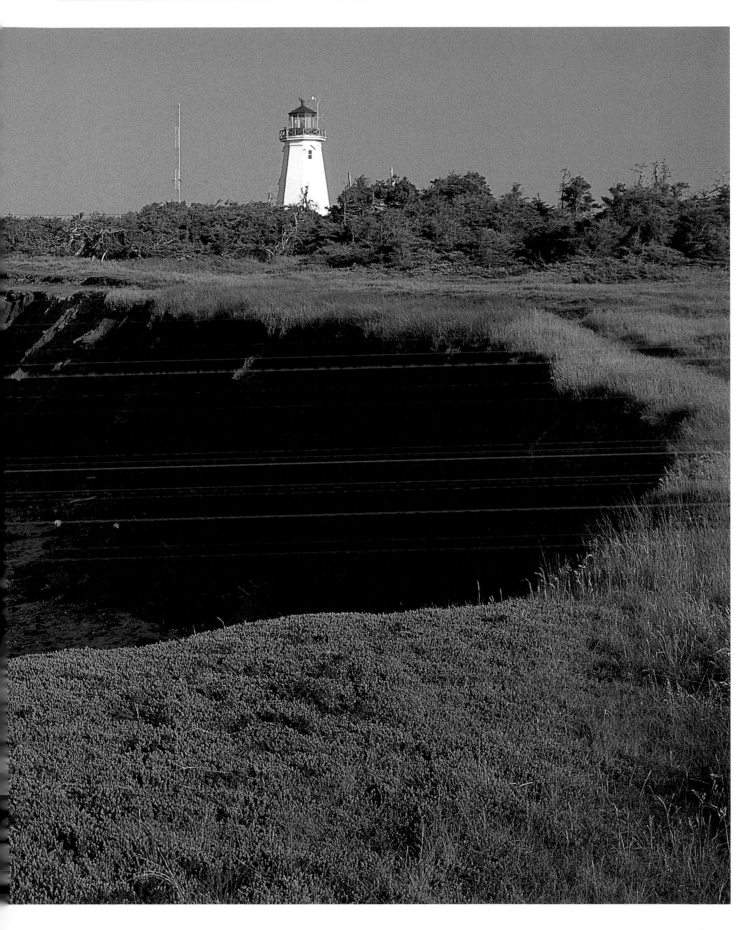

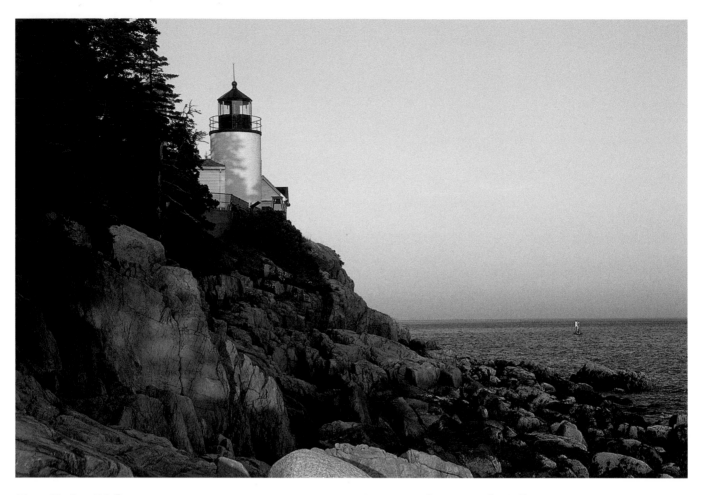

### East Point Light *Previous pages*
*Prince Edward Island*

Originally located on the easternmost point of Prince Edward Island, this light overlooks the confluence of the Gulf of St. Lawrence and Northumberland Strait. Built in 1867, the 65-foot white tower was moved in 1885 to provide better visibility. The erosion of the cliffs threatened the lighthouse, and in 1908 the octagonal wooden structure was moved farther inland. A fog-alarm building was added that same year. Today the light stands some 100 feet above sea level. One of the last on the island to be automated, East Point flashes a white signal visible up to 20 miles.

### Bass Harbor Head Light *Above*
*Mount Desert Island, Maine*

Located in what is now Acadia National Park, the Bass Harbor Head Light was built to guide traffic entering Blue Hill Bay and Bass Harbor. The original tower and attached keeper's dwelling, built in 1858, still stand. Clinging precariously to the cliff face, the beacon displays a flashing red light every 4 seconds.

### Point Conception Light *Opposite*
*Lompoc, California*

The original lighthouse at Point Conception (1855) was one of the first sixteen lights built on the West Coast of the United States. Located high on a headland, its tower rose through the roof of the keeper's dwelling. When cracks began to appear in the structure, a new light was built on a lower site. Now 133 feet above sea level, its beacon is visible for 26 miles. For some years, Point Conception and Pigeon Point were the only lights along this dangerous part of the Pacific Coast.

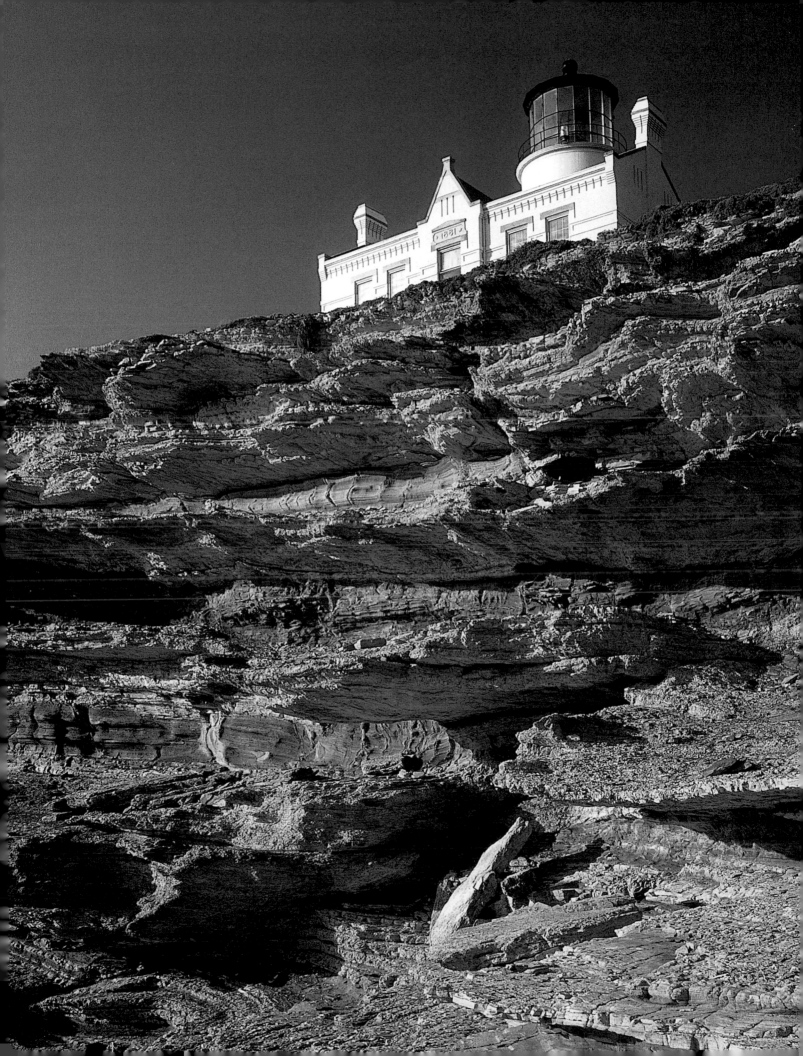

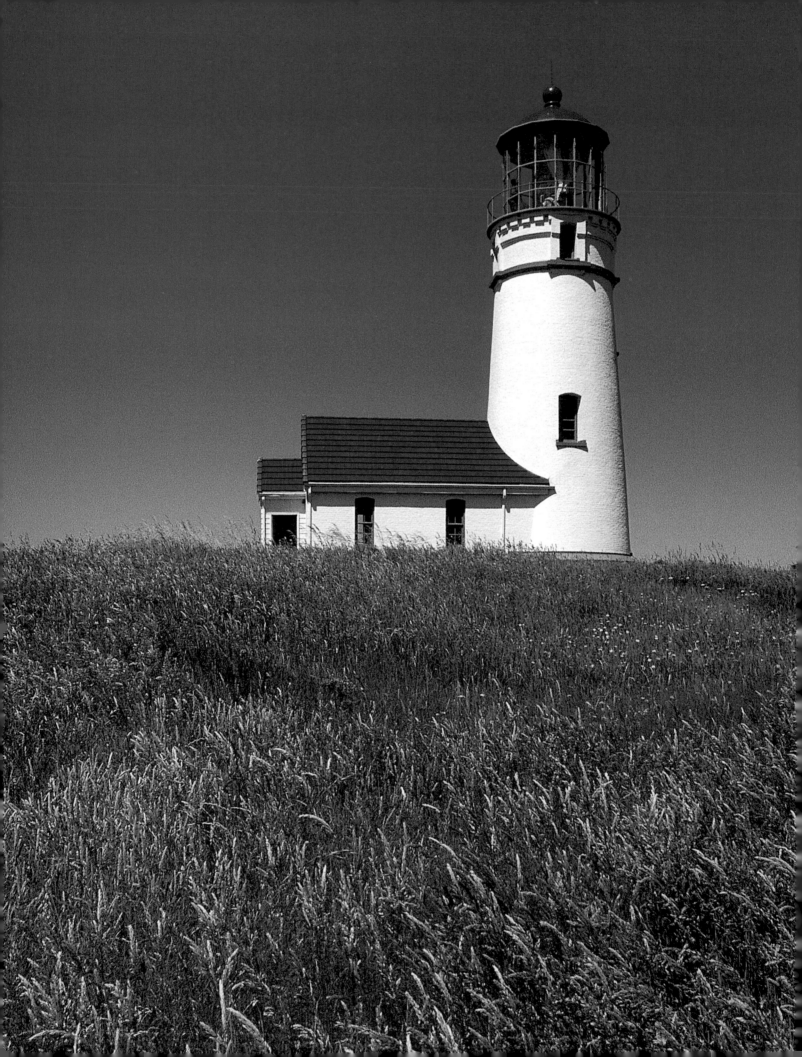

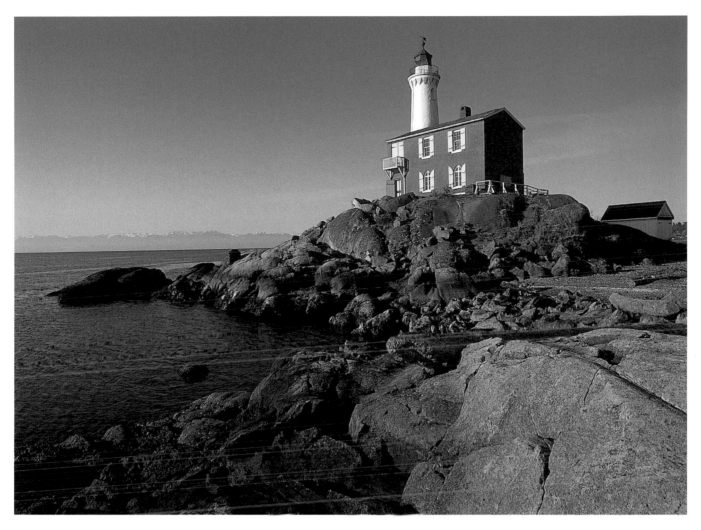

**Cape Blanco Light** *Opposite*

*Port Orford, Oregon*

Oregon's oldest continuously operating and southern-most lighthouse was first lighted on December 20, 1870. The conical brick tower at Cape Blanco is 59 feet high, but its steep vantage point places it 245 feet above sea level. The white cliffs here—named for their color by the Spanish—give the beacon its name. Originally equipped with a first-order Fresnel lens handmade in Paris by the renowned Henry Lepaute, Cape Blanco was equipped with a second-order rotating lens whose light is visible up to 22 miles at sea. The U.S. Coast Guard assumed control of the light in 1939.

**Fisgard Light** *Above*

*Victoria, British Columbia*

Located on the west side of Esquimalt Harbour on Vancouver Island, the Fisgard Light was built in 1860 with brick shipped from Great Britain. This was British Columbia's first official lighthouse, funded by the British Empire's Board of Trade like other Canadian "Imperial Lights." Standing 72 feet above sea level, the 56-foot cylindrical tower is attached to a Victorian-style dwelling, both of which were designed by John Wright. Constructed upon a granite foundation 2 feet thick, the station has 4-foot-thick brick walls. Named for the British frigate *Fisgard*, the light went into service on November 16, 1860, under the supervision of George Davies. The flashing red, white and green signal was automated in 1929. Still operational, Fisgard now has an aero-marine beacon and is located in the Fisgard Lighthouse National Historic Site.

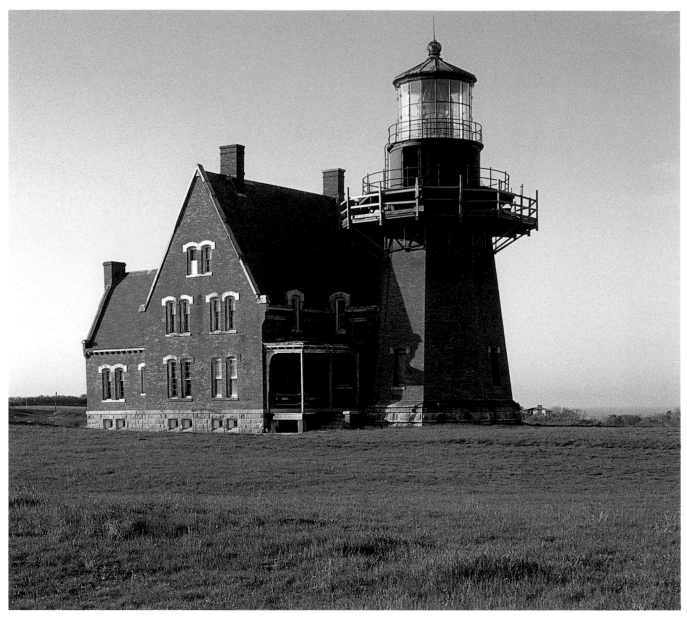

**Block Island Southeast Light** *Above*

*Block Island, Rhode Island*

The Block Island Southeast Light was built in 1875 at a cost of $75,000. The 67-foot octagonal brick tower stands on the Mohegan Bluffs, placing its focal plane more than 200 feet above sea level. Equipped with a $10,000 first-order Fresnel lens made by the Parisian Henry Lapaute Company, the beacon emits a flashing green signal. In 1993 the Victorian lighthouse and attached dwelling were moved 300 feet inland to protect them from erosion.

**Highlands (Navesink) Lights** *Opposite*

*Highlands, New Jersey*

Overlooking the Lower Bay, the Twin Lights of Navesink were built of brownstone in 1841 to guide ships into New York Harbor. The first lighthouses in the United States to employ Fresnel lenses, the beacons made Sandy Hook Light obsolete. One of the 200-foot-tall octagonal towers exhibited a flashing light and the other, a fixed light. The north tower was discontinued in 1894, when authorities began to phase out paired lights. The south tower was extinguished in 1953, but it has a small sixth-order light to commemorate the importance of this historic site.

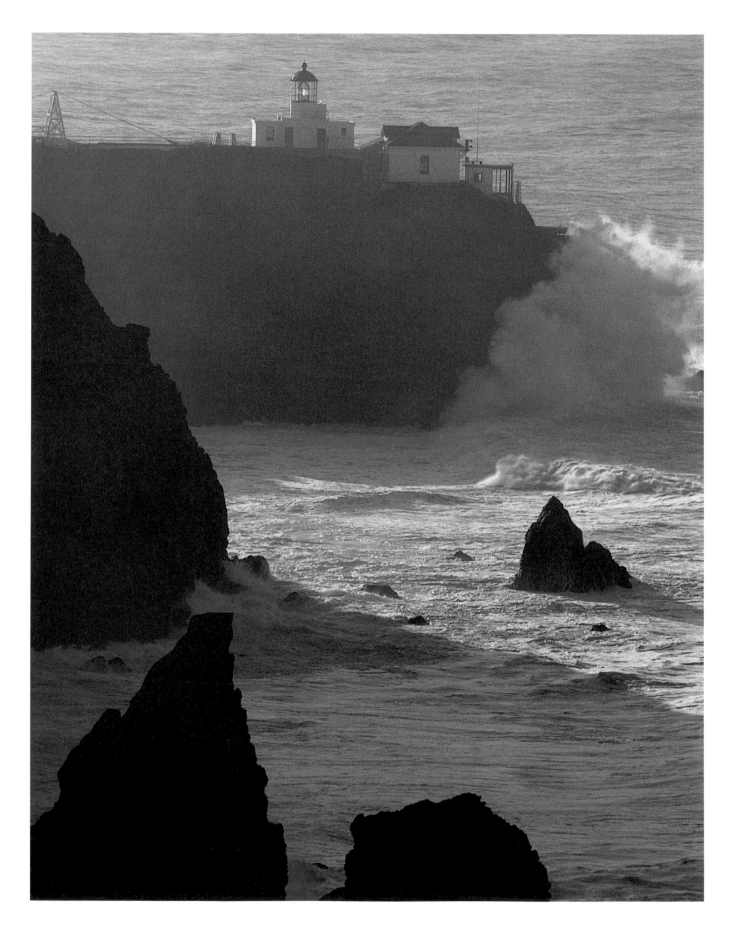

**Point Bonita Light** *Opposite*

*San Francisco, California*

The Point Bonita Light was built to guide ships enter-ing San Francisco Bay through the narrow Golden Gate Straits. The first lighthouse was erected on a ledge more than 300 feet above water level in 1855. Mariners complained that it was often obscured by fog and low-lying clouds, so in 1877 this second tower was con-structed on a dangerously narrow ledge 124 feet above sea level. The 33-foot tower is accessible only by a wooden suspension bridge.

**Cape Arago Light** *Above*

*Charleston, Oregon*

Two miles southwest of Coos Bay, the Cape Arago light is the third to stand on this site. The first, built in 1866, was an iron tower designed to guide ships entering Oregon's thriving lumber port of Charleston. When erosion threatened, the tower was replaced with a wooden light. In 1934, when erosion encroached again, the present lighthouse was constructed. Made of con-crete, the 44-foot octagonal tower was equipped with a fourth-order Fresnel lens. Standing some 100 feet above sea level, the light is visible up to 16 miles at sea. The lighthouse is reached by an iron footbridge.

## Old Cape Spear Light

*St. John's, Newfoundland*

Located 20 miles east of Newfoundland's capital, St. John's, the Old Cape Spear Light was built on the easternmost point in North America and marks the entrance to St. John's Harbour. The picturesque station was the second in the province and the first built under the direction of the Newfoundland Lighthouse Board. The light stands in the center of the dwelling, 300 feet above sea level on a sandstone cliff. In 1955 the Old Cape Spear Light was moved farther inland and replaced with the New Cape Spear Light, an octagonal concrete structure. Old Cape Spear Light is now the centerpiece of the National Historic Park that was opened in 1983 by Great Britain's Prince Charles and Diana, the late Princess of Wales.

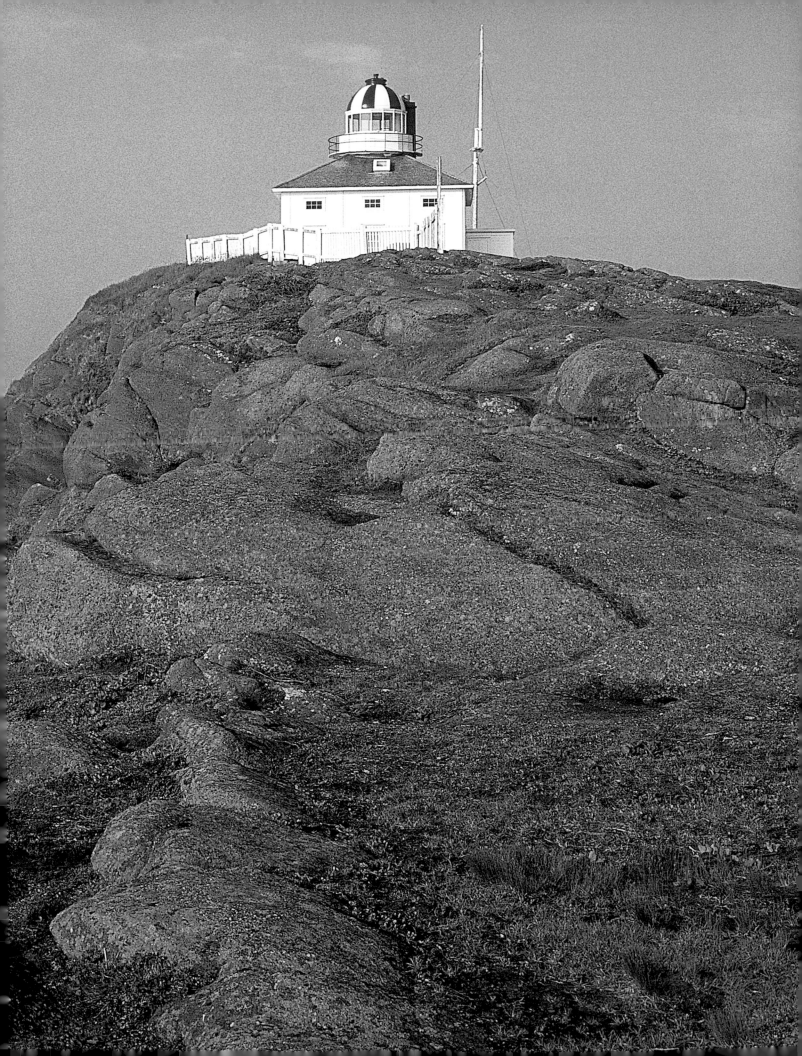

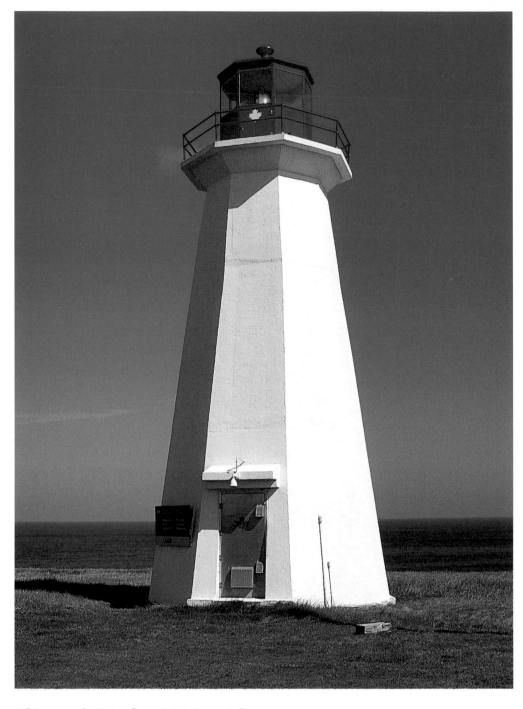

**Shipwreck (Naufrage) Point Light** *Above*

*Naufrage, Prince Edward Island*

The 48-foot pyramidal tower at Shipwreck Point stands
99 feet above sea level in an open field on the north
side of Prince Edward Island. The picturesque white
lighthouse is one of two concrete towers on the island.
Built in 1913 to guide ships through Naufrage Harbor,
the tower was repaired and moved west in 1968. Its
flashing white light can be seen 18 miles at sea.

**Cabo Espichel Light** *Below*

*Lisbon, Portugal*

The picturesque Cabo Espichel Light is located in Lisbon, the capital city of Portugal and the country's most important port. Libson's magnificent natural harbor made the area a strategic trading center from Phoenician times; legend tells that the city itself was found by Ulysses. Carefully maintained, the pyramidal light tower overlooking the Mar de Palha is surrounded by a cluster of whitewashed buildings.

**Cape Tryon Light** *Overleaf*

*Prince Edward Island*

Built in 1865, the original Cape Tryon tower and keeper's house were relocated because of erosion. The present lighthouse was built in 1905. Automated in 1965, the 39-foot square wooden tower overlooks the Gulf of St. Lawrence, where it provides a welcome beacon to traffic passing along the north side of Prince Edward Island. The Cape Tryon Light stands 117 above sea level; its flashing white light can be seen 18 miles at sea.

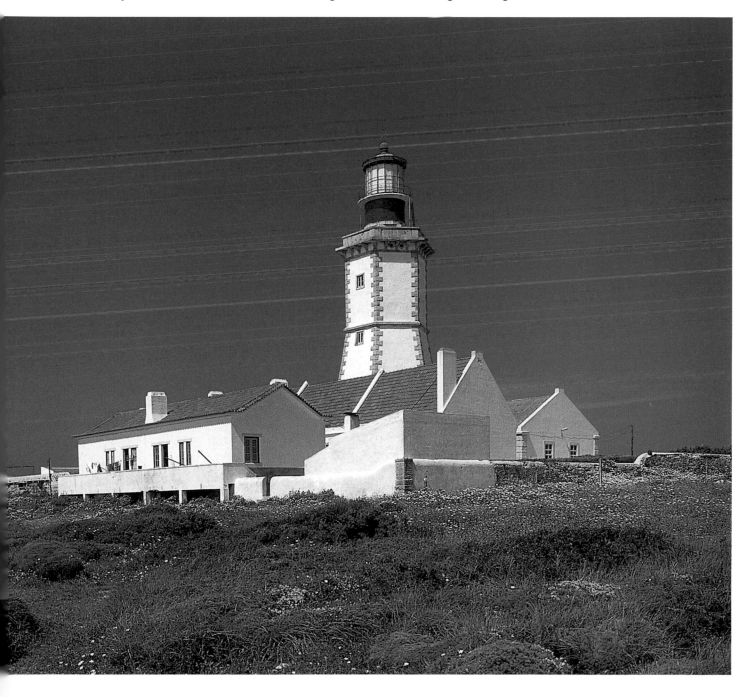

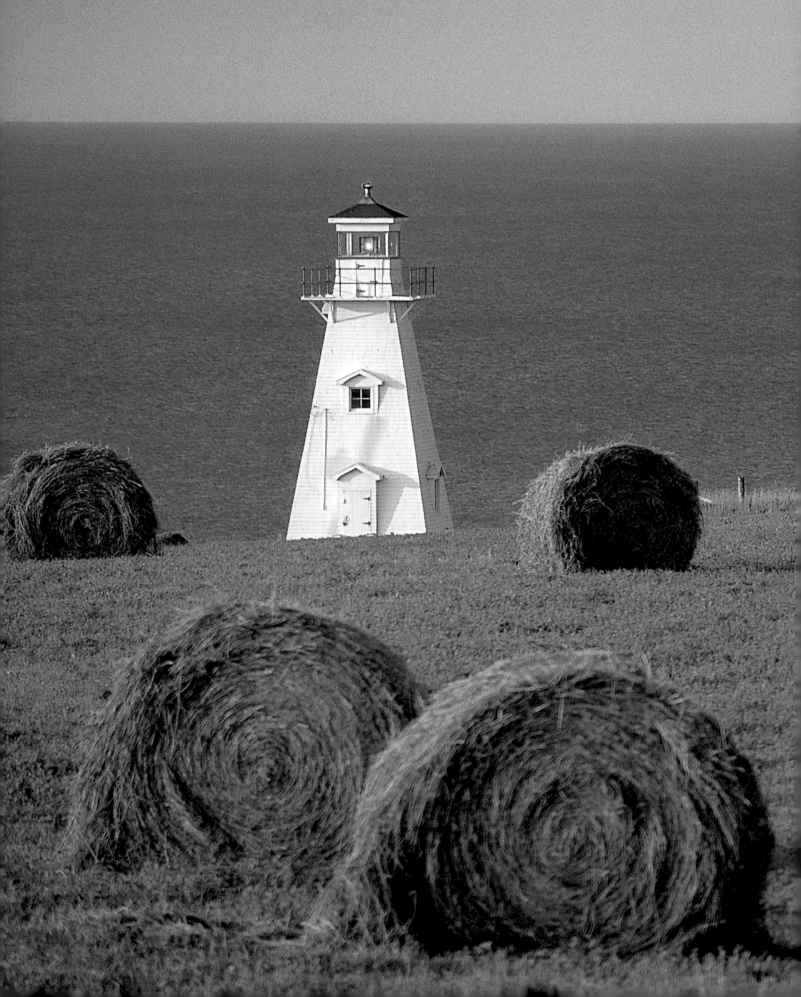

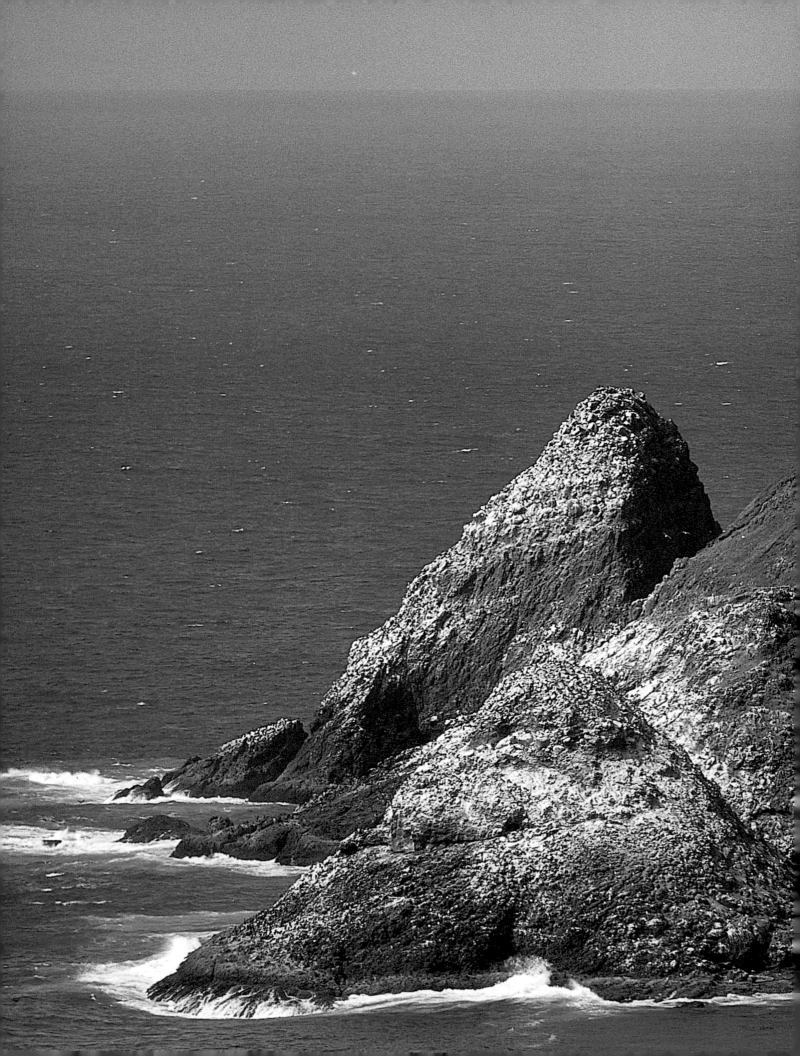

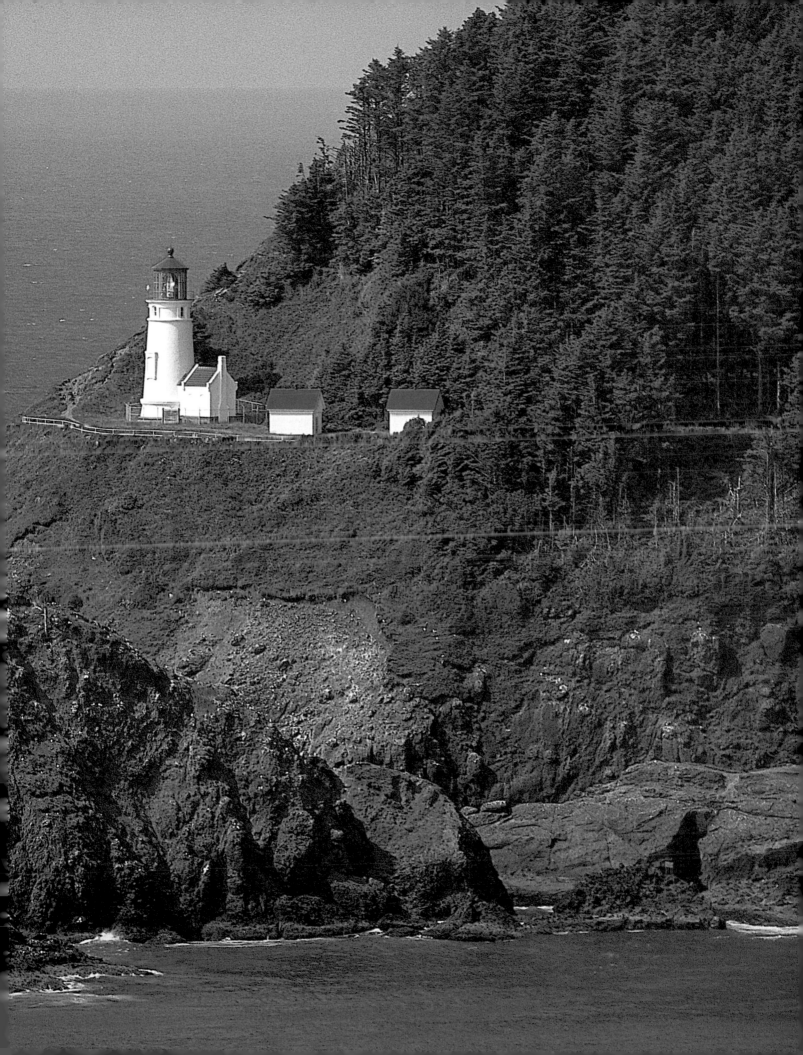

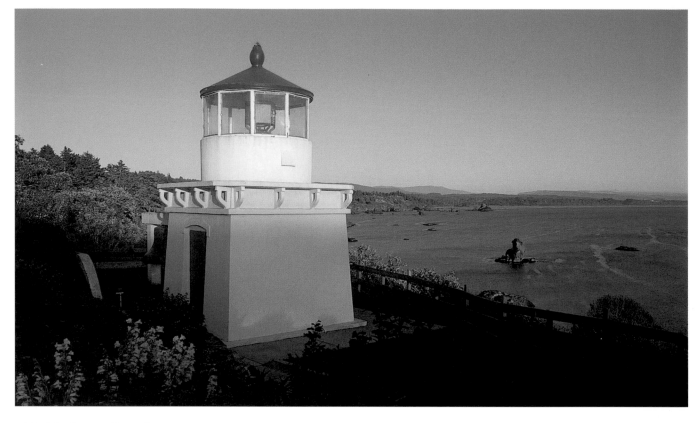

### Trinidad Head Light *Above*

*Trinidad, California*

Fred Harrington was the keeper of the Trinidad Light in 1940 when a giant tidal wave swept over the tower, which is located on a 200-foot cliff. Inside the lighthouse, Harrington hung on for dear life as water rushed in through the broken windows. Despite the force of the wave, the tower survived the onslaught. Built in 1871 to guide traffic into and out of Trinidad Harbor, Trinidad Light is now automated.

### Heceta Head Light *Previous pages*

*Florence, Oregon*

Named for the Spanish explorer Don Bruno de Heceta, who charted this area in 1755, the jagged cliffs at Heceta Head posed a tremendous challenge to nineteenth-century engineers. Materials had to be transported to the site by boat and hoisted up the 200-foot cliffs. The 56-foot tower was completed in 1894 at an exorbitant cost of $180,000. Equipped with its original first-order Fresnel lens, which casts a light visible for 21 miles at sea, the Heceta Head Light continues to guide traffic along the Pacific Coast.

### Point Sur Light *Opposite*

*Big Sur, California*

Point Sur Light stands on a near-vertical sandstone cliff. Engineers constructed a special railway to transport materials to the site for construction of the lighthouse, which took two years and $100,000 to build. Completed in 1889, the beacon at Point Sur warns mariners of the Big Sur coastline, a treacherous outcropping that extends south for 100 miles. The granite light clings to a precarious site more than 250 feet above sea level. Its original first-order Fresnel lens is now on display at the Monterey Station Center. Weighing 3 tons, the lens is 10 feet tall and 6 feet in diameter, comprising more than 1,000 prisms. Point Sur is now equipped with an automated aerobeacon that flashes every 15 seconds and is visible 25 miles at sea.

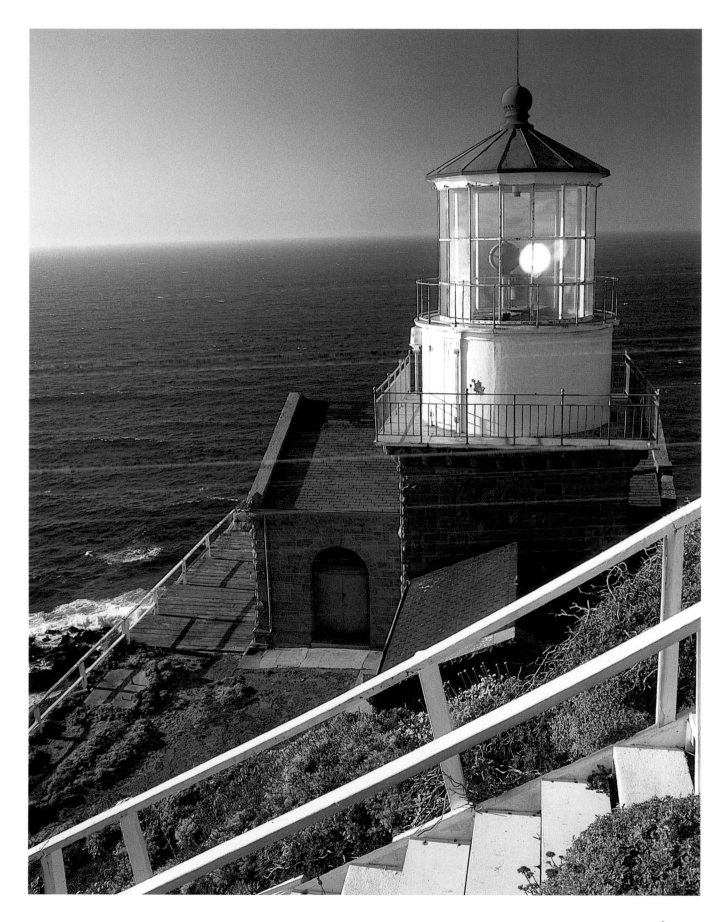

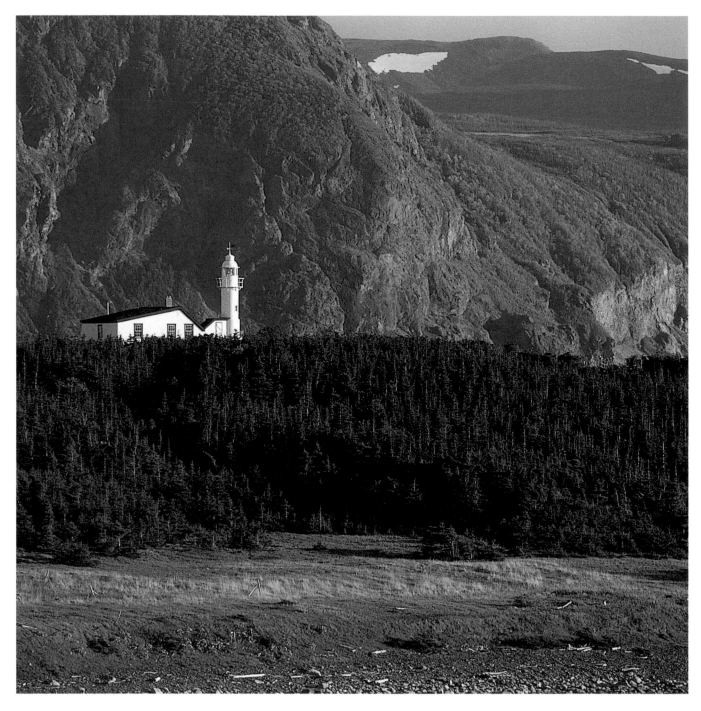

**Lobster Cove Head Light** *Above*
*Gros Morne National Park, Newfoundland*
The picturesque lighthouse at Lobster Cove Head was built in 1892 to guide ships entering Newfoundland's rugged Rocky Harbour. Located in what is now Gros Morne National Park, the cylindrical white-painted beacon, which is attached to a two-story keeper's residence, has served generations of the island's fishermen. It was automated in 1970.

**Fort Amherst Light** *Opposite*
*St. John's, Newfoundland*
Built on top of the Fort Amherst Harbour battery in 1813, the Fort Amherst Light was Newfoundland's first navigational aid, built and maintained by voluntary contributions. It was constructed to mark the entrance to the Narrows—the channel that connects the Atlantic Ocean to St. John's Harbour. The original wooden tower was replaced in 1852 and again in 1951.

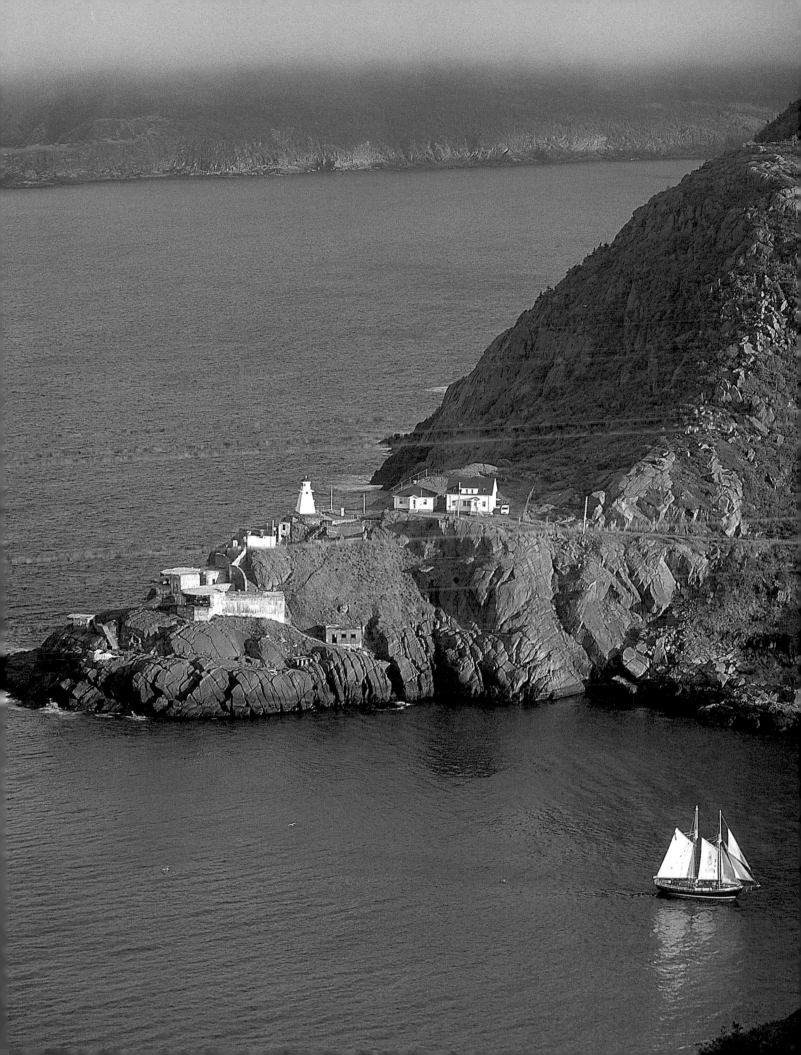

**Admiralty Head Light** *Below*

*Whidbey Island, Washington*

The first lighthouse above the Straits of Juan de Fuca on Whidbey Island was completed on Red Bluff in January 1861, just weeks before the outbreak of the Civil War. Equipped with a fourth-order Fresnel lens, it guided vessels through Admiralty Inlet into Washington's Puget Sound. Its fixed white light was visible up to 16 miles away. The tower was demolished during the Spanish-American War for construction of Fort Casey. In 1903 the present Spanish Colonial-style complex was built 127 feet above water on Admiralty Head, near Coupeville. During World War I, it was used as an officers' residence for U.S. Army personnel. After shipping routes changed, the light became obsolete, and in 1927 the tower was darkened and its lantern placed in the New Dungeness Light. Today the Admiralty Head Light, acquired by Washington State, has been restored to its former beauty with the help of the Island County Historical Society.

**Cape Elizabeth Light** *Opposite*

*Portland, Maine*

Two rubblestone towers were built on Cape Elizabeth in 1828 to mark the entrance to Portland Harbor from Casco Bay. They were replaced in 1874 with a pair of cast-iron towers separated from each other by 300 yards. One exhibited a flashing light, the other a fixed light, to distinguish them from other beacons in the area. During the 1920s the west tower was dismantled. The east tower's second-order Fresnel lens continues to serve as a navigational aid, with a focal point 129 feet above the water.

**Rua Reidh Light** *Overleaf*

*North West Highlands, Scotland*

Built in 1910 by David Stevenson, a cousin of Robert Louis Stevenson, Rua Reidh Light is located on a remote peninsula in Scotland's North West Highlands. Now automated, the tower overlooks the Minch, the channel separating the Outer Hebrides from the mainland.

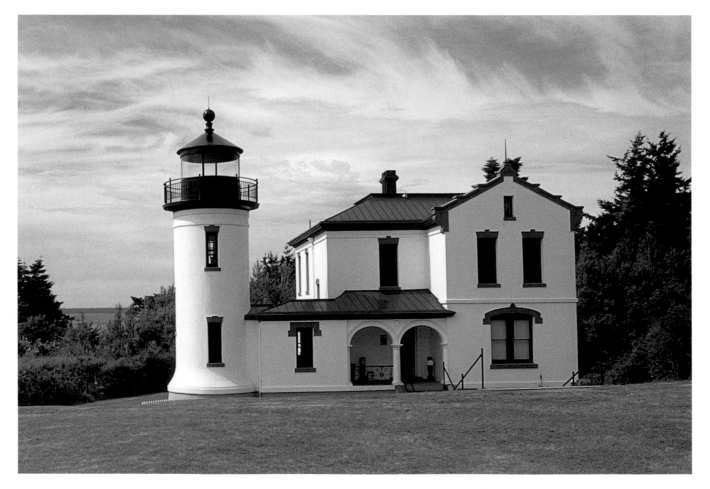

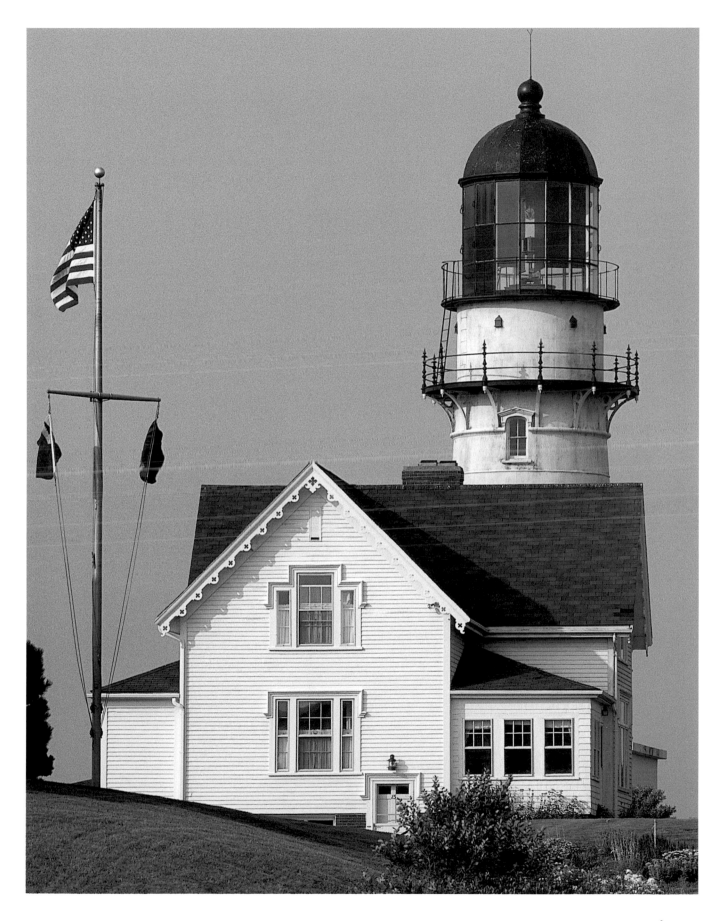

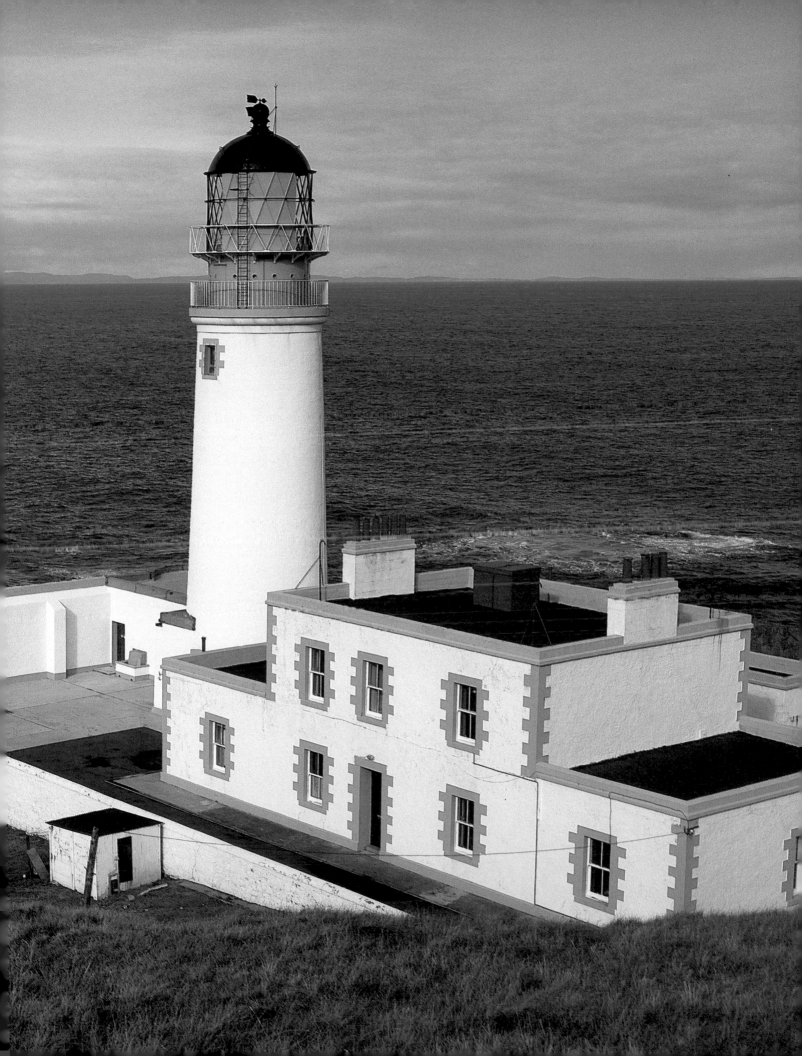

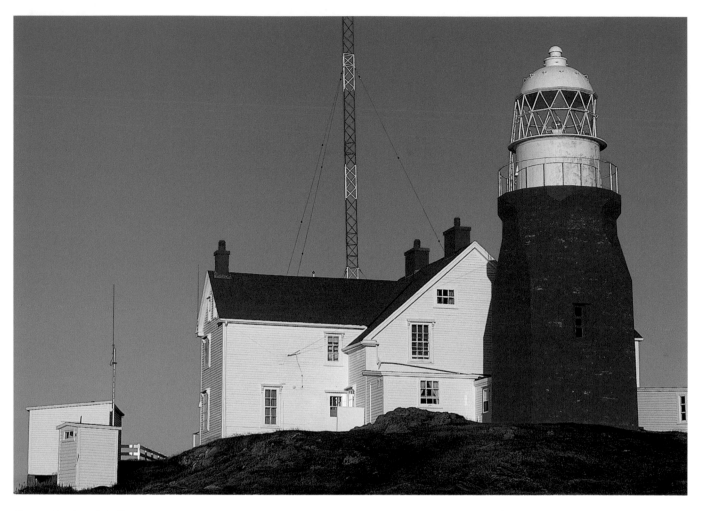

**Long Point Light** *Above*

*Twillingate, Newfoundland*

Newfoundland's Long Point Light is attached to a fog-horn building by a covered walkway. Perched on a rocky ledge some 280 feet above the entrance to Notre Dame Bay, the red-and-white lighthouse is located off the northeast corner of Twillingate. The site extends into the "iceberg corridor," where the Titanic met with disaster. It provides visitors with a stunning view of gigantic icebergs floating by. They are seen most frequently during the months of June and July.

**Cape Bonavista Light** *Opposite*

*Bonavista, Newfoundland*

Cape Bonavista Light was built in 1843 to mark the entrance to Trinity and Bonavista Bays. John Cabot first sighted the headland known as Cape Bonavista from H.M.S. *Matthew* on June 24, 1497. The massive red-and-white striped lighthouse was deactivated in 1966, when it was replaced by a nearby steel tower. The brightly painted original Cape Bonavista Light is now a Newfoundland Provincial Historic Museum.

**Swallowtail Light** *Overleaf*

*Grand Manan Island, New Brunswick*

The octagonal white Swallowtail Light was built on New Brunswick's Grand Manan Island in 1860 to mark the entrance to the Bay of Fundy. Now automated, the sturdy tower is still an active aid to navigation. The nearby former keeper's house is now a picturesque bed-and-breakfast inn.

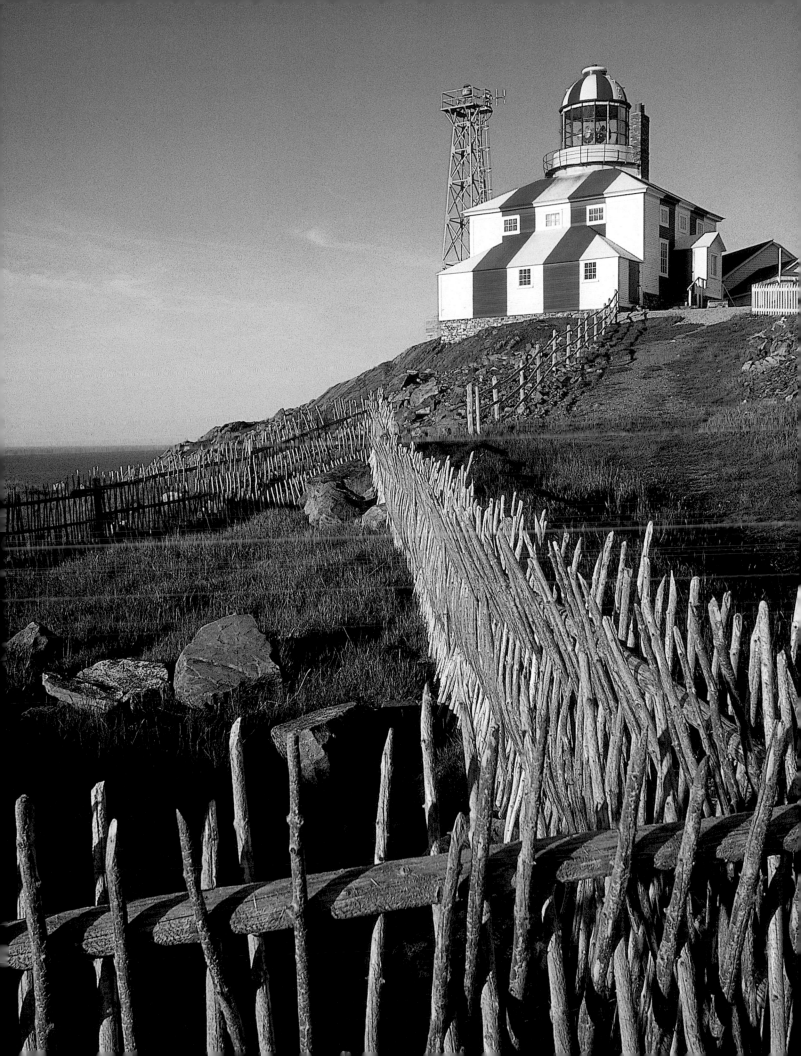

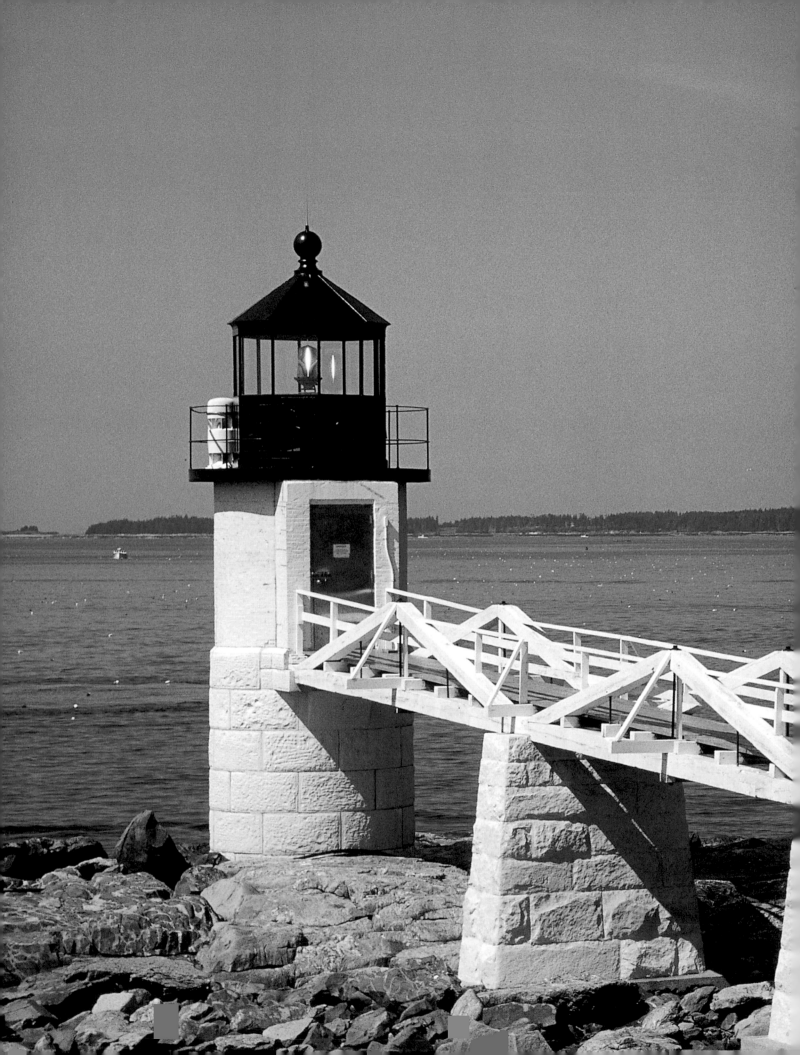

# Inlet and Harbor
# Channel Guides

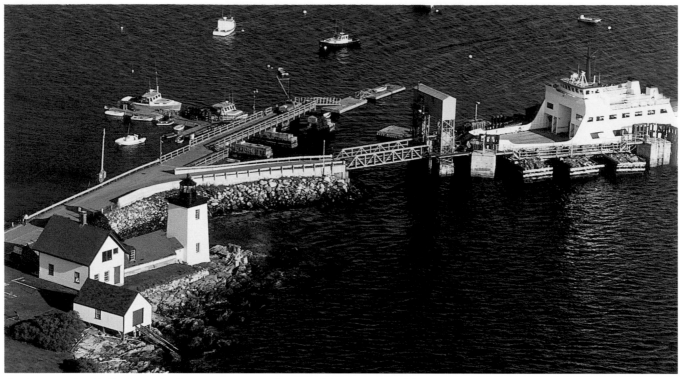

*Previous pages:* **Marshall Point Light, St. George, Maine;** *Above:* **Grindel Point Light, Isleboro, Maine**

*"Being thus arrived in a good harbor, and brought safe to land, they fell upon their knees and blessed the God of Heaven who had brought them over the vast and furious ocean, and delivered them from all the perils and miseries thereof, again to set their feet on firm and stable earth, their proper element."*

— WILLIAM BRADFORD

Thus the future governor of the Pilgrim settlement at Plymouth, Massachusetts, recorded the historic landing of the Mayflower. His journal *Of Plimoth Plantation* (1620–47) gives some idea of the hardships involved in seventeenth-century sea travel and the relief experienced in finding safe harbor. Such havens have been important since travel and commerce by sea became a part of human history. Many people are familiar with the stories of Greek and Phoenician sailors who found their way around the Mediterranean Sea in ancient times by dead reckoning. They became expert at gauging the wind and waves, and they found accessible harbors in southern Europe, the Middle East and on numerous islands. Since these ports were unmarked, it

took a combination of luck and skill to deliver cargo and passengers safely. The Phoenicians kept their routes a secret in order to maintain a monopoly on trade in the Mediterranean.

Lighthouses built for in-harbor locations are sometimes overlooked, even by lighthouse aficionados, because they are usually less exposed than clifftop lights, and do not dominate their surroundings as a tall beach light does. Given a choice among New England's Minots Ledge, Portland Head and Derby Wharf Lights, all within the radius of a day's drive, the lighthouse fancier will often choose the most dramatic or remote—in this case, Minots Ledge. But should one travel to Salem's Derby Wharf, he or she will be rewarded with a site that can be seen and explored at close range.

Harbor lights became important during the Middle Ages, when Italian city-states like Venice, Genoa and Pisa built beacons of dense, nonporous stone to guard the entrances to, and guide vessels into, their enviable harbors, the primary source of their wealth. In fact, some historians assert that without the stimulus provided by those city-states and their Mediterranean trade, the Italian Renaissance would not have occurred.

Antonio Columbo, the uncle of Christopher Columbus, kept Genoa's Lanterna, the most celebrated Italian lighthouse, in 1449. Perhaps he told his nephew seafaring tales that helped inspire the historic voyage of 1492.

One of the most long-lived harbor-entrance towers was the one at Boulogne, northern France. First built by order of the notorious Emperor Caligula, and rebuilt during the time of Charlemagne, the Tour d'Ordre (English sailors called it "the Old Man of Bullen") was an octagonal stone shaft twelve stories high and 124 feet above sea level. Its upper levels grew progressively smaller, like those of a ziggurat. This lighthouse served off and on until 1644, when it collapsed.

Both of the first lighthouses built in the Americas marked entrances to harbors. The famous Morro of Havana, Cuba, was constructed around 1563, and rebuilt in 1763 and 1845. Today it is a UNESCO World Heritage Site. The Santo Antonio Light in Salvador, Brazil, was built by the Portuguese government in 1698, as part of the colony's first fortress. Now painted in bold black and white bands that make it an effective daymark, and fitted with a powerful halogen light, it remains a major South Atlantic landmark.

Among the vital requirements for a functional harbor are: sufficient water depth at low tide to accommodate vessels; shelter from storms and heavy surf; and a navigable route to ensure safe passage between the harbor and open water. In sandy areas, regular dredging may be required to maintain harbor channels. Rocky locations may have numerous submerged rocks and reefs that must be marked with warning lights and buoys. Few harbors have ideal navigating conditions, and each poses its own set of challenges for maintenance and safety.

The world's most successful port cities have developed along the banks of easily navigable rivers, like London, or on exceptional natural harbors. The sheltering islands surrounding the Hong Kong Harbor make its conditions for ready access and secure shelter for a large number of ships almost ideal. Lisbon, Portugal's capital city, is built on hills overlooking a protected bay several miles long. Antwerp, Belgium's largest port—one of the world's busiest—is located on a long, protected inlet. New York City's harbor has the

dual advantage of shelter from the New Jersey coast and the western side of Long Island. French colonists chose Louisbourg Harbour on Nova Scotia's Cape Breton Island because it was one of the few inlets in that area that did not freeze in the winter.

Considering the diversity of natural conditions at these and countless other harbors and inlets along our shores, it should come as no surprise that the lighthouses stationed there display so much variety in their styles and sizes. From the monumental making lights at harbor or inlet entrances, like Boston Harbor and Ponce de Leon Inlet Lights, to breakwater markers, as at Spring Point Ledge, Portland, Maine, to unique monuments including the Statue of Liberty, navigational aids of all descriptions can be found at or near harbors and along their entrance channels.

Boston Light, on Little Brewster Island in Boston Harbor, was the first lighthouse built in North America. Blown up by the British during the Revolutionary War, Boston Light was rebuilt in 1783 and is now the only manned lighthouse in the United States. Boston Harbor and Massachusetts Bay itself are littered with islands and reefs and subject to heavy storms. The light was provided with walling more than 7 feet thick at the base during the reconstruction of 1783.

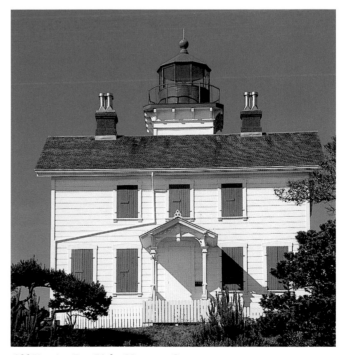

Old Yaquina Bay Light, Newport, Oregon

Fort Point Light, San Francisco, California

The second North American light of which we have certain knowledge was built by the French to guard the entrance to the harbor at Fortress Louisbourg on Cape Breton Island, off Nova Scotia. Completed in 1733, it succumbed to fire in 1736 and was rebuilt as a concrete, fireproof structure. This tower overlooks the historic fortress—recently restored to its original condition, when this was one of the Eastern Seaboard's three largest ports. In 1745 New England farmers and fishermen joined a British fleet to besiege and capture Louisbourg. Its light was destroyed in 1758, but it was rebuilt in 1833 and remains an important symbol of the opening of Eastern Canada, much as Boston light is symbolic of early New England.

British-American colonists built eleven other lights prior to the American Revolution. Nearly all of them were at or near harbors, indicating the importance of commerce to the early colonists. Brant Point Light guarded the south side of Nantucket Harbor; Tybee Island Light guided sailors into Savannah; Beavertail Light stood at the entrance to Narragansett Bay. Connecticut's New London Light was built in 1760; New Jersey's Sandy Hook Light guarded busy New York Harbor (as it does today); South Carolina's Morris Island Light marked the entrance to Charles Town (later Charleston) Harbor; and Plymouth and

Portsmouth Lights illuminated their respective harbors in Massachusetts and New Hampshire. Meanwhile, British Canada built a light on Sambro Island, at the entrance to the harbor of Halifax, Nova Scotia. The red-and-white octagonal tower still stands.

New England continued to build harbor lights as its post-Revolutionary commerce flourished. The first New Haven Harbor Light was established in 1805. The island light at Scituate, Massachusetts (1811), indicated the coastal harbor there, and the 1820s saw construction of important new markers for the ports of Newport, Rhode Island, and Stonington, Connecticut. In busier ports, additional lights and markers were installed gradually to improve navigation along the heavily used or most hazardous channels. Portland, Maine's largest port, had four lighthouses when Ram Island Ledge Light was activated in 1905.

The acquisition of new areas of coastline in the nineteenth century created the need for additional harbor lights. From Florida to Texas, the Gulf Coast presented numerous challenges to architects and builders. The Gulf Coast is more irregular than that of the Atlantic, with countless inlets, both estuarial and tidal. Even the great Gulf ports of Pensacola and Mobile result from a whole series of inlets rather than comprising natural harbors. This holds true all the way to the Mississippi Delta.

Alabama's Mobile Point Light has been built three times: in 1822, 1873 and 1966. A series of barrier islands and reefs force ships to enter Mobile Bay through the narrow channel that runs past Mobile Point. The original 55-foot brick tower here served its purpose until 1864, when Union gunners blasted it and Fort Morgan to bits at Admiral David Farragut's famous command: "Damn the torpedoes; full speed ahead!" After the Civil War, an iron skeleton tower was erected on a bastion of the fort (1873). This structure, now lying on its side, was replaced in 1966 with a tall skeleton tower.

On the Pacific Coast, harbor lights to guide vessels into the increasingly busy San Francisco Bay area were the first priority of the Lighthouse Board in 1852. Fort Point Light was completed in 1853, and Alcatraz Island Light went into service the following year. The Bay Area also acquired Point Bonita light (see chapter 2), on the Golden Gate Strait, in 1855.

Meanwhile, construction of lighthouses at harbors and inlets continued on the East Coast. Derby Wharf Light in Salem, Massachusetts, one of three lights to guide traffic into Salem's inner harbor, was finished in 1871. Placed at the end of the famous Derby Wharf (self-named for the nation's first millionaire), the short square tower resembles a brick box. Ironically, it was built after the heyday of Salem shipping; it stands today (relighted in 1983) as part of the Salem Maritime National Historic Site.

By contrast, the new light that rose in New York Harbor in 1886 was celebrated for its beauty as a monument. The Statue of Liberty served as a lighthouse for more than twenty years. Steamboats, tugboats, ocean liners, fishing trawlers—all vessels making port in New York City were greeted by this regal gift from France.

The need for harbor and channel lights on the Great Lakes increased as inland waterways multiplied. The first lighthouse of record at Buffalo, New York, was built in 1818. Just seven years later, completion of the Erie Canal made Buffalo a major port, and construction of a new beacon was planned. Finished in 1833, the octagonal limestone lighthouse stands at the end of a 1,400-foot pier. Other growing ports on the Great Lakes that were illuminated during this period include Toronto (Gibraltar Point, 1808) and Chicago (1832). As

the century progressed, lighthouses were built to mark harbors all along the Great Lakes' shores.

The mid-nineteenth and early twentieth centuries saw the addition of many lighthouses in Canada. Halifax, Nova Scotia, was the greatest Canadian harbor and port of the time. Comparable to New York City in terms of immigration, Halifax received 96,000 newcomers from abroad in 1913, the same year that immigration to the United States was at its peak. Halifax itself had a population of only 46,000 at the time. Marking the entrance to Halifax Harbour, the Chebucto Head Light was built in 1872. On a breakwater nearby stands Maugher Beach Light, built in 1828 and also known as Halifax Harbour Middle Range. In the middle of the harbor itself is Georges Island Light, an octagonal white tower that illuminated this site from 1876.

Vancouver, British Columbia's most flourishing port city, had several lighthouses to mark its major hazards and shipping routes by the early twentieth century. Atkinson Point Light, built in 1875 and rebuilt in 1910, stands at the harbor entrance. Prospect Point Light lies 3 miles farther along the channel, and the inner-harbor lighthouses include Brockton Point (1890) and Capilano Point (1908). This deep, sheltered harbor is one of the best natural havens on the continent, but its dangerous rocky approaches had to be identified clearly before it could reach its full potential for maritime commerce and, more recently, leisure boating.

In addition to the wide variety of lighthouses featured on the following pages, North America's harbors and inlets are made safer by the myriad buoys, daymarks, range lights, sound signals and other navigational aids (see chapter 8) that guide ships in and out to open water. Radar, radio and digital satellite systems have greatly reduced the importance of lighthouses for commercial vessels. Today, both merchant ships and passenger vessels use them to make their way to harbor and inlet entrances. However, when navigating through narrow channels and preparing to dock by night, lights remain vital. And for the thousands of pleasure boaters whose craft lack sophisticated equipment, safe passage still relies upon lighthouses, as it did for the sailors of earlier times.

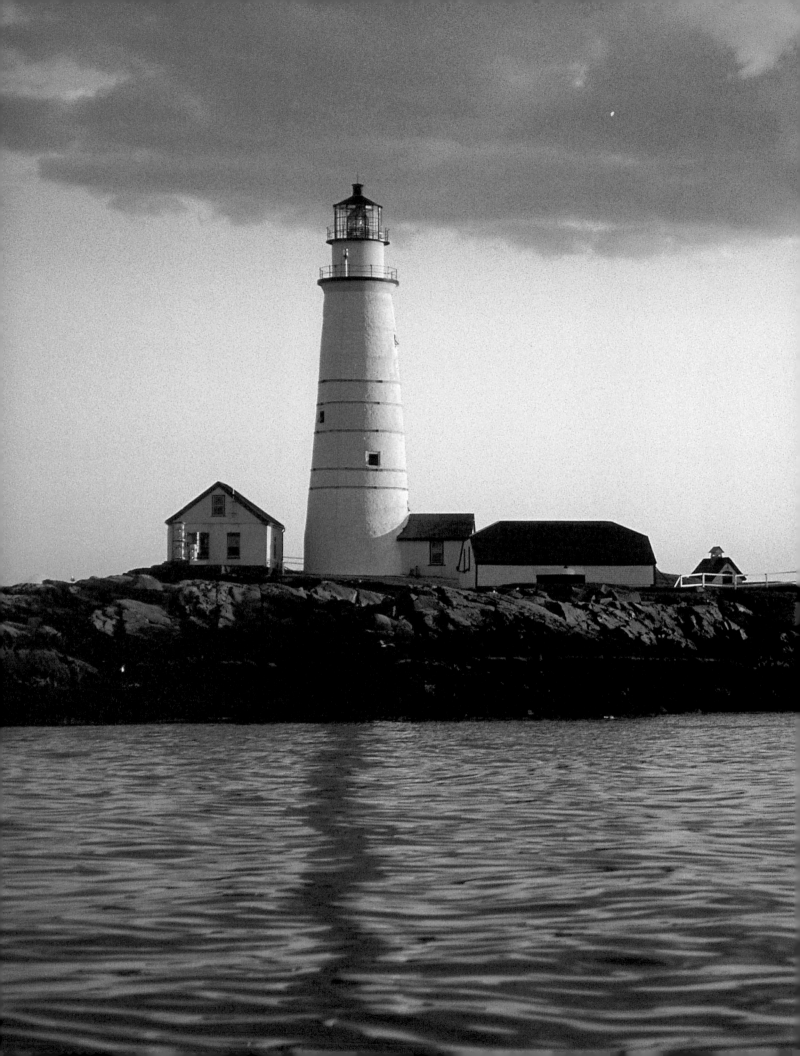

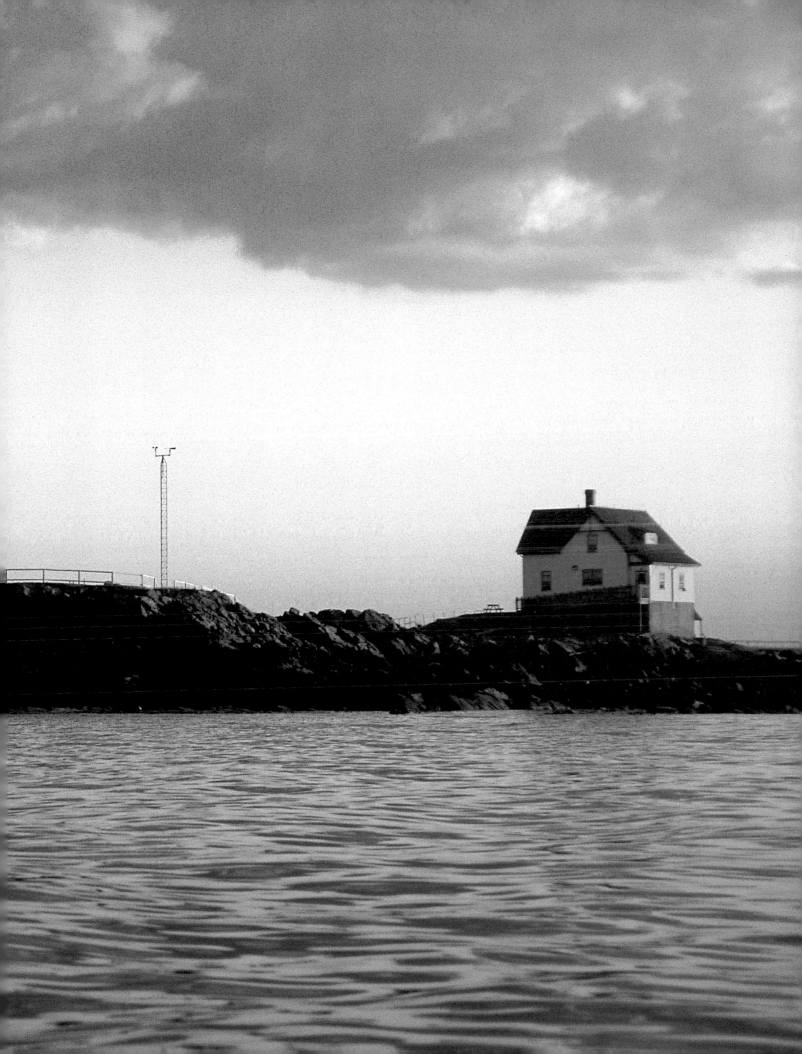

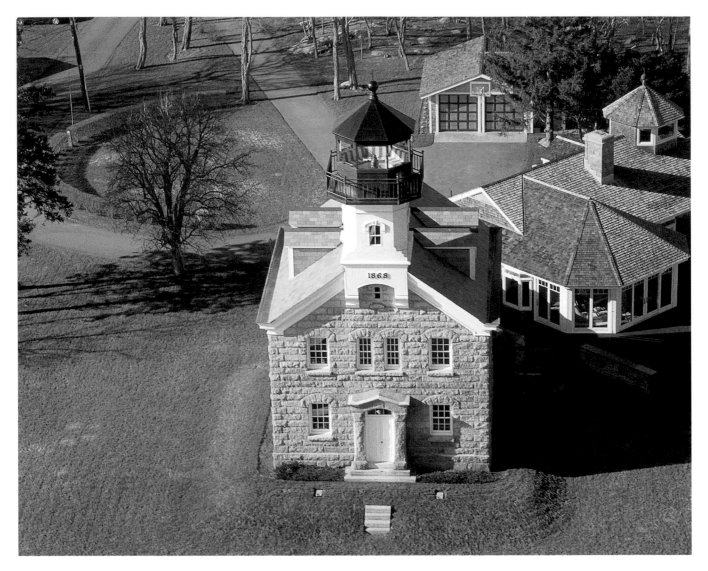

**Boston Harbor Light** *Previous pages*

*Little Brewster Island, Massachusetts*

The first lighthouse built on the mainland of North America, Boston Light stands on Little Brewster Island, at the outer extremity of Boston Harbor. First built in 1716 by order of the Massachusetts legislature, it stood until the Revolutionary War, when it was blown up by retreating British soldiers. Rebuilt soon after, this was one of the nation's key beacons until Boston's importance as a port of entry was superseded by that of New York City. Standing 75 feet above sea level, Boston Harbor Light has withstood more than two centuries of winds and weather. Its historic significance was recognized in 1989, when Congress voted to keep the lighthouse manned: Today it is the only one in the United States that has a permanent keeper.

**Morgan Point Light** *Above*

*Noank, Connecticut*

The U.S. government built the first lighthouse on this peninsula that marks the mouth of the Mystic River in 1832. The native Mohegan called the land "Naiag," which means "a point." Because of increased commerce, this granite tower was replaced in 1868 by a second granite beacon, outfitted with a light imported from Germany. The three-story structure combines the keeper's dwelling with the lighthouse and reflects Noank's transition from a simple fishing community to a modest seaside resort, as seen in the decorative Eastlake decoration that adorns the light's gable. Discontinued in 1922, the light was replaced with an automatic electric beacon. Today, the Morgan Point Light, listed on the National Registry of Historic Places, is privately owned.

### East Point (Maurice River) Light *Below*
*Delaware Bay, New Jersey*

Built in 1849 to mark the entrance to the Maurice River from Delaware Bay, the East Point Light was called the Maurice River Light until 1913. The two-story lighthouse guided oyster schooners traveling to Port Norris and Port Elizabeth. During World War II, the simple Cape Cod-style structure was used as an aircraft spotter post. After almost a century of service, the light was deactivated in 1941; it was later restored and eventually reactivated, in 1980. Today it continues to serve as an active aid to navigation, although the station is steadily falling into a state of disrepair. The Maurice River Historical Society is working to restore this historic lighthouse to its former condition.

### Elbow Reef (Hope Town) Lighthouse *Overleaf*
*Elbow Cay Harbour, Abaco, Bahamas*

As England's maritime trade increased, it became necessary to construct lighthouses along the shores of her colonies, including the islands of the Bahamas. Some native Bahamians objected to this decision because they had come to depend on salvaging the cargo of wrecked ships. The British identified the need for a lighthouse at Hope Town—the site of countless wrecks—to guide sailors around the dangerous Elbow Reef. The candy-cane-striped tower was completed in 1864 and equipped with a standing wick-type light. In 1936 London's Imperial Lighthouse Service moved the first-order Fresnel lens from the Gun Cay Light to the Elbow Reef Light. The fixed light can be seen up to 17 miles at sea. Maintained today by the Bahamas Lighthouse Preservation Society, the mechanically operated light is one of three kerosene-powered lighthouses in the world.

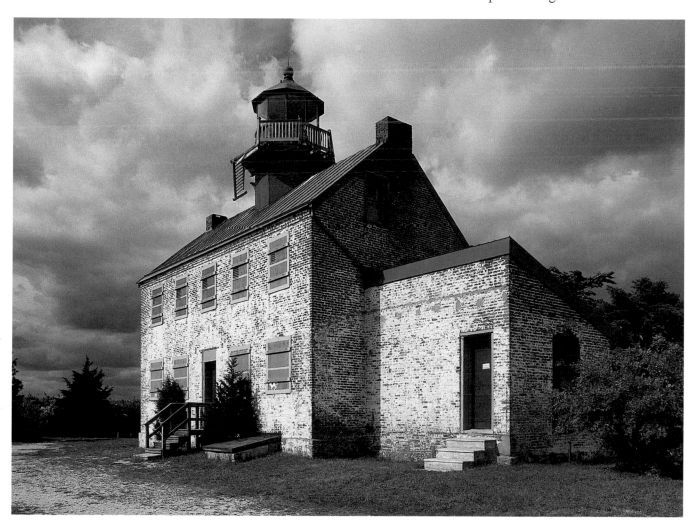

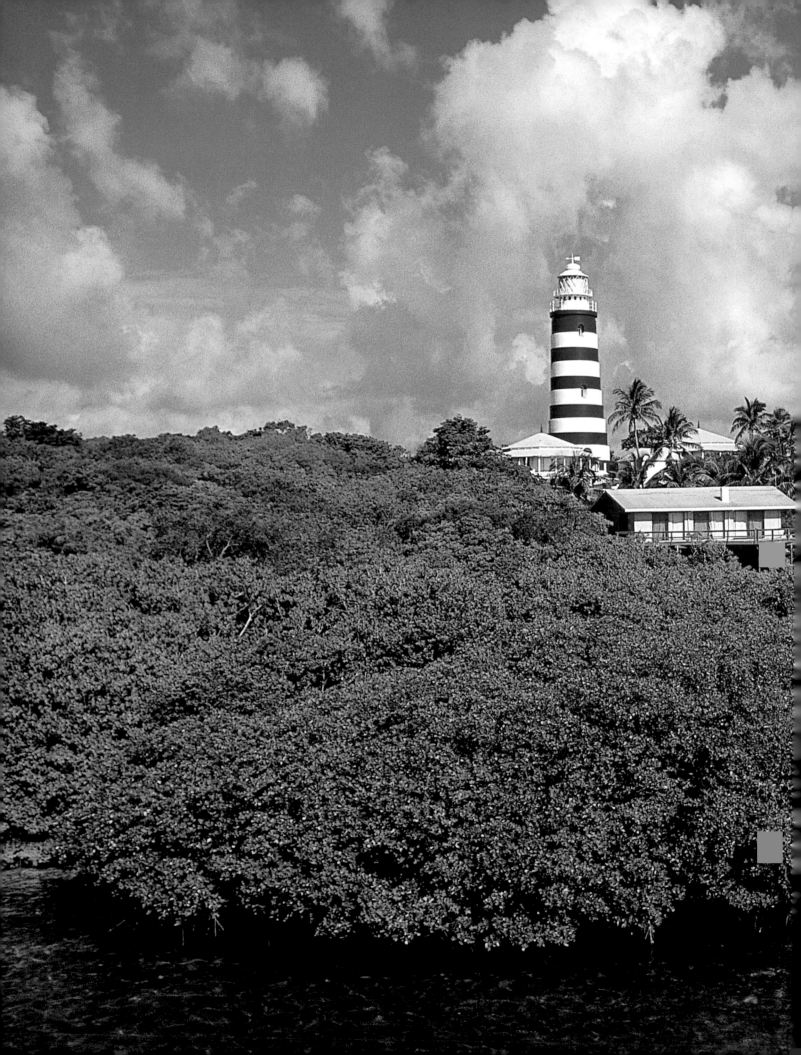

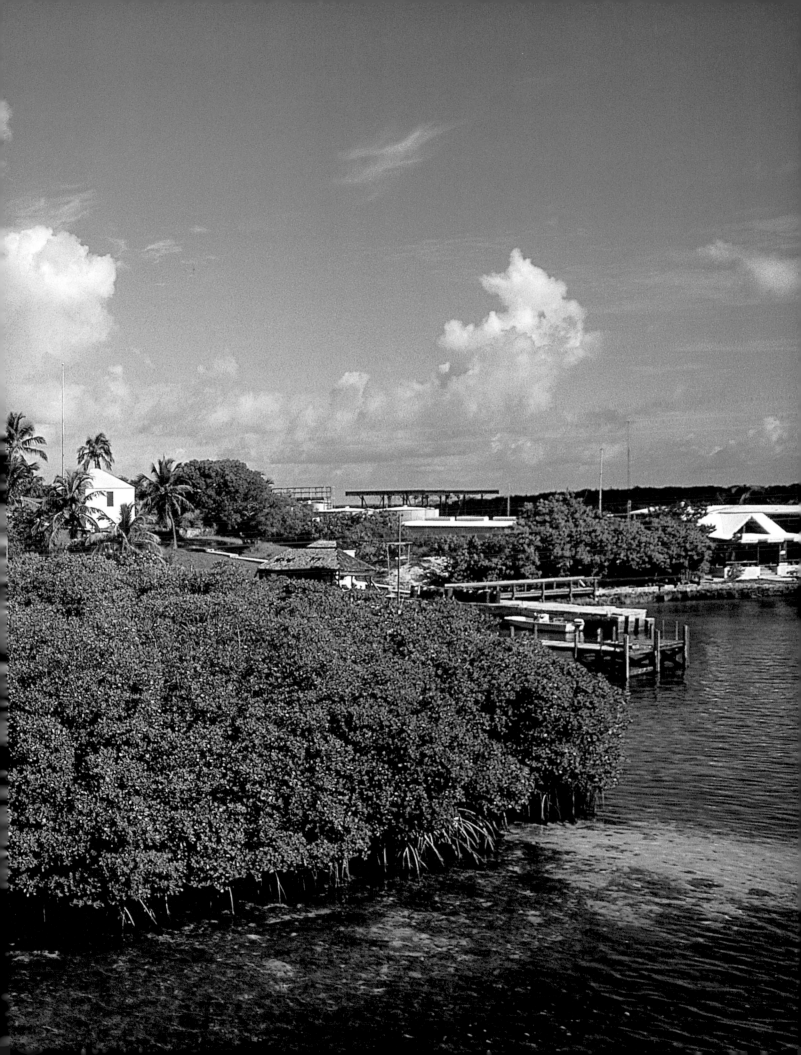

**Spring Point Ledge Light** *Below*
*Portland, Maine*

One of four lighthouses along the rocky passage to the harbor at Maine's largest city, Spring Point Ledge Light was completed in 1897 to warn navigators away from a dangerous submerged ledge. The prefabricated cast-iron structure was originally anchored on an isolated caisson that took two years to complete. The light was connected to the mainland by a 900-foot granite breakwater in 1950. Its fifth-order Fresnel lens emits both white and red flashes at an interval of 5 seconds.

**Castle Hill Light** *Opposite*
*Newport, Rhode Island*

Castle Hill Light was built in 1890 on the property of the famous naturalist Alexander Agassiz (1835–1910). Believed to have been designed by influential architect Henry Hobson Richardson, this handsome granite structure built into a cliff face is one of many navigational aids for ships making their way into Newport and Providence. Castle Hill Light remains important, especially since Newport became a center for American yacht racing. Countless races have begun there or ended as the lead vessel sails past the lighthouse. Automated by the Coast Guard in 1957, its fifth-order Fresnel lens continues to guide traffic into the main shipping channel of Narragansett Bay.

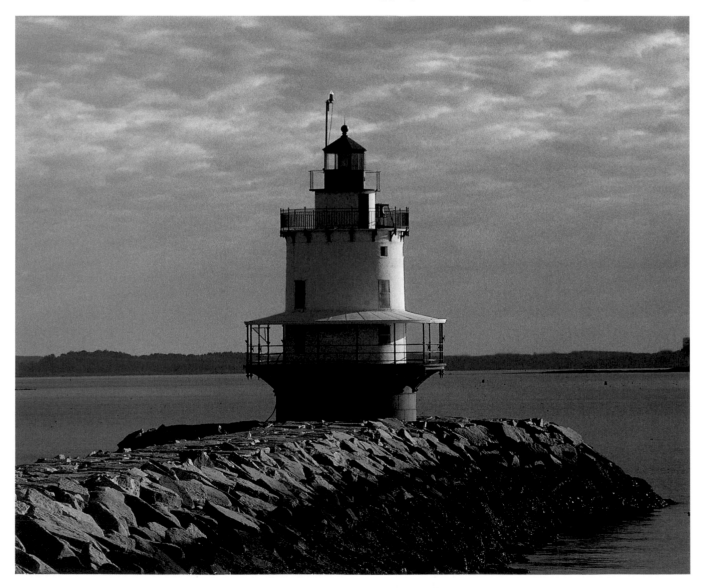

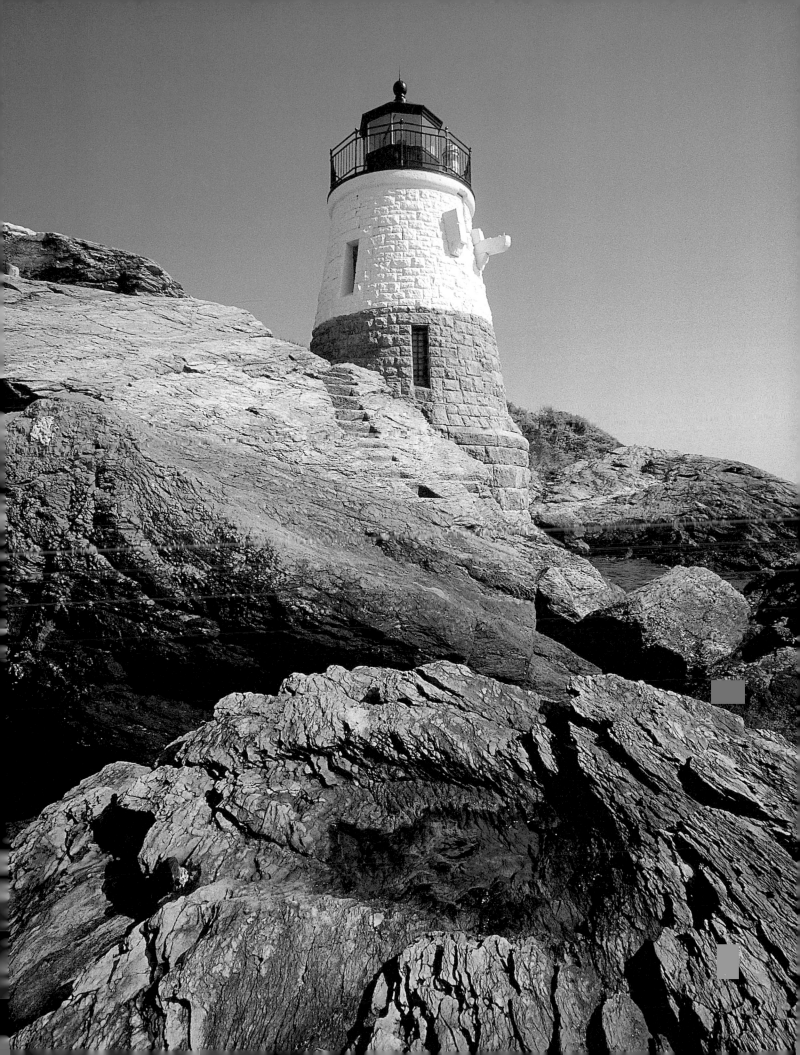

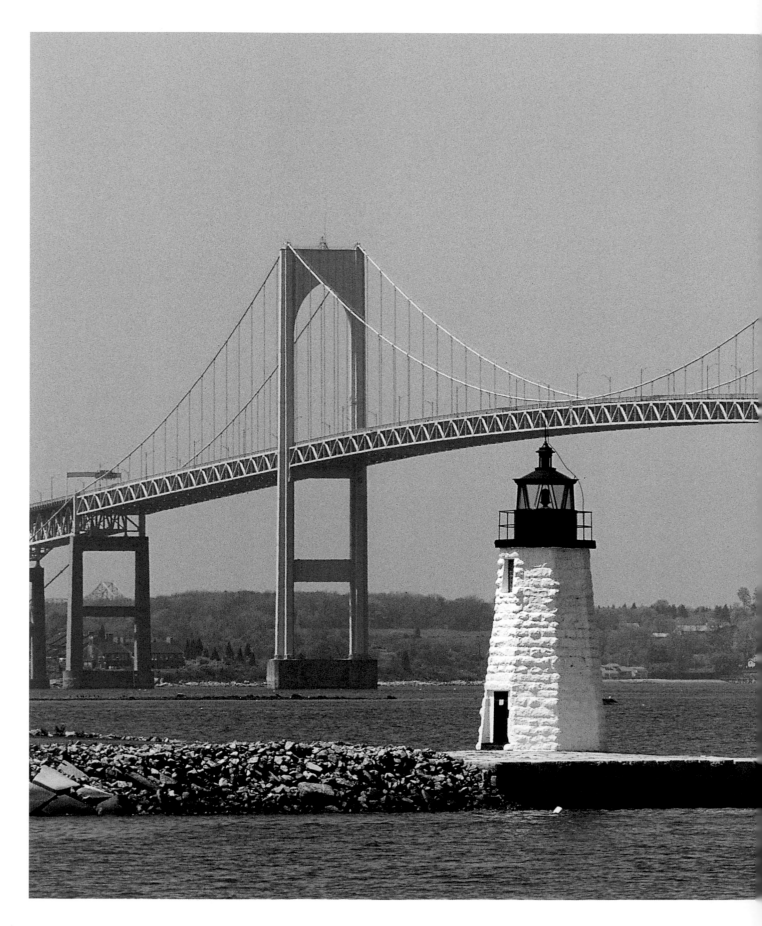

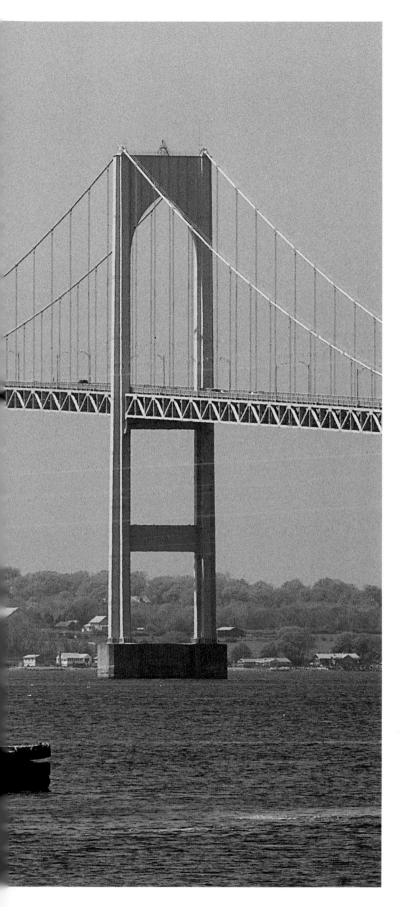

## Newport Harbor Light *Left*
*Goat Island, Rhode Island*

While Castle Hill and Beavertail Lights guide the mariner into Narragansett Bay, this beacon on the northern end of Goat Island directs traffic into Newport's harbor. Completed in 1865, the 35-foot octagonal lighthouse is made of granite blocks painted white. It stands just below Newport Bridge and is one of the first landmarks seen as visitors approach the city. Equipped with a fifth-order Fresnel lens, the tower emits a flashing green light.

## Saint John Harbour Light *Page 142*
*Market Square, Saint John, New Brunswick*

Founded in 1785 by the Loyalists after the American Revolution, Saint John is the oldest incorporated city in Canada. Saint John Harbour is located where the 450-mile-long Saint John River reaches the Bay of Fundy. This confluence causes an extraordinary natural phenomenon called the Reversing Falls. Twice a day, the incoming Fundy tide pushes the river's waters upstream—an impressive sight, as the Saint John River has been referred to as the Rhine of North America. Still one of Atlantic Canada's most important harbors, Saint John embraces a multiethnic heritage including American Loyalists, French Acadians and Irish immigrants. This replica of Canada's many simple clapboard lighthouses commemorates the seafaring heritage of this historic port.

## Brant Point Light *Page 143*
*Nantucket Island, Massachusetts*

Located in Nantucket's sheltered harbor, Brant Point Light has its focal plane only 26 feet above sea level, but its light can be seen from 10 miles at sea. The first light at this spot was built in 1746, after members of the Nantucket town meeting voted in favor of a beacon to protect their whaling ships as they entered the harbor. This was the third light (after Boston and Nova Scotia's Louisbourg) built in British North America. Brant Point was rebuilt in 1759, and the present picturesque salt-shaker-style lighthouse dates from 1901.

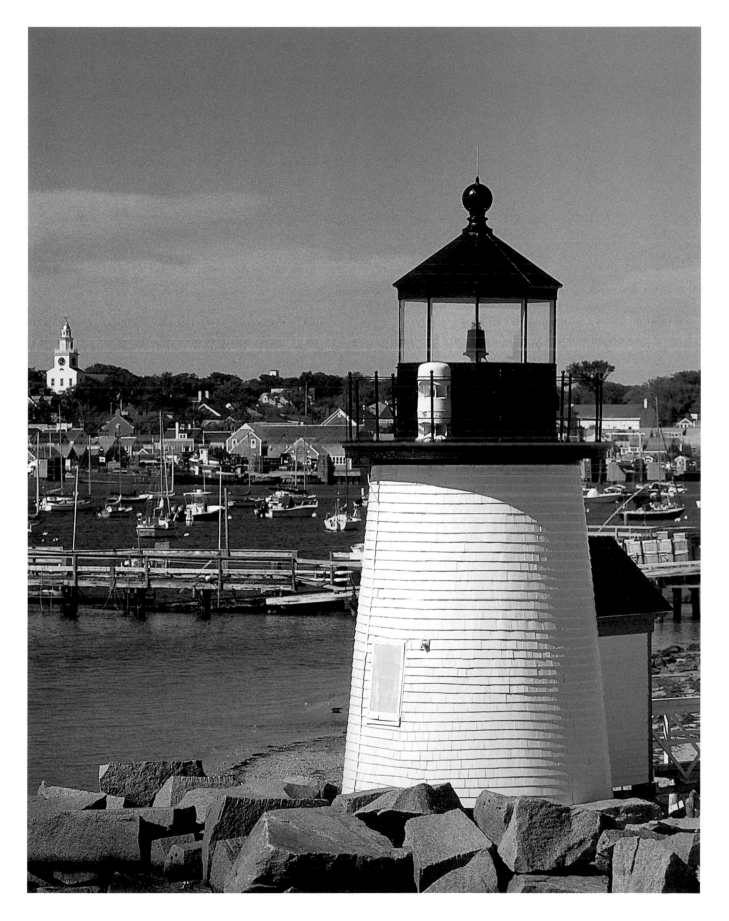

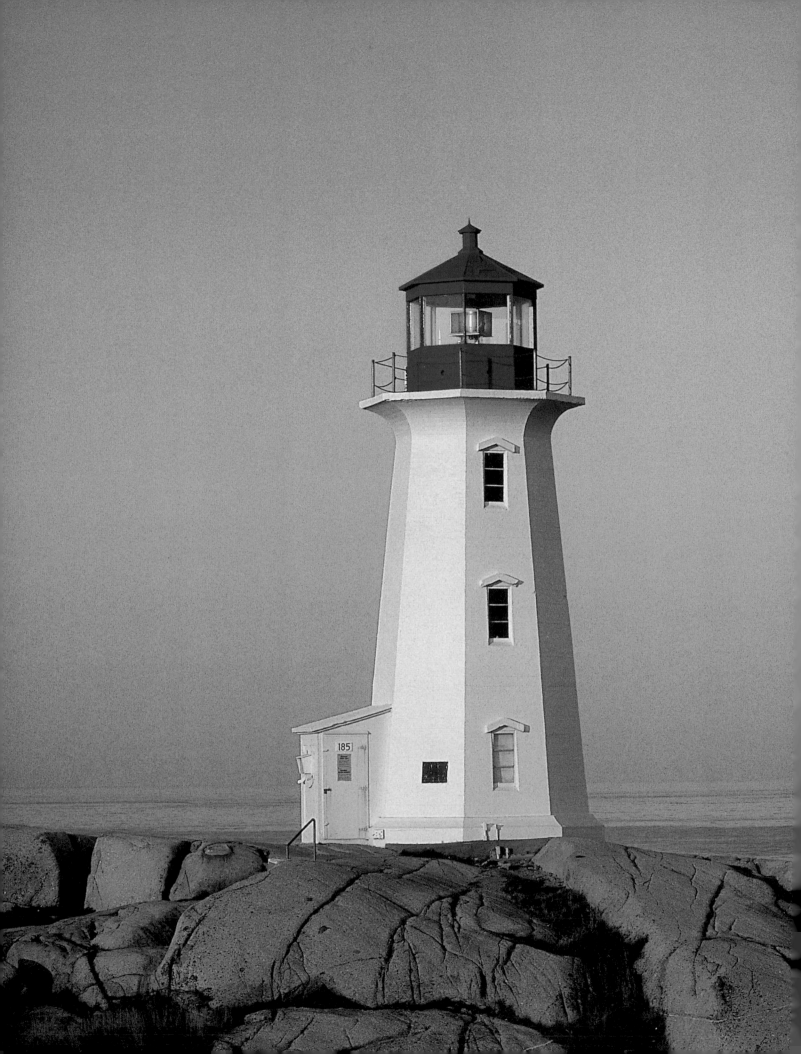

## Peggy's Cove Light

*St. Margaret's Bay, Nova Scotia*

Canada has many remarkable lighthouses, but none as well known or loved as Peggy's Cove, southwest of Halifax, Nova Scotia. The 37-foot octagonal tower was finished in 1868, one year after the Confederation of Canada was formed. The tower is surrounded by large granite ledges that are estimated to be 400 million years old. A monumental stone carving on one of the boulders commemorates the nautical emphasis of life in the Canadian Maritimes. It depicts thirty-two fishermen, their wives and children, and the legendary Peggy. The lighthouse doubles as a post office, and letters sent from here bear a special lighthouse stamp.

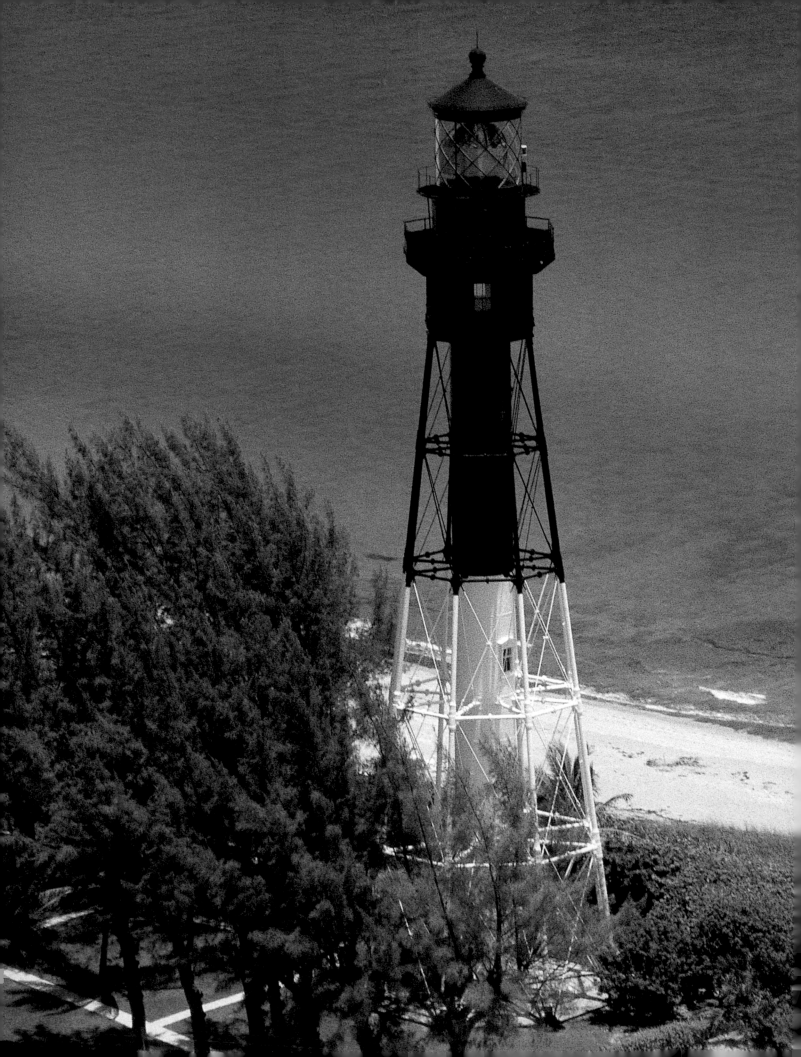

**Hillsboro Inlet Light** *Opposite*

*Pompano Beach, Florida*

The iron-skeleton tower of this 132-foot lighthouse rises 136 feet above sea level, marking an inlet between Boca Raton and Fort Lauderdale that leads to the Intracoastal Waterway. Prefabricated in a Chicago foundry, the beacon was originally exhibited at the St. Louis Exposition of 1904. Reassembled on Hillsboro Inlet, the black-and-white metal cylinder houses the stairwell to the now automated lantern, which is equipped with a first-order Fresnel lens. Its flashing white light can be seen 28 miles at sea.

**Ponce de Leon Inlet Light** *Below*

*Ponce de Leon, Florida*

This is the second-tallest of all American lighthouses; at 168 feet, it is surpassed only by Cape Hatteras Light at 196 feet. The need for a light here was recorded by the Lighthouse Board during the 1870s, and the work was accomplished between 1884 and 1887. Originally known as Mosquito Inlet, and since 1927 as Ponce de Leon Inlet, this strip of land lies just south of busy Daytona Beach. Prior to construction of this impressive tower, there was no light on the 60-mile stretch of coast between St. Augustine and Cape Canaveral. Discontinued in 1970, the Ponce de Leon Inlet Light was recommissioned in 1983.

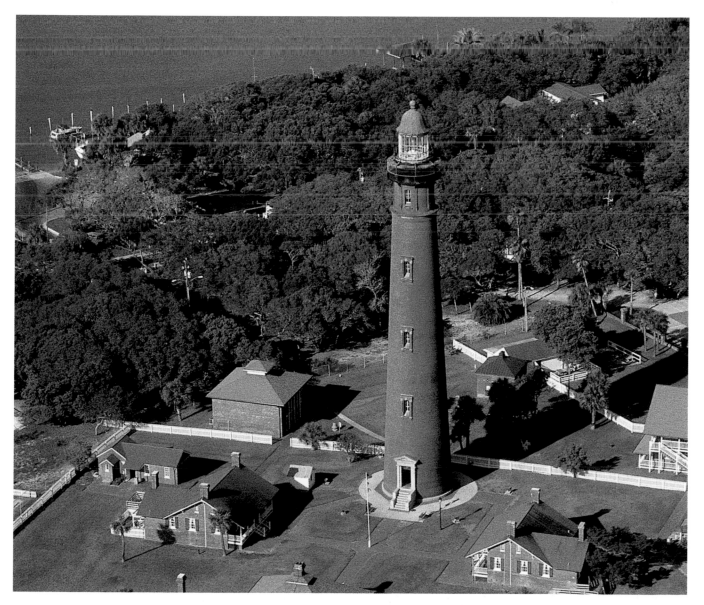

## Mystic Seaport Light

*Mystic, Connecticut*

The Connecticut coast is dotted with narrow inlets, and many famous ships sailed from the small sheltered ports on the eastern shore at Mystic, New London, Groton and Stonington. Today Mystic is foremost among the old whaling towns in maintaining its historic maritime connections. The restored Mystic Seaport welcomes Tall Ships and thousands of visitors and hosts seminars on the age of sail. Its lighthouse, a copy of Nantucket's Brant Point Light, lies 2 miles upriver from Noank at Mystic's whaling harbor.

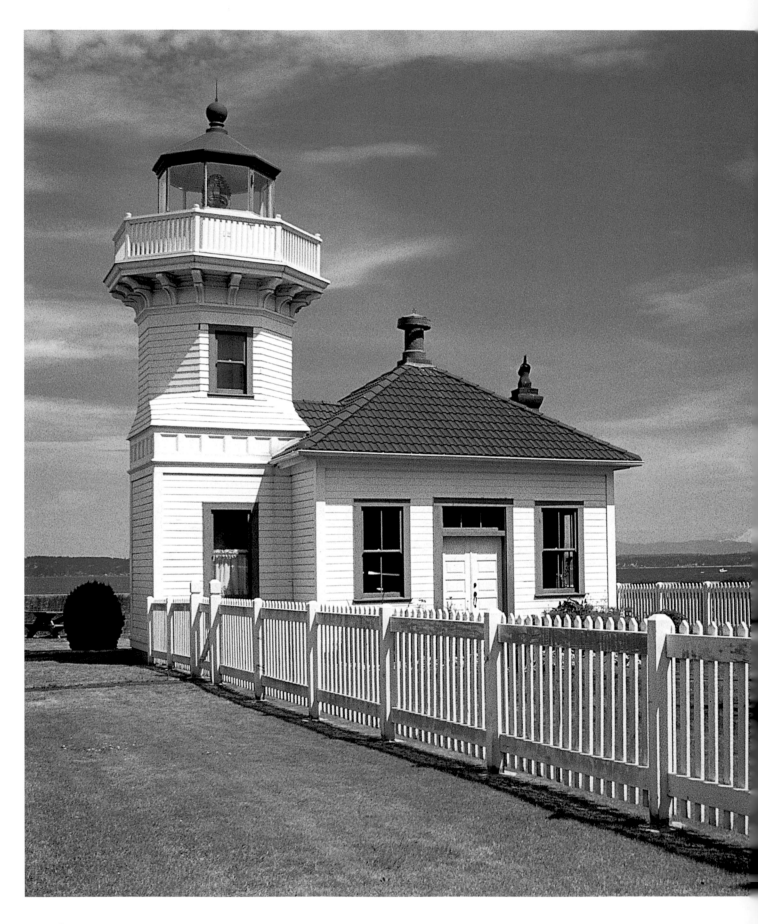

**Mukilteo Light** *Left*

*Mukilteo, Washington*

Built in 1906, Mukilteo Light was designed to guide ships through Possession Sound en route to Everett, Washington, which was then a thriving lumber and railroad center. Located just south of Everett, this 30-foot octagonal wooden tower is one of Puget Sound's many "street lights." Equipped with a fourth-order Fresnel lens, the Victorian-style beacon was also outfitted with a Daboll trumpet, which was used to warn ships during severe weather. Today it is a landmark seen by the many commuters and tourists who take the nearby ferry to scenic Whidbey Island. Everett is one of several harbor towns in the vicinity that never realized their full potential due to the tough competition posed by Seattle's deep-water harbor.

**St. David's Light** *Overleaf*

*Lighthouse Hill, St. David's Island, Bermuda*

First lighted on November 3, 1879, St. David's Light was the second and final beacon to be built in Bermuda, the oldest British colony. Only 22 square miles in total area, Bermuda is made up of seven main islands that are located in the middle of the Atlantic Ocean. Cape Hatteras, North Carolina, is the closest land, 600 miles to the west. Constructed of local limestone, the 55-foot red-and-white striped lighthouse was built at the easternmost end of Bermuda. Standing 285 feet above sea level, the tower guides vessels entering Castle Harbour from the Atlantic Ocean. The picturesque lighthouse was recently refurbished.

## Hereford Inlet Light *Opposite*

*North Wildwood, New Jersey*

This unusual Victorian stick-style lighthouse rises 50 feet above sea level in North Wildwood, which was once known as the fishing village of Anglesea. Completed in 1874, the light overlooks a wide inlet leading from the Atlantic Ocean to the Intra-Coastal Waterway. The light was moved from its original location after a severe storm in 1913 damaged the foundation. Hereford Inlet Light was decommissioned in 1964, when an automatic light tower was built nearby. The former station has been restored as a private aid to navigation.

## North Rustico Harbour Light *Below*

*Prince Edward Island*

This picturesque light guards the western entrance to North Rustico Harbour, which serves a small fishing community of Acadian heritage on the northern side of Prince Edward Island. Because of erosion, the 33-foot tower has been moved several times since its completion in 1899. Like the island itself, the area around Rustico Bay is known for its scenic beauty and unhurried way of life. The white light station with bright red trim and its adjoining keeper's dwelling are typical of the lighthouses in the small harbor towns of the island.

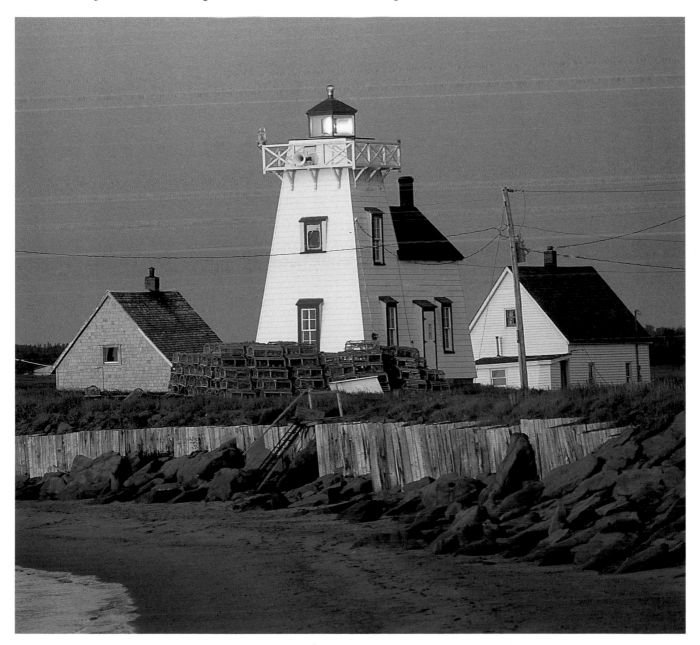

**Baddeck Harbour Light** *Right*

*Cape Breton Island, Nova Scotia*

Baddeck Harbour Light stands on low ground overlooking the Bras d'Or, the largest salt-water lake on the east coast of North America. The low structure tapers gracefully from base to lantern and marks the resort town of Baddeck, located in the scenic Cape Breton Highlands. Alexander Graham Bell had a summer home here, and Baddeck is a popular point of departure for one of the world's best-known scenic marine drives—the Cabot Trail.

# Wave-swept,
# Reef and
# Island Lights

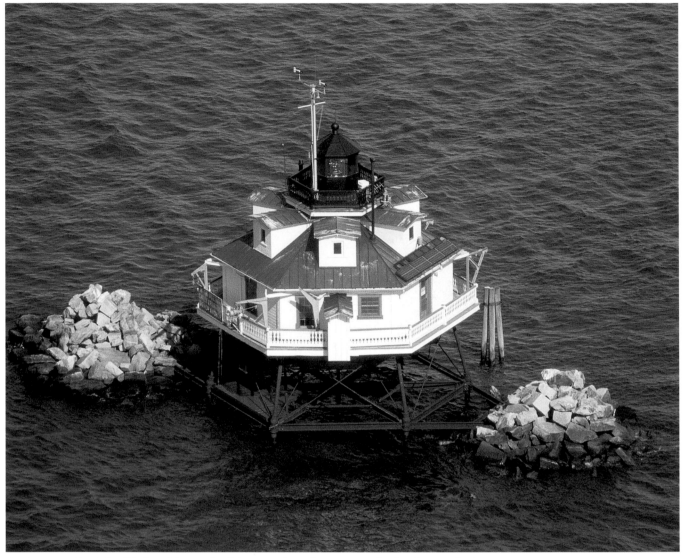

*Previous pages:* **Ram Island Ledge Light, Portland, Maine;** *Above:* **Thomas Point Shoal Light, Maryland**

*"Lights intended to guard vessels from reefs, shoals and other dangers, should, in every case where it is practicable, be placed seaward of the danger itself, as it is desirable that seamen be enabled to make the light with confidence."*
— ALAN STEVENSON

Reefs present one of the greatest hazards to even the most experienced mariners. Only in the nineteenth century was significant progress made in marking these dangerous rock formations, which are often wholly or partly submerged. Early lighthouse engineers could not find a way to emplace structures on wave-swept reefs as they had on coastal headlands.

Alan Stevenson was among the few engineers of his time who knew a great deal about lighthouse construction on reefs and wave-swept islands: His family had specialized in tackling such challenges for more than half a century. But although England, Scotland and France had led the way, architects and engineers from other nations were exploring new paths based on their own terrain and requirements. In North America, these pioneers of the mid-1800s included Captain Barton Stone Alexander and Thomas Albertson Scott, who were instrumental in creating the lights at Minots Ledge, Spectacle Reef, St. George's Reef, Race Rock and others. Lieutenant George G. Meade and Major Hartman Bache were pioneers in developing the

screwpile lighthouse. The first protected screwpile light in North America was built in the Delaware Bay at Brandywine Shoals in 1850. It was supported on eight screw-tipped iron stilts, cross-braced and anchored deeply in the sand below water level. Several more lighthouses of this type were built in the Chesapeake region, including at Thomas Point Shoal (1875) and Drum Point (1883). The technology was refined for exposed locations in the Florida coral reefs, including at Carysfort Reef (1852) and Fowey Rocks (1873), by securing large foot plates of iron above the screw tips to provide extra stability.

Wave-swept lighthouses were uncommon until the eighteenth century, but one notable early exception was at Cordouan, off the mouth of the Gironde River in France's Bay of Biscay, where a wooden tower was first erected on a cliff in a group of treacherous rocks and islets during the thirteenth century. It was replaced by a 53-foot stone tower in 1360. More than two hundred years later, renowned architect Louis de Foix began work on a new, elaborate lighthouse that would become one of the world's best known. Construction of this graceful tower, which served as a light, a chapel and a royal residence, was ongoing from 1584 until 1611, and the result was enduring. De Foix's 227-foot tower of ashlar (cut stone) on a wide circular base still stands majestically on its exposed site. The light was registered as a historic landmark in 1862, and it is staffed to this day.

At Eddystone Rocks, off the English port of Plymouth, a wave-swept lighthouse was built in the late seventeenth century. Engineer Henry Winstanley and his workers were rowed daily to the reef, 14 miles from Plymouth, for almost two years to construct the 80-foot tower on this dangerous site. Eddystone Light first displayed its candles in 1698. The tower was destroyed by waves in 1703, and a second, built of wood, was completed in 1709. The second lighthouse burned down in 1755 and was replaced four years later by an interlocking masonry-block tower built by John Smeaton. It is an interesting coincidence that this light was completed in England's *annus mirabilis* — the year when she gained access to an overseas empire in Canada and India through command of the seas. This third light at Eddystone stood for more than 120 years before it was dismantled and brought ashore to Plymouth in 1882. The fourth tower was built on an adjacent rock in 1882 and still stands today. Perhaps the best-known of all lighthouses, Eddystone reminds us of the Herculean efforts made by eighteenth-century builders who lacked machine power of any kind.

Scotland came next in the fame of its lighthouses, especially those built on islands and reefs. Robert Stevenson built the historic Bell Rock Light on the east coast between 1807 and 1811. He must have been gratified by the fact that for the rest of his life, no ship was wrecked on the treacherous reef that had claimed some seventy vessels in a single year, 1799. His son Alan Stevenson built Skerryvore on a challenging reef off the west coast of Scotland between 1838 and 1842. This remarkable achievement bolstered the Stevensons' reputation as the world's preeminent lighthouse builders and established Scottish engineering as perhaps the best of its day.

North America's convoluted coastlines, thousands of miles in extent, are dotted with rocks and reefs that can dash a vessel to pieces. The mouth of the St. Lawrence River, gateway to Canada, is filled with such dangers—as is the whole coastline of the Maritime Provinces, and that of Maine. The Pacific Coast and, to a lesser extent, the Great Lakes, present similar hazards to navigation, but the combination of lighthouses and other navigational aids has made maritime disasters like the loss of the *Edmund Fitzgerald* in 1975 comparatively rare. Several factors are responsible for this increase in safety along our coasts.

From colonial times through about 1840, American and Canadian sailors had to rely mainly on skill, luck and good weather. But discoveries in engineering and more accurate charting from the mid-nineteenth century onward fostered the growth of shipping, whaling and allied industries. It was a period of expansion on many fronts, and improved lighthouses and other navigational aids were one sign of the times.

Two towers of the 1850s exemplify the skill and determination of the lighthouse engineers of the age: Bishop's Rock and Minots Ledge Lights. The former

is a granite peak 7 miles southwest of the Scilly Isles, off the southwestern coast of England, once the first "making" light seen by most eastbound transatlantic passengers (until Ireland's Fastnet Light was built). Bishop's Rock, some 155 feet long and 52 feet wide, took a heavy toll on passenger ships. British engineers built a 94-foot iron tower between 1847 and 1850, but this was swept away soon after completion. Nicholas Douglass, the engineer in charge, then built a stone coffer dam around the only feasible building site and had the area pumped dry and filled. It took seven years to erect the new 120-foot tower that was lit in 1858, but the result was safer passage for ships bound for the English Channel ports.

At almost the same time, American engineers tackled one of their worst navigational hazards: Minots Ledge, off the southeast side of Massachusetts Bay. A contemporary observer noted that: "These rocks or ledges, with others in their immediate vicinity, are also known as the 'Cohasset Rocks,' and have been the terror of mariners for a long period of years; they have been, probably, the cause of a greater number of wrecks than any other ledges or reefs upon the coast. The Minots are bare only at three-quarters ebb, and vessels bound in with the wind heavy at north-east, are liable, if they fall to the leeward of Boston light, to be driven upon these reefs."

It was decided to build on Outer Minot, the most seaward of the group of ledges. Between 1847 and 1850, Captain William Henry Swift, who had traveled in Europe and become familiar with iron lighthouses, built an octagonal tower 25 feet wide at the base anchored to the ledge by pilings. The bottom half of the structure was open to provide less resistance to the fierce storms called "Nor'easters" that batter the area. Despite all this, a three-day gale in 1851 swept away the tower and two keepers.

The disaster prompted renewed action, because Bostonians had seen a sharp decrease in the loss of ships and lives while the tower stood. Between 1855 and 1860, Captain Barton Stone Alexander supervised the work that resulted in the second Minots Ledge Light. The new structure stood 102 feet high and was built of interlocking iron-braced granite blocks that bonded even more tightly under wave pressure—the same principle used successfully by Smeaton at Eddystone. This lighthouse, which weighs more than 2,300 tons, was automated in 1947.

Other engineers were at work in Florida and on the Gulf Coast. Here, unmarked wholly or partially submerged sandbars, reefs and shoals caused ships to run aground. Lieutenant George G. Meade undertook to build an exposed iron-pile lighthouse on Carysfort Reef, Key Largo, in the northern Florida Keys. A lightship had been on duty there since 1825. Meade's workers drove iron piles 10 feet into the ocean floor. The eight piles were connected by braced cross members and anchored by massive iron discs for stability and resilience. The 110-foot iron skeleton, built in open water directly over the reef, represented a new era in American lighthouse construction. When the light was finished in 1852, its two platforms supported a keeper's dwelling 24 feet in diameter and the lantern, accessed by an enclosed central stairwell. The light has been unmanned since 1960, when battery-charged solar panels were installed.

The American Civil War (1861–65) provided a new impetus for lighthouse development. Existing lights on the Southeastern and Gulf Coasts had been "blacked out" by Confederate forces during the conflict, but nearly all had been restored to operation by 1868. At the same time, thousands of civil engineers became available at war's end, some of whom turned to the construction of navigational aids on locations once thought impossible. The decades between 1870 and 1890 saw major progress in building lighthouses on wave-swept locations. This period also saw a rapid increase in the nation's population and industry, and many navigational aids were needed as a result.

Foremost among the new generation of builders was Major Orlando Metcalfe Poe, who had been the chief U.S. Army engineer on General Sherman's Civil War march through Georgia to the coast. On Michigan's Cheboygan Island, in Lake Huron, Poe set out to create a tower that would protect mariners from the submerged limestone shoals at Spectacle Reef. Blocks of limestone were shipped in from Marblehead, Ohio, and a crib, or wooden

case, was towed to the rock, securely bolted by long metal rods and filled with stone to support the lighthouse foundation. Accessible only by boat, Spectacle Reef Light has a base 32 feet in diameter and 11 feet below water level. The tower's focal plane is 97 feet above the lake. Built between 1870 and 1874, the monolithic beacon still stands, 12 miles northeast of Cordwood Point. Automated in 1972, the lighthouse is now solar-powered.

Race Rock Light, near Fishers Island, New York, was also under construction during the 1870s. Francis Hopkinson Smith (1838–1915) was given the challenge of building a light on the underwater reef. He had made a name for himself constructing harbor breakwaters, and he worked at Race Rock with foreman Captain

Thomas Albertson Scott. It took seven years to lay the masonry foundation on the reef—an artificial island of stone and concrete—and build the lighthouse, which comprises a granite dwelling with a square tower attached. Visible for up to 14 miles, the 67-foot tower was equipped with a fourth-order Fresnel lens and went into service on February 21, 1879.

Another new technology that came into use on American shores during the 1870s was the caisson foundation, as seen at Duxbury Pier Light, Massachusetts (1871). First developed in England in 1845, this method of building an underwater foundation involved sinking a shell of plate iron into the sea bed, pumping in air to expel the water, then filling the caisson with concrete, sand or rocks. The process was much quicker and

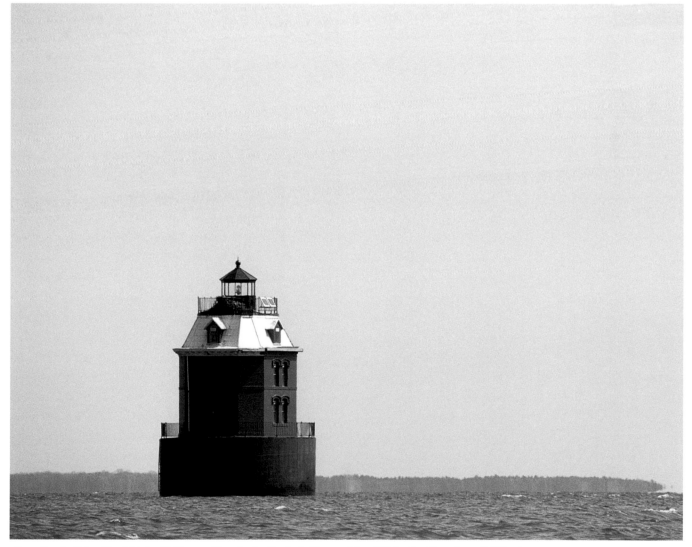

*Above:* **Sandy Point Shoal Light, Skidmore, Maryland;** *Overleaf:* **Alcatraz Island Light, San Francisco, California**

cheaper than laying underwater foundations piecemeal and more suitable for northern locations than the screw-pile lighthouses, which could not withstand the ice.

Island lighthouses have played an important role on the East Coast since about 1800. Only two of the original thirteen Colonial lights (Little Brewster's Boston Harbor and Nantucket's Brant Point) were built on small islands, because of the difficulty involved in construction and maintenance. One of the first areas in the U.S. to receive a section, or number, of island lights was the coastal waters off Connecticut and Long Island. Falkner's, Little Gull and Sands Point Islands were lit in 1802, 1806 and 1809 respectively.

Additional lights were erected on small islands between 1815 and the Civil War, when maritime commerce continued to prosper in the northeast. In 1827 Matinicus Rock, some 25 miles off the coast of Maine, received two wooden towers. Rebuilt with stone in 1848, they became the venue for one of the nation's early lighthouse heroines—Abigail Burgess—who, at the age of seventeen, first tended the lights in her father's absence when a storm raged for weeks along this isolated stretch of coast.

Mount Desert Rock Light, 26 miles from Maine's coast, was first lit in 1830. Mount Desert Rock was considered one of the most exposed (and loneliest) assignments in the Lighthouse Service. An important "making" light for sailors coming from Europe or Atlantic Canada, the first beacon here was an octagonal wooden tower adjacent to the keeper's house. In 1847 Boston architect and engineer Alexander Parris designed a new conical granite tower for the site. Automated in 1977, it remains active today under the auspices of the U.S. Coast Guard.

British Canada planned to overcome one of the most formidable obstacles on its West Coast late in the 1850s. The granite blocks for Race Rocks Light were cut in Scottish quarries and shipped 16,000 sea miles to Victoria, British Columbia. Located in the Strait of Juan de Fuca, just south of Victoria, Race Rocks had claimed many ships and the lives of hundreds of sailors. When the rusticated-granite tower went into service on Boxing Day (December 26), 1860, migration to British Columbia became considerably safer.

American engineers, too, were addressing the dangers of the Pacific Northwest coastline. This area had been frequented by many ships well before 1850—Spanish and English explorers, Russian fur traders and others. One site that was identified as needing a light during the West Coast Survey of the early 1850s was Cape Flattery, the extreme northwestern point of present-day Washington State. The point marks the entrance to the Strait of Juan de Fuca, an important shipping route for the growing lumber trade of what was then Oregon Territory. Cape Flattery Light stands on Tatoosh Island, an area sacred to the local Neah tribe. The 65-foot stone tower, rising from the keeper's dwelling, was finished in 1857. The site is subject to strong gales and the powerful surf crashing constantly at the steep cliffs of the island. Although the light is on level ground well above sea level, construction was problematic because of the difficulty gaining access to the island. Several keepers succumbed to the isolation of this site. One threw himself off the cliff, but failed in his suicide attempt, while another pair nearly fought a duel with pistols.

Island lights on the West Coast are not numerous, but some notable examples include East Brother Island and Alcatraz Island Lights, in California's Bay Area, and Anacapa Island Light, off Ventura County, California. The remote Farallon Islands Light, 26 miles west of San Francisco, was constructed in 1856 on South Farallon Island. Like Maine's Mount Desert Rock, keepers were reluctant to man this lonely outpost, especially when the so-called "Egg War" broke out. Poachers came to the islands regularly to retrieve eggs from the millions of seabirds that nested on South Farallon and its neighbors. Disputes over "gathering rights" escalated from fist fights to gunfights before California lawmen finally intervened to end the fracas.

Construction of lighthouses on reefs, underwater hazards and previously inaccessible islands came to the fore during the nineteenth century. Taking the lessons learned by European engineers—and sometimes improving upon them—American and Canadian engineers erected marvels of architectural and engineering accomplishment in these most challenging, remote locations.

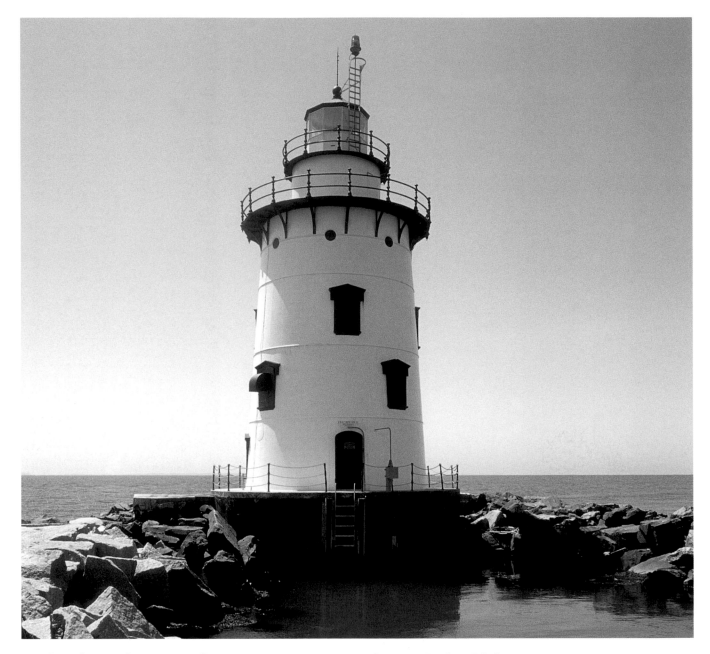

**Saybrook Breakwater Light** *Above*

*Old Saybrook, Connecticut*

Known to locals as the "Outer Light," this breakwater light is a veritable fortress—50 feet of cast iron. Its strength was proved when it withstood the ferocious hurricane of 1938. First lighted in 1886, the lighthouse is a Connecticut landmark and appears on many of the state's license plates. Prior to its construction, Lynde Point Light, known as the "Inner Light," had been the sole guardian of the Connecticut River's point of entry into the Atlantic. Automated in 1959, Saybrook Breakwater Light is an active aid to navigation.

**Greens Ledge Light** *Opposite*

*Norwalk, Connecticut*

This sturdy cast-iron tower, painted red-brown and white as a daymark, was completed in 1902 at the outer end of a mile-long ledge jutting into Long Island Sound across the entrance to the channel into Norwalk Harbor. Located slightly west of historic Sheffield Island Light (1826 and 1868, deactivated in 1902), Greens Ledge still flashes its alternating red-and-white signal for commercial lobster boats and leisure crafts. Now equipped with a modern 190mm optic, the 52-foot beacon was automated in 1972.

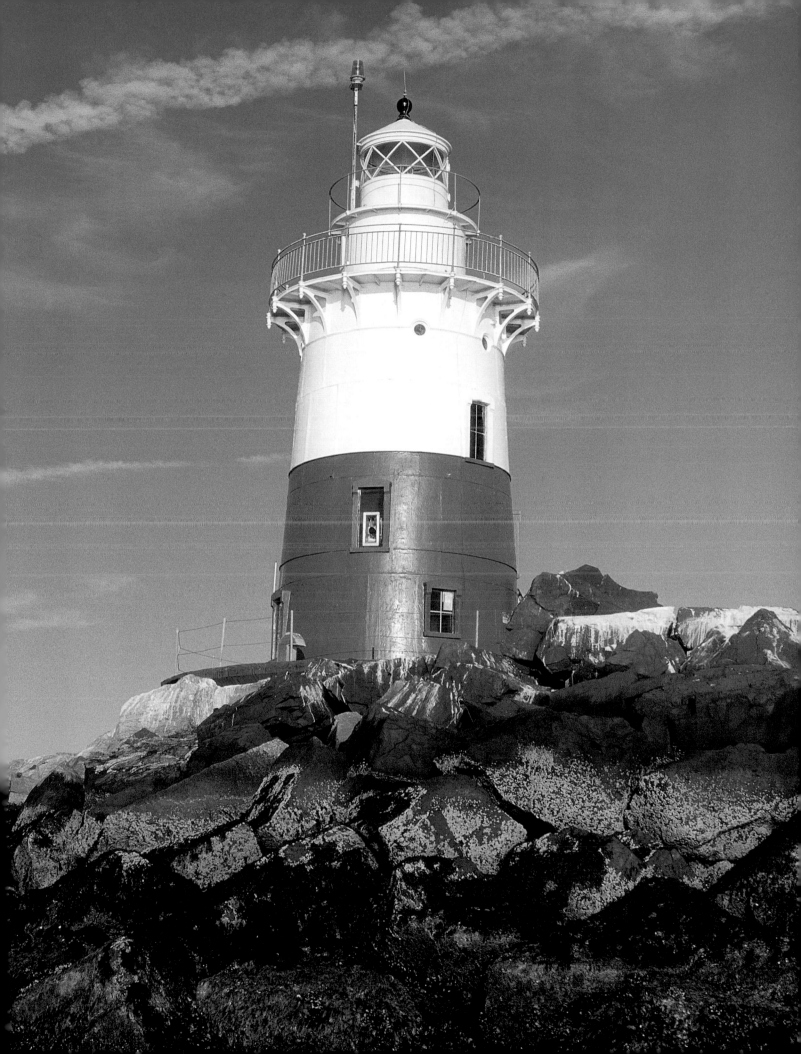

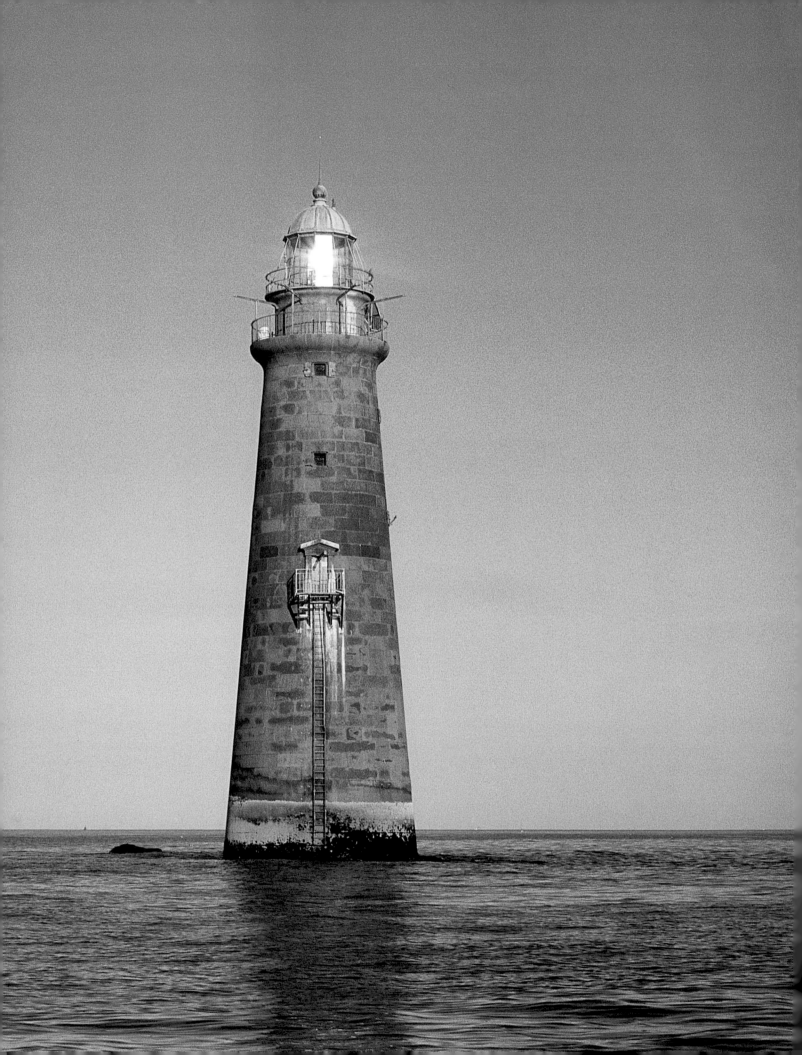

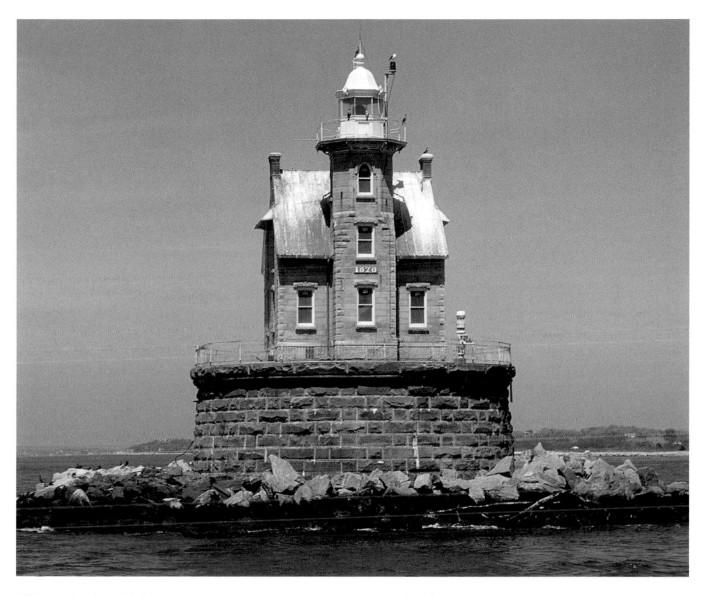

## Minots Ledge Light *Opposite*

*Cohasset, Massachusetts*

Many ships were wrecked on this ledge before 1850, when the first lighthouse was constructed on the shoal. Built on pilings in the open-leg style, the iron skeleton tower was swept away in a fierce gale less than a year later. Engineers pored over plans for a new light and resolved upon this 97-foot tower of 1,079 interlocking granite blocks, completed in 1860. The result is one of the most remarkable wave-swept lighthouses in North America—its massive walls are actually strengthened by the pressure of storm-driven waves. Minots Ledge Light's unique flashing sequence earned it the nickname "Lover's Light," from locals who read the 1–4–3 light sequence as "I Love You."

## Race Rock Light *Above*

*Fishers Island, New York*

Race Rock Light is one of the continent's best known. Located just off Fishers Island, New York, Race Rock Light guards sailors from a reef that claimed at least 100 ships during the nineteenth century. Built between 1871 and 1878, it was designed by Francis Hopkinson Smith, who later engineered the foundation for the Statue of Liberty. Construction was particularly challenging because of the powerful currents around this part of the Long Island shore. A manmade island of stone and concrete was created on the submerged shoal to accommodate the granite tower/dwelling. Its flashing red signal, 67 feet above sea level, still warns fishing vessels and pleasure boaters of this dangerous shoal today.

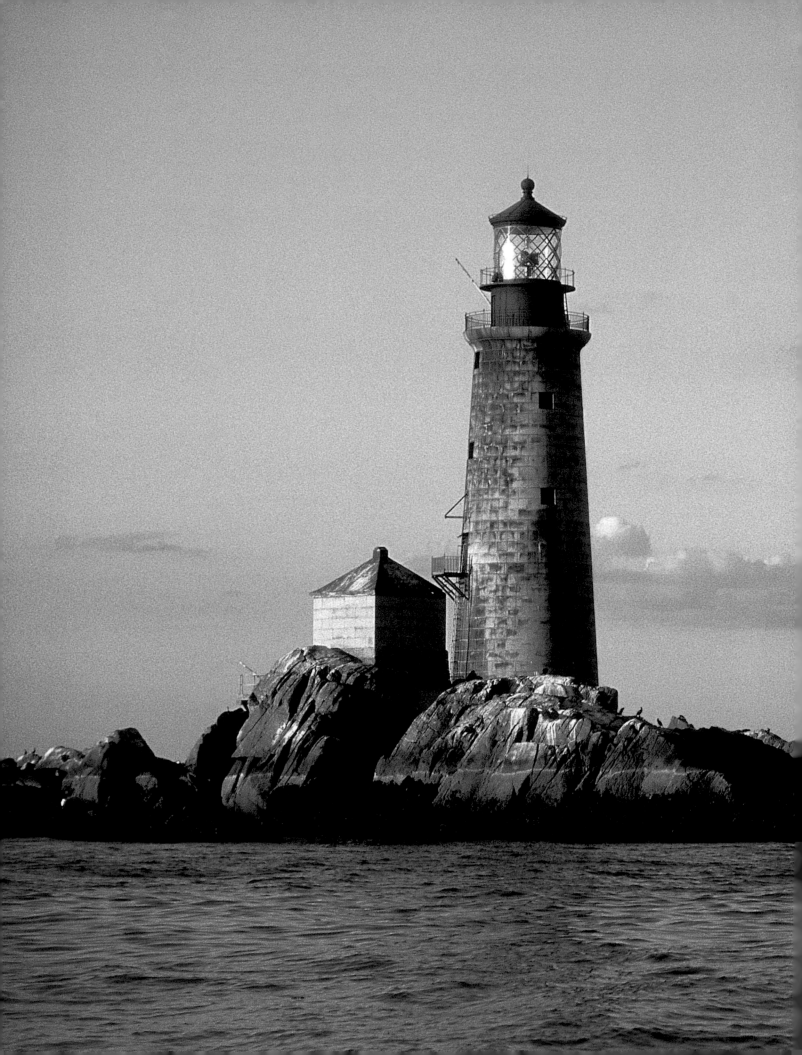

**Graves Ledge Light** *Previous pages*

*Boston Harbor, Massachusetts*

Boston Harbor Light was first built in 1716, and the short-lived skeleton tower at Minots Ledge was completed in 1850. Even after its replacement in 1860, this rocky coast remained a dangerous area, and in 1905, Graves Ledge Light was lit for the first time to guide ships entering the Broad Sound Channel. Named for Thomas Graves, an important merchant of colonial Massachusetts, the 113-foot tower of granite housed a first-order Fresnel lens. The station was automated in the Bicentennial Year 1976, which saw the Tall Ships sail majestically into Boston Harbor. Its original 12-foot Fresnel lens is now at the Smithsonian Institution.

**New London Ledge Light** *Below*

*New London, Connecticut*

New London Ledge Light rises midway through the channel where the Thames River enters the Long Island Sound. Built in the Second French Empire style on a monumental concrete platform secured on underwater foundations like at Race Rock, this lighthouse was designed to augment nearby New London Harbor Light. New London Ledge is rich in lore: Reportedly, one its keepers, nicknamed "Ernie," committed suicide here after his wife ran away with the captain of the Block Island Ferry. Legend has it that his ghost still haunts the station where he leaped to his death. Completed in 1909, the beacon was automated in 1987.

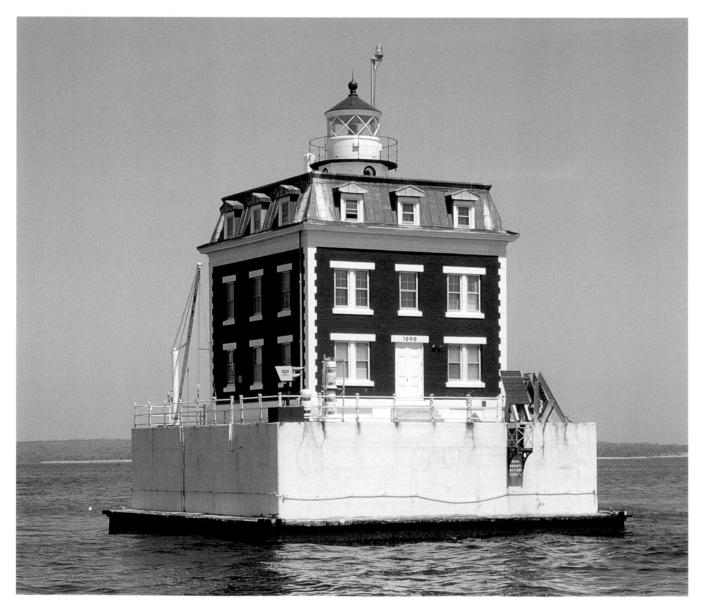

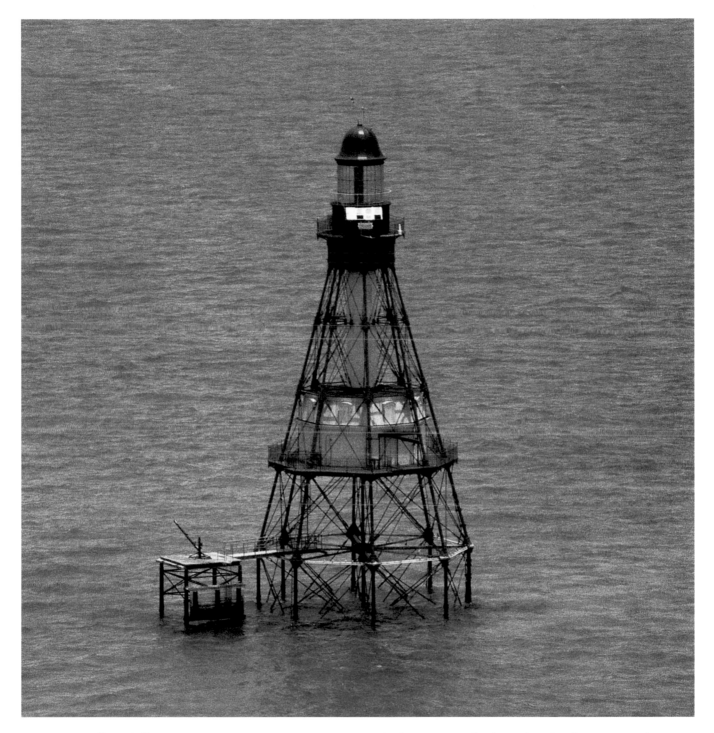

**Fowey Rocks Light** *Above*

*Key Biscayne, Florida*

This screwpile reef light, first lighted on June 15, 1878, was a model for many later beacons along the Florida coast. It superseded the state's first lighthouse, Cape Florida, which commanded the south end of scenic Key Biscayne from 1825. Fowey Rocks Light was named for the British frigate H.M.S. *Fowey*, which was wrecked on the shoal in 1748. The 110-foot tower was constructed on the northernmost offshore reef at a cost of $163,000, using recently developed exposed screwpile technology to anchor the steel legs into the ocean floor. Now automated, the light's first-order Fresnel lens is on permanent display at the U.S. Coast Guard's National Aids to Navigation School in Yorktown, Virginia.

## Rose Island Light *Below*

*Newport, Rhode Island*

Built in 1869, this 35-foot tower rises from a mansard-roofed keeper's dwelling in the Second French Empire style of the day. Equipped with a sixth-order Fresnel lens, it helped to guide vessels through the east passage of Narragansett Bay and those entering Newport Harbor until 1971, when the Coast Guard closed the station upon completion of the Newport Bridge. The Rose Island Lighthouse Foundation assumed control of the light in 1985 and restored the old station in conjunction with the City of Newport. The light station is now a private aid to navigation. Across the bay from the 16-acre island is the Ida Lewis Yacht Club, built on the site of Lime Rock Lighthouse, which was tended by America's lighthouse heroine Ida Lewis.

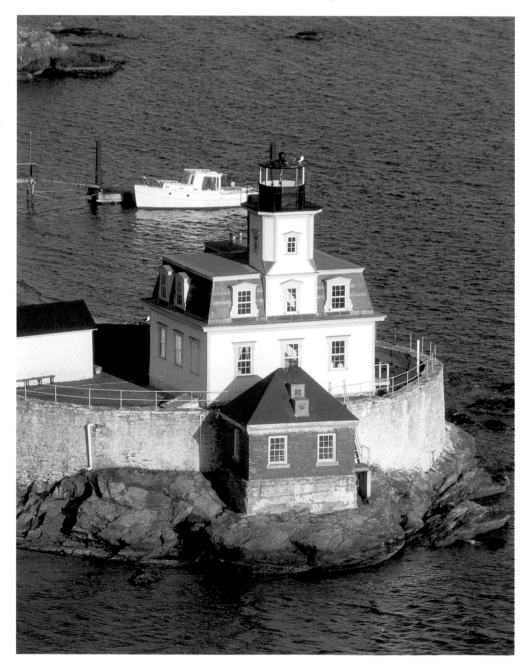

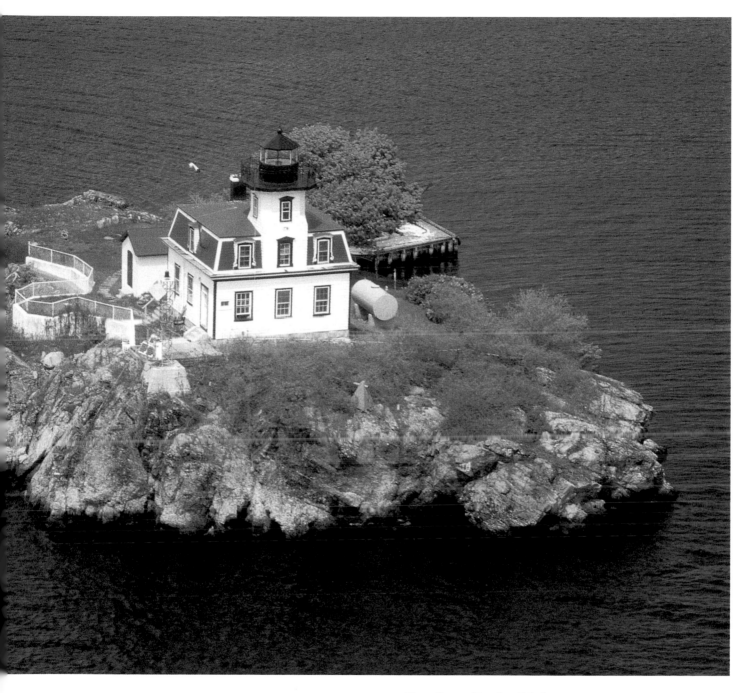

**Pomham Rocks Light** *Above*

*East Providence, Rhode Island*

First lighted on December 1, 1871, this picturesque French Empire dwelling with frontal tower, fencing and outbuildings marked the main shipping channel for the busy port of Providence. Named for the Narragansett chief Pomham, it housed a sixth-order Fresnel lens until 1939, when it was replaced with a fourth-order lens. The station was deactivated in 1974.

**Orient Point Light** *Above*

*Long Island, New York*

An example of the "coffeepot" style or sparkplug light-house, Orient Point is a cast-iron cylinder only 21 feet in diameter at the base and 64 feet high. It was built on the end of the North Fork in 1899 to warn sailors away from Oyster Pond Reef, one the most feared obstacles off the coast of Long Island. Buttressed by hundreds of tons of broken rock, it was manned by Norwegian immigrant N.A. Anderson for twenty years. Automated in 1966, the station emits a white flash every 5 seconds that can be seen 17 miles at sea.

**Southwest Ledge Light** *Below*

*New Haven, Connecticut*

Also referred to as New Haven Breakwater Light, Southwest Ledge Light was constructed in Baltimore and exhibited at the 1876 Centennial Exposition in Philadelphia before being shipped to New Haven, where it was emplaced in 1877. Marking the tip of New Haven's eastern breakwater, the 45-foot cast-iron cylinder was automated in 1973. Visitors can contrast its modest appearance with that of the elegant tower of nearby Five Mile Point Lighthouse, built in 1840 and decommissioned in 1877.

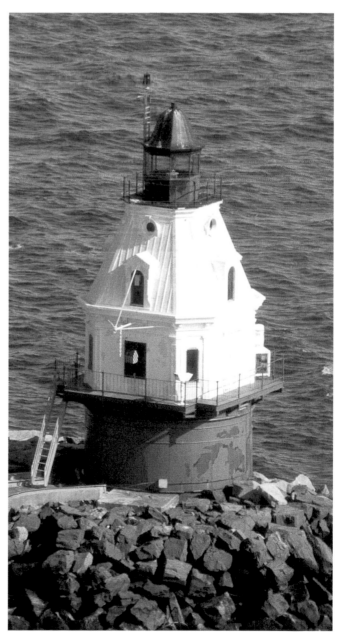

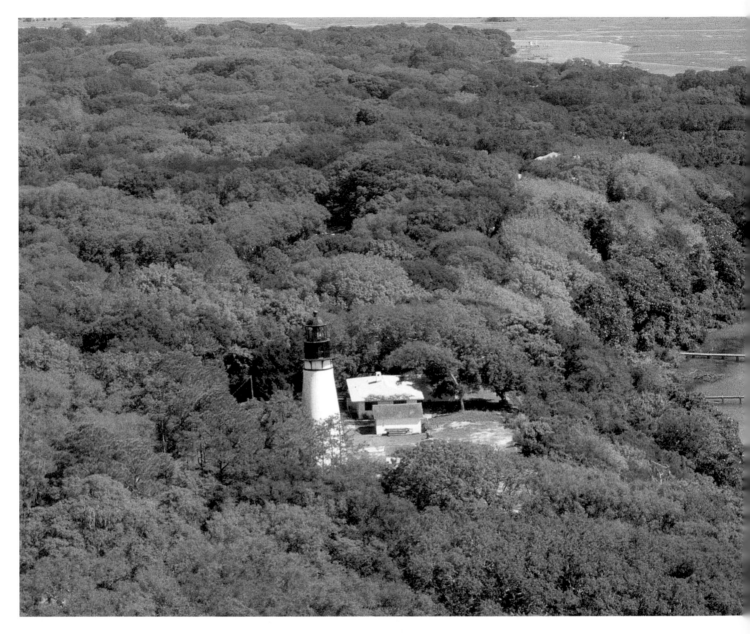

**Amelia Island Light** *Above*

*Fernandina Beach, Florida*

Florida's most northerly lighthouse, this 64-foot white tower stands 107 feet above sea level on Amelia Island, near the mouth of the St. Marys River, the peninsular state's border with Georgia. It was built in 1838 from the discontinued Cumberland Island Light at a cost of $17,000. During the Civil War the light was extinguished. It was renovated in Victorian style in 1885. Automated in 1956, the tower is equipped with a third-order Fresnel lens, whose white light, visible for 19 miles at sea, still guides ships through Nassau Sound. The former keeper's dwelling now houses U.S. Coast Guard personnel.

**Old Charleston (Morris Island) Light** *Opposite*

*Charleston, South Carolina*

The present Old Charleston lighthouse was built in 1876, but two others, dating from 1767 and 1837, occupied this site before it. The first lighthouse was one of two south of Delaware Bay after the Revolutionary War (the other was on Tybee Island, Georgia). Erosion claimed first the keeper's dwelling and then the entire island: Old Charleston Light is now surrounded by water. It survived a massive earthquake in 1885, probably because it rests on piles sunk up to 50 feet to support a timber and concrete foundation. Deactivated in 1962, the light is now in private hands.

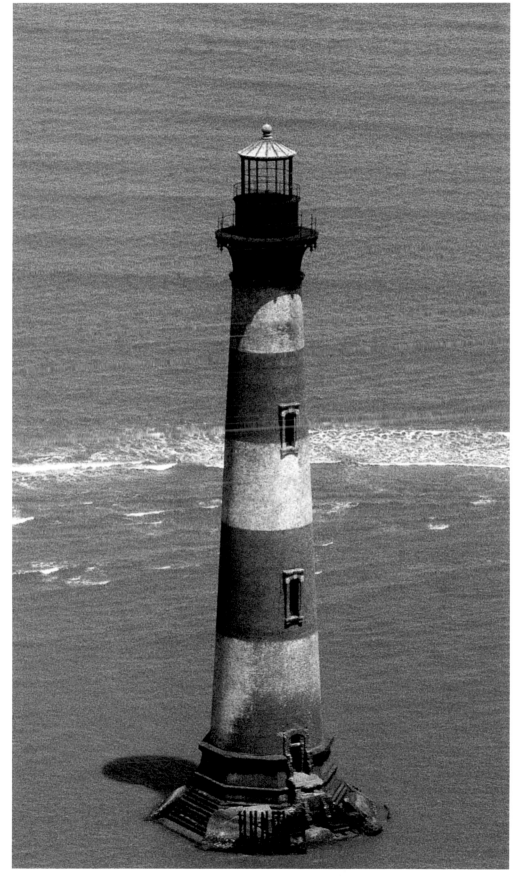

**Isle Madame Lighthouse** *Right*

*Cape Breton Island, Nova Scotia*

Located off the southern tip of Cape Breton Island, Isle Madame is surrounded by Lennox Passage to the north, Chedabucto Bay to the southwest, the Strait of Canso—separating Cape Breton Island from the rest of Nova Scotia—to the west, and the Atlantic Ocean to the east. The simple light station consists of a white-painted two-story keeper's dwelling with the lens system protruding from its roof. Before the lighthouse was automated, keepers lived a lonely existence on this rugged outcropping, which was named for Madame de Maintenon, the second wife of France's King Louis XIV.

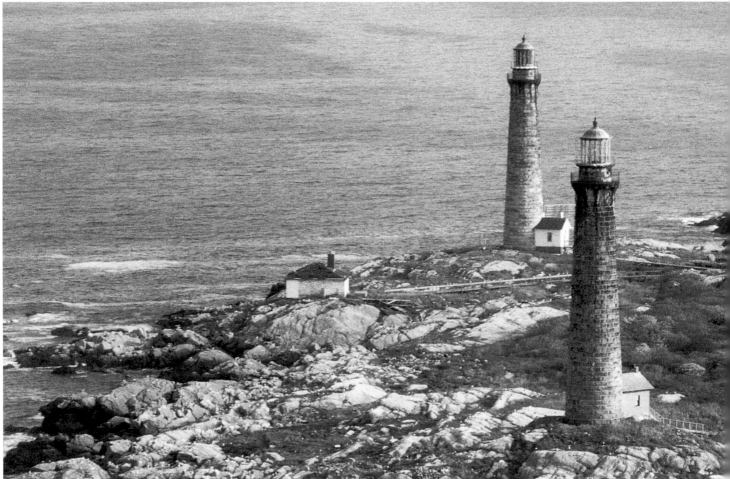

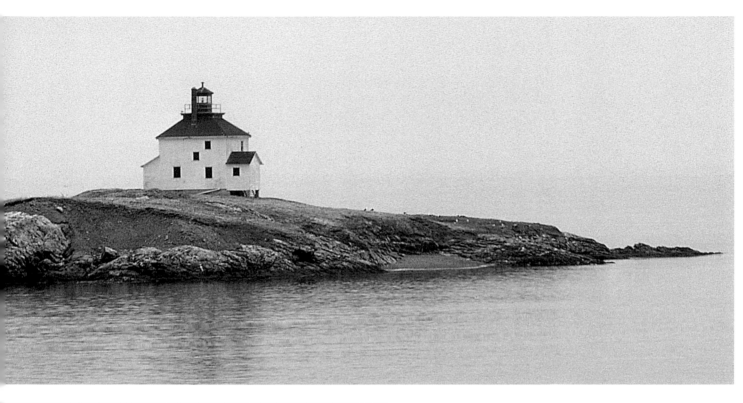

**Cape Ann Twin Lights** *Left*

*Thatcher Island, Rockport, Massachusetts*

Gloucester and Rockport, Massachusetts, were already important fishing centers in 1771, when the first set of twin lights was built on Thatcher Island. The 124-foot towers that stand today were erected in 1861, the year the Civil War began. In 1919 they may have saved the life of American president Woodrow Wilson and fellow passengers, whose fog-blinded ship, the *George Washington*, was returning from Europe after the Versailles peace conference that ended World War I. Cape Ann's nautical tradition was enhanced by the British writer Rudyard Kipling, who wrote *Captains Courageous* about the region's fishermen.

**Hockamock Head (Burnt Coat) Light** *Right*

*Swans Island, Maine*

Built in 1872 to mark the entrance to Maine's Burnt Coat Harbor, the Hockamock Head Lighthouse stands 75 feet above sea level on the southern tip of Swans Island. When the island was purchased by its namesake, Colonel James Swan, in 1784, lumbering was the main industry. Today the picturesque site is home to a thriving fishing community. The 32-foot light, a simple square-shaped structure, was originally connected to the keeper's house by a covered walkway. Automated in 1975, the beacon is equipped with a 250mm lens.

**Race Rocks Light** *Overleaf*

*Victoria, British Columbia*

One of the famous "Imperial Towers" built by the British-Canadian government during the nineteenth century, Race Rocks Light stands in the Strait of Juan de Fuca, just south of the entrance to Victoria Harbour, on Vancouver Island. The lighthouse was designed in Britain, and its granite blocks were quarried and cut to size in Scotland and shipped 16,000 sea miles to Victoria. When the 105-foot light went into operation on December 26, 1860, it curtailed the many shipwrecks that had occurred on these reefs, which lie directly in the path of ships approaching Victoria. The treacherous, rocky strait is also prone to impenetrable fog, and a series of fog horns were mounted on a nearby tower to further improve safety in the area.

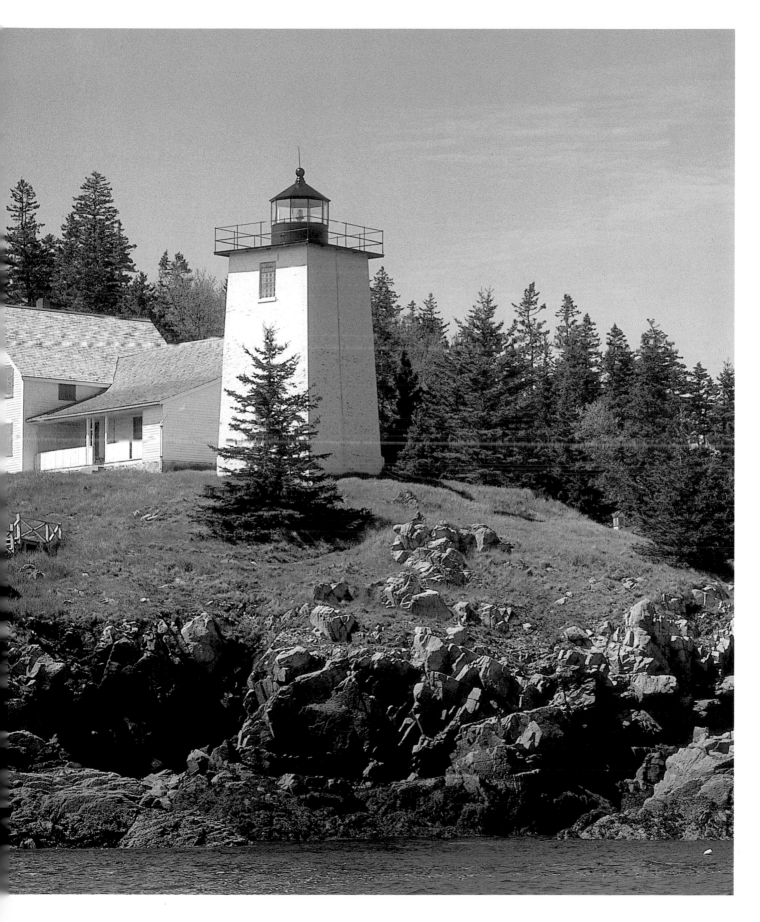

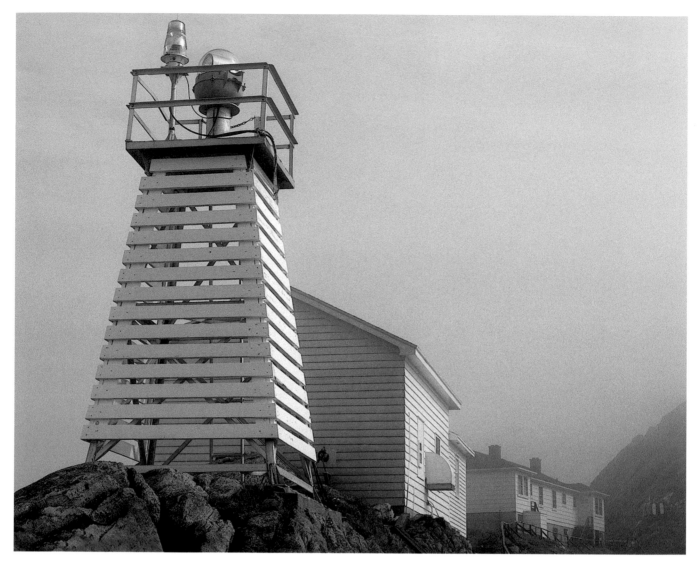

**Baccalieu Island Light** *Above*

*Newfoundland*

Typical of Newfoundland's coastline, the terrain on Baccalieu Island is rugged and includes precipitous cliffs rising more than 450 feet above sea level. Two lightkeepers, along with their dog, maintain the lonely beacon on this otherwise uninhabited island, which is now an ecological reserve. Located just north of the Avalon Peninsula, Baccalieu Island boasts the most numerous and diverse colony of seabirds in eastern North America. More than 3 million breeding pairs of Leach's Storm-Petrel and 45,000 pairs of Atlantic Puffins nest on the four-square-mile island.

**Anacapa Island Light** *Opposite*

*Channel Islands National Park, California*

Anacapa Island is one of three islets—the peaks of a mountain range that sank beneath the sea thousands of years ago. Located 11 miles off the coast of Ventura County on the southernmost of the three islands, the light was first built in 1912 as a steel tower, which was replaced in 1932 by this cylindrical masonry tower 277 feet above the sea. At that time, a fog horn was added. No keepers live on the island today: It was once populated mainly by rabbits introduced by the U.S. Navy during World War II to ensure a reserve food supply. The light was recently renovated at a cost of $350,000.

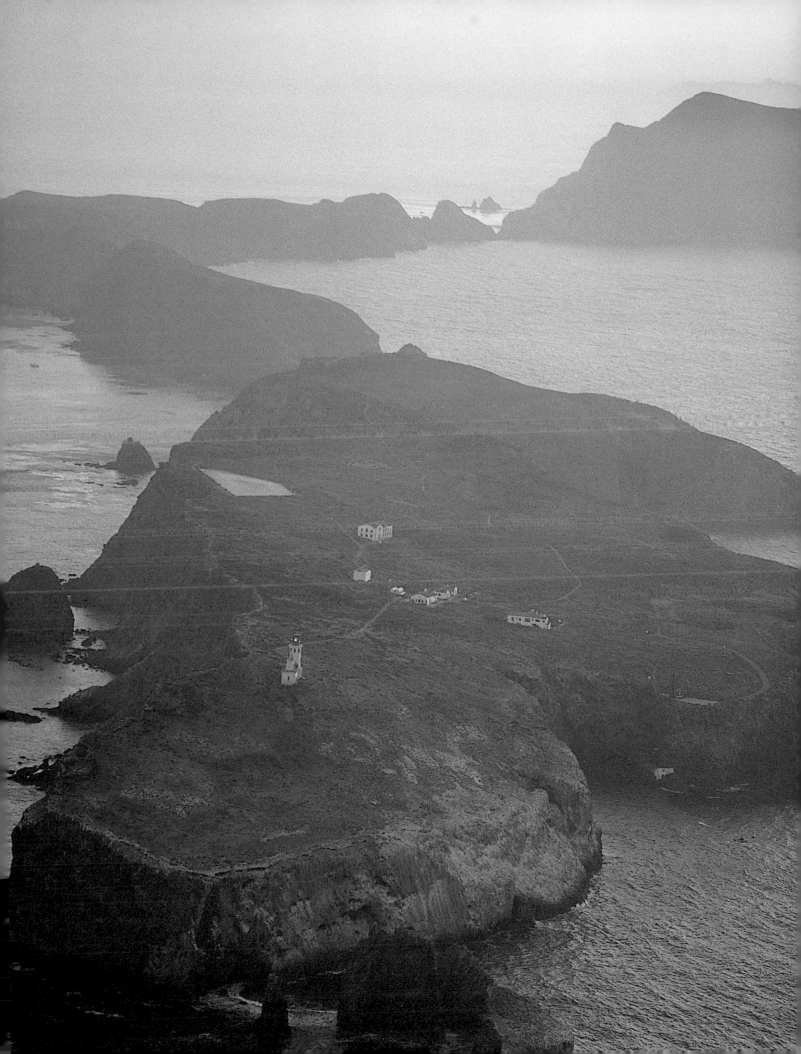

**East Brother Island Light** *Above*

*Richmond, California*

Built in 1874, East Brother Island Light marks the channel through the narrow, often fog-bound, San Pablo Straits connecting the Sacramento River estuary with San Francisco Bay. Construction here was difficult: Laborers had to dynamite most of the island to level the site. The square light tower is attached to a Stick-style dwelling, which has been modernized over the years. The lighthouse was automated in 1969, and the station and its outbuildings were restored to their original condition for use as a bed-and-breakfast inn.

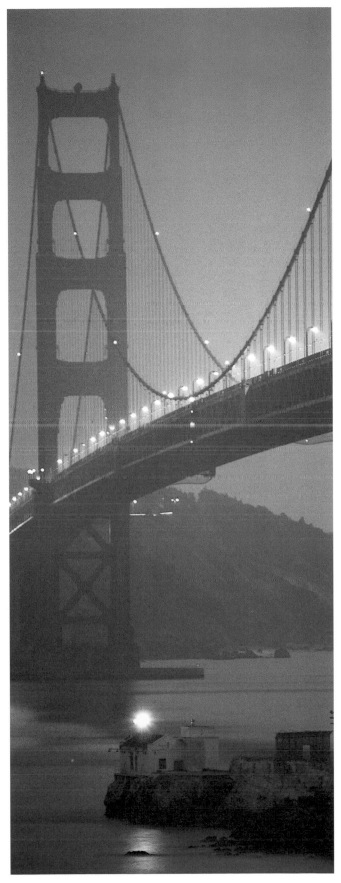

## Lime Point Light *Right*

*San Francisco, California*

Lime Point Light is situated below the Golden Gate Bridge on the north side of the strait. It began as a fog-signal station in 1883; the present light tower was built seventeen years later. Automated in 1961, the 20-foot concrete tower is still an active aid to navigation. Most travelers are more familiar with the discontinued Fort Point Light, which stands under the bridge on the San Francisco side, and with the still-operational lighthouse on nearby Alcatraz Island.

# Lake and River Beacons

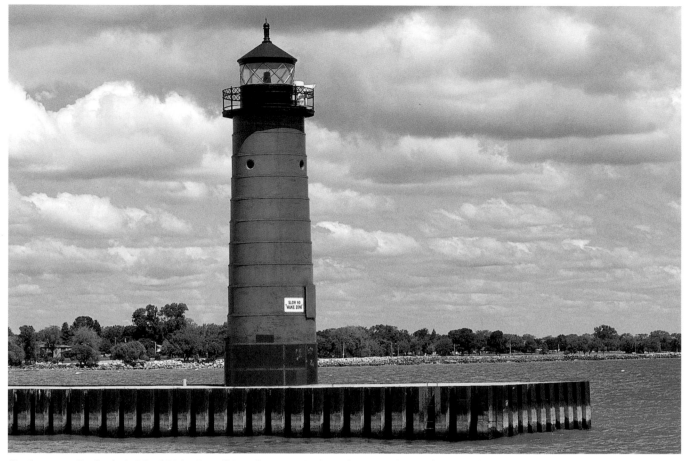

*Previous pages:* Boularderie Island Light, Bras d'Or Lake, Nova Scotia; *Above:* Kenosha North Pier Light, Kenosha, Wisconsin

avigation on North America's inland waterways has been important since the seventeenth century, when colonial settlers transported passengers and cargo along the Hudson and St. Lawrence Rivers, building thriving new towns along their banks.

As early as 1797, navigational improvements were made along the Hudson River, because of the volume of commercial traffic, which was steadily increasing with population growth. Whaling vessels, lumber, grain and all manner of cargo was transported by barge between the growing Hudson Valley towns. During the nineteenth century, traffic burgeoned with the opening of the Erie, Delaware and Hudson, and Champlain Canals, which linked the river with the Great Lakes. The canals were upgraded under the New York State Barge Canal project, completed in 1918, to accommodate container barges up to 300 feet long and 43 feet wide with a draft of up to 12 feet. Ocean-going vessels were constantly plying the waterway, and they required the protection of navigational aids at trouble spots.

The first lighthouse on the Hudson was the Stony Point Lighthouse, built in 1826. Another five were in service by the end of the 1830s, including those at Saugerties and Upper Kinderhook, south of Albany. By century's end there were eleven (perhaps the most famous of which, Jeffrey's Hook, was illuminated for only eleven years, but still serves as a daymark).

Burlington, Vermont, on the shores of Lake Champlain, became a busy port after the opening of the new canals: It was now within easy reach of the Great Lakes ports and New York City. Traffic entering Burlington's harbor was threatened by a reef off nearby Colchester Point, and in 1871 a lighthouse with keeper's dwelling was constructed on a massive granite pier over the reef. The four-bedroom dwelling eventually served eleven successive lighthouse keepers and their families. The light remained in use until 1933.

The St. Lawrence Seaway connects the Atlantic Ocean with the Great Lakes ports and has a total length of over 2,500 miles, from the Gulf of St. Lawrence to the St. Louis River, west of Duluth, Minnesota, the westernmost point of the Great Lakes. Only 740 miles of this route is the St. Lawrence River proper, between the eastern end of Lake Ontario and the Gulf. The Seaway is navigable for ten months of the year: In winter, parts of it are icebound. Around 60 percent of the Seaway's traffic carries goods between North America and overseas ports, via seven locks, and with the aid of many lighthouses and other aids to navigation.

For several centuries before the 1959 improvements in locks and maintenance were completed for the Seaway, this was one of the world's busiest inland waterways. Traders used the river soon after its earliest explorations by Jacques Cartier in the 1530s. Over time, westward population migration into the Great Lakes region increased the prominence of the river as a trading route. Traffic from the Canadian provinces of Quebec and Ontario and the American states of Illinois, Michigan, Minnesota, Indiana, Wisconsin, Ohio, New York and Pennsylvania are all connected to the Atlantic Ocean via this waterway—hence its enormous volume of commercial activity.

Lighthouses on the St. Lawrence River include Tibbett's Point Lighthouse (first built in 1854) at Cape Vincent, New York, the entrance to Lake Ontario; and Rock Island and Sunken Rock Lights, both built in the 1880s. Many more lighthouses line the shores of the Great Lakes themselves.

By about 1800, Americans had crossed the Allegheny and Appalachian Mountains and were making their way into the broad lowland expanse of the Ohio and Mississippi River Valleys. In 1807 Robert Fulton demonstrated the possibility of steamboat travel with his famous Hudson River trip on the *Clermont* from New York City to Albany and back. The question was, could that feat be duplicated on the many transmontane waterways drained by the Mississippi?

One answer came in the form of the steamboat *New Orleans*, financed by Fulton and Robert Livingston and built in Pittsburgh, Pennsylvania. The 371-ton vessel made her maiden voyage in November 1811 and reached New Orleans in January 1812, having survived the worst earthquake in recorded North American history—at New Madrid, Missouri, on December 16, 1811.

By the 1820s, steamboats were replacing flat-bottomed boats and keelboats on the inland waterways, from Louisville, Kentucky, and Cairo, Illinois, to St. Louis and New Orleans. However, as the pressure to meet timetables and delivery schedules increased, steamboats began to travel by night, leading to a rash of accidents. Between 1825 and 1850, 1,400 people were killed on the Western rivers in steamboat explosions. The Civil War increased steamboat traffic, and on April 27, 1865, the *Sultana* exploded just above Memphis, Tennessee, killing 1,647 persons, most of them Union soldiers returning home from Confederate prisons at war's end. It was the nation's worst maritime disaster to date.

On June 23, 1874, the U.S. Congress authorized expanding the jurisdiction of the Lighthouse Board to the Western rivers. Two new lighthouse districts were created: the Fourteenth, which encompassed the Ohio and Mississippi Rivers between Pittsburgh and New Orleans; and the Fifteenth, comprising both the Mississippi from St. Paul, Minnesota, to Cairo, Illinois, and the Missouri River from Kansas City to its mouth. The act provided for "establishment of such beacon-lights, day-beacons and buoys as may be necessary for the use of vessels navigating these streams."

From the start, it was clear that these would not be lighthouses on the scale of open-water beacons, but sporadic warning lights emplaced at riverbends, sandbars and snags that had proved hazardous to steamboats. Known to local people as post lights, they consisted of a 14-inch hand lantern enclosed in a square or triangular tin case with plain glazed sides. These lamps burned kerosene and usually emitted a fixed white light, although some had red globes or shades. The more sophisticated post lights had braces and steps to the lantern. In some areas, they were attached to trees.

The first river lights designed and maintained by the U.S. Lighthouse Board, as opposed to private enterprise, were those at Jefferson Barracks, near St. Louis, and at Twin Hollows, Missouri, both placed in 1874. The Mississippi River was also lit at the dike below

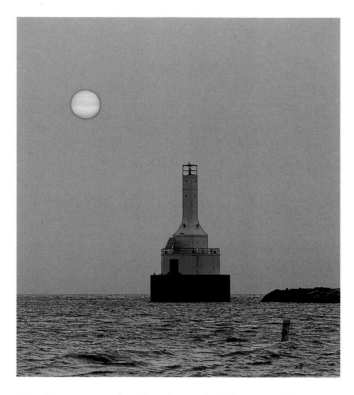

The Lighthouse Board continued its work into the twentieth century, and by 1915 there were 1,798 lights and 861 buoys marking 4,226 miles of the Mississippi and Ohio Rivers and their tributaries. Many new post lights indicated crossings and bends in the river channels. These simple lights consisted of either a flat wick lamp in a small pressed-glass lens, or an ordinary hand lantern enclosed in a triangular tin case with glass sides. Set on posts along the river banks, they had large painted wings to make them daymarks as well.

This ingenious system had a rather makeshift appearance, and so did the arrangements with its keepers. Since the lights required minimal maintenance, people living in the vicinity were paid a small wage to keep them supplied with oil. The system resembled that used by the Dutch to maintain their dikes. Later in the twentieth century, battery-powered blinkers 20 feet tall were installed. They are serviced by a number of Coast Guard tenders, including seven in the area between Cairo and New Orleans. One of them, the *Chena,* tends to 175 channel buoys and 101 lights.

The rapid lighting of these major rivers came too late for the steamboat, whose day had largely passed by the turn of the century. Steamboat pilots had their heyday between 1820 and 1880, when there were few aids to navigation. By the time they were in place, the railroads had become paramount in transportation.

Late in life, Mark Twain looked back on his experience as a pilot and reflected: "No, there's nothing known to man like piloting on the Mississippi River….I was not much better than a half-baked amateur at it, but the memory of its raptures [has] never left my finger ends. To this day, I had rather take a good steamboat through Coon Slough than hold any other job I ever heard of. By comparison, to be king of England must be like washing dishes."

River lights increased rapidly, too, in other parts of the country, and by the start of World War I, the Klamath, Platte, Rio Grande, Brazos, St. Johns and Columbia Rivers had numerous navigational aids. Lights were also erected along the 2,000-mile Intracoastal Waterway, a navigable route consisting of a series of canals, rivers, bays, lagoons and sounds connecting ports between Boston and Key West, and Gulf Coast ports.

Des Peres, completed at the end of that year. Between St. Louis and Cairo, the lanterns were fueled by mineral oil. Riverboat pilots considered this 180-mile stretch the worst on the river: Sunken rocks and submerged islands wrecked so many vessels that the area around Cairo was known (inevitably) as the Graveyard. In *Life on the Mississippi,* Mark Twain (Samuel Clemens) reported that one Illinois farmer claimed: "Twenty-nine steamboats had left their bones strung along within sight from his house." The great American humorist had worked on the river as a pilot himself, and derived his pen name from a phrase used in depth soundings. "Mark Twain" indicated a depth of two fathoms.

Congress changed the boundaries of the river districts in 1876, and in 1887 it created a Sixteenth Lighthouse district because of the growing number of light stations. By 1890 there were 359 Mississippi beacon lights, or buoys, between St. Paul, Minnesota, and Cairo, Illinois, and another 320 from Cairo to New Orleans. More than 450 lights marked the Ohio River, the best-lit waterway in the nation. Other tributaries of the Mississippi included: the Missouri River, 27; Illinois River, 37; Tennessee River, 37; Kanawha River, 27; and the Red River, 7. In short, 1,276 lights had been installed along the Western rivers within six years.

The long-standing problem of navigating the mouth of the Mississippi River became acute as ship traffic increased. The river's current carried logs, sand, debris and silt to pile up at or near the mouth of the river, which was known as the Great Muddy for its quantity of alluvial soil. To complicate matters, there were four passes through the river delta to the Gulf (Northeast, Pass *à l'Outre*, Southwest and South Passes), all of which reconfigured themselves from year to year, making navigation not only hazardous, but sometimes impossible.

The first efforts to light the area came after the United States acquired Louisiana from the French in 1803. Benjamin Latrobe, architect of the U.S. Capitol, designed Franks Island Light, built by Winslow Lewis in 1818. It succumbed to the pressure of mud almost at once, but its replacement, finished in 1823, still stands, although its foundation has sunk 20 feet into the subsoil. The river's ever-changing flow began to favor the Pass *à l'Outre*, and a lighthouse was built there in 1856. The 82-foot iron tower guided shipping until 1930, when the channel became nearly impassable due to sedimentation. Other lighthouses at the river mouth marked the

South Pass (1832), the Southwest Pass (1836) and the Head of Passes (1836). All these towers remain.

In 1874 Congress debated the relative merits of building a cutoff pass or jetties at the mouth of the Mississippi. The latter solution was favored, and between 1875 and 1879, James Buchanan Eads (1820–87), who had designed Eads Bridge over the Mississippi at St. Louis, built a series of jetties to contain the silt and sandbars that had wrecked so many ships. The acid test of his system came in 1883, when the British cable ship *Silvertown* left New Orleans with the heaviest cargo ever loaded there. Totaling 5,020 tons, and drawing 25 feet and 4 inches, the *Silvertown* made her way safely through the delta into the Gulf.

Both Americans and Canadians in the Great Lakes region needed protection for vessels carrying passengers and goods between ports. After the United States and British Canada negotiated the Rush-Bagot Agreement in 1817, many new lighthouses were built. Among the first on Lake Erie were those at Presque Isle (later Erie, Pennsylvania), and Buffalo, both built in 1818. Buffalo's original light was replaced in 1833, and a third was built at the end of a 1,000-foot-long

*Opposite:* **Keweenaw Waterway Upper Entrance Light, Keweenaw Waterway, Michigan;** *Above:* **Umpqua River Light, Winchester Bay, Oregon**

7 steamships, 1 tugboat, 8 barks, 4 brigs, 56 schooners, 18 scows and 3 barges—a total of 97 vessels. U.S. government records show that 5,999 vessels were wrecked between 1878 and 1898, and of these, as many as 1,093 were deemed unsalvageable.

Of necessity, shipping declines during the winter months, when the Lakes are often icebound. Keepers of the lights were once removed from their stations by December 15, leaving behind enough kerosene to light the lamps for two more weeks. The problems faced by lighthouse engineers here differed from those of coastal builders in American waters because of the danger posed by ice. Most major Great Lakes lighthouses were built after the 1850s, when the crib and caisson styles of lighthouse building had been perfected.

As mentioned earlier, several feats of construction had enabled greater mobility on the Lakes. Irish-Americans newly arrived from their homeland were instrumental in building the great Erie Canal between 1817 and 1825, and British Canadians finished the Welland-Niagara Canal, between Lakes Ontario and Erie, in 1829. Together, these manmade waterways connected New York City, Montreal and several other ports to the Lakes and were crucial to the land and timber booms that followed.

Some of the most important port city lights were built before the Civil War. Chicago's first light, known as the "old light tower in the town," was built on the south bend of the Chicago River in 1832. Located on Lake Michigan, Chicago would become one of the great inland ports and harbors before the turn of the twentieth century. The great fire of 1871 devastated the port facilities, but reconstruction was rapid and efficient. The present active lighthouse here, built in 1893, is a 48-foot brick-and-steel tower that was moved to the end of the harbor breakwater. The tower houses a fine third-order Fresnel lens that had been displayed at Chicago's World's Columbian Exposition in 1893.

An enormous volume of ship traffic passes through the Detroit River, Lake St. Clair and the St. Clair River, which comprise one of the major waterways in North America, linking Lakes Erie and Huron. Detroit received its first light in 1837 at the outlet of Lake St. Clair; a second was placed at the mouth of the Detroit

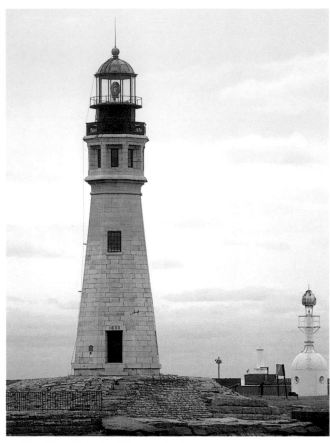

**Buffalo Main Light, Buffalo, New York**

breakwater in 1872. The oldest lighthouse still in operation on the Lakes is Marblehead Light, at Sandusky, Ohio, built in 1821. The 65-foot stone tower still flashes its green light over Lake Erie.

Ship captains on the five Great Lakes had to be their own aerologists, as these freshwater "seas" at the heart of the continent lie in the path of cyclonic storm systems. Thousands of miles of flat prairies and plains border the Great Lakes, and polar-chilled fronts from the north often collide with warmer, moister winds from the south. The result: unpredictable gales, blizzards, fog banks and thunderstorms. Winter temperatures on the eastern side of Lake Michigan can be 20 to 30 degrees higher than those on the western (Wisconsin) shore. A ship leaving Buffalo, New York, on a clear summer day may have to put in at Erie a few hours later to evade a storm or fog system.

During the last 150 years, records have been kept of the major storms that buffet the Lakes region. A four-day hurricane in 1869 caused the destruction of

River a year later. The Detroit River Lighthouse rises from 22 feet of water near the channel in the mouth of the river. Completed in 1885, it has a wooden crib foundation filled with concrete.

Ohio's Toledo Harbor Light (1904), on Lake Erie, is one of the most remarkable of its type. Architecturally, it is a unique blend of Romanesque arches and Russian-Orthodox-style rooflines. Structurally, the light is anchored solidly to its stone-and-concrete foundation.

The first Canadian lighthouse on the Lakes was at the mouth of the Niagara River on Lake Ontario, built in 1804. Next came Gibraltar Point Light, built on the island that forms the harbor of Toronto. Canadian beacons on other Lakes include Long Point tower, on Lake Erie, 1830; Goderich Light, on Lake Huron, 1847; and Thunder Bay Light, on Lake Superior, 1939. Canada also built six "Imperial Lights" on the northern Lakes (1855–59), including Chantry Island Light, Cove Island, Griffith Island, Nottawasaga Island and Point Clark, all on Lake Huron and Georgian Bay.

Two lights stand out as examples of construction on the Great Lakes. The first is Spectacle Reef Light, built by the Lighthouse Board between 1870 and 1874. Located at the eastern end of the Straits of Mackinac, where Lake Huron meets Lake Superior, Spectacle Reef was described by a contemporary observer as "probably more dreaded by navigators than any other danger now unmarked throughout the entire chain of lakes." When two ships were wrecked upon the rock simultaneously in 1867, the need for a beacon here could no longer be ignored.

Spectacle Reef Light (begun 1870) was built in much the same way that Minots Ledge, in Massachusetts, had been: A crib dam was placed around the site, the water was pumped out and the building crew went to work. Once the foundation was leveled, the men bolted preshaped stones to the rock with three-foot bolts. The tower is a solid mass of limestone rising five stories (95 feet) to the lens. Work stopped for the winter in mid-December 1873, and when the engineers returned in the spring, they had to hack their way through ice that had piled up to a height of 30 feet to finish their job. First lit in 1874, the tower still guides ships past this bottleneck near the Straits of Mackinac.

Rock of Ages Light guards the western tip of Isle Royale on Lake Superior. This was an especially dangerous spot for ships bound for the iron-ore port of Duluth, Minnesota. The five-level, 130-foot steel tower is one of the most isolated stations in North America: Keepers had to cross 50 miles of turbulent water to see a doctor, or pick up supplies. It was the Great Lakes equivalent of the light at Tillamook Rock, Oregon. In 1933 the freighter *George M. Cox* ran onto a nearby reef shrouded by fog. Rescued by the keeper and his assistant, 125 survivors huddled in the lighthouse until emergency vessels arrived to transport them to the mainland.

The renowned "Big Storm" on the Lakes occurred on November 9–11, 1913. Forty vessels were wrecked and 235 lives lost, but all of the lighthouses remained intact, confirming the engineering skill and determination of the Great Lakes builders. By 1945 there were 698 lights on the American side and almost one-third as many significant beacons on the Canadian. After World War II, increasing use of automation and radar began to reduce both the number of functioning lighthouses and their importance.

**Two Harbors East Breakwater Light, Two Harbors, Minnesota**

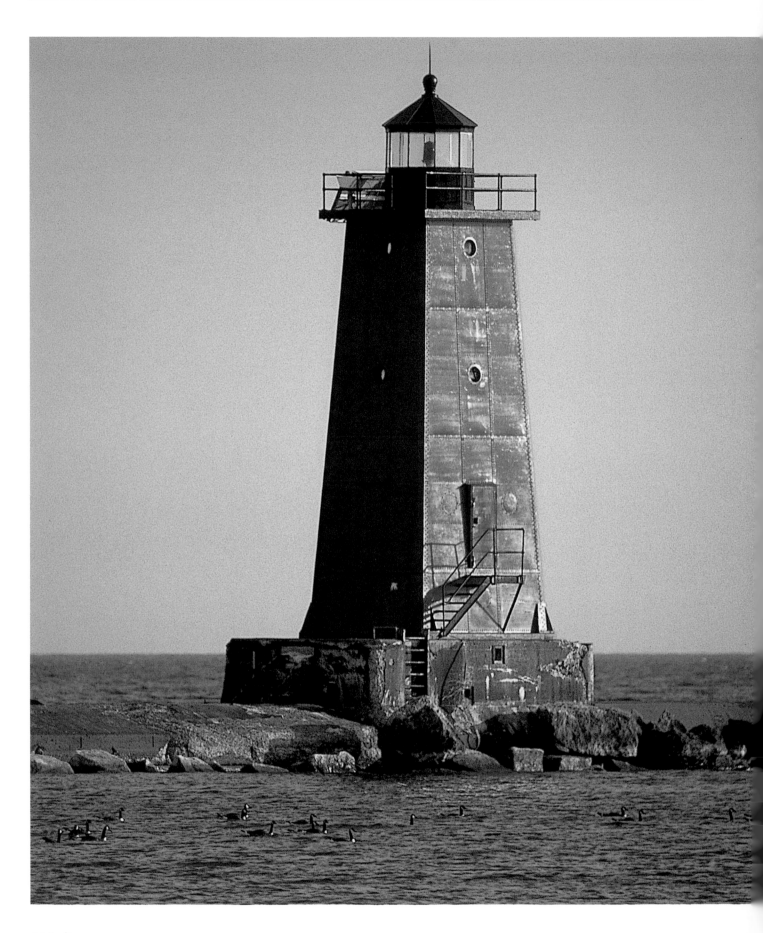

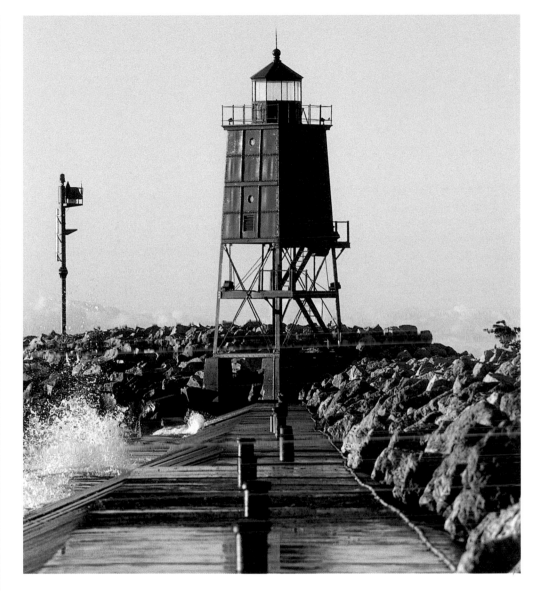

### Racine North Breakwater Light *Above*

*Racine, Wisconsin*

With a population of 84,000, the port of Racine lies 20 miles southeast of Milwaukee on Lake Michigan. The town improved its harbor after the first lighthouse here was constructed in 1839; it was replaced after the Civil War, when the railroad increased local prosperity. The present lighthouse, now inactive, is a pyramidal steel tower on a skeletal base that has survived winter's ice and storms since 1912.

### Manistique East Breakwater Light *Left*

*Manistique, Michigan*

Completed in 1917, this pyramidal cast-iron lighthouse stands on a concrete pier at the end of the eastern breakwater marking the entrance to the Manistique River, on northern Lake Michigan. The 35-foot-tall tower is sheathed with steel plating. Automated in 1969, its original fourth-order Fresnel lens was replaced with a lighter 300mm plastic lens as its optic.

## Manistee North Pierhead Light
### *Manistee, Michigan*
This Lake Michigan station was established at Manistee in 1875; the present cylindrical tower was built in 1927 at the end of the North Pierhead to mark the entrance to the Manistee River. The old wooden catwalk by which the keepers entered the light was often damaged by storms, so it was replaced by a sturdy steel-and-wire walkway. The 39-foot lighthouse stands 55 feet above Lake Michigan. Now equipped with a 300mm lens, the light is still an active aid to navigation.

**Point Betsie Light** *Below*

*Frankfort, Michigan*

In 1858 Point Betsie Light was built to mark a key point for ships entering or leaving the Manitou Passage. The 37-foot brick tower, painted white, is attached to the two-story dwelling. Until 1996, when the rotating mechanisms for the lens failed, the lantern (automated in 1983 and still active) retained its original third-order Fresnel lens. The lens has now been removed for display at the Sleeping Bear Dunes Maritime Museum.

**Lake Dora Light** *Opposite*

*Mount Dora, Florida*

Lake Dora Light is the only lighthouse on a freshwater lake in Florida. Civic groups in the region raised the funds to construct this lighthouse in Mount Dora's Gilbert Park. The 35-foot brick-and-stucco tower was dedicated on March 25, 1988. Equipped with a 750-watt photocell, the beacon guides boaters back to the Mount Dora dock. From the nearby boardwalk, visitors can see alligators, otter, herons and other wildlife.

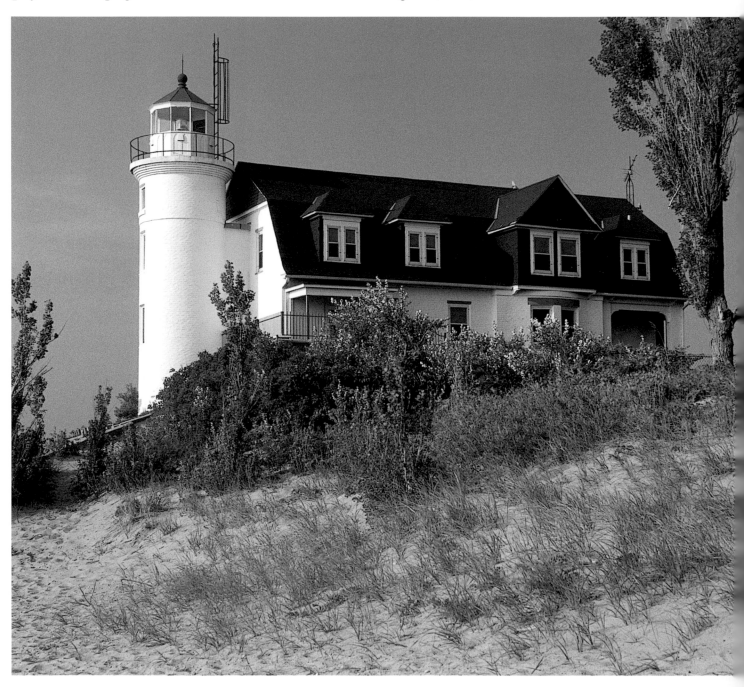

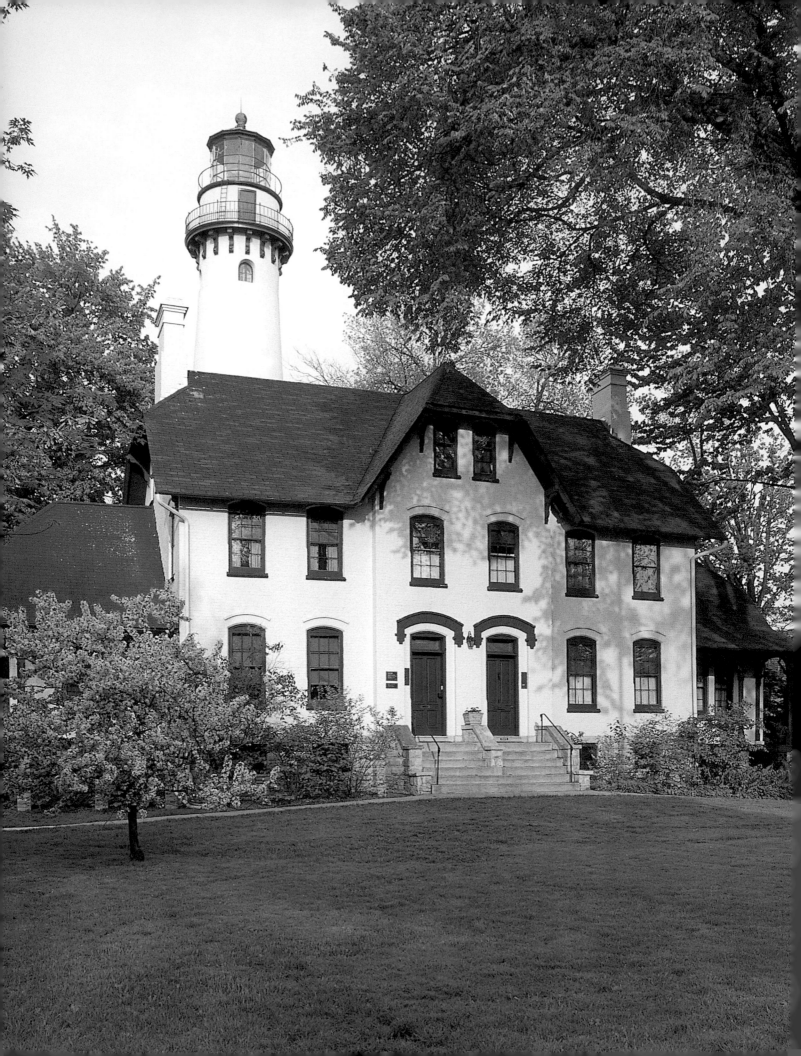

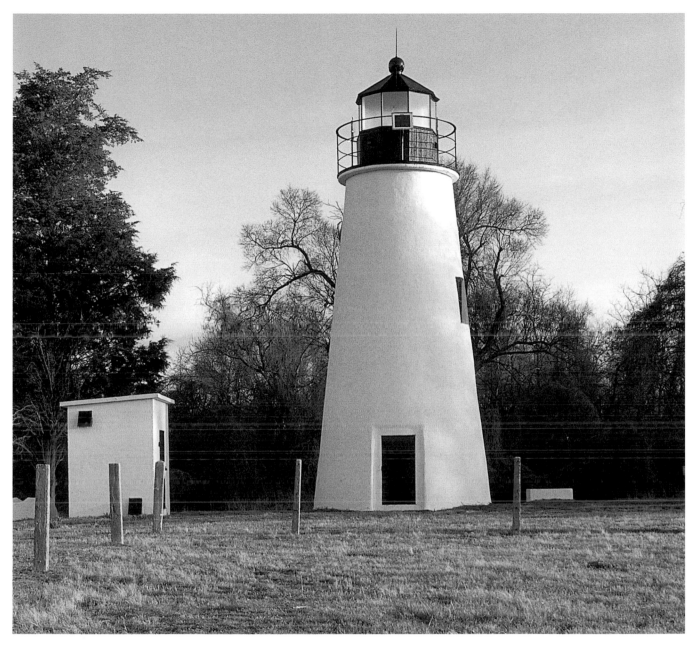

**Grosse Point Light** *Opposite*

*Evanston, Illinois*

Located on Lake Michigan just north of Chicago, Grosse Point Light, with its imposing Tudor Revival-style dwelling, was built in 1873 at a cost of $50,000. The 113-foot tower, made of brick encased in concrete, was equipped with a second-order lens; the fixed white light emitted a red flash every 3 minutes. The Bureau of Lighthouses automated the light in 1935, and it was decommissioned by the Coast Guard in 1941. Evanston citizens restored and relit the lighthouse after World War II, when the property reverted to the city.

**Turkey Point Light** *Above*

*Elk Neck, Maryland*

Turkey Point Light stands at the end of Elk Neck, a 12-mile-long peninsula that juts into the head of Chesapeake Bay. Built in 1833, the 38-foot masonry tower, on a 100-foot elevation, was designed as a marker for ships coming up the bay or down the Susquehanna River via the Chesapeake and Delaware Canal. The last civilian woman in the lighthouse service kept the station until she retired in 1947. Elk Neck Light was automated at that time and now stands in a state park and game preserve.

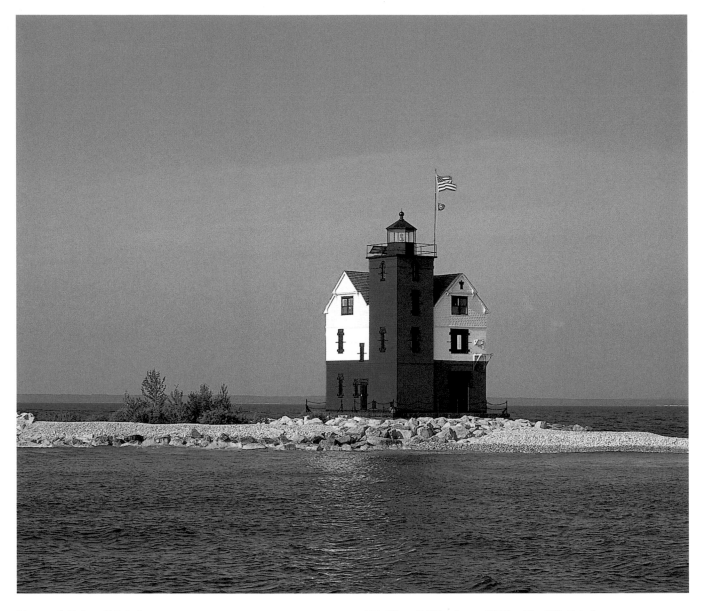

**Round Island Light** *Above*

*St.Ignace, Michigan*

Round Island lies in the Straits of Mackinac, which sep-
arate Lakes Michigan and Huron. The light was built
in 1895 near St. Ignace, Michigan, to mark the danger-
ous shoals in the heavily traveled channel between Round
and Mackinac Islands. The square tower is integral with
the Gothic Revival dwelling, which fell into disrepair
after the light was automated in 1924. Decommissioned
in 1947, the site was saved by a consortium of preser-
vation groups working with the U.S. Forest Service.
Today it is the most-photographed lighthouse on the
Great Lakes, viewed by countless passengers on
hydroplane ferries to Mackinac Island.

**Holland Harbor ("Big Red") Light** *Opposite*

*Grand Haven, Michigan*

Located at the end of Holland's south inner pier,
Holland Harbor Light is a massive square building
with an integral cast-iron tower. The steel-plated struc-
ture (the fourth on this site) marks the narrow chan-
nel that connects Lakes Michigan and Macatawa. It
was built in 1936 and owes its size and design to the
need to house the huge boilers that powered the sta-
tion's steam fog signal. Painted red, like many Lake
Michigan lighthouses, Holland Harbor Light is a famil-
iar landmark known affectionately as "Big Red."

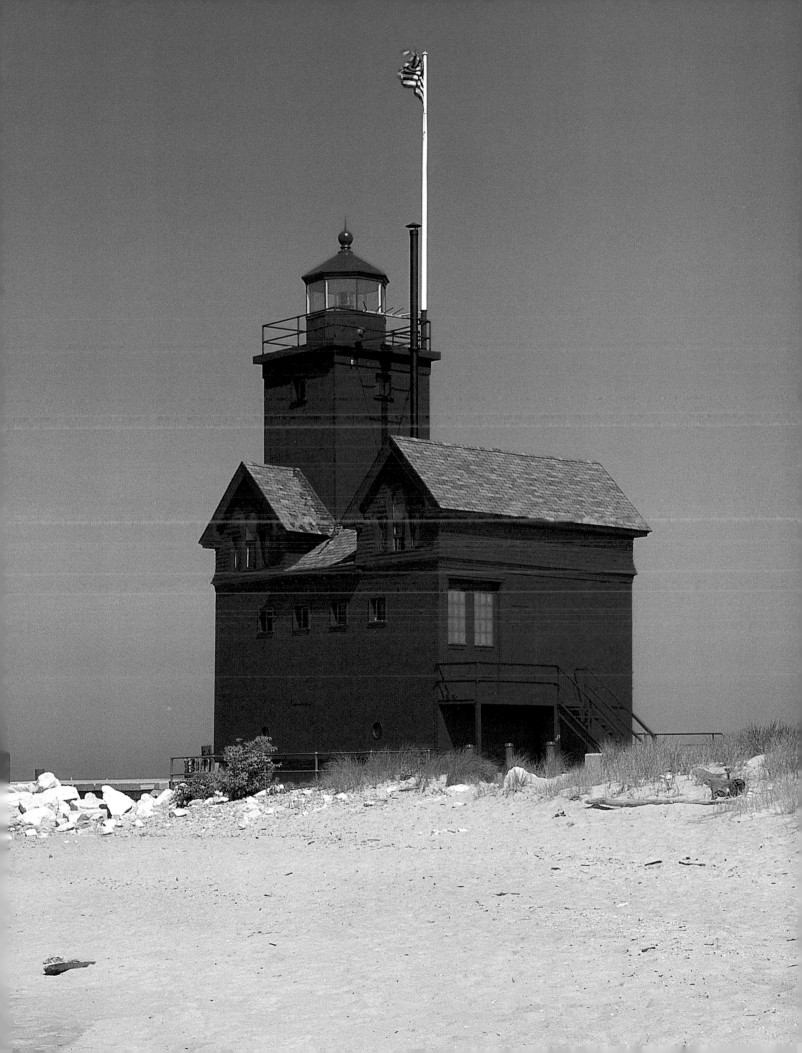

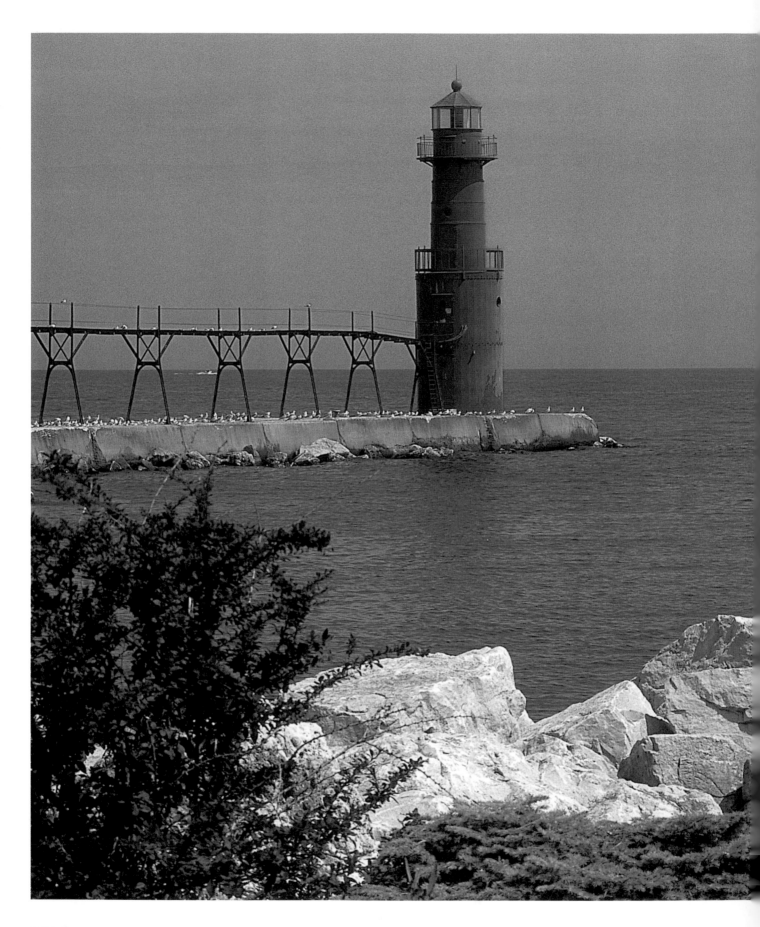

## Algoma North Pierhead Light *Left*

*Sturgeon Bay, Wisconsin*

The station at Algoma, Wisconsin, was established in 1893, and the tower was rebuilt in 1908 as a conical cast-iron-and-steel structure. Located at the end of the city's north pier, the present light was installed in 1932 by placing the older 26-foot tower on a new steel base and raising the lantern's height to 42 feet. Automated in 1973, it is still in service.

## South Haven South Pier Light *Below*

*South Haven, Michigan*

This is the second light at the South Haven station, which was established in 1872. Built in 1903, the conical cast-iron tower is accessed by a steel catwalk and overlooks summertime art festivals on the resort town's south pier. Once a commercial crossroads on Lake Michigan, South Haven is now frequented mainly by pleasure boaters. Its light is still active.

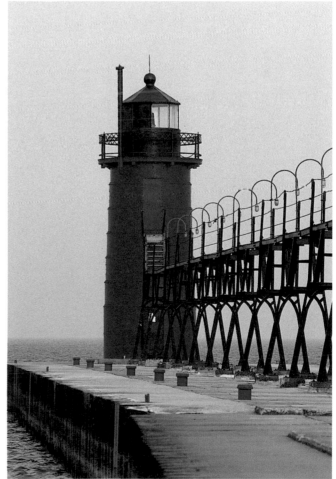

## Mendota (Bete Grise) Light *Right*

*Bete Grise, Michigan*

Built in 1895 to mark the Mendota Ship Channel near Bete Grise, Michigan, this station was deactivated in 1960 and is now a private residence. The square brick tower is integral with the brick dwelling, with its steeply sloping gabled roof. This Lake Superior station was established in 1870, when maritime activity on the Great Lakes was already flourishing.

## Copper Harbor Light *Below*

*Copper Harbor, Michigan*

Lake Superior's original Copper Harbor Lighthouse, on Michigan's Upper Peninsula, was established in 1849 after a rich vein of copper was discovered nearby. This sturdy yellow-brick keeper's dwelling with its square frontal tower was built in 1867. In 1933 its light was moved to an adjacent skeleton tower, and the well-kept old building is now a maritime museum in Fort Wilkins State Park.

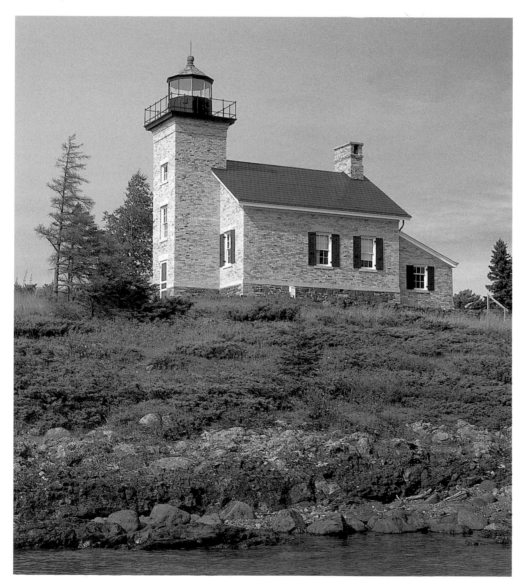

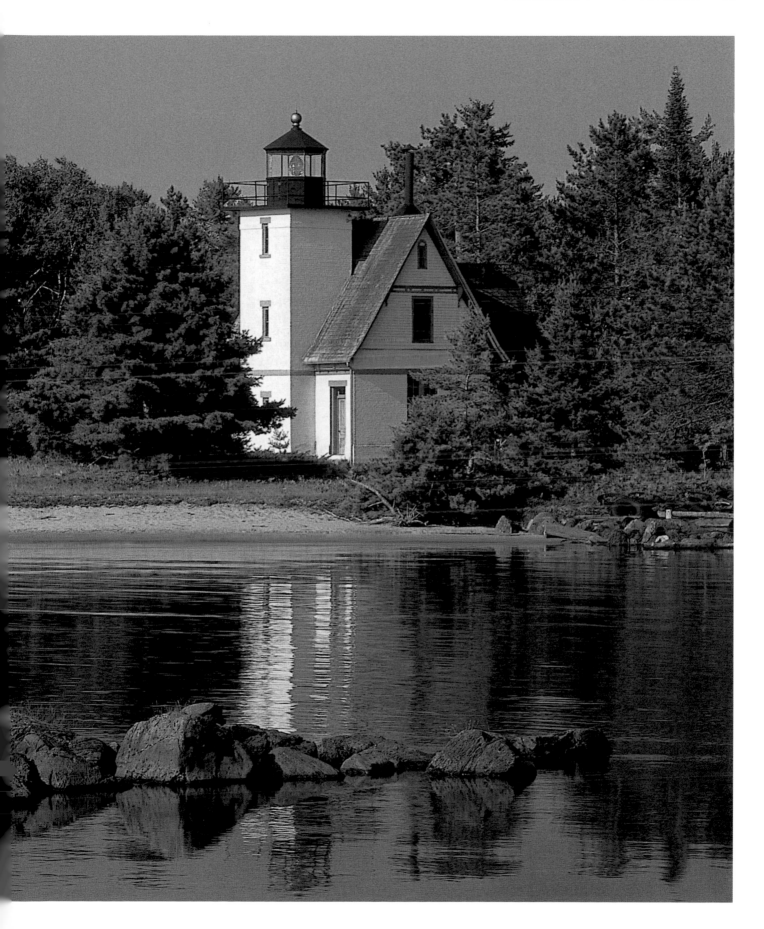

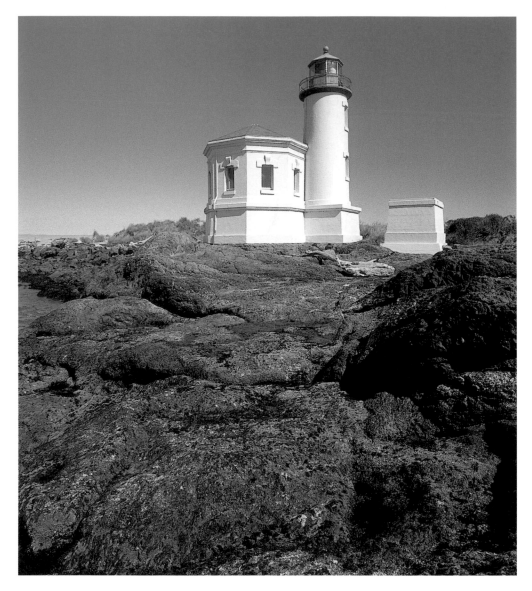

**Coquille River Light** *Above*

*Bandon, Oregon*

This handsomely restored fog-signal station with attached tower was built in the classical style in 1895 to mark the entrance to Oregon's Coquille River. The 40-foot conical brick tower, covered with stucco, was reclaimed from vandalism along with the fog-signal station by the U.S. Army Corps of Engineers and the State of Oregon after the light was deactivated in 1939.

**Cheboygan Crib Light** *Right*

*Cheboygan, Michigan*

This crib-foundation structure was established in 1852 on a strong concrete base designed to resist the region's destructive ice floes. First lit in 1910, the 25-foot tower marked the entrance to the Cheboygan River on the Michigan shore of Lake Huron. In 1988 the deactivated octagonal cast-iron tower was moved to the base of the west pier in what is now a Cheboygan city park.

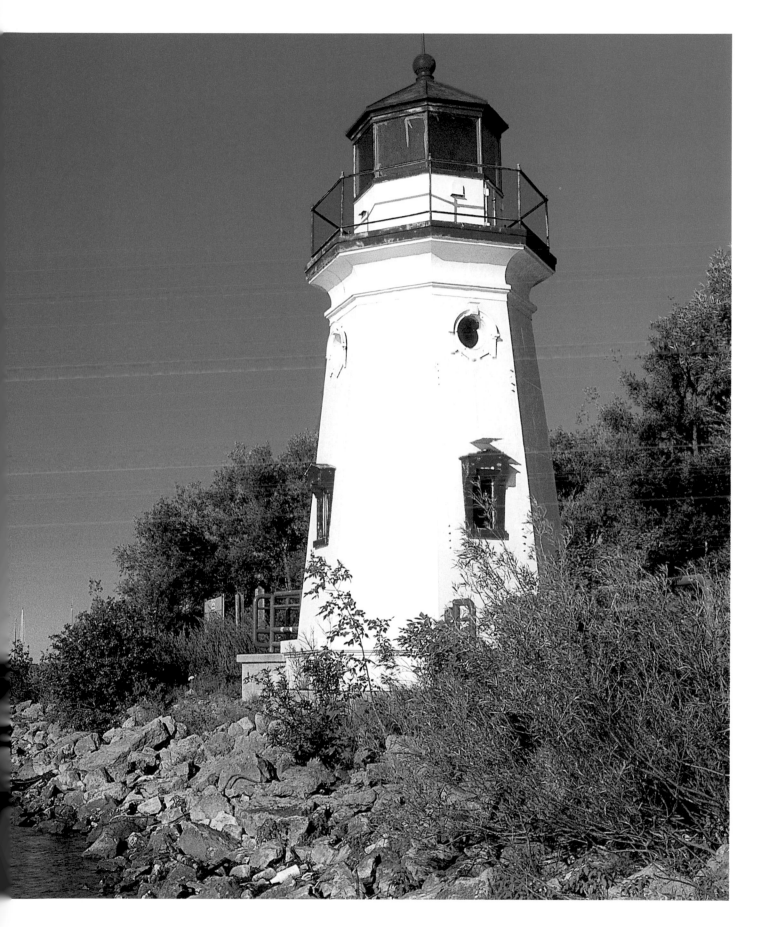

**Hooper Strait Light** *Below*

*St. Michaels, Maryland*

Today the Hooper Strait Light stands on Navy Point, beside the Chesapeake Bay Maritime Museum on Maryland's eastern shore. It is the second of two screwpile lighthouses built to mark the difficult channel of Hooper Strait. The first, built in 1867, was swept away by a massive ice floe; the second, completed in 1879 with platform dwelling, served faithfully until 1954, when the 44-foot-wide hexagonal lighthouse was discontinued and purchased by the museum.

**Drum Point Light** *Opposite*

*Solomons, Maryland*

Typical of the "cottage-style" screwpile lighthouse, Drum Point Light was built in 1883 to mark a sandy spit. Originally located at the entrance to Maryland's Patuxent River, it was equipped with a fourth-order Fresnel lens and anchored in 10 feet of water some 100 yards off the point. Tidal patterns changed, and by the 1960s, the lighthouse stood completely above water at low tide. The Coast Guard decommissioned the light in 1962, and it was moved two miles upriver to the Calvert Marine Museum in 1975.

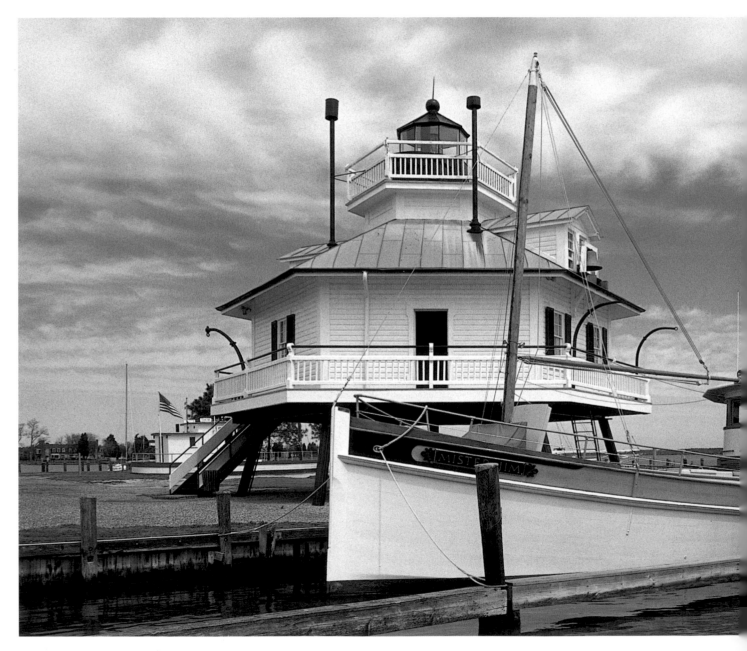

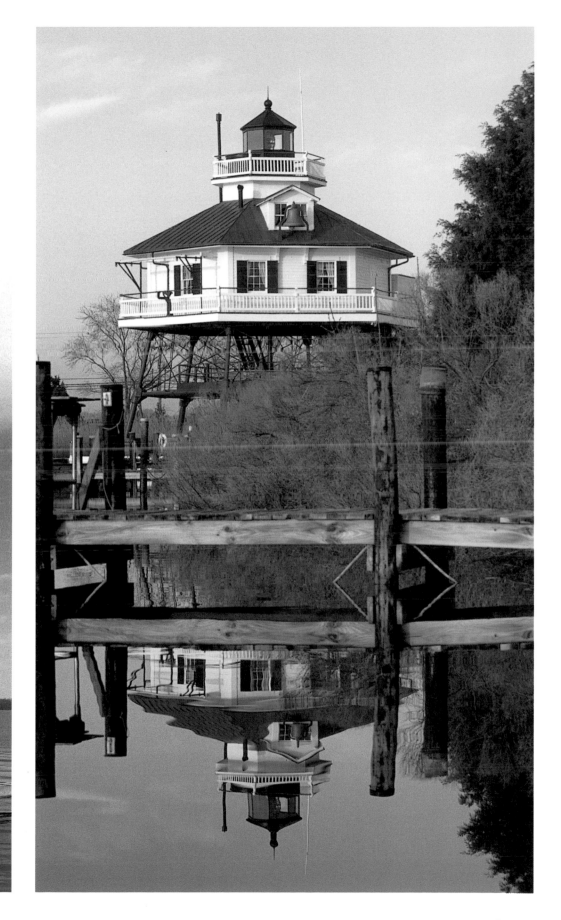

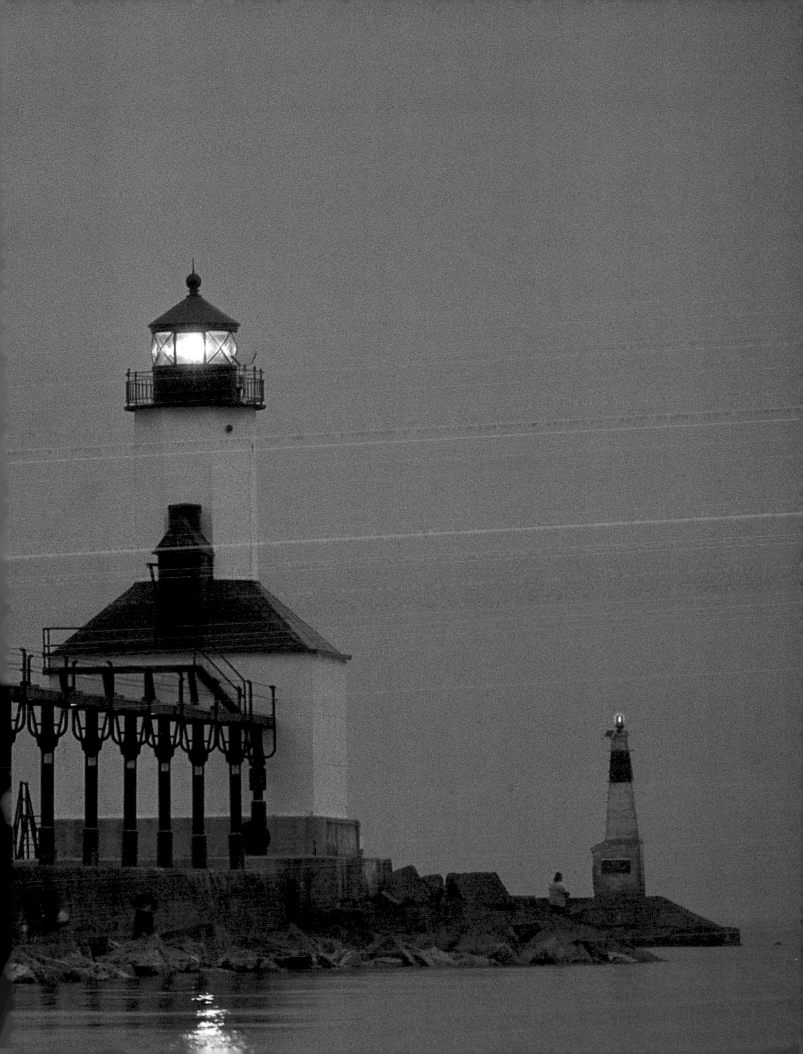

**Michigan City East Pier Light** *Previous pages*

*Michigan City, Indiana*

Built in 1904 on Michigan City's outer pierhead, this massive structure replaced the original lighthouse, called Old Michigan City, which is now a museum on the mainland. Constructed on a concrete platform, the 49-foot octagonal tower rises from the boiler-powered fog-signal building, reached by an elevated catwalk. Automated in 1960, the station is still an active Coast Guard facility.

**Port Sanilac Light** *Below*

*Port Sanilac, Michigan*

The Michigan city of Port Sanilac established this lakeside lighthouse in 1886, and it is still an active aid to navigation, although the Tudor-style keeper's dwelling is now a private residence. The octagonal brick tower stands 69 feet above lake level, and its beam can be seen for 16 miles.

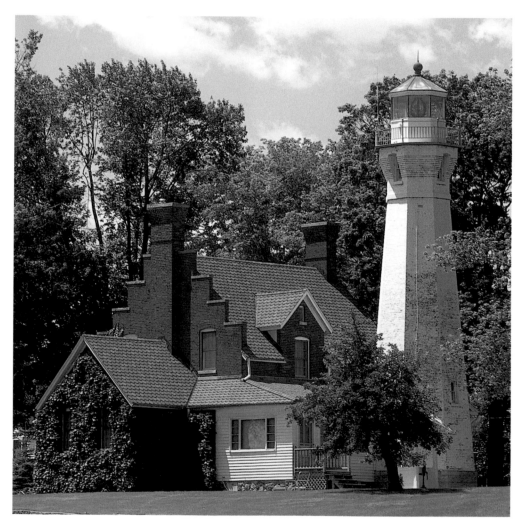

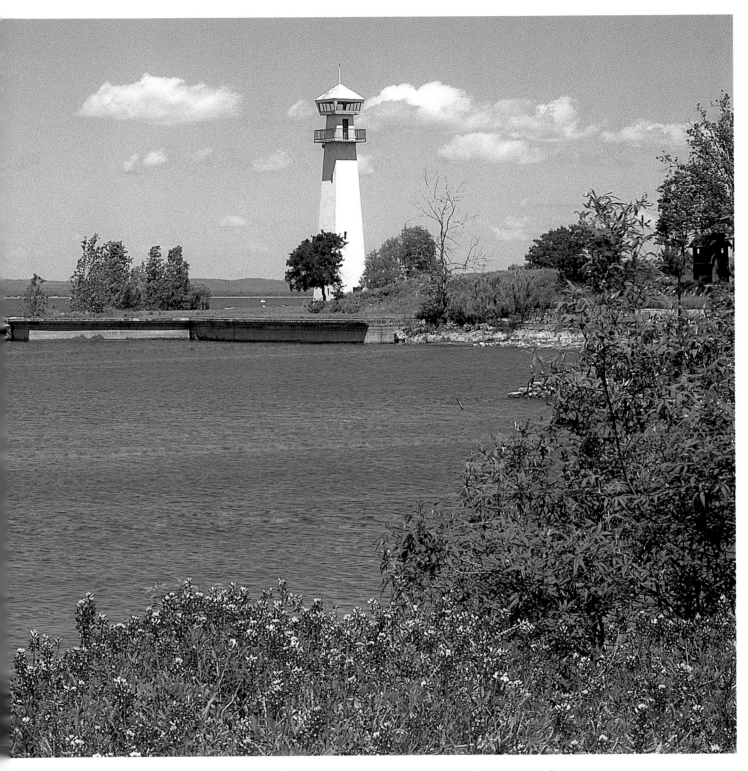

**Lake Buchanan Light** *Above*
*Lake Buchanan, Texas*
This privately owned lighthouse overlooks Lake Buchanan, the largest of the first four Highland Lakes in central Texas. Located near the Buchanan Dam, this pyramidal tower has been carefully maintained.

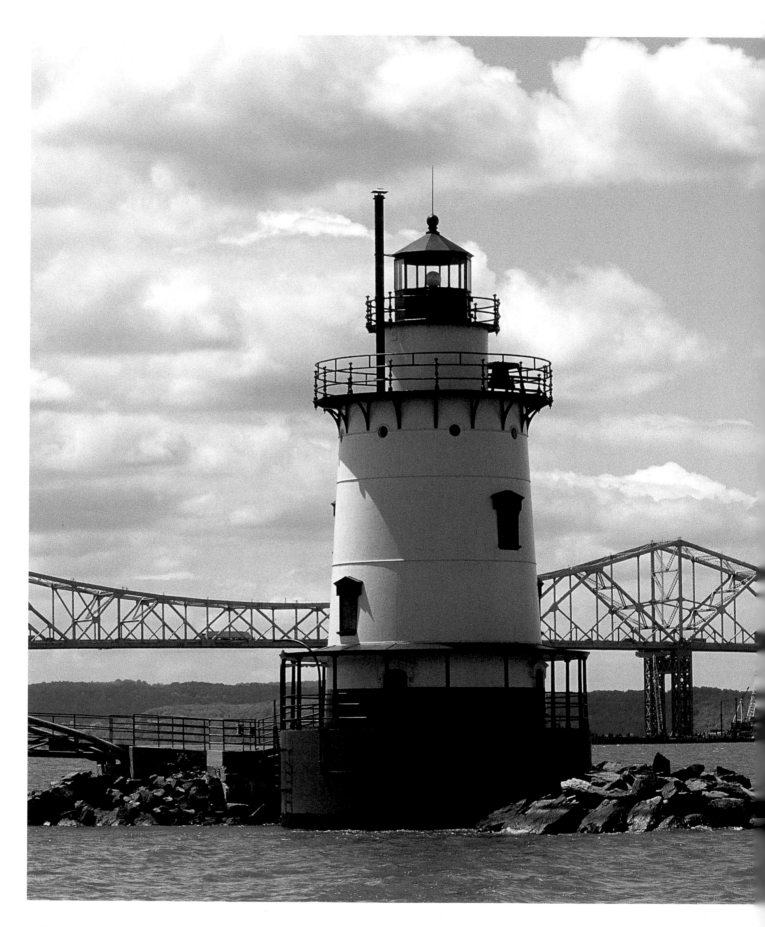

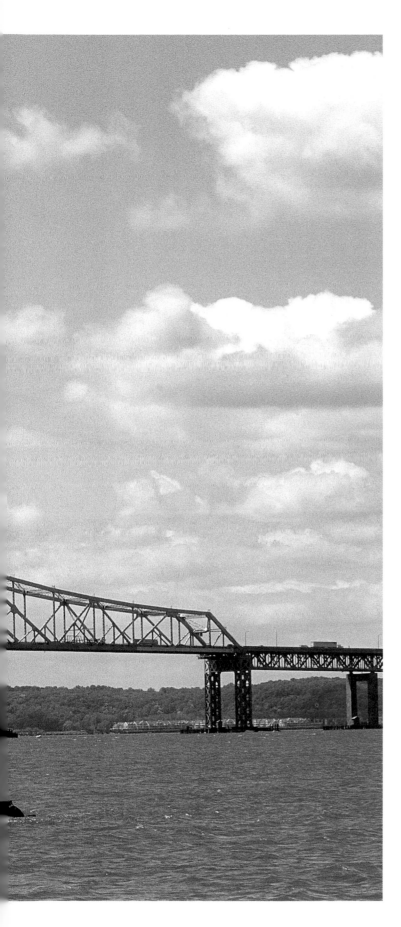

## Tarrytown Harbor Light *Left*

*North Tarrytown, New York*

This sturdy steel caisson lighthouse was built in 1883 to warn Hudson River navigators of the Tarrytown Shoals. Rising from a stone pier, the five-story conical tower was staffed until 1957, when the light was automated. Now inactive, it is part of Kingsland Point Park.

## Sturgeon Bay Ship Canal Lights *Below and overleaf*

*Sturgeon Bay, Wisconsin*

This 98-foot skeletal tower (below) on Lake Michigan was built in 1903 as a marker for the Sturgeon Bay Ship Canal entrance. Still an active Coast Guard facility, its companion light (overleaf) is on the North Pierhead of the canal entrance. Constructed in 1882, the North Pierhead Light is a cast-iron-and-concrete tower integral to the massive fog-signal building.

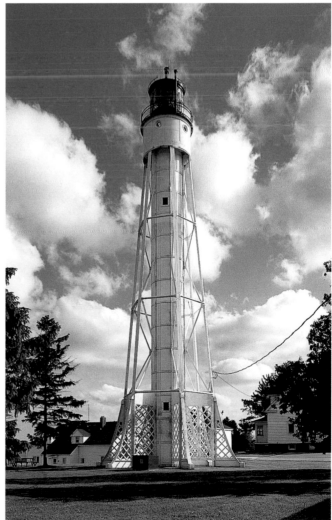

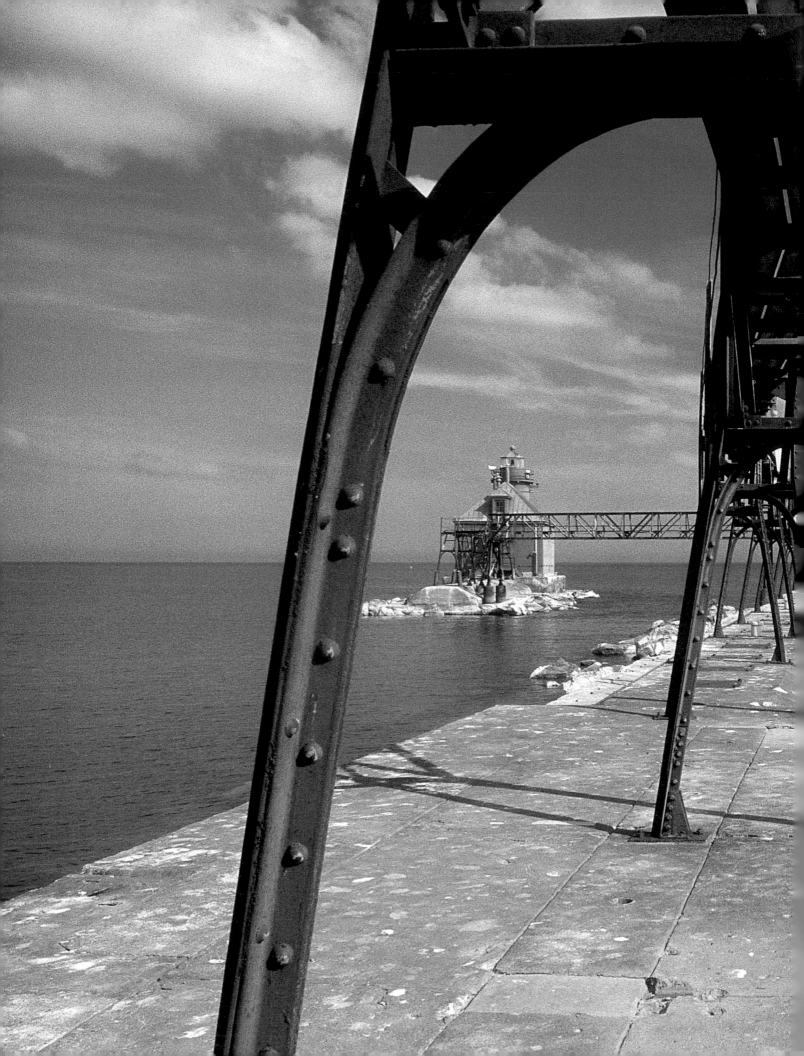

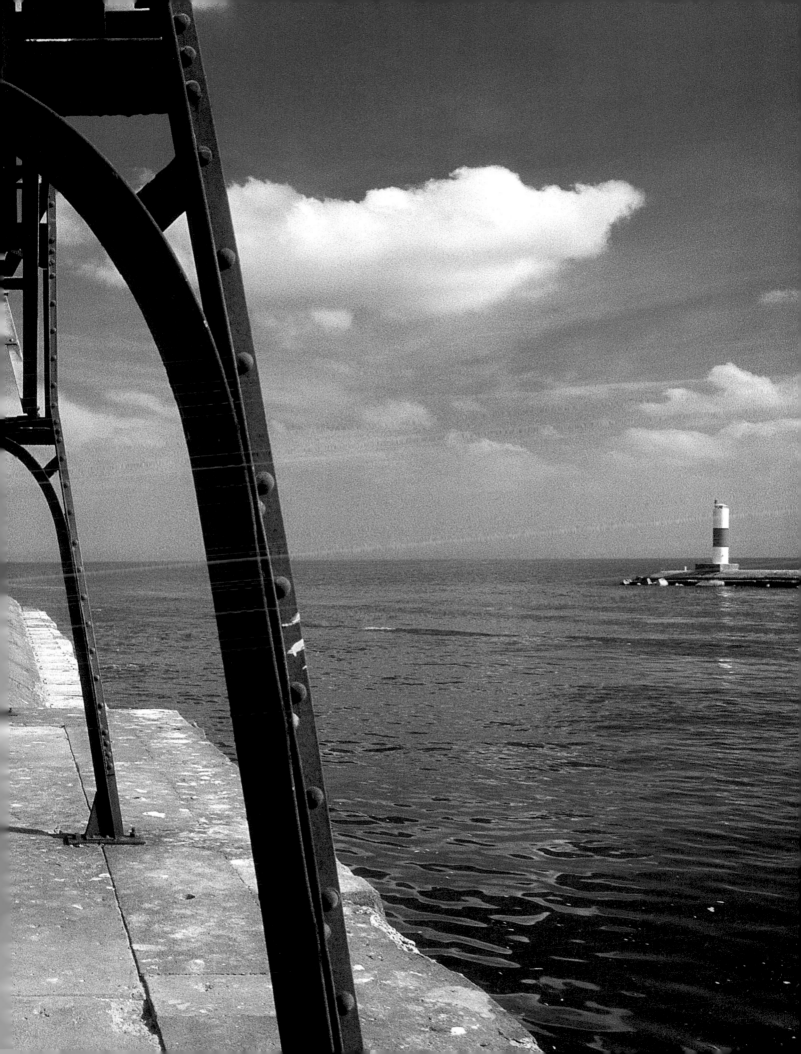

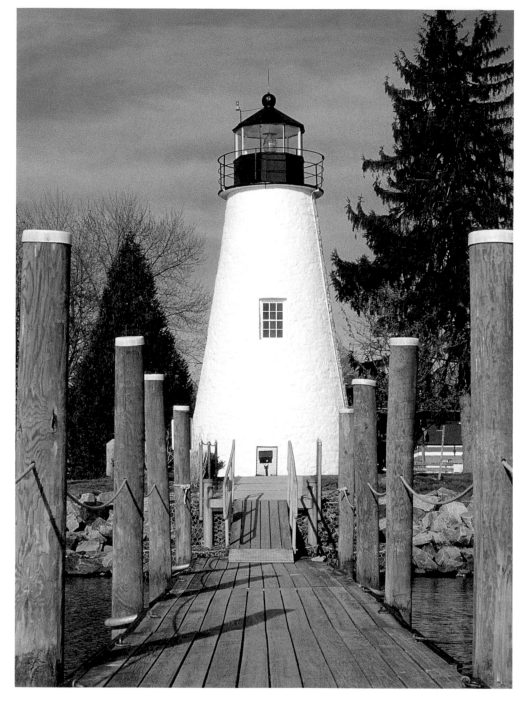

**Concord Point Light** *Above*

*Havre de Grace, Maryland*

Built in 1827 at a cost of $3,500, this 32-foot stone tower now displays a fixed green light. It is located near the U.S. Naval Academy at Annapolis and shares this institution's distinction in naval history. Until is was automated in the 1920s, Concord Point Light was tended entirely by members of the family of John O'Neil, a hero of the War of 1812, who was the first keeper.

**Frankfort North Breakwater Light** *Below*

*Frankfort, Michigan*

The wave-swept North Breakwater at Frankfort, Michigan, is the site of this pyramidal 67-foot steel tower. The present light was built in 1932 on a station established in 1873. Now automated, it is still in service.

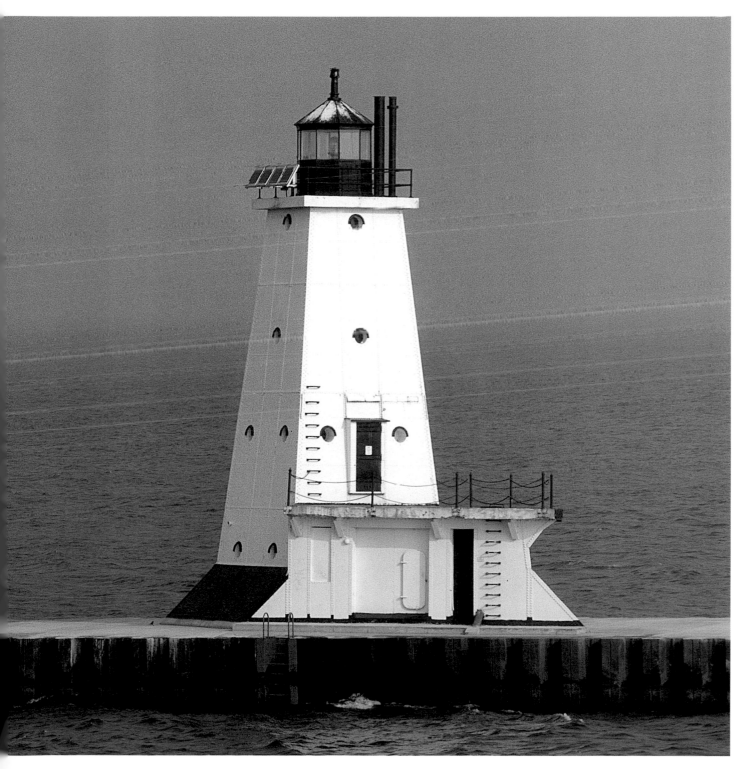

**Tawas Point Light** *Below*

*Tawas City, Michigan*

The original Tawas Point Light on the Michigan shore of Lake Huron was built in 1853 to mark the entrance to Saginaw Bay. Only twenty years later, the lake's boundaries had shifted to the point where the beacon was more than a mile from the water. The present 67-foot conical brick tower was built in 1876 and equipped with a rotating fourth-order Fresnel lens. The site remains an active Coast Guard facility.

**Wind Point Light** *Opposite*

*Racine, Wisconsin*

It took three years to build Lake Michigan's Wind Point Light with attached dwelling 3.5 miles north of Racine Harbor. Completed in 1880, the 108-foot conical brick tower displayed two Fresnel lenses: a third-order, with a flashing white light, and a fifth-order, which marked Racine Reef with a red light. Automated in 1964, the station is now owned by the village of Wind Point and is still an active aid to navigation.

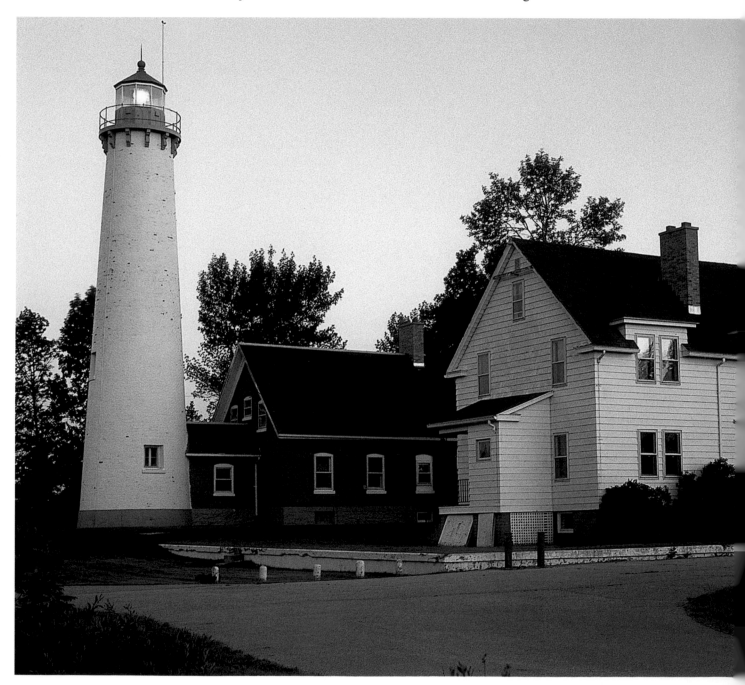

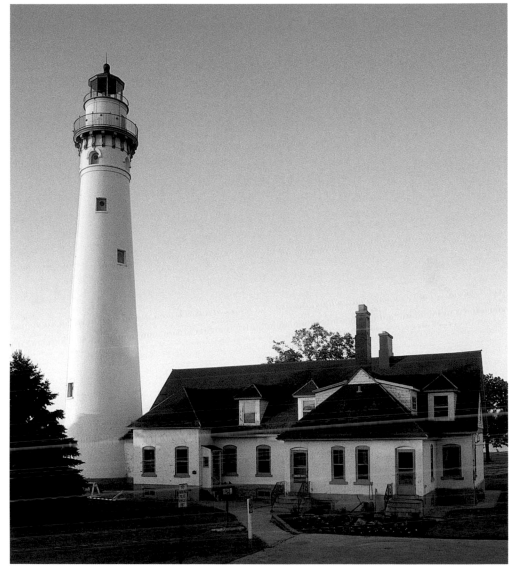

### Jeffrey's Hook Light *Overleaf*

*Fort Washington Park, New York City*

Since the 1930s, children have delighted in the story of *The Little Red Lighthouse and the Great Grey Bridge*, written by Hildegarde Hoyt Swift. It celebrates Jeffrey's Hook Light, a steel-plated tower built in 1921 to replace a pair of stake lights on the Hudson River. Only eleven years later, the conical 40-foot light was rendered obsolete by completion of the George Washington Bridge. Discontinued by the Coast Guard in 1947, the site was for sale until Swift wrote her classic and popular protest demanded that the diminutive light remain. Jeffrey's Hook Light was acquired by New York City and incorporated into Fort Washington Park.

**Eagle Bluff Light** *Below*

*Ephraim, Wisconsin*

Established in 1868 to mark the entrance to the East Channel into Green Bay, the 43-foot Eagle Bluff Light stands 75 feet above Lake Michigan. One of the first beacons in the U.S. to be automated, its original third-order Fresnel lens was replaced with a 300mm solar-powered lens. The brick tower is still an active aid to navigation.

**St. Joseph Inner and Outer Pier Lights** *Opposite*

*St. Joseph, Michigan*

This unusual site has a pair of lights on the same pier at the mouth of the St. Joseph River. The cylindrical tower stands in front of an octagonal tower rising from the fog-signal station on Lake Michigan. Both lights were constructed in 1907, to function as front and rear range lights to guide mariners into the channel.

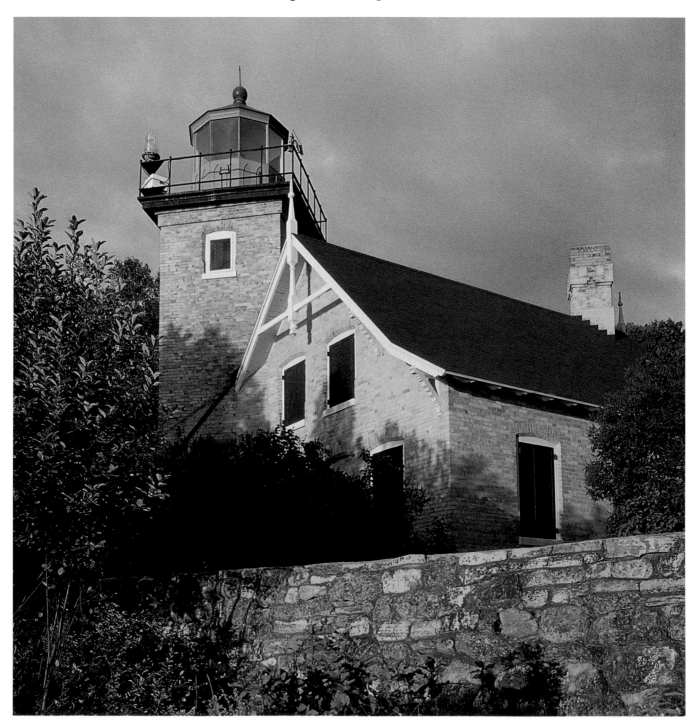

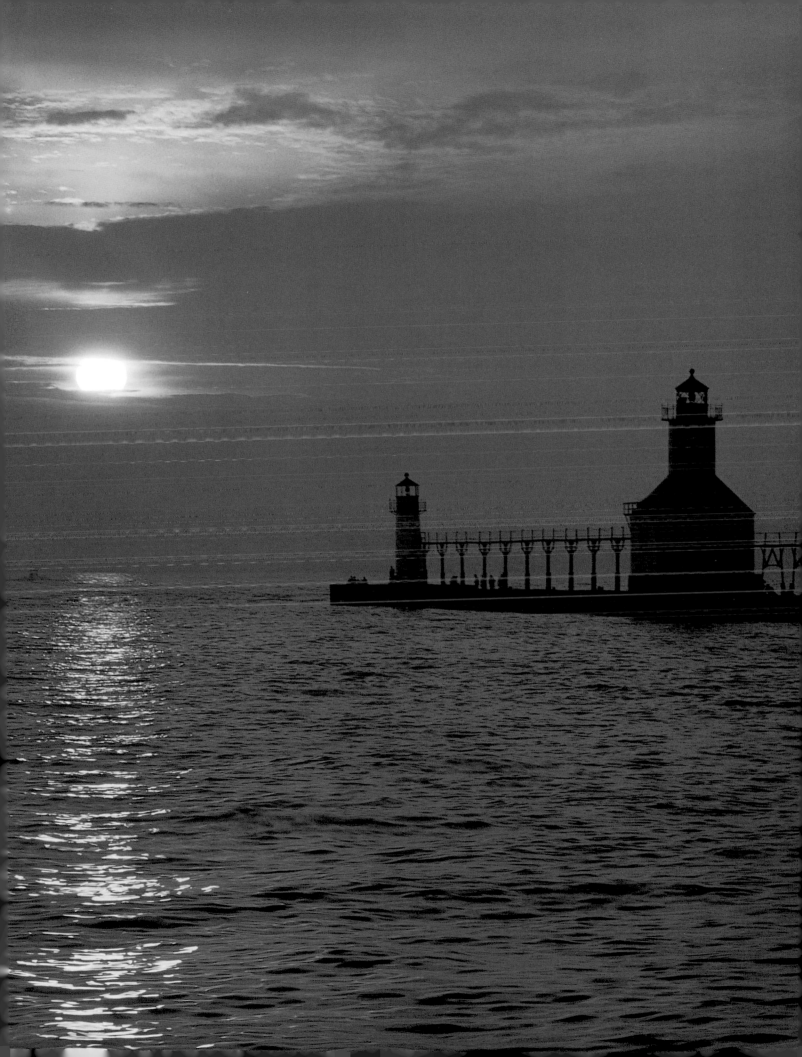

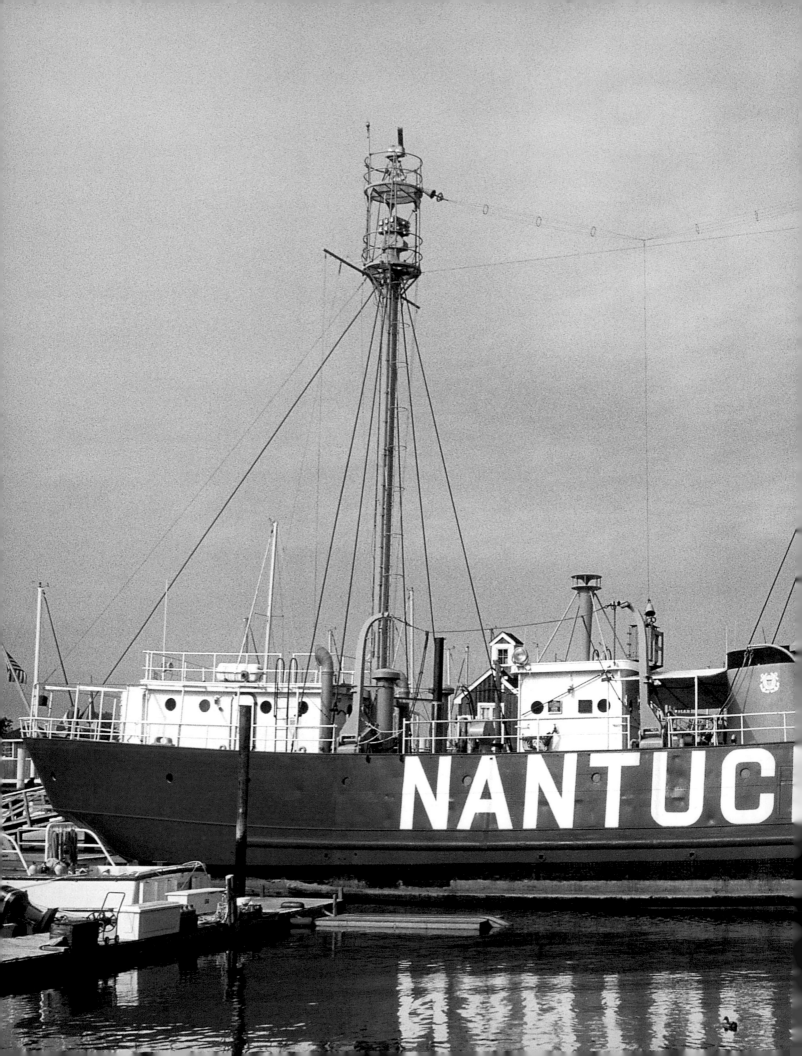

# Anatomy of a Signal

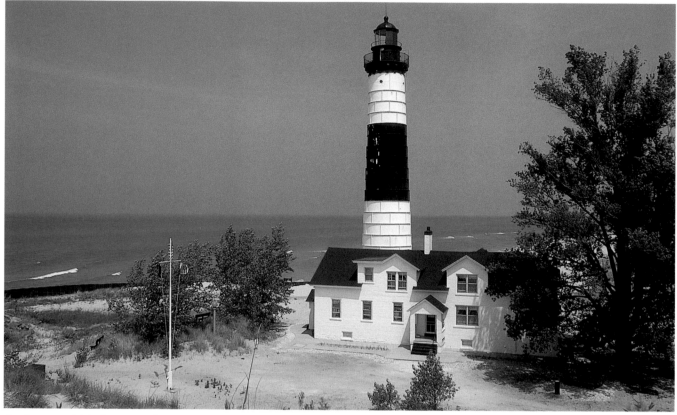

*Previous pages:* **Lightship** *Nantucket,* **Bridgeport, Connecticut;** *Above:* **Big Sable Point Light, Presque Isle, Michigan**

As we have seen briefly in the previous chapters, many different types of navigational aids have been used in conjunction with, or in addition to, the lighthouse itself. These include daymarks; sound signals such as fog horns, bells, whistles and sirens; range lights; several major types of lenses housed in lighthouse and lighted marker lanterns; and lightships, widely used as mobile navigation aids for more than a century. Different types of buoys, both lighted and unlighted, have also played a major role in maritime safety.

## Visible Aids to Piloting

Landmarks used to negotiate waters close to shore include daymarks: boldly striped or patterned structures, including lighthouses, readily seen from a distance—and buoys, both of which are identified on nautical charts for the mariner's guidance. Buoys are floating objects anchored in harbors, lakes, rivers and other waterways as markers. They were first employed in North America on the Delaware River in 1767. The

first lighted buoy, which burned oil gas, was put into service outside New York Harbor in 1881, and bell buoys were introduced four years later.

Over time, a color-code system was developed in the United States whereby red buoys marked the right side of a channel, as viewed by a vessel entering a harbor, and black ones, the left. Buoys with black-and-white vertical stripes marked the middle of a channel, and those with horizontal red and black stripes indicated danger spots. The color-coding system was eventually altered to conform to international convention, and the black buoy indicating the left side of a channel was changed to green.

Spar buoys are wooden or metal poles that are tall and tapered. The can buoy is a metal flat-topped cylinder, while the nun buoy is cone-shaped. Buoys sometimes have lights for night piloting: The color of their lights and the length of their flashes, in conjunction with a chart, tell the navigator what their signals identify. By the mid-twentieth century, these lights were operated by compressed gas or electric batteries.

Pairs of fixed lights called range lights in some harbor, port and estuarial areas give directional signals in which two lights must be lined up to indicate a safe channel. These may consist of a pair or set of three buoy lights or a small light used in tandem with a local lighthouse. Another range system in major channels consists of two lighthouses at different elevations standing a short distance, perhaps a half-mile, apart. The mariner steers to keep the two lights in line, one above the other, to find passage through the channel. Many of these two-house range lights have been built on Canadian waterways, including the St. Lawrence and Ontario's Wilson Channel. In the United States, a number are found on Great Lakes harbor channels, including those at Presque Isle, Michigan. Such two-house systems usually incorporate the phrases "Front Range" and "Rear Range" in the name of the lighthouse.

## Sound Signals

Most lighthouses were equipped with fog signals, and some stations had such signals before the lighthouse itself was erected. Sound signals can be confusing because, to the human ear, sound seems to travel unpredictably over water. The strength of a sound signal varies considerably, too, with changes in wind direction. However, in thick fog, the presence of a sound signal can provide the only practical warning of a hazard, so their use remains vital, especially to vessels not equipped with radar or global positioning systems.

For almost thirty years, San Francisco's Point Montara had only a fog signal house to warn sailors of the jagged rocks below its clifftop site. A wooden tower, built in 1900, was replaced by the present cast-iron beacon in 1928, and the fog signal now sounds from a buoy anchored offshore.

Puget Sound's Point Robinson Light, on Maury Island, was originally a fog-signal station, established in 1885 to guard a busy "intersection" between Tacoma and Seattle, Washington. Two years later, a red light was placed on top of a 25-foot scaffold, and the station was rebuilt in 1915 to include a keeper's dwelling with a frontal tower housing a fifth-order Fresnel lens.

Steam whistles, bells, cannon fire, horns and sirens have all been used as fog-signals that can be identified in heavy weather or darkness at particular spots on the navigator's chart. The haunting quality of the fog horn has been memorialized in sea chanteys and folklore, like the lonely sound of a train whistle on the night air, vanishing into the unknown. Many types of sounding buoys are activated by the motion of the waves to signal their message by bells, gongs, or whistles. In still waters, they are now automated to signal at regular intervals when fog obscures the lighted buoys. In the United States, the government publication *Notices to Mariners* regularly advises navigators of changes to these and other aids to navigation.

## Lightships

The captain of the *Sandy Hook* lightship described the challenges faced by his crew in an 1851 report to the Lighthouse Service: "If you will but look at the model of this ship, you will at once perceive that her broad bluff bow is not at all calculated to resist the fury of the sea, which, in some of the gales we experience in the winter season, break against and over us with almost impending fury....The model of the present ship and her bottom is similar to a barrel; she is constantly in motion, and when it is any ways rough she rolls and labors to such a degree as to heave the glass out of the lanterns, the beds out of the berths, tearing out the chain-plates, &, rendering her unsafe and uncomfortable." In fact, lightship service at this time was both dangerous and monotonous, but it was essential in high-traffic areas where a lighthouse was not feasible: over sandbars that might shift after a storm and before offshore foundation techniques were developed; at the infamous Diamond Shoals off Cape Hatteras; at complex harbor entrances like the one to New York City; and in estuaries including that of the Columbia River.

Great Britain was the first country to use lightships. In 1731 a British entrepreneur secured a patent that allowed him to station a lightship at the Nore Sandbank, in the mouth of the Thames River. This single-masted sloop had two ship's lanterns placed 12 feet apart on a cross-arm attached to the mast. The vessel proved so effective that Britain soon had five lightships in use, and more would follow.

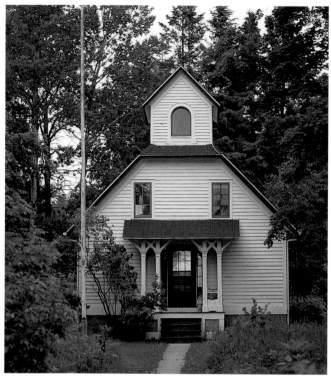

Rear Range Light, Bailey's Harbor, Wisconsin

The first American lightship went into service in 1821, anchored off Craney Island at the entrance to the Elizabeth River, near Norfolk, Virginia. Four other lightships were placed in Chesapeake Bay in 1822, and the first "outside," or oceanic, lightship was stationed in the Atlantic 7 miles off Sandy Hook, New Jersey, in 1823. At 230 tons, this was the largest of the early lightships. Only two others were placed at outside stations: at Five-Fathom Bank and Carysfort Reef, Florida.

Lightships multiplied along American shores during the tenure of Stephen Pleasonton, Fifth Auditor of the Treasury Department. There were twenty-six in operation by 1837 and forty-two when Pleasonton yielded control of the service to the Lighthouse Board in 1852. During this period of growth, lightship duty was especially trying. A conscientious bureaucrat, with no experience at sea, Pleasonton economized rigorously to keep lighthouse expenditures below the Congressional budget. Thus for a long period, no tender (relief) ship was provided. In 1852 there was only one such ship to serve the needs of forty-two lightships. When something went wrong aboard a lightship, whether due to a crew member's illness, or the loss of

critical equipment, the ship simply returned to port, leaving its station without a light. The tragicomic aspect of Pleasonton's thrift was manifested in 1826, when the Diamond Shoals lightship off Cape Hatteras snapped her moorings and had to make harbor at Norfolk, Virginia. Rather than purchase a new anchor and cable, Pleasonton ordered a search for the missing equipment, with the incentive of a $500 reward. Only when this approach failed did he replace the anchor and cable, having left the treacherous Diamond Shoals without a lightship from May through November.

Improvements came soon after the Lighthouse Board assumed control in 1852. All of its members had some type of maritime experience, and responded to complaints like those from the *Sandy Hook's* captain. One of the first new lightships was stationed at Minots Ledge, off Cohasset, Massachusetts, in 1854. It remained until the famous lighthouse on the reef was finished in 1860. The Lighthouse Board began the practice of numbering the ships, beginning on the Northeast coast and ascending to the Southeast. From that time, lightships retained their original numbers even when they changed their stations.

To millions of immigrants who arrived before 1914, the *Fire Island* lightship was their first glimpse of the New World. The red hull of the flush-deck, schooner-rigged ship, with her dual masts, rode in 96 feet of water, 10 miles south of the Fire Island Lighthouse. From there, they were guided into the New York Harbor channel by the *Ambrose* lightship, which served until 1967 and is now on display as part of New York City's South Street Seaport Museum.

On the West Coast, the *Blunts Reef* lightship was stationed off Cape Mendocino, and another was anchored at San Francisco. Canada found the need for a lightship where the Fraser River runs into the Strait of Georgia, just outside Vancouver, when British Columbia's population exploded with the discovery of gold in 1858. The government purchased the *South Sands Head* and anchored her off the river's mouth. Despite severe gales and low morale, the *South Sands Head* remained on station for fourteen years, until 1879, when she was no longer serviceable. She ended her career as a fishing barge. The lightship was replaced

by the North Sands Lighthouse, which stood guard until 1905, when shifting sands rendered it obsolete. The lightship *Mermaid*, which was once rammed by a steamship, served at the confluence until 1911. Two years later, the *Thomas F. Bayard*, an American ship, was rechristened *Sands Head Number 16* and anchored in the channel. She remained on station until 1957, and the Canadians built a new lighthouse in 1960.

Marine architects made significant improvements to lightships late in the nineteenth century. They installed bilge keels, to reduce the amount of roll, and flattened the hulls, while considering new types of building material. The original lightships were, of course, made of wood, and in 1851, Pleasonton noted that the lifetime of the average ship was only five to ten years. In 1852 the Lighthouse Board found that a marine worm was the culprit: "A whole plank is completely riddled with worm-holes before the least indication is visible on the skin of the ship inside. A small leak is a sure warning that the vessel must be docked right away." Even then, it was not until 1886 that the Board recommended replacing wooden-hulled ships with iron-hulled vessels. The first "iron boat," weighing 400 tons, was placed at Merrills Shell Bank, Louisiana, in 1847. From 1882 onward, new lightships were built of either iron or steel.

A number of lightship tenders were either purchased or built after 1852. At first, all were sailing vessels; the steam tender *Shubrick* was introduced in 1858, on the West Coast. After the Civil War, steam-powered tenders became the norm. It was customary to name them for flowers, trees and other plants, for example, the *Iris*, *Cactus*, *Geranium* and *Heliotrope*. The tenders displayed the Lighthouse service flag, which was adopted in 1869. Triangular in shape, with a red border, it bore a blue lighthouse on a white field.

Even as these developments improved safety and increased the longevity of lightships, their use was declining as offshore lighthouse building techniques enabled permanent beacons to mark many of the hazards formerly patrolled by ships. Lightships were expensive, requiring large crews perhaps fifteen to twenty strong, and hazardous, often endangering crew members' lives. A fixed structure would prove far more economical by comparison with a lightship within just a few years of its construction date. In addition to the various types of lighthouses described in chapter 4, by the twentieth century lighthouses could be built far offshore, like the "Texas Towers." These openwork steel structures are based largely on the design of offshore oil and gas wells and have upper decks housing the light, power plant, equipment and, in some cases, personnel accommodations. In 1967 the last lightship anchored at Ambrose Channel, the entrance to New York Harbor, was replaced by a platform light, which was automated in 1988. Some fifteen towers of this type have replaced the old lightships in American waters in the past few decades.

## Lamps and Lenses

Early light sources for lighthouses, as we have seen, included wood fires, coal grates and candelabra, as used at Eddystone. The next refinement was the introduction of lamps with up to ten wicks, which needed careful trimming and frequent replacement. Soot for the glass chimneys housing the wicks, as well as the reflectors and lenses, required relentless cleaning. Anything that impaired visibility through the thick panes of storm glass that protected the lens from the elements had to be removed. Fuel oil was carried daily from a separate oil house into the tower. Whale oil was used until the

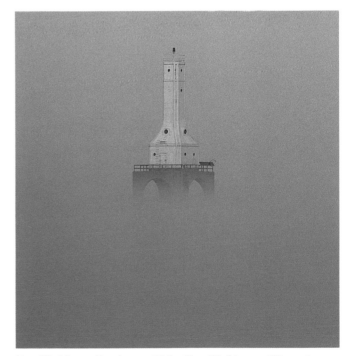

**Port Washington Breakwater Light, Port Washington, Wisconsin**

**Light mechanism, Point Reyes Light, Point Reyes, California**

The study of double refraction was Fresnel's last major contribution to optics. Thereafter, his responsibilities on the Lighthouse Commission absorbed most of his time. He brought the same concentration and inventiveness to the design, construction and location of lighthouses that he had demonstrated in his work on scientific and mathematical theories. His *Complete Works* were published in three volumes in the 1860s, thirty-five years after he died of tuberculosis at the age of thirty-nine. They contained almost everything that was known about optics up to the time of his death in 1827.

The first lighthouse lens Fresnel developed was a "dioptric" system, which combined the use of lenses and prisms. He devised a concentric series of thin lenses in a ring, centered around a bulls-eye lens. Prisms placed in conjunction with these lenses captured light that would otherwise have diffused outward and refracted it into the main light beam. In this way, the available light was concentrated, creating a powerful beam from a much less heavy system than from a similar-strength solid lens. The parabolic reflector, pioneered in the seventeenth century and refined during the 1760s by Antoine Lavoisier, was an enormous improvement over previous light sources because it concentrated the light beam. Fresnel improved his system by adding reflectors, to create a lamp known as "catadioptric" system when combined with the lenses and prisms. This new compound system of reflection and refraction dramatically increased the range of light beam: In a first-order lens, the signal could be seen more than 20 miles away—much farther than a comparable weight of structure using a solid lens, or a system without prisms and reflectors.

Fresnel's lenses were rapidly adopted throughout Europe and, some decades later, in North America. Although few Fresnel lenses remain in service today, a great many have been preserved in nautical and naval museums. However, Fresnel's principle of lenses made from a series of glass rings to concentrate light beams is still used in the production of automobile headlights, spotlights, traffic signals and projectors.

Fresnel lenses were made in seven different sizes called "orders." The largest, first-order lenses, were employed in seacoast towers: Their beams of light were visible for

1850s, when it became too expensive; it was replaced first by lard oil and later by kerosene.

The Argand Lamp, introduced in 1781, had a hollow circular wick and produced an intense smokeless light. In 1789 it was paired with a parabolic reflector and served long and usefully, being adopted and modified later by the French physicist Fresnel.

Jean-Augustin Fresnel was born on May 10, 1788, in Broglie, Normandy. At the age of sixteen, he began studies in engineering. After completing his training, he entered government service as a civil engineer. Fresnel became interested in optics, and his scientific investigations included light interference, diffraction and polarization. He was particularly influenced by the ground-breaking optical research of mathematician Antoine de Condorcet, who pioneered the development of compound lenses built up of concentric lens rings with prismatic cross-sections. Fresnel's most brilliant writings, relating light-polarization phenomena to Thomas Young's hypothesis of transverse waves, were published between 1818 and 1821. They won him unanimous election to the *Académie des Sciences* in 1823 and to the Royal Society of London four years later.

more than 20 miles. Some 6 feet in diameter and 10 to 12 feet high, they weighed more than 4 tons. Fourth- and fifth-order lenses were used mainly for harbor-entrance lights and were about 3 feet high by 20 inches in diameter, a little smaller in fifth-order systems. Each lens was made in brass-framed sections, with numbers inscribed into the frames. They were shipped in sections from their factory of origin in several European locations and were reassembled at their destinations.

Lighthouse lenses were designed to allow adjacent lights to display a characteristic signal that distinguished it from its neighbors. Some lights cast a constant beam, while flashing lanterns varied in time sequences and/or colors. Sequencing was determined by the varying combinations of lighted and blank panels. Rotation systems were also devised for these heavy lenses, supported on ball bearings or, later, mercury baths. Initially, lens rotation was done by a hand-wound clockwork mechanism; later, the process was automated. These advances meant that paired lights, once built routinely to enable the pair to be distinguished from nearby markers, soon became obsolete.

While the lens systems were undergoing these radical changes, so, too, were the light sources themselves and the fuel used to power them. Early fuels, from whale oil to paraffin (a coal by-product introduced in the nineteenth century), were highly flammable. Various gases also came into use for lighthouse lamps in the nineteenth century, and these, usually amplified by an incandescent mantle, were easier to maintain than oil lamps. By the turn of the twentieth century, acetylene was becoming the norm.

In 1901 Arthur Kitson invented the pressurized vapor burner, in which an inflammable gas burned under pressure in an incandescent mantle. Burner technology was advanced by Sweden's Nils Gustav Dalén, who produced his Dissolved Acetylene Gas Burner in 1906. In the absence of electricity, this burner is still the normal method of illuminating unmanned lights. Dalén also invented a solar-activated light-valve that increased the intensity of light as night approached and decreased it before dawn, thereby conserving fuel by almost half.

The early twentieth century witnessed tremendous increases in candlepower, far beyond anything the early

pioneers of illumination had imagined. In the two decades following 1909, a maximum candlepower of 25,500 grew to 930,000. Great advances in safety and maintenance costs were also accomplished, paving the way for the automation of lighthouses. Eventually, most gas-powered lamps were replaced by electrical systems, some incorporating modern solar cells, and their beam was concentrated with lightweight, low-maintenance plastic optical systems.

Through all the vicissitudes of technology, navigational techniques and patterns of traffic on the world's waterways, the lighthouse has maintained its hold on the popular imagination as a symbol of safety and security. It is heartening to see the growing concern about lighthouse preservation and history at a time when many landmarks have been obliterated by the march of "progress," or allowed to fall into ruin through disuse and neglect. These proud features of the manmade landscape have fascinating stories to tell generations to come, and they are eminently worth our efforts to maintain them as monuments to architecture, engineering and our maritime heritage.

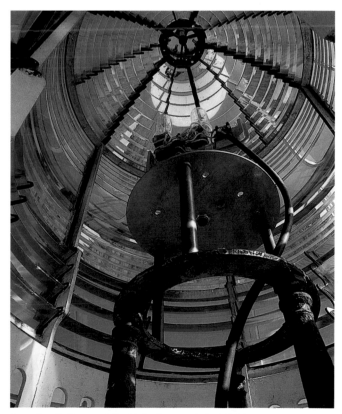

**Lens detail, Presque Isle Light, Presque Isle, Michigan**

**Brier Island Light**

*Brier Island, Nova Scotia*

Just 4 miles long and 2 miles wide, Brier Island is located at the southern end of Digby Neck, on the southwestern side of Nova Scotia. Standing at the entrance to St. Mary's from the Bay of Fundy, which is famous for its high tides, the boldly striped 60-foot lighthouse is the first marker seen by most navigators as they approach the entrance to the bay on the Canadian side. Built in 1944, the red-and-white tower, painted to stand out against the snow, is the second lighthouse on the site: The first was constructed in 1807.

**Holland Channel Marker** *Below*

*Holland, Michigan*

Located on the eastern side of Lake Michigan, Holland Channel Marker is a tall cylindrical tower supported on four sturdy posts at the outer end of the northern pier. The marker is red-and-white striped to make it an effective daymark. The channel to the port of Holland flows between converging breakwaters and eventually reaches Lake Macatawa.

**Nauset Beach Light** *Opposite*

*North Eastham, Massachusetts*

This was once the site of the "Three Sisters of Nauset," the only set of triple lights built in the United States. The first set rose on Cape Cod in 1838 and was replaced in 1892. Eventually, the triple lights were replaced by the existing 48-foot conical cast-iron tower, painted a bright red and white. Erosion often threatens the Nauset tower, and in 1996 it was moved inland, where it continues to flash its automated red-and-white signal.

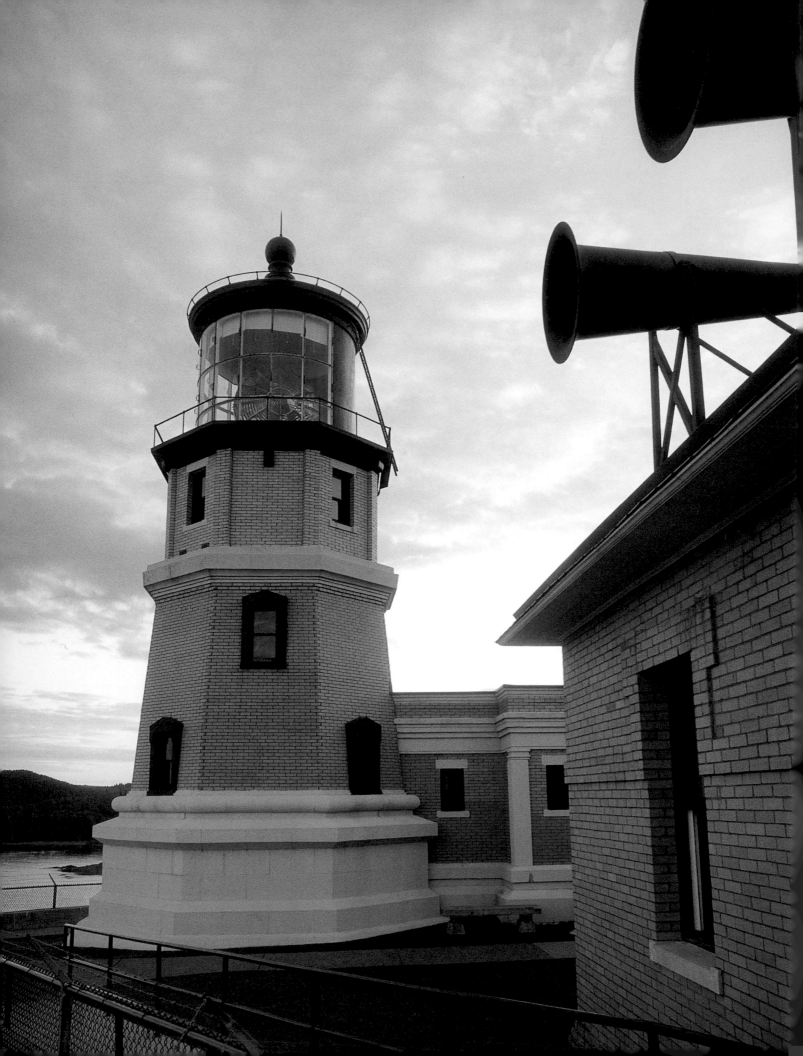

**Split Rock Light** *Opposite*

*Two Harbors, Minnesota*

Split Rock (see chapter 2) is one of the most impressive and frequently photographed of American lighthouses. The area it lights, along Lake Superior, was especially hazardous to mariners because local iron-ore deposits confounded compasses. After a disastrous 1905 storm, the Lighthouse Board had this octagonal brick tower built on a promontory 130 feet above the lake, complete with a separate building that housed diaphone fog horns, an oil house and two storage barns. Finished in 1910, the 54-foot tower was in use until 1969, when the Coast Guard decommissioned it. Restored by the Minnesota Historical Society, the station is now the centerpiece of 100-acre Split Rock State Park.

**Baccalieu Island Light** *Below*

*Baccalieu Island, Newfoundland*

Newfoundland's coastline, where frigid continental air meets the warmer North Atlantic air masses, is often enveloped by fog, and its rock- and reef-studded areas become even more hazardous to mariners. This modest frame station is equipped with powerful automated sound signals that augment the light tower under conditions of low visibility. Supplies must be hoisted up the jagged cliff face to this inaccessible light station, which is guarded today by two keepers and their dog.

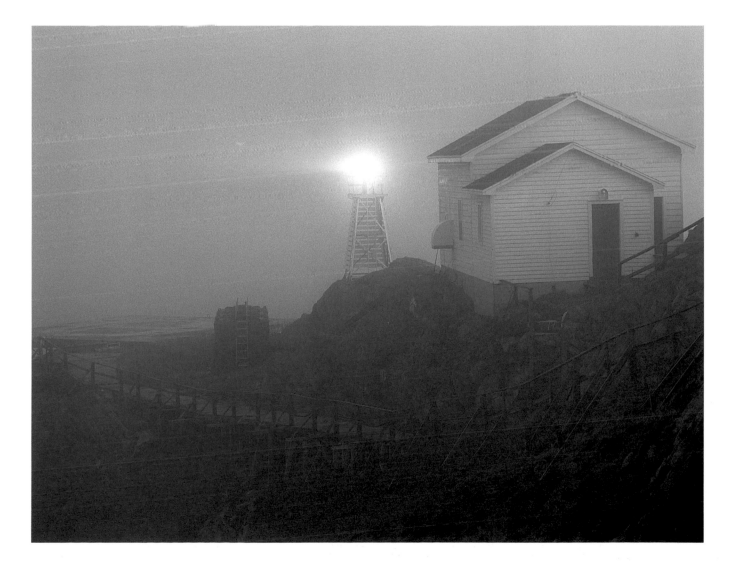

**Lightship Ambrose** *Opposite and below*
*South Street Seaport Museum, New York*
The 488-ton *Ambrose* took up its station at the entrance to the eponymous channel into New York Harbor on December 1, 1908. Built to mark the hazardous shoals and sandbars of this deep bay, the 112-foot-long lightship was a breakthrough in safe passage for the busy harbor's many passenger and commercial vessels. After 1933, the *Ambrose* was moved closer to Sandy Hook, New Jersey, where she served as the *Scotland* lightship until 1963. Each of its two steel masts supported gimbal-mounted oil lamps that were replaced in 1936 with 1,000-watt lamps with 375mm lenses (opposite, top). The main fog horn is mounted on a cylindrical tower amidships (detail, opposite below). In 1968 the Coast Guard transferred the *Ambrose* to New York City's maritime museum.

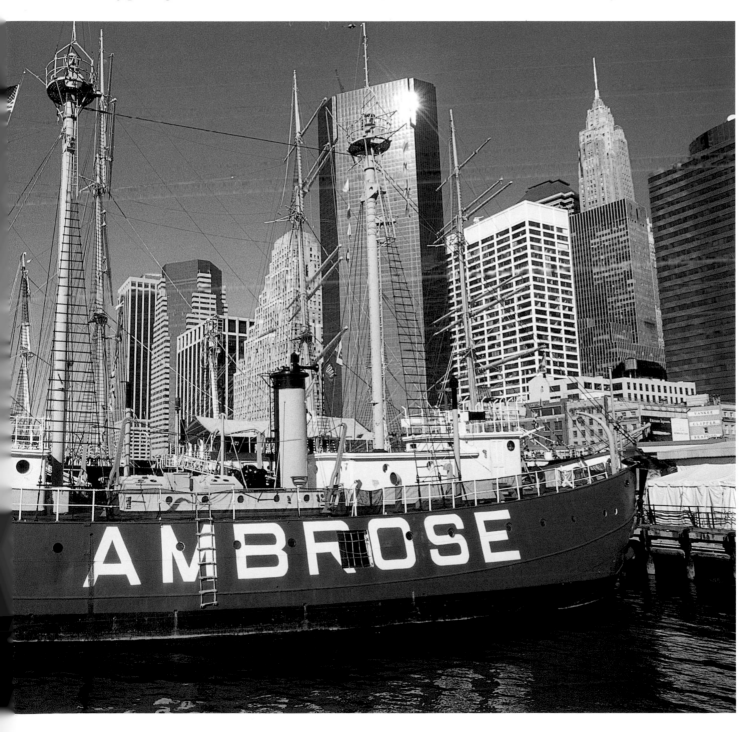

### Lightship Columbia *Below*

*Astoria, Oregon*

The *Columbia* was the last lightship to serve on the U.S. West Coast. It kept its station at the entrance to the Columbia River on the Pacific Ocean, southwest of Washington's State's Cape Disappointment, from 1951 until 1974, when the Columbia River Maritime Museum acquired it from the Coast Guard and moved it to Astoria's waterfront. Built at the Rice Brothers Shipyard in East Boothbay, Maine, the steel-hulled vessel is 128 feet long, with steel light towers and twin diaphone fog signals. Still in operating condition, it has a 7,000-pound mushroom anchor.

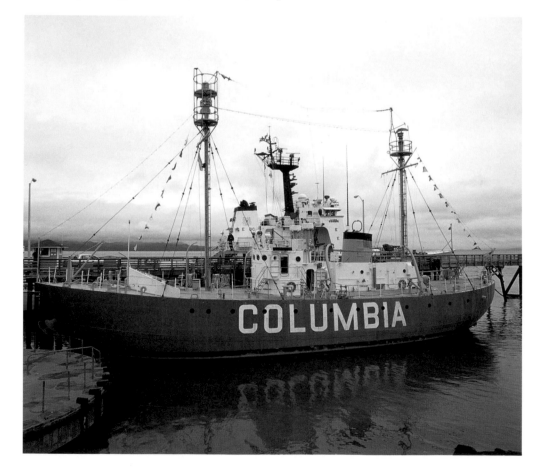

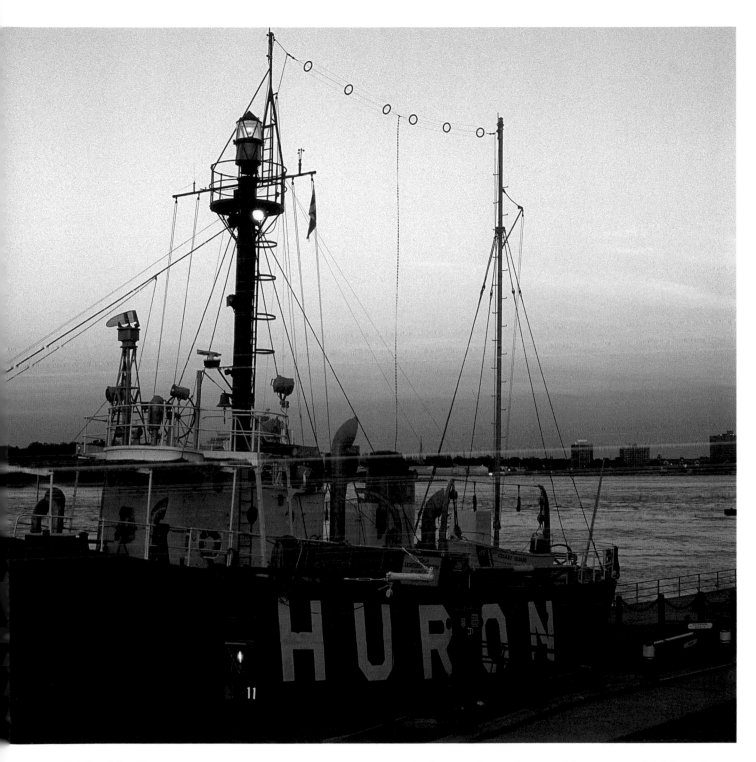

**Lightship Huron** *Above*

*Port Huron, Michigan*

Designated "No. 103" (the order in which it took up its station), Lightship *Huron* first went into service on May 1, 1920, as a relief vessel on Lake Michigan. Built between 1918 and 1920 by the Consolidated Ship-building Corporation, the lightship is 97 feet long, and its lantern has a beam with a range of 24 feet. From 1936 until 1970, it was stationed at Corsica Shoals on Lake Huron. The only surviving lightship from the Great Lakes and the smallest surviving lightship in the United States, the *Huron* was decommissioned in 1970. The City of Port Huron acquired the light in 1971 and docked it on the St. Clair River near Pine Grove Park.

**Lens detail, Cape Blanco Light** *Below*

*Port Orford, Oregon*

The oldest and southernmost of Oregon's major lights, Cape Blanco went into service on December 20, 1870. The 59-foot conical tower stands 245 feet above sea level, and its original first-order Fresnel lens is rated at one million candlepower, visible up to 22 miles. Unfortunately, vandals damaged several prisms in the classical lens in 1992, but it has been painstakingly restored by master optician Larry Hardin of nearby Bandon, Oregon.

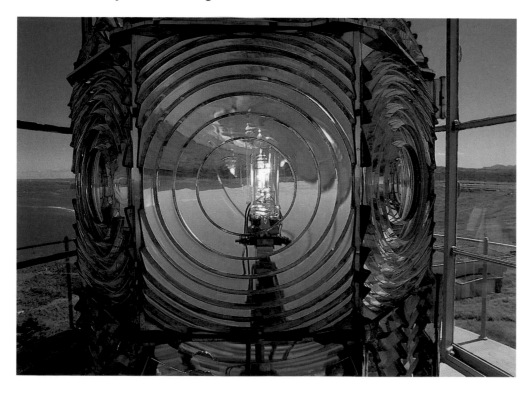

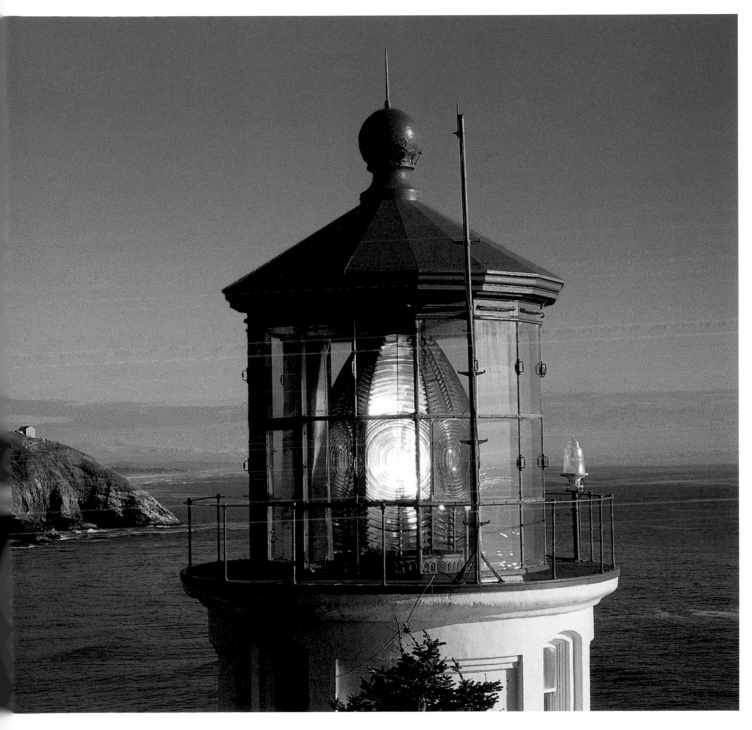

**Heceta Head Light** *Above*

*Florence, Oregon*

First lighted on March 30, 1894, the lantern at Heceta Head Light still has its original first-order Fresnel lens, with a focal plane 205 feet above sea level. An impor-tant making light, it now focuses an automated light visible at 21 miles. Perched on a jagged cliff, the 56-foot conical masonry tower here was built on a scenic headland bearing the name of a Spanish explorer, Don Bruno de Heceta, who first charted the area in 1755.

**Lens detail, Anacapa Island Light** *Above*
*Channel Islands National Park, California*
The original third-order Fresnel lens on this inacces-
sible clifftop site went into service in 1912, focusing an
automated acetylene lamp. The Channel Islands had
posed a danger to shipping here for centuries. The
steamer *Winfield Scott* was wrecked on Anacapa's rocks
in 1853, stranding its 250 passengers for several weeks,
but it would be sixty more years before a skeleton tower
was engineered with materials brought from the main-
land. A new 39-foot masonry tower replaced it in 1932,
when resident keepers were appointed for the first time.
Automated in 1969, the station's Fresnel lens was
replaced with a modern lens, as shown here, in 1991.

### Point Sur Light *Below*
*Big Sur, California*

A powerful first-order Fresnel lens was installed in the 1889 lighthouse at Big Sur, a 50-foot granite tower on a sandstone cliff south of Monterey. Keepers had to climb almost 400 steps twice a day to service the light, which emitted red and white flashes. The station was automated in 1972, when a rotating aerobeacon replaced the original Fresnel lens.

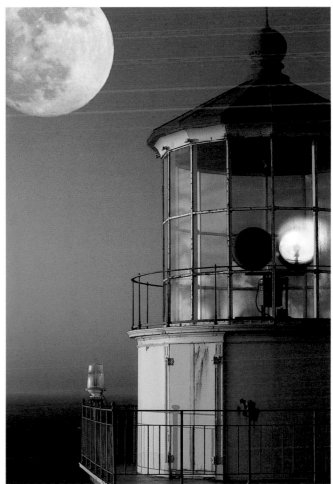

## BIBLIOGRAPHY

Adams, W.H. Davenport. *Lighthouses and Lightships: A Descriptive and Historical Account of Their Mode of Construction and Organization.* N.Y.: C. Scribner and Co., 1870.

Baird, David M. "Lighthouses of Canada," *Canadian Geographic*, 1982, 102(3): 44–53.

Baldwin, Leland B. *The Keelboat Age on Western Waters.* Univ. of Pittsburgh Press, 1941.

Banta, R.E. *The Ohio.* N.Y.: Rinehart & Co., 1949.

Bathurst, Bella. *The Lighthouse Stevensons.* N.Y.: HarperCollins, 1999.

Beaver, Patrick. *A History of Lighthouses.* Seacaucus, N.J.: Citadel Press, 1973.

Bush, Edward F. "The Canadian Lighthouse," *Canadian Historic Sites*, 1975, (9): 5–107.

Caravan, Jill. *American Lighthouses: A Pictorial History.* Phila.: Courage Books, 1996.

Chase, Mary Ellen. *The Story of Lighthouses.* N.Y.: W.W. Norton & Co., 1965.

Clifford, Mary Louise, and J. Candace Clifford. *Women Who Kept the Lights: An Illustrated History of Female Lighthouse Keepers.* Williamsburg, Va.: Cypress Communications, 1993.

Corbin, Thomas. *The Romance of Lighthouses & Lifeboats.* Phila.: J.B. Lippincott Co., 1926.

Crompton, Samuel Willard. *The Lighthouse Book.* N.Y.: Barnes & Noble, 1999.

Crump, Harry T. "Canadian Lighthouse Lens and Fog Systems on the Great Lakes Before Automation," *Inland Seas*, 1993, 49(2): 84–87.

Curtis, Muriel M. "From Santa Marta to Key Biscayne," *Update* (Hist. Assn. of Southern Florida), 1988, 15(2): 12–14.

Davis, Richard A., Jr. *The Evolving Coast.* N.Y.: Scientific American Library, 1997.

Dean, Love. "The Kalaupapa Lighthouse," *Hawaiian Jnl. of History*, 1989, 23: 137–169.

De Wire, Elinor. *Guardians of the Lights.* Sarasota, Fla.: Pineapple, 1995.

Dillon, Rodney E., Jr. "'A Gang of Pirates'": The Confederate Lighthouse Raids in Southeast Florida, 1861," *Florida Historical Quarterly*, 1989, 67(4): 441–457.

Farraday, Michael. *A Course of Six Lectures on the Various Forces of Matter and Their Relations to Each Other.* London: R. Griffin, 1861.

Fazio, Michael W. "Benjamin Latrobe's Designs for a Lighthouse at the Mouth of the Mississippi River," *Jnl. of the Soc. of Architectural Historians*, 1989, 48(3): 232–247.

Gleason, Sarah C. *Kindly Lights: A History of Lighthouses of Southern New England.* Boston: Beacon Press, 1991.

Graham, Donald. *Keepers of the Light: A History of British Columbia's Lighthouses and Their Keepers.* Madeira Park, B.C.: Harbour Publishing Ltd., 1987.

———. *Lights of the Inside Passage: A History of British Columbia's, Lighthouses and Their Keepers.* Madeira Park, B.C.: Harbour Publishing Ltd., 1993.

Grant, John, and Ray Jones. *Legendary Lighthouses.* Old Saybrook, Conn.: Globe Pequot Press, 1998.

Gray, Doug. "Putting Out the Lightkeepers," *Freshwater* [Canada], 1994, 9(1): 3–7.

Hamilton, Harlan. *Lights & Legends: A Historical Guide to Lighthouses of Long Island Sound, Fishers Island Sound and Block Island Sound.* Stamford, Conn.: Wescott Cove Publishing, 1987.

Hardy, W.J. F.S.A. *Lighthouses: Their History and Romance.* N.Y.: Fleming H. Revell, 1895.

Hart, Cheryl. "The Queen's Wharf Lighthouse," *Freshwater* [Canada], 1987, 2(1): 40–43.

Hart, Frederick C. "Keepers of the Matinicus Light: Isaac H. and Abbie E. (Burgess) Grant and Their Families," *New England Hist. and Genealogical Register*, 1994, 150 (October): 391–416.

Hatcher, Harlan. *Lake Erie.* Indianapolis: Bobbs-Merrill Co., 1945.

Hawkins, Bruce. "A Miserable Piece of Workmanship: Michigan's First Lighthouse," *Michigan History*, 1989, 73(4): 40–42.

Heap, D.P. *Ancient and Modern Lighthouses.* Boston: Ticknor & Co., 1889.

Havighurst, Walter. *The Long Ships Passing: The Story of the Great Lakes.* N.Y.: Macmillan, 1961.

———. *Voices on the River: The Story of the Mississippi Waterways.* N.Y.: Macmillan, 1964.

Hefner, Robert J. "Montauk Point Lighthouse: A History of New York's First Seamark," *Long Island Hist. Jnl.* 1991, 3(2): 205–216.

Holland, F. Ross, Jr. *America's Lighthouses: An Illustrated History.* N.Y.: Dover Publications, 1988.

———. *Great American Lighthouses* Wash., D.C.: Preservation Press, 1989.

———. *Lighthouses.* New York: Barnes & Noble, 1997.

International Association of Marine Aids to Navigation and Lighthouse Authorities. *Lighthouses of the World.* Old Saybrook, Conn.: Globe Pequot Press, 1999.

Johnson, Arnold Burges. *The Modern Light-House Service.* Wash., D.C.: Government Printing Office, 1889.

Larabee, Benjamin W., et al. *America and the Sea: A Maritime History.* Mystic, Conn.: Mystic Seaport Museum, 1998.

Majdalany, Fred. *The Eddystone Light.* Boston: Houghton Mifflin, 1960.

Nash, John. *Seamarks: Their History and Development.* London: Stanford Maritime Press, 1985.

Noble, Dennis L. *Lighthouses & Keepers: The U.S. Lighthouse Service and Its Legacy.* Annapolis, Md.: Naval Institute Press, 1997.

O'Connor, William D. *Heroes of the Storm.* Boston: Houghton Mifflin, 1904.

Patey, Stan. *The Coast of New England: A Pictorial Tour from Connecticut to Maine.* Camden, Me.: International Marine, 1996.

Putnam, George R. *Lighthouses and Lightships of the United States.* Boston: Houghton Mifflin, 1917.

Putnam, George R. *Sentinel of the Coasts: The Log of a Lighthouse Engineer.* N.Y.: W.W. Norton & Co., 1937.

Reynaud, Leonce. *Memoir Upon the Illumination and Beaconage of the Coasts of France*, trans Peter C. Hains. Wash., D.C.: Government Printing Office, 1876.

Roberts, Bruce, and Ray Jones. *American Lighthouses: A Comprehensive Guide.* Old Saybrook, Conn.: Globe Pequot Press, 1998.

———. *Eastern Great Lakes Lighthouses.* Old Saybrook, Conn.: Globe Pequot Press, 1996.

———. *Western Great Lakes Lighthouses.* Old Saybrook, Conn.: Globe Pequot Press, 1996.

Rogue, Jean. *Ships and Fleets of the Ancient Mediterranean*, trans. Susan Frazer. Middletown, Conn.: Wesleyan Univ. Press, 1981.

Schmitt, Paul J. "The Last Lightship on the Great Lakes," *Michigan Historical Magazine*, 1996, 80(4): 38–42.

Shaw, Barbara. "There's No Life Like It: Reminiscences of Lightkeeping on Sambro Island," *Nova Scotia Hist. Review*, 1983, 3(1): 64–70.

Smith, Chadwick Foster. *Seafaring in Colonial Massachusetts.* Boston: Colonial Society of Massachusetts, 1980.

Snow, Edward Rowe. *Famous New England Lighthouses.* Boston: Yankee Publishing Co., 1945.

———. *Great Sea Rescues and Tales of Survival.* N.Y.: Dodd, Mead & Co., 1958.

———. *Great Storms and Famous Shipwrecks of the New England Coast.* Boston: Yankee Publishing Co., 1943.

———. *The Lighthouses of New England, 1716–1933.* N.Y.: Dodd, Mead & Co., 1945.

Spencer, Herbert R. "The First Federal Lighthouse on the Great Lakes," *Inland Seas*, 1966, 22(2): 127–128.

Sterling, Robert Thayer. *Lighthouses of the Maine Coast and The Men Who Keep Them.* Brattleboro, Vt.: Stephen Daye Press, 1935.

Stevens, M. James, "Biloxi's Lady Lighthouse Keeper," *Jnl. of Mississippi History*, 1974, 36(1): 39–41.

Stevenson, Alan. *A Rudimentary Treatise on the History, Construction, and Illumination of Lighthouses.* London: J. Weale, 1850.

Stevenson, D. Alan. *The World's Lighthouses Before 1820.* London: Oxford Univ. Press, 1959.

Stick, David. *Graveyard of the Atlantic: Shipwrecks of the North Carolina Coast.* Chapel Hill: Univ. of North Carolina Press, 1952.

Storer, W. Scott, "The Guiding Light of Boston Harbor," *New England Galaxy*, 1977, 18(4): 36–42.

Sutherland, Donald. "The Guardian of Saint George Reef: America's Costliest Lighthouse," *Sea History*, 1992 (63): 20–23.

Talbot, Frederick A. *Lightships and Lighthouses.* Phila.: J.B. Lippincott, 1913.

Terras, Donald J. *The Grosse Point Lighthouse, Evanston, Illinois: Landmark to Maritime History and Culture.* Evanston, Ill.: Windy City and Grosse Point Lighthouse Preservation Fund, 1995.

Twain, Mark. *Life on the Mississippi (1874).* N.Y.: Viking Penguin, 1985.

U.S. Coast Guard. *Historically Famous Lighthouses.* Wash., D.C.: Government Printing Office, 1957.

Van Hoey, Mike. "Preserving the Lights of the Straits," *Michigan History*, 1986, 70(5): 24–30.

Vogel, Mike. "Buffalo: Beacon to the Heartland," *Anchor News*, 1988, 19(5): 84–89.

Weaver, Helene. "John Brown's Imperial Towers: End of an Era," *Inland Seas*, 1992, 48(3): 161–163.

White, Richard D., Jr. "Saga of the Side-wheel Steamer *Shubrick*: Pioneer Lighthouse Tender of the Pacific Coast," *American Neptune*; 1976, 36(1): 45–53.

Wiley, Peter B. *Yankees in the Land of the Gods: Commodore Perry and The Opening of Japan.* N.Y.: Penguin Books, 1990.

Willoughby, Malcolm F. *Lighthouses of New England.* Boston: T.O. Metcalf Co., 1929.

Wilmerding, John. *American Marine Painting.* N.Y.: Harry N. Abrams, 1987.

## ACKNOWLEDGEMENTS AND PHOTO CREDITS

The publisher would like to thank the following individuals for their assistance in the preparation of this book: Jill Ergenbright, Marilyn Holnsteiner and Veronica Langley for supplementary research; Andrea at the Mount Dora Area Chamber of Commerce, Florida; Ngaire Nelson at the Market Square Tourism Bureau, Saint John, New Brunswick; and numerous travel and tourism agencies and historical societies across the continent.

Particular thanks are due to the photographers and agencies listed below for permission to reproduce the photographs on the following pages: © **Tony Arruza:** 13, 20, 40, 48–49t, 89, 109, 136–37, 152–53, 203; © **2000 Kindra Clineff:** 2, 8, 15, 34–35, 60–61, 65, 71, 82–83, 143, 182–83; © **Cameron Davidson:** 29; © **Robert Drapala:** 38, 41, 43, 50, 62, 63, 72, 73, 128, 134, 146, 147, 160, 173, 174, 175, 176, 177, 178, 179, 180b; © **Ric Ergenbright:** 76–77, 120–21, 181t; © **Rudi Holnsteiner:** 24, 46, 47, 49b, 92, 95, 194, 198, 206, 207, 208, 209t, 210, 211, 213, 218, 219, 226, 231, 234, 237, 239, 249, 250, 251; © **Rod Patterson:** 52; © **Chuck Place:** 4–5, 16, 25, 51, 68–69, 99, 104, 105, 115, 165, 187, 188, 189, 238, 252, 253; © **John Sylvester:** 1, 14, 18–19, 53, 54–55, 64, 70, 75, 80–81, 86–87, 88, 94, 96–97, 101, 106–107, 108, 110–11, 112–13, 116, 117, 122, 123, 124–25, 142, 144–45, 155, 156–57, 184–85, 186, 190–91, 240–41, 245; © **2000 Charles J. Ziga:** 3, 6–7, 10–11, 17, 21, 22, 23, 26, 27, 30, 32, 36–37, 42, 44, 45, 56, 57, 58, 59, 66, 67, 78–79, 84, 85, 90–91, 93, 98, 100, 102, 103, 114, 118, 119, 126–27, 129, 130, 132–33, 135, 138, 139, 140–41, 148–49, 150–51, 154, 158–59, 163, 166, 167, 168, 169, 170–71, 172, 192, 195, 196, 197, 199, 200–201, 202, 204, 205, 209b, 212, 214, 215, 216–17, 220–21 (both), 222–23, 224, 225, 227, 228–29, 230, 232–33, 236, 242, 243, 244, 246–47 (all), 248; **Library of Congress, Prints and Photographs Division:** 9, 33.